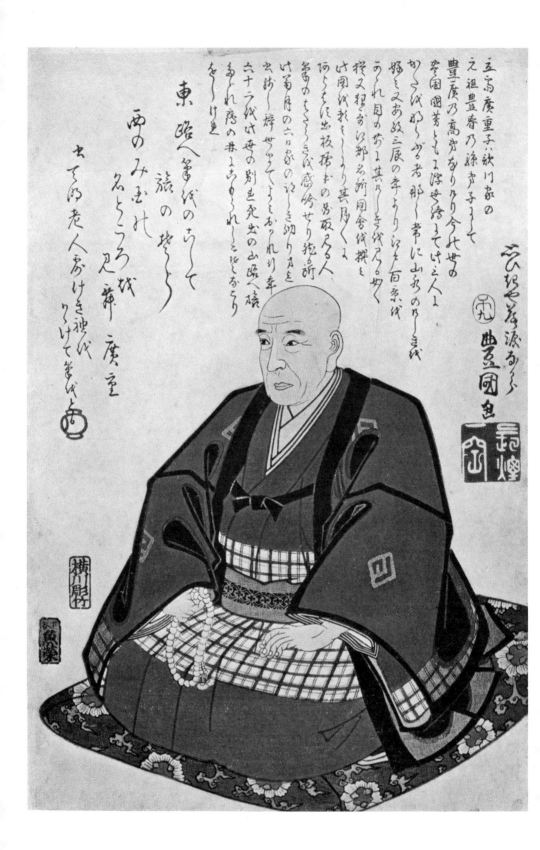

HIROSHIGE'S WOODBLOCK PRINTS

A Guide

by
EDWARD F. STRANGE

Dover Publications, Inc., New York

To
J. J. and D. J.
A Recognition

FRONTISPIECE

MEMORIAL PORTRAIT OF HIROSHIGE. By KUNISADA.

Signed, Toyokuni. *Dated*, Horse Year, 9th month (A.D. 1858). *Publisher*, Uwoyei.

From a print in the British Museum.
(See color plate A.)

Published in Canada by General Publishing Company, Ltd., 30 Lesmill Road, Don Mills, Toronto, Ontario.

Published in the United Kingdom by Constable and Company, Ltd., 10 Orange Street, London WC2H 7EG.

This Dover edition, first published in 1983, is an unabridged republication of the Edition de Luxe (limited to 250 copies) of the work originally published by Cassell & Company, Limited, London, n.d. [1925] with the title *The Colour-Prints of Hiroshige*. In the present edition, all the original color plates are reproduced both in black-and-white and in color, and there has been one small rearrangement of plates but no omissions.

Manufactured in the United States of América
Dover Publications, Inc., 180 Varick Street, New York, N.Y. 10014

Library of Congress Cataloging in Publication Data

Strange, Edward Fairbrother, 1862–1929. Hiroshige's woodblock prints.

Originally published: The colour-prints of Hiroshige. London; New York: Cassell & Co., 1925.
Includes index.
1. Ando, Hiroshige, 1797–1858. I. Title.
NE1325.H6S7 1982 769.92′4 82-9458
ISBN 0-486-24412-1 AACR2

PREFACE

IT is a very pleasant duty to record my acknowledgment of the great assistance I have received in the preparation of this volume, from many friends both in this country and in Japan. My best thanks are due in the first instance to Mr. J. S. Happer of Tōkyō, whose efforts on my behalf have been untiring and disinterested to a remarkable degree. All students of the work of Hiroshige are under a great obligation to Mr. Happer, who was the first to draw attention to the important seal dates on the prints of that great artist, and to their significance ; and who also first clearly indicated the distinction between his individuality and that of his principal pupil. To this public service he has added, very largely for my benefit. He placed at my disposal, in the most generous manner, not only the material already published by him, but a large mass of information which he has since acquired ; and assisted me further by prosecuting researches among his expert friends in Japan, and by procuring and editing translations of matter not obtainable elsewhere. I am also indebted for assistance in various forms, to Mr. S. Watanabe for permission to use the invaluable information contained in the Catalogue of the Hiroshige Memorial Exhibition, held at Tōkyō in 1918, and to the editors generally of that rare but indispensable work ; as well as to Mr. H. Shugio, Mr. Mihara, Mr. Minoru Uchida and Mr. K. Matsuki, for their most useful assistance. The sale catalogues issued at various times by Messrs. Sotheby, Wilkinson and Hodge should also be mentioned.

Dr. Jonathan Hutchinson, F.R.C.S., generously placed his original sketch-book, with diary notes, at my disposal ; and Sir Leicester Harmsworth, Bart., Mr. Oscar Raphael and Professor William

PREFACE

Bateson have lent prints and drawings for reproduction from their collections ; while I have also had the privilege of reproducing examples from the collections in the British Museum and the Victoria and Albert Museum ; in the latter case I must especially acknowledge the help of Mr. Martin Hardie, R.I., R.E., and of Mr. L. W. Michelletti. In the preparation of the Catalogue, and assistance in translations, my best thanks are due to Messrs. K. Murakami and S. Kato ; and to Mr. Sotaro Nakai for his illuminating appreciation of Hiroshige with which the text concludes.

In conclusion I would pay a tribute to the work of other students of the subject, and particularly to the late Edgar Wilson and to Mr. Arthur Morrison, who shared my early investigations into the question, and to the later writings of Mr. Yone Noguchi, Mr. Laurence Binyon, Major Sexton O'Brien and Mr. Kojima Osui.

<div align="right">EDWARD F. STRANGE.</div>

CONTENTS

CONTENTS

LIST OF ILLUSTRATIONS

In the present edition, the color plates appear in black and white at their original locations in the book, and are repeated in color in the color section following page 14.

COLOUR PLATES

LIST OF ILLUSTRATIONS

LIST OF ILLUSTRATIONS

LIST OF ILLUSTRATIONS

THE COLOUR-PRINTS OF HIROSHIGE

CHAPTER I

TECHNIQUE AND HISTORY OF JAPANESE COLOUR-PRINTS

IN order fully to appreciate the work by which the Japanese artist, Hiroshige, is best known, a clear understanding of the technical processes involved is absolutely necessary. The social and artistic environment in which he lived also merits attention, as well as some slight outline of the conditions which led up to it.

The colour-prints which have deservedly won so high a reputation throughout the civilized world, and are beginning even to attract the notice of educated people in Japan, were produced by a method with which we find the earliest parallel in the so-called *chiaroscuro* prints made in Italy and elsewhere during the sixteenth century ; for these, too, were done from boldly cut wood-blocks with a separate printing for each colour. The Chinese seem to have had the process before it became established in Japan ; and, although the art of engraving on wood goes back in both countries to a date far earlier than that of the European productions, it seems quite possible that the hint embodying the essential feature of the Far Eastern colour-print was derived from the prints of sacred subjects taken out by the Jesuit Fathers. Those who went to China, at all events, were keenly interested in the arts and sciences, as their published works show ; and they are known in more than one instance to have imparted a considerable amount of worldly learning to their hosts.

The method used in the production of Hiroshige's prints had no great antiquity, so far as Japan was concerned ; for its beginnings cannot be placed much earlier than about the year 1744. Some

twenty years later, under the auspices of Harunobu, assisted by the engraver Kinroku, and the printers Ogawa Hatcho and Yumoto Yukiye, it may be said to have reached its fullest technical development, subject, of course, to variations due to the personality of the men who used it. And that method may shortly be stated as follows :

A Japanese colour-print was the product of three separate operations, carried out by different individuals, viz. : The artist who made the design, and whose name it bears ; the engraver who cut the blocks ; and the printer. In this sense, it furnishes a quite remarkable example of the harmonious and efficient co-operation of distinct classes of craftsmen. The designer—Hiroshige certainly— began by making a rough sketch or note of his subject. This would be re-drawn and elaborated, in clean line, on thin paper, to the scale selected for publication ; the drawing being done with the brush and, as a rule, almost entirely in black. On paper of this slight substance, correction in the methods used by our artists was impossible. When necessary, and only to a small extent, it was effected by re-drawing the portion of the design concerned and pasting it over the first version. How far a completed version, in full colour, was first made by the artist, it is difficult to say ; but, judging from the very few examples that seem to have survived, this was not the general practice.

The drawing in line now went to the engraver, who pasted it, face downwards, on a block of cherry-wood (*yamazakura*), using a weak rice-paste for this purpose. The paper was then rubbed away sufficiently to enable all lines to be seen clearly, a little oil being used, if necessary, to render them more visible. The outlines were incised with a sharp knife, and the superfluous wood removed with chisels or gouges, so as to leave the design in clearly defined relief. Registration marks for printing (*kento*) were cut at the same time— consisting simply of a right angle at one corner and a vertical line at one side ; as well as such inscriptions, signatures or seals as were desired to appear in black on the finished print. The wood, it should be said, was cut plank-wise, and not across the grain in the manner practised by the later European engravers. Moreover, great care was taken in the selection of it ; and the engraver must be given the

credit (unless he was very closely supervised by the artist) of choosing, frequently, blocks for particular parts of the design, with a grain that substantially added to the effect of the latter. The names of few engravers are known ; but the beauty and precision of their work claim a larger meed of recognition than they have ever yet received.

So far, however, we have only completed one block—the key-block of the design. This now goes to our third craftsman, the printer, who takes from it a number of proofs. His method is simple, involving the use of no mechanical device whatever. The ink is laid on the block, and the paper on that. The impression is then rubbed off with a convenient tool (the *baren*), consisting merely of a coil of cord made of bamboo-sheath fibre, stiffened with card and enclosed within bamboo sheath, the turned-up ends of which form the handle. For accuracy of register and quality of colour the printer relies on his craftsmanship alone, except for the guiding marks on the block mentioned previously.

From the key-block he takes proofs to the extent of one for each colour proposed to be used. On these the artist, so to speak, dissects his design, and indicates on each the precise portion allotted to it. The engraver proceeds to make a corresponding set of blocks, so that we have now a key-block for the black lines and another block for each colour. The printer does the rest. He it is who arranges the colour on the various blocks—wiping off to produce that exquisite gradation on which Hiroshige relied more than any of his fellows. It is he who is responsible for the variations in degree of this gradation, which the student will note in comparing one impression with another. To what extent the artist supervised the printing we do not know. In Hiroshige's best period—from, say, that of the First Tōkaidō to about 1850—we must think that often he did so, so tender, so admirably conceived are the colour-schemes in the outstanding examples, and so high the average of merit throughout. Surely he must, at least, have coached his printers, trained them to his methods. These methods vary—one has only to compare the colouring of the First Tōkaidō with that of the Biwa Series, the Yedo Kinkō Hakkei, the Eight Kanazawa and the artist's own work in the Kisokaidō, to be convinced of the deliberate intention

underlying the colour-design, and the infinite variety of it. Yet we must praise the printer, for he was the craftsman who placed this tool in the hands of the Master. Later, these qualities decline. The colour is thick and coarse. There is no evidence of mastery, of originality. The printer had arrived at a convention and was allowed to adhere to it. In truth, even this is better work than Western colour-printers have ever yet been able to do. But think what might have been made of the " Hundred Views of Yedo," or any other of the parallel series, if the colours and printing had been equal to those of the *Ōmi Hakkei*. Hiroshige was then, however, probably more concerned with other things—and his chief pupil had little imagination, although competent enough in the bare technique of colour-prints.

From that technical point of view, then, the Japanese colour-print may be said to have consisted simply in a print produced from a key-block in black and a succession of impressions in colour, each from a separate block. This production necessarily stated the design of the artist in terms of a series of flat printings, perfectly even in colour and tone, but for such modifications as were capable of being produced by the grading of the flat tint when laid on the block. There is no shading, no blending of colour, practically no over-printing. Yet within the stringent limits thus created, and by the use of the most simple, almost elementary conventions, Hiroshige was able to express distance, atmosphere—indeed, the whole gamut of Nature's music—in a way that has never been surpassed by any other practitioner of any of the graphic arts.

The relationship of the three classes of craftsmen concerned with the publisher is not very clear ; probably the latter provided and controlled the engraver and printer. Almost always he was careful to put his own seal or label on the prints, and he appears to have been the owner of the blocks. Incidental references seem to suggest that, at times, he went so far as to maintain the designers— in order to get work out of them which they had contracted to supply ; but there is no evidence that Hiroshige was ever entangled in this manner. No record has come to light of the wages paid to any of the craftsmen, though one of the diaries printed in Chapter VIII gives a

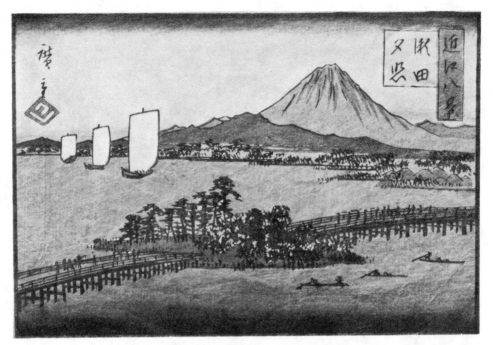

EVENING GLOW AT SETA.

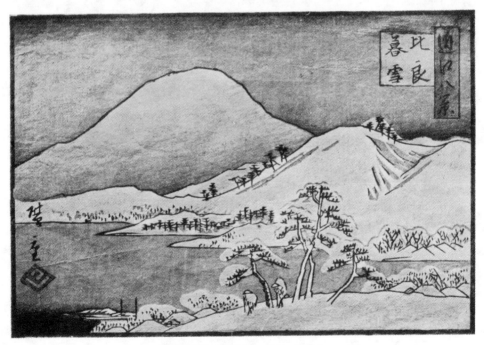

EVENING SNOW AT HIRA.

From a series, Ōmi Hakkei ("Eight Views of Biwa").

note of Hiroshige's earnings for other work. Neither do we know the prices at which the prints were sold ; but they must have been very small. Several prints by Hiroshige illustrate, casually, shops or tea-houses where prints of various kinds were put on sale, and probably the chief method of distribution was through the latter. The people who bought them were those of the lower social orders and perhaps the lesser degrees of retainers of the daimyō. Lafcadio Hearn gives an instance of the work of Hiroshige being offered to him for purchase in a settlement of that curious pariah class of Japanese who were so far outside the pale as to live in their own communities apart, and who ranked even below the lowest of the artisans and labourers.

One authority states that an edition of Hiroshige's work con- sisted as a rule of 200 prints only; but this can hardly have been the fact. Certainly successive editions, sometimes with and sometimes without alterations, were issued of the more popular series ; as a rule, each marked by blurred outlines, inferior colour and other signs of decadence and wear and tear. Often the blocks changed hands, and later editions appear with the imprint of a new publisher. Alterations of this kind were easily within the skill of the Japanese craftsman. He cut out the original seal or mark and plugged the new one into the place (or elsewhere) so cleverly that signs of the operation can very rarely be detected. Cases will be observed where the issue of a set of prints extended over several years, and also where complete editions were published in volume form. The Japanese public collected them and bound them in albums, generally without having taken care to complete sets by individual artists and often not even to obtain or to put together the separate prints constituting three- or five-sheet subjects. For instance, we have seen an album inscribed by the owner, Mori Takamune of Ōsaka—" I had great trouble to collect all of these but at last succeeded in completing it in the 3rd year of Bunkyū [1863]. Bound by Watanabe." Two-sheet prints are relatively scarce ; but Hiroshige made several in his earliest period and a few, and those of his best, in *kakemono-ye* form when he was at the height of his powers. *Surimono*, or presentation cards for special occasions, are described elsewhere in this volume. The

only technical difference in the making of them—and that not exclusively confined to this class—is a liberal use of *gauffrage*, or blind printing, which produces an indented, uncoloured line on the soft thick paper generally used. It has been incredibly said that this was done, or partly done, with the point of the elbow ; but no doubt some more suitable tool was employed, and one harder than the *baren*, to rub the paper into the block so deeply as to procure the desired result.

One other variant must be mentioned, the *aizuri* or blue print. This is merely a matter of colour-scheme and does not involve any other alteration of technique than the selection of the suitable colour. In this class the print is almost entirely executed in a fine blue, though other subordinated colours may appear on quite a small scale. *Aizuri* belong almost, we think, entirely to that part of the nineteenth century which closed soon after 1860. Yeisen, Kunisada, Kuniyoshi and some others indulged in them with remarkable success ; and there are few things more essentially decorative than the somewhat uncommon examples in this style by these artists. The blue is, as a rule, very good, and may be said also to be characteristic of the above-named period, whether in *aizuri* or in more usual combinations. It is an indigo said to have been obtained by extraction from old textile fabrics. The limitation of the colour-scheme was due to a sumptuary regulation issued by the Government.

While on this point, we may remark that the colours used by the Japanese printers were chiefly of natural vegetable or mineral origin, up to the final period of decadence ; when imported European colours begin to make their appearance—a particularly offensive aniline violet, which runs in water, being the first, and a sure indication of late date. The paper was tough and semi-absorbent, made from the inner bark of a species of mulberry; for printing it was slightly damped. A detailed account of the whole process will be found in a pamphlet compiled by the author for the Victoria and Albert Museum, " Tools and Materials illustrating the Japanese Method of Colour-printing " (2nd edition, 1924).

Hiroshige made a few *aizuri*, chiefly fan-prints, which are extremely rare and very beautiful in effect. In most of these he uses

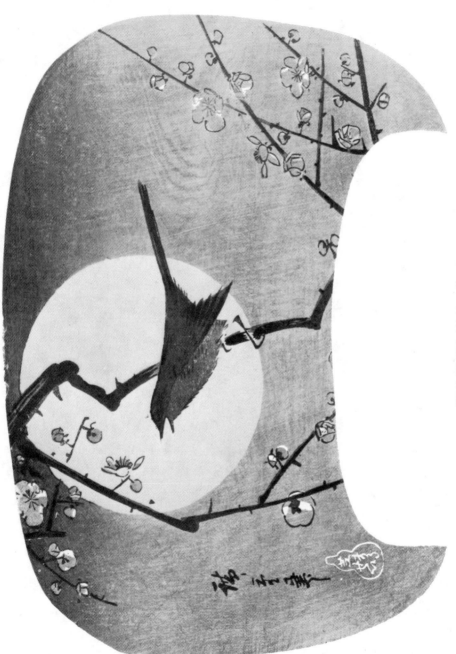

FAN-PRINT (*Uchiwa Shape*).

Nightingale. Full Moon and Plum-blossom. *Publisher*, Marusei.

red for both title and signature-panel, or for one of them. In the Victoria and Albert Museum are also two original blocks cut with designs by him ; a key-block for a subject in an early lateral set of prints entitled *Tōto Meisho Saka Tsukushi-no Uchi Yedo*—" Series of Steep Roads in Yedo "—which it is interesting to note was afterwards used (on the reverse) for one of a set of views by Hiroshige and Kunisada. The other is the key-block for a half-plate Tōto Meisho —"View of Yedo "—the reverse of which has been used for one of the colour-blocks. The economy of material is interesting, and other examples of it have been noted. Both blocks were presented to the Museum by Mr. Happer.

The seals and marks (other than inscriptions) appearing on prints of the period under notice are of four kinds, viz. : that of the artist, generally placed below or near his signature ; the imprint of the publisher, which may either be a seal of ordinary Japanese type; his name, with or without his address, in a small compartment; or a trade-mark constituting a sort of abbreviated cypher of his trade-name and having a sort of distant relationship to the *mon* or crests of the well-born. By way of analogy, one recalls the merchants' marks, also often embodying an indication of name, which were in use in England in the fifteenth and sixteenth centuries. In addition to these is a class of marks of very great importance, the seal-dates, consisting of the zodiacal animal signs for the recurrent cycles of twelve years which were a feature of old Japanese chronology. With these is the number of the month—so that one reads, for example, one of them as " Snake 4," meaning 4th month of the Year of the Snake—which might be 1845, 1857 or 1869 and so on. Beyond consideration of style, etc., there is thus no means of dating a print bearing one of the marks, except within one of the cycles of twelve years ; but external evidence of this kind generally affords a safe clue. And in one year the necessity of rectifying the error in the lunar calendar used by the Japanese and Chinese, by the inter-position of an additional or intercalary month, fixes its date quite definitely: for the addition of the intercalary sign *uru* to the Year of the Rat establishes it as 1852—that being the only Rat year between 1842 and 1858—in which this occurred. Mr. J. S.

Happer first brought this important fact to the notice of Western students of colour-prints, and especially its bearing on the dating of prints by Hiroshige, in his preface to the sale catalogue of his collection issued by Messrs. Sotheby, Wilkinson & Hodge in 1909. Major J. J. O'Brien Sexton has since explored the subject in great detail ; and his chronological tables now published[1] give much additional information. Such seal-dates occur now and again in quite early prints ; but most of those found in Hiroshige's works belong to his later period—from about 1852 onwards.

The last group of seals throws a curious and interesting light on the circumstances attending the publication of colour-prints. No nation ever experienced so rigid and far-reaching control by its Government, as that enforced—so far as possible—by the Government of the Shōgun. Sumptuary laws of the most stringent character were enacted; and, in some instances dating far back into the almost legendary history of the country, industries were regulated to an astonishing extent. The quantities of material to be used, for example, in making certain articles of lacquer-ware, were laid down by decree, as early as the tenth century of our era. Some sort of censorship[2] of printed matter generally and of colour-prints in particular was imposed during the eighteenth century and was carried out, in Yedo, by the municipal authorities, whose approval of a design was necessary before it was allowed to be engraved. This was called for, both on grounds of public morality and to prevent attacks on the Government ; and its effects appear on the prints in the form of the *kiwame* (approval) seal, which is commonly found thereon. In 1790 the censorship appears formally to have been placed in the hands of the Wholesale Publishers' Guild, who nominated members to see it carried out. In 1842 and henceforward the seals of the censor appear as well as and sometimes in combination with the seal of approval ; after 1852 there are generally two censors' seals in addition to the date-stamp already mentioned.

By far the greater number of prints made by Hiroshige are

[1] "Japanese Colour-prints." By L. Binyon and J. J. O'B. Sexton, 1923.

[2] Major O'Brien Sexton (*op. cit.*) gives a full account of the censorship and reproduces many specimens of seals.

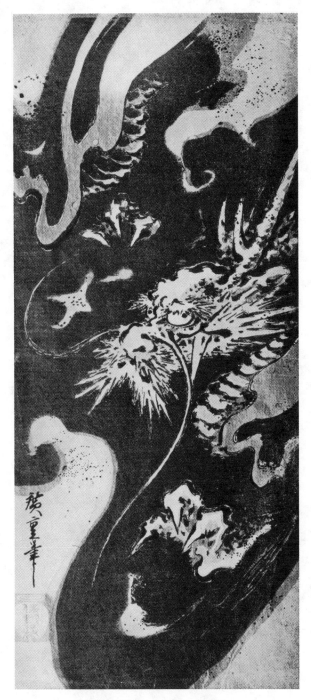

DRAGON IN CLOUDS.

Signed, Hiroshige. *Seal*, Sanoki (*Publisher*).

single-sheet designs, though it is curious that a few of his earliest efforts were of the 2-sheet lateral form. He seems to have made none of the interesting *hashirakake*, those long, narrow, upright compositions which are said to have been used as decorations for the vertical timbers of houses ; though the *kakemono-ye*, compositions of two vertical sheets placed one over the other, inspired him to some of his best efforts. Such prints were often actually mounted with rollers and formed a cheap substitute for paintings in the orthodox manner, though most specimens that one sees on this side of the world have been, as a rule, removed from these accretions, if ever they had them. Occasionally, from an early date, he made 3-sheet prints, almost always consisting of vertical panels placed side by side ; the view of the Asakusa Temple Festival, described elsewhere, may be the first of these, and other views of temples also come high on the list in order of appearance. Towards the end of his life many such were made, both entirely by himself and also in collaboration with his friend Kunisada, who supplied figures for the landscape settings of Hiroshige. The 3-sheet prints of the Ukiyoye artists generally have a remarkable characteristic, which is also found in those of Hiroshige: if the sheets are taken separately, it will be found that, from the point of view of composition, they can almost always stand alone, and in our eyes will make quite satisfactory pictures. This is no doubt due largely to our imperfect appreciation of the subject, so that we fall back on the mere mechanics of the design ; but the fact that the artist carried out his work in terms of separate units must also be a factor in arriving at this result. In no circumstances, so far as we are aware, was a single block used for a design of 3-sheet size, although there are one or two late examples of dimensions somewhat larger than and otherwise varying from the standard *ōban* ; and, of course, many smaller.

We have referred in the foregoing paragraph to the Ukiyoye School of Artists. This was the name given to the whole group to which Hiroshige belonged ; and it may be freely translated " Mirror of the Passing World." The group includes some painters as well as practically all the makers of colour-prints ; and derives its title from the fact that they delineated subjects drawn from

the life of the common people—subjects considered, by the aristo-
cratic and cultured classes of society, in most cases with reason, as
essentially vulgar—though this censure, from our point of view,
cannot be applied to many of the theatrical prints or to the landscapes.
But it presents a remarkable and solitary instance of a beautiful art
entirely restricted to, and enjoyed by, the lower orders of a highly
developed civilization, and practised by artists who ranked none too
high even among their fellow-artisans.

THE SIZES OF PRINTS

Most of the prints designed by Hiroshige are of what may be
termed a standard size, ruled by that of the paper used generally
by the printers. This standard paper averaged about 15 by 10 inches
(say 375 by 255 millimetres), but the actual design as a rule is nearer
to 14 by 9 inches. In many cases a border has to be allowed for ;
often, the seal of the censor and sometimes the publisher's mark is
placed in the margin, outside the limits of the composition. Prints of
the above dimensions are termed *Ōban* ; those in which the com-
position is horizontal being described as *Ōban Yokoye*, the vertical
as *Ōban Tateye*.

Prints half the size of *Ōban* are termed *Chūban* ; quarter-size
prints, *Yotsugiri*, the same terms being used to signify the arrange-
ment of the composition.

Larger designs consist of multiples of the *Ōban* ; either 2-sheet
subjects—*Kakemono-ye* where one vertical print is placed above
another as in the famous " Snow Gorge," or *Sammai-tsūzuki* when
three sheets of *Ōban* size are joined—again with the addition
Tateye where the composition consists of three vertical panels side
by side as in the " Naruta Torrent," or *Yokoye* formed with three
horizontal panels as in " The 47 *Rōnin* Crossing the Bridge."

Ō-tanzaku are narrow vertical prints about 15 by 6½ inches.
The standard paper, *Ōbōsho*, was made in sheets large enough to
provide two *Ōban*. This paper would cut into three *Ō-tanzaku*,
which were about the size of the prints called *Ōban Hoso-ye* before
the time of Hiroshige. The *Chū-tanzaku*—the same height but

slightly narrower—was made from a sheet of *Ōbōsho* cut into four. A still smaller panel of similar proportion, the *Kō-tanzaku*, averages about 13 by 4 inches.

Aiban is a size smaller than *Ōban* but larger than *Chūban*— about 13 by 8¾ inches.

It is convenient here to refer to the *Harimaze*, or Mixed Prints. Hiroshige produced several series of these, consisting of sheets of *Ōban* size, each with several designs of varying size. These have often been cut up, and the separate designs may, at first sight, be taken for individual compositions of unusual dimensions.

CHAPTER II

THE LIFE OF THE ARTIST

WE have but a bare outline of the biographical facts of Hiroshige's life. His father was the third son of Tokuyemon Tanaka, a teacher of archery in Yedo, who was formerly a chief page in waiting on the daimyō of the Tsugaru clan ; and (as Mr. Minoru Uchida states)[1] was called Tokuaki Tanaka. Later, he was adopted into the family of Andō, taking the new name, Genyemon Andō. In spite of this change, Mr. Uchida remarks that Genyemon's family tombstones still retain the old family name of Tanaka and that a few of Hiroshige's prints bear it in seal form. Genyemon held an official appointment, which appears to have been of the kind that, in the closely-knit social system of old Japan, were confined to the members of particular families—the *hikeshi-dōshin*, or fire-police. He was attached to the fire-brigade station on the bank of Yayesugashi, in Yedo.

Hiroshige's family, then, were of humble station in life. The firemen, or, perhaps more correctly, fire-police (*hikeshi-dōshin*), were officials of sorts ; and, as such, had some measure of authority and influence as compared with unofficial persons of their grade in the Japanese social scheme—influence which was, later on, so far serviceable to the artist as to procure him the opportunity of making his first journey over the Tōkaidō. The duties had become almost nominal in the general slackness which characterized the last phase of the Tokugawa regime ; and it is related that these fire-police occupied most of their time in amusements, in gambling, or in the practice of such easy arts as lay within the scope of comparatively uneducated folk. Thus, some achieved quite a reputation as amateur artists, makers of *surimono*, for instance, carvers of *netsuke*, practitioners of the tea-ceremony, or members of the clubs of artisan-poets,

[1] Memorial Exhibition Catalogue, p. 9.

who embellished their periodical meetings or picnics with the pro-
duction of simple verses, popular or even cheerfully vulgar in style
and form. Hiroshige's friend and contemporary, Okajima Rinsai,
was one of these, and also a member of the *hikeshi-dōshin*. Shigenobu
was another, and owed his later connexion with Hiroshige to the fact.

In this environment Hiroshige was born in the 9th year of the
Period Kwansei (A.D. 1797) ; and the circumstances of his earlier
years are not without some importance, when one considers the
effective use made in some of his best designs of the look-out towers
used in Yedo by the firemen of his day.

In the normal course of events, Hiroshige—or, to give him the
name that belonged to this period, Tokutarō Andō—would have
followed, throughout his life, his father's occupation ; and the world
would have lost, thereby, a great artist. But in 1809 both his father
and his mother died. He had, almost from infancy, displayed his
inclination towards art ; and his father had already arranged for him
to have lessons from a friend and neighbour, an amateur painter
named Okajima Rinsai. In his fifteenth year he desired greatly to
become a pupil of Toyokuni ; but the studio of the great man,
then at the height of his popularity, could not accommodate him ;
and he joined that of Toyohiro, who had been a fellow-pupil of
Toyokuni under Toyoharu. Here he progressed so rapidly that
within the short space of a year his master, in accordance with the
custom of the profession, formally admitted him to membership of
the Utagawa fraternity, his diploma, in Toyohiro's own writing,
giving him the artist-name of Utagawa Hiroshige, being dated the
9th day of the 3rd month, Period Bunkwa, 9th year (March 9,
1812). This document was known recently to be still preserved in
a private collection in Tōkyō. Whether it has survived the disaster
of 1923 has not yet been ascertained.

Hiroshige, then, had already attained the status, such as it was,
of a designer of colour-prints, in 1812 ; but he still held his post of
fireman—though to what extent he performed the duties we cannot
even conjecture. It was not until 1823 that he resigned his appoint-
ment. Before this date he had married a woman of *samurai* descent,
said to have been " a gentle woman possessed of every feminine

virtue and of a graceful mien characteristic of refined family."
She died in 1840 ; but her son Nakajiro had already been born
when Hiroshige left the fire brigade. The post was filled tem-
porarily by a kinsman, Tetsuzō Andō, until, in 1832, Nakajiro was
old enough to resume it. As Hiroshige himself was then only
thirty-six years of age, the duties cannot have been very onerous,
if they could be taken on by a boy so young as Nakajiro must
then have been.

One cannot ignore the significance of this latter event. The year
1832 was not only that in which Hiroshige definitely established
his son in his hereditary calling, but was also that of his first journey
from Yedo to Kyōto along the Tōkaidō Road—the journey which
produced the most famous of all his works, the first and greatest
series of his " Views of the 53 Stations of the Tōkaidō." It is not
unreasonable to assume that now, having provided for his son, he
found himself free to wander at will—to devote his life to the
occupation that had been his heart's desire since the days of his
early boyhood—the trade of a painter.

Nakajiro only lived until 1845. His mother had died five years
previously ; and Hiroshige married again, his second wife, Yasu,
being more than twenty years his junior. Mr. Uchida remarks that
" she appears to have been a woman of the world ";[1] and the com-
ment does not suggest a compliment. Hiroshige also had a daughter,
Tatsu, who may have been—according to different Japanese state-
ments—either the daughter of " the woman of the world," or
adopted into the family. Whatever was the quite unimportant truth,
the minor part played by Tatsu in the story is not without signifi-
cance in its way. The maintenance of the family succession was one
of the most cherished traditions of the Japanese ; and when the
direct line failed, it was the practice, from the highest to the lowest
in the land, to adopt a son whose piety would preserve the ancestral
legend. So that, on the death of Nakajiro—in 1845, it will be remem-
bered—this was done. The adopted son, who married Tatsu, was
Shigenobu (Hiroshige II), about whose relations with his master
and father-in-law there has been so much discussion. The question

[1] Memorial Exhibition Catalogue, p. 10.

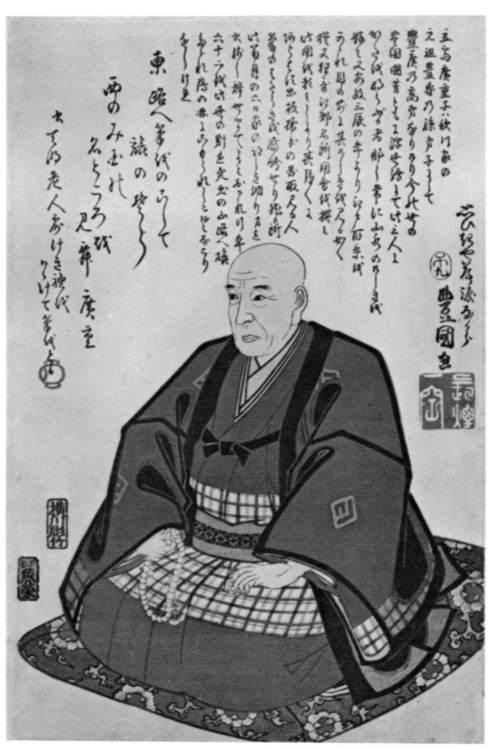

A. KUNISADA: MEMORIAL PORTRAIT OF HIROSHIGE, 1858

(see frontispiece).

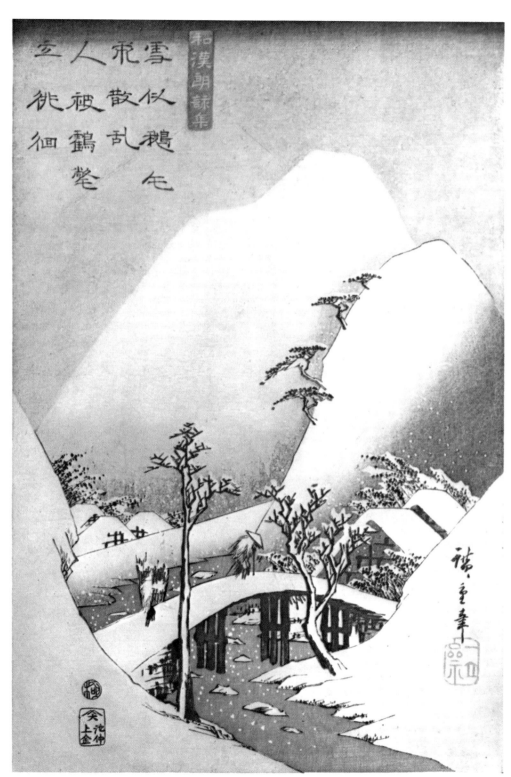

B. MOUNTAIN STREAM IN SNOW

(see plate facing p. 36).

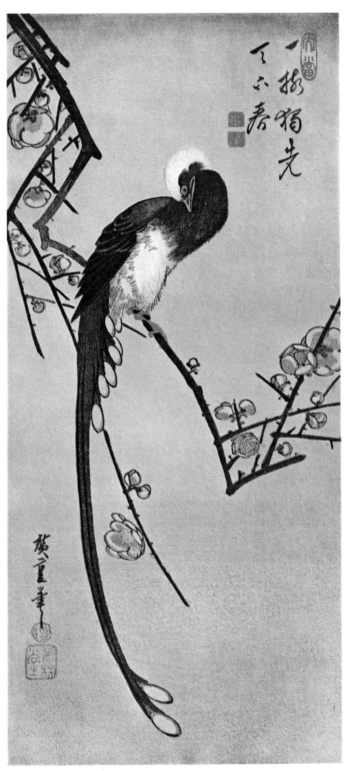

C. BIRD ON BRANCH OF PLUM TREE

(see plate facing p. 38).

D. EVENING SNOW AT KAMBARA

(see plate facing p. 44).

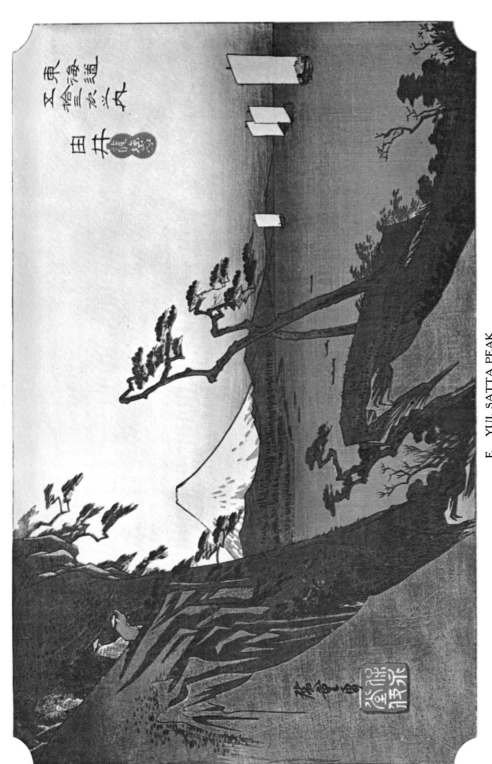

E. YUI, SATTA PEAK

(see plate facing p. 46).

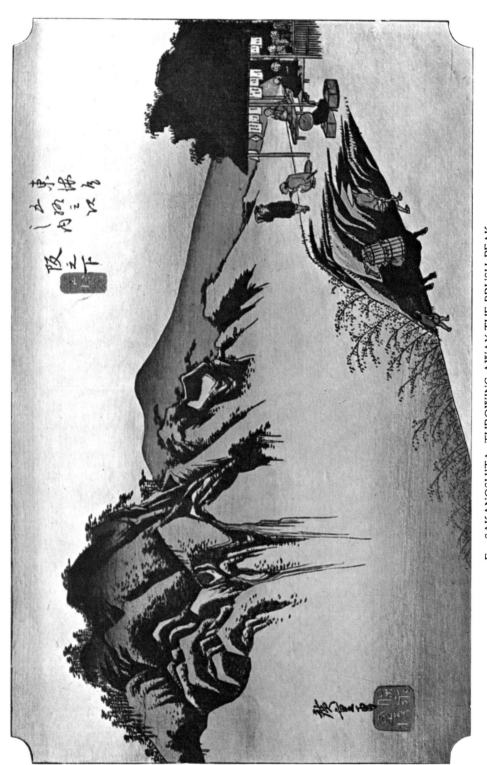

F. SAKANOSHITA, THROWING-AWAY-THE-BRUSH PEAK

(see plate facing p. 52).

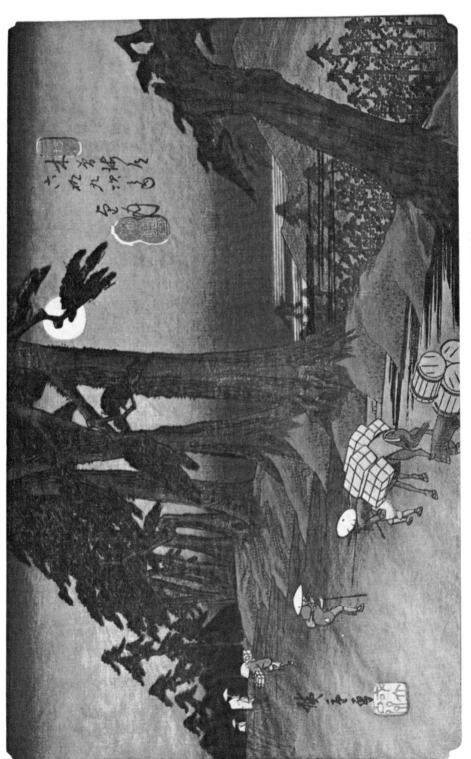

G. MOCHIZUKI, ROADSIDE PINES UNDER FULL MOON

(see plate facing p. 54).

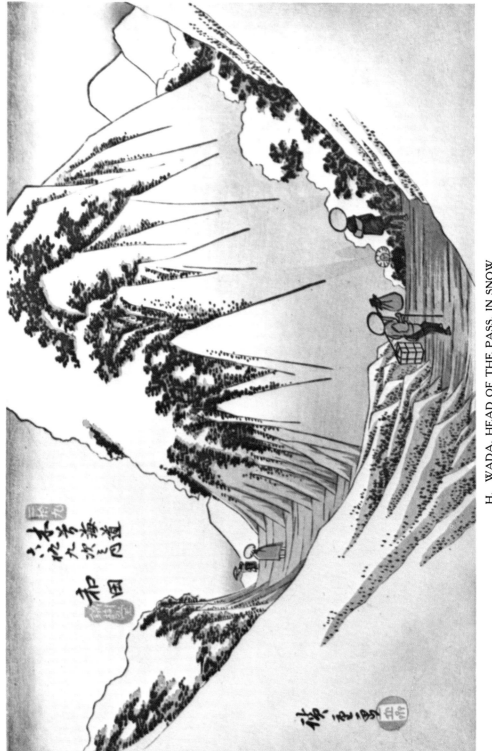

H. WADA, HEAD OF THE PASS, IN SNOW

(see plate facing p. 58).

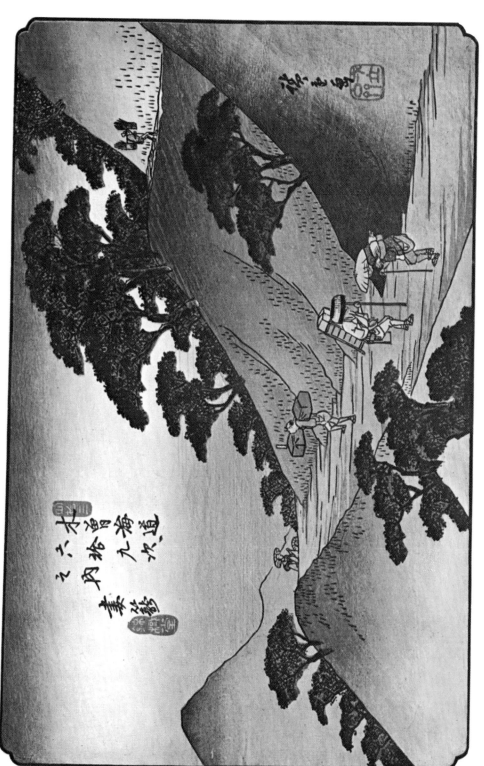

I. TSUMAGOME
(see plate facing p. 60).

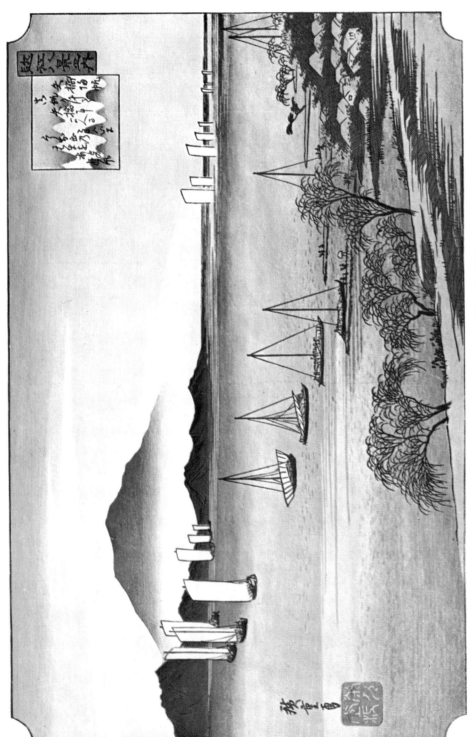

J. FISHING BOATS RETURNING TO YABASE

(see plate facing p. 62).

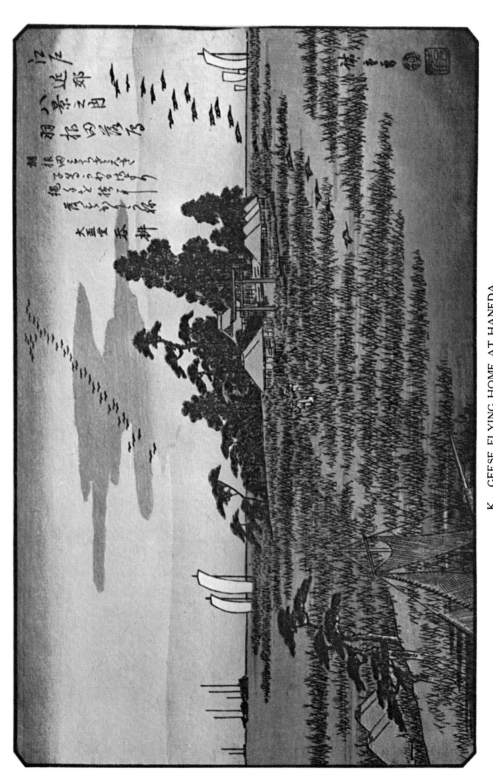

K. GEESE FLYING HOME AT HANEDA

(see plate facing p. 64).

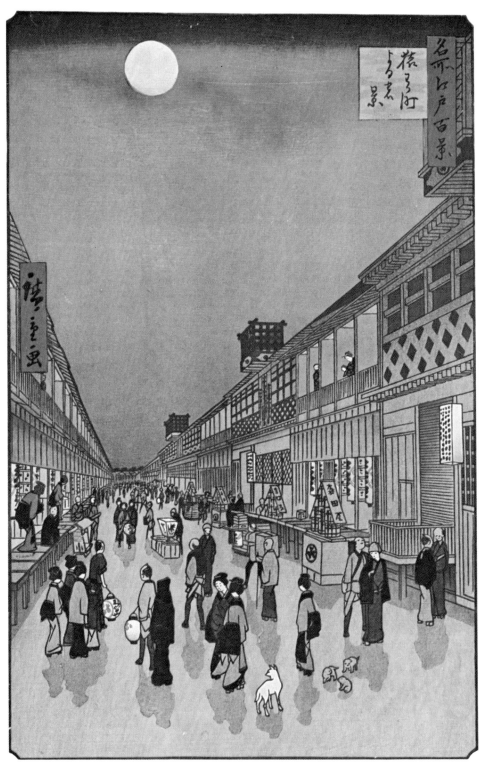

L. SARUWAKA STREET, YEDO, WITH THEATRES

(see plate facing p. 68).

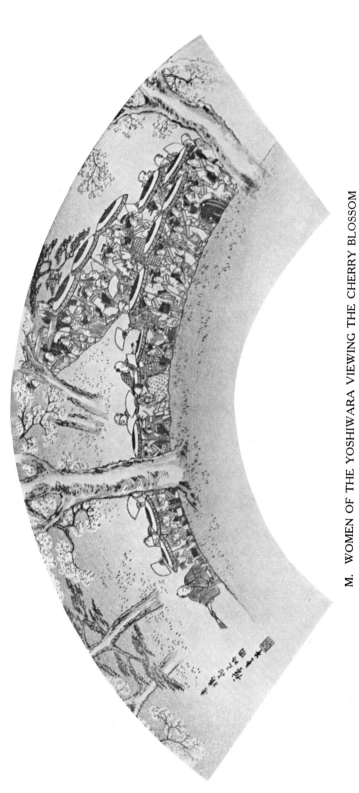

M. WOMEN OF THE YOSHIWARA VIEWING THE CHERRY BLOSSOM

(see plate facing p. 88).

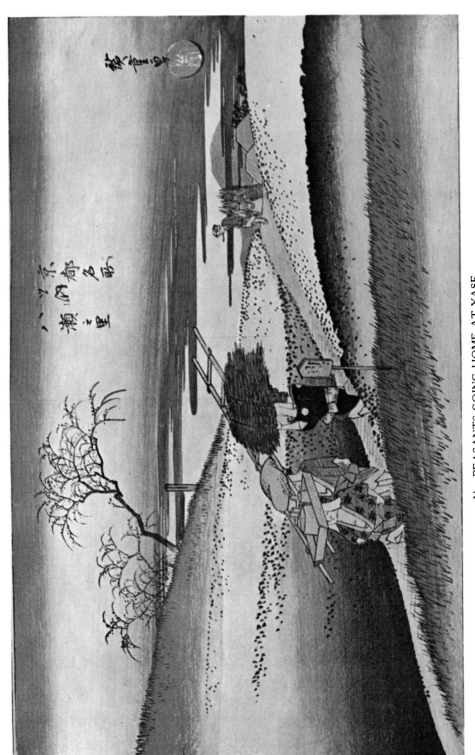

N. PEASANTS GOING HOME AT YASE

(see plate facing p. 132).

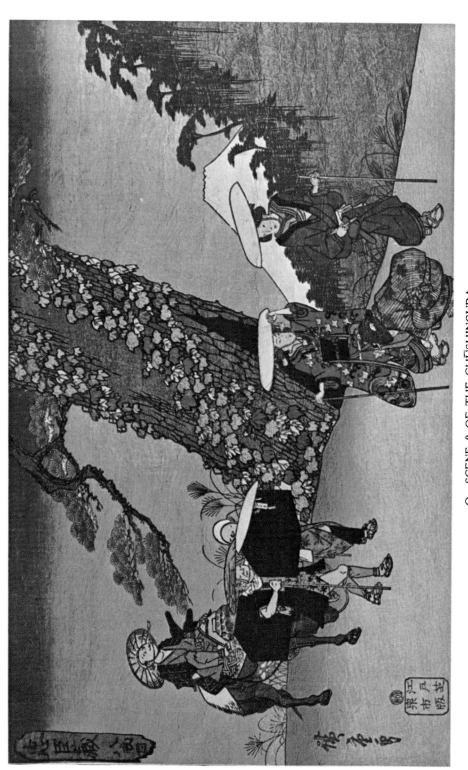

O. SCENE 8 OF THE CHŪSHINGURA

(see plate facing p. 134).

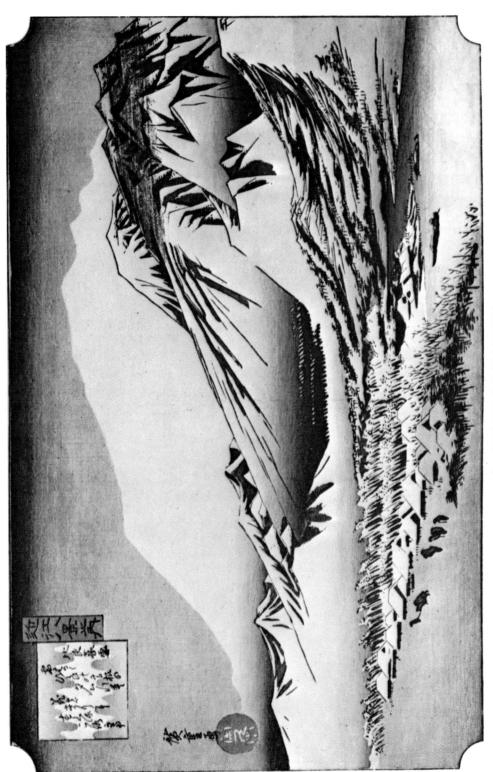

P. EVENING SNOW AT HIRA

(see plate facing p. 172)

is fully considered in Chapter III, and in this place we need only draw attention to the fact that the adoption and marriage must have taken place after the year previously mentioned. Its actual date has not been ascertained ; but this limitation in one direction has at least a definite bearing on the problem. Tatsu eventually was separated from Shigenobu, and married Shigemasa (Hiroshige III). Yasu, the second wife of Hiroshige I, died in 1876.

There is little more to be said of the life of Hiroshige I in the way of mere biography. His life is in his work, as it should be ; and, of that, we are fortunate enough to possess a very considerable quantity. His house was always in Yedo—the modern Tōkyō ; first at Ogachō, whence he moved to Tokiwa-chō in 1846, and again, in 1849, to Kano Shinmichi. His residence in Yedo was enlivened by the journeys he made at various times, journeys which resulted in the accumulation of the material for most of his colour-prints. That of 1832 throughout the Tōkaidō has already been mentioned. In 1841 he made a trip to Kōshu, in the province of Kai, of which we give a full account elsewhere. He visited the provinces of Awa and Kadsusa in 1852 (the Kanōsan journey), and on another occasion worked the district round Kominato on the east coast, where is the Temple of Tanjō-ji, sacred to the memory of Nichiren, who is said to have been born there. It was probably on this occasion that he visited Naruto and obtained the material for his famous sketch. His last undertaking of this kind seems to have been in 1854, when, says Mr. Shugio, he renewed his acquaintance with " certain parts of the Tōkaidō, to inspect and to make the survey maps of several rivers which cross that great highway, for the Shōgun's Government." Of this journey a series of fan-prints may have been the outcome.

Hiroshige died of cholera in his 62nd year, on the 6th day of the 9th month in the 5th year of Ansei (A.D. 1858). The Memorial Exhibition included a copy of a paper sold by hawkers giving an account of well-known people who perished in the cholera epidemic of 1858. The artist's name is mentioned, with the note, " Hiroshige's death cannot be too much deplored." He was buried in the inner garden of the Togakuji Temple of the Zen sect at Kita-Matsuyamachō,

Asakusa, the family temple for the House of Andō. " At the
northern corner of the garden, over a little pond, there stands the
stone by two hemp-palm trees twined round by wires. Thus
the scene is both lonely and inspiring." [1] This stone is inscribed
" Ryūsai Hiroshige-no Haka " (Tombstone of Ryūsai Hiroshige),
" Andō Yakeyo Koreo Tatsu " (Erected by Mrs. Andō Yaye—the
daughter of Hiroshige, who married first Shigenobu and then
Shigemasa), and " Shimizu Seifu Sho " (Drawn with the brush
by Shimizu Seifu). On the back are the posthumous Buddhist
names of Hiroshige, " Issei Genkōin Tokuo Ryūsaikoji," with the
date of his death, and the similar names of Shigemasa (Hiroshige III,
who claimed the title of Hiroshige II), " Nisei Koryuin Kigai Ryūsai
Shinshi," with the record of his death on the 28th day of the 3rd
month, Meiji 27th year (1894). This stone was erected by the
widow of the latter. It is illustrated in the Memorial Catalogue and
also in Mr. H. Shugio's article in *The Japan Magazine*, together
with the original monument, a plain cylindrical shaft of stone.
Hiroshige's burial-place was devastated in the disaster of September,
1923. His monuments remain but were seriously damaged. The
stone dedicated to the Andō family was removed in 1916. In 1882
a stone memorial tablet was erected to the memory of Hiroshige
in the sacred grounds of Akihajinsha, a Shintō temple in Mukojima,
on the banks of the Sumida River, which forms the subject of a
print in the Honcho Meisho Series.[2] It consists of a large monolith
on which is engraved Hiroshige's death-poem ; and a representation
of the master seated and in the act of writing on a *tanzaku* (poem-
card). This monument was due to the piety of Shigemasa, who
published a print of it with the following inscription :—

The late Mr. Ryūsai Hiroshige, my teacher, was one of the best pupils of
Mr. Toyohiro, who was a direct pupil of Mr. Toyoharu, the founder of the
Utagawa school. He (Hiroshige) did not study long under his master, for he
lost him when he was 16 years of age. Since then he did not seek another master,
for he had an ambition to establish an independent school. For that purpose he
studied hard by himself, and had often to climb mountains and descend to valleys,

[1] Memorial Exhibition Catalogue, page 4.
[2] No. 78 in the Memorial Exhibition Catalogue.

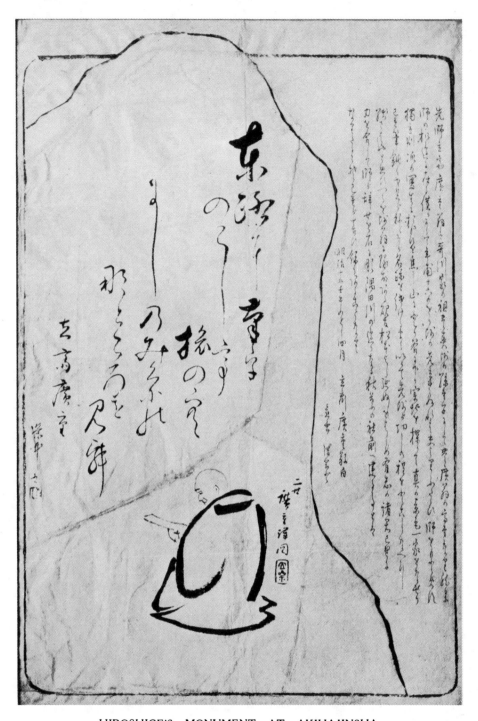

HIROSHIGE'S MONUMENT AT AKIHAJINSHA.

Proof of a wood-cut with original drawing of the portrait by Ryūsai Hiroshige II (Shigemasa).
Date, 1882.

in order to sketch from Nature. Thus he established an independent school of realistic landscape.

Though I am a dull and poor painter, yet I have succeeded to his name, therefore I tried to think of a good plan to commemorate his favour permanently. I have, fortunately, succeeded lately in fulfilling my desire by the very kind help of Mr. Matsumoto Yoshinobu and a few other gentlemen, who had been related in art with my late teacher, by erecting in front of Akiha Temple, on the bank of the Sumida River, a stone monument with my teacher's last poem engraved on it. I am extremely delighted that this has been done.

Meiji XV., Horse Year (A.D. 1882), 4th month (April).

Respectfully expressed by

Ryūsai Hiroshige (II).

The Victoria and Albert Museum has an impression of this print, as well as a proof of an early state completed with the drawing in ink of the portrait by Shigemasa, signing himself as stated. The latter also painted a portrait of his master, illustrated in Mr. Shugio's article in *The Japan Magazine* already referred to, which is evidently copied from Kunisada's memorial portrait ; and another portrait, carved in wood, is reproduced by the same writer.

Shigemasa's portrait, however, cannot be relied on to give us a faithful presentment of the great artist. For that we must go to the colour-print issued in the year of his death by his friend Kunisada (signing Toyokuni) and reproduced as the frontispiece to the Memorial Exhibition Catalogue and also to this volume. Here he is depicted as a man of—perhaps, from our point of view—rather more than his age ; seated, looking to the left, his hands on his lap and in the right holding a rosary. He is clad in green robes bordered with black of a religious recluse and with the diamond-shaped cypher (*Hiro*) on the sleeves and shoulders. About his waist is an under-garment of a sort of tartan. His shaven head is nearly bald. It strikes one as a strong face, perhaps a little tired, but full of character ; and with a hint of humour about the half-closed eyes—the face of a man who has lived well and enjoyed the adventure.

The print is inscribed as follows :—

Ryūsai Hiroshige is a distinguished follower of Toyohiro, who was a follower of Toyoharu, the founder of the Utagawa School. At the present time, Hiroshige, Toyokuni (Kunisada) and Kuniyoshi are considered the three great

masters of Ukiyoye—no others equal them. Hiroshige was especially noted for landscape. In the Ansei period (A.D. 1854-1859) he published the " Yedo Hiakkei " (Hundred Views of Yedo), which vividly present the scenery of Yedo to the multitude of admirers. About this time also appeared a magazine entitled " Kyōka Kōto Meisho Dzuye " (Humorous Poems on the Famous Views of Yedo), published monthly, with illustrations by Hiroshige and displaying his wonderful skill with the brush to the admiration of the world. He passed away to the world beyond on the 6th day of the 9th month of this year, at the ripe age of 62. He left behind a farewell sonnet :—" Azumaji ni fude wo nokoshite tabi-no sora ; Nishi no Mikuni-no Nadokoro wo min." This, written by Temmei Rōjin.

> The Eastern City
> I leave. And—without a brush—
> To see new scenes
> I take the long road
> That leads to the distant West.

To the right of the signature of Toyokuni are the characters, in script, " *Omoi kiya rakurui nagara* " (While thinking of him we shed tears). The seal date is Horse Year, 9th (month)—1858. That of the publisher is Uwoyei, who issued the " Hundred Views of Yedo " ; and of the engraver, Yokogawa Take. The red seal under the signature of the artist has been read " *Chō-en Ikku*," which may mean " Life but a Vapour " ; literally, " Long smoke reaches Heaven."

Outside his own little circle of friends and customers Hiroshige was a man of small importance in Japan. The cultured classes knew him not ; and it is only since his work has begun to gain its great and growing reputation in Europe and America, that he is beginning to be appreciated in his own country. His farewell poem was prophetic. In the worldly sense, Hiroshige—as Mr. Yone Noguchi confesses—has indeed come to the West.

CHAPTER III

THE PUPILS OF HIROSHIGE

IT was a custom among Japanese artists and craftsmen for a pupil, on attaining a certain standard of merit, to be given a *nom de pinceau* by his master, in which was generally embodied the characteristic syllable of the master's name. Thus the names Toyokuni and Toyohiro express the artistic debt of those men to their master Toyoharu; and, as we have already seen, Hiroshige's name was given to him for similar reasons, by Toyohiro. So far as this practice went, it is decidedly reasonable, and of considerable value to the student and biographer; for it at least indicates a chain of influence which may be important in considering the development of style. But, unfortunately for Western critics and historians, the artists of Japan, and especially those of the popular school, were not content with so intelligible a practice. In many instances, the whole name was transmitted to, or adopted by a successor, even unto several generations in extreme cases. Thus, the entanglements of those members of the Torii family bearing the names Kiyonobu and Kiyomasu are the subject of some involved discussion—in little apparent relation to the artistic merit of the prints concerned. A second Shikō seems now to be emerging from the mists of antiquity, on slender evidence, mainly presumptive. Utamaro and Toyokuni had their titular successors—in each case, persons whose individuality has been clearly established ; and other, less conspicuous, instances might be mentioned. But when, in 1897, on Japanese authority which, however imperfectly informed, was then well in advance of European knowledge of the subject, the present writer indicated the existence of a second Hiroshige and even ventured to suggest that he was responsible for a considerable share in the designing of prints signed with that name, the announcement was met with a flat and contemptuous denial from a Continental writer who has never realized that dogmatic

assertion is not proof. Even in the latest publication on the general subject of colour-prints, is a reference to " a mysterious second Hiroshige," coupled with a comment which we venture to quote. Messrs. Sexton and Binyon say on this point : [1] " These reconstructions from the evidence of an artist's works, in disregard of other evidence, are always dangerous. We may recall from the history of Italian painting the case of Bonifazio. At first there was a single master ; then two were invented, Bonifazio Veneziano and Bonifazio Veronese. Then Morelli, with his detective criticism, deduced from the actual paintings that there were not two but three Bonifazios. And finally an Austrian archivist showed from documents that there were neither two nor three, but one single painter after all." Now all this has nothing to do with the question unless it is to be taken—as it will have been taken by all intelligent readers—to imply that the mere existence of a second Hiroshige rests on no better foundation than that of the mythical (in the case before us, say—" mysterious ") Bonifazios. Before passing to a consideration of the only thing that really matters, the question of the work, if any, done by a second (or third) Hiroshige, we must evidently make it clear that such an individual or individuals really did exist. We have no fear of a negative being astonishingly proved by any documents whatever.

He who, later, was to be known for a time as Hiroshige II, was a member of a family of those *hikeshi-dōshin* or fire-police, to which the first Hiroshige's family also belonged. His family name was Suzuki Chinpei, and he was born in Bunsei, 9th year (A.D. 1826). Hiroshige never had many pupils ; but this man, to whom he gave the name of Shigenobu, was not only the most able of them, but the one for whom Hiroshige had the greatest affection. He took Shigenobu into his own household, married him to his daughter and undoubtedly collaborated with him. Mr. Kojima refers specifically to a *kakemono* to which Hiroshige contributed a plum-tree in blossom and Shigenobu the figure of a girl ; the painting bearing the signature of each artist. This seems to be the one sold in the Happer Sale (Lot 686) unless—as is probable—there are others.

[1] " Japanese Colour-prints," 1923, p. 186.

Shigenobu appears to have succeeded to the name Ichiryūsai, soon after Hiroshige discarded it. Indeed, Mr. Kojima says he published a series of *Yedo Hakkei* ("Eight Views of Yedo") with this signature as early as Tempō 11th year (A.D. 1840), but as he would then have been only in his 15th year, there may be some mistake—though such precocity is by no means impossible. At all events, he was still using the name in Ansei 2nd year (A.D. 1855) on a set of Chūsingura prints ; and it was not until after the death of Hiroshige I that he assumed the latter's appellation of Ichiryūsai, written in characters identical with those of the master. In a very short time, however, he dropped the " Ichi " syllable, in order not to be confused with a certain public story-teller named Ichiryūsai Bunkaku ; and for a while used only the remainder, Ryūsai, as, indeed, his master had sometimes done.

A contemporary painter, Ochiai Yoshi-iku, has left a record that Shigenobu was a very honest man who lived quietly at home and did not engage in the dissolute pursuits of many other of the Ukiyoye artists of the period. He had inherited Hiroshige's property—including his seals—and it is related that one morning, for reasons unrevealed, he left the house where his master and he had lived for so long, without his breakfast. Carefully taking with him his master's seals, he proceeded to join an old friend of his master, Kishimoto Kyūshichi, an amateur painter who had taken lessons from Yeizan ; and he divorced his wife. We are told that Shigenobu was an ugly man, with square-shaped, pock-marked face. Shigemasa, who married the divorced lady, on the other hand, was younger, better-looking and much favoured by women—hence, perhaps, the domestic tragedy. However, Shigenobu found it difficult to get a living. He was helped by Okajima Rinsai and also by Toyokuni (Kunisada), who contributed figure-subjects to Shigenobu's landscapes. He married again and in his new circle was known as Kisai Risshō—a name he would seem to have adopted between the years 1864, when he signed the 9th volume of the *Yehon Yedo Miyage*, " Hiroshige II " (in collaboration with Shigemasa), and 1867, when the 10th and last volume has the signature " *Sakino* Hiroshige Risshō "—Risshō changed from Hiroshige.

In 1866 the Tokugawa Bakufu (says Mr. Kojima) made a collection of Japanese works of art for the Paris Exhibition of 1867.[1] Mizu-no Izumi-no-kami, the commissioner appointed to get the collection together, seems to have had some knowledge and appreciation of the Ukiyoye School, and ordered one of his subordinates to secure a representation of it. Among the artists on whom the choice fell was Shigenobu, who, under his new name of Risshō, contributed paintings of Sumida-no-Watashi, Asukayama, Ume-Yashiki and others. It is interesting to note that the " mysterious " Hiroshige II was among the first Japanese artists to exhibit in Europe. That fact alone is some sort of testimonial to a degree of artistic merit which has been admitted by several modern Japanese critics.

In spite of this distinction, Shigenobu had, at this time, little success. Indeed, the troubled times which culminated in the Meiji revolution seem to have been hard on the artists of the popular school, generally ; and Shigenobu was driven to abandon his painting and struggle for a bare living in decorating lanterns (chōchin), kites and the like. Towards the end, he moved to Yokohama, resumed his own name, and found employment in painting chabako (tea-boxes) for export to Europe. His friend Kishimoto still helped him from time to time ; but in Meiji 2nd year (A.D. 1869) he died in great poverty, in his 44th year. Kishimoto paid for his funeral. He left no family.

The question of the extent to which Shigenobu is entitled to share in the credit for the prints bearing the signature of Hiroshige, without further qualification, is one that demands at least careful examination. My earlier suggestion, that most of the upright landscapes should be attributed to him, should probably be modified. Yet it was made on what was at the time considered to be competent Japanese authority, and has since been supported to a considerable extent by the opinion of Mr. Hogitaro Inada, an accomplished and unprejudiced critic, who has a remarkably extensive practical acquaintance with the subject. On the other hand, the present tendency of Japanese critics generally (who, following the lead given to them

[1] They were exhibited under the name of the Daimyō of Satsuma.

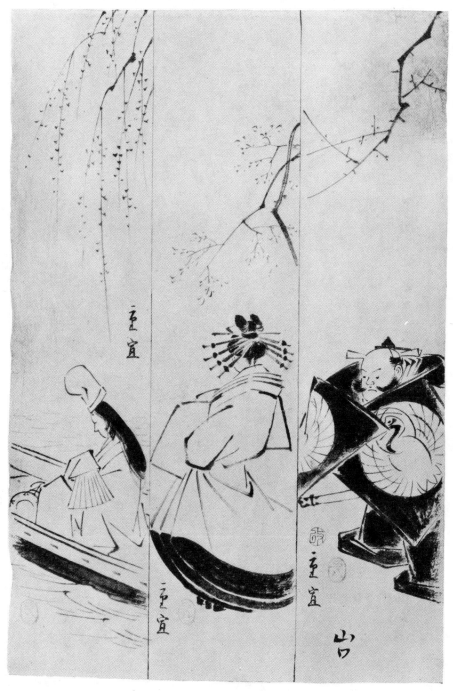

SHIGENOBU (HIROSHIGE II): ORIGINAL DRAWINGS FOR *TANZAKU* (poem-cards).

Court Lady and Willow.　　　　　A Geisha.　　　　　Asahina.
(*Asazuma Bune.*)

Date, Snake Year, 1857.

by European writers, seem at last to have begun really to appreciate the landscapes of Hiroshige) is to give everything published during his lifetime and some work only completed shortly after his death to the first (and, of course, greatest) of the name. And this point of view has the unbending adherence of Mr. J. S. Happer, to whose patient and tireless researches we all, and the present writer in particular, owe so much. Moreover, it may here be conveniently stated, that Mr. Happer is entitled to the credit of having been the first to identify Shigenobu as the second Hiroshige. I had already, in a comment on landscape prints signed Shigenobu, referred to an evident influence derived from Hiroshige ; but I was not then furnished with information as to the existence of a Shigenobu who was not the better-known Yanagawa Shigenobu, a disciple of Hokusai.

As long ago as April 1904, Mr. Happer wrote to me from Yokohama that he had identified the designer of these landscapes with the second Hiroshige and had secured a series of prints with signatures in proof ; and in his introduction to the catalogue of his collection sold in 1909 he elaborated the point and proved it beyond —as one would have thought—the possibility of controversy. This identification was accompanied with an explanation of the dated seals found on many of the later prints, on which they were placed under the censorship at that time existing. These seals referred only to the year of the cycle of 12 years then used in Japanese chronology ; and, alone, could not be trusted to furnish a precise date within the limits therein prescribed. But the occasional occurrence of the symbol of an intercalary month supplied an exact clue to the particular year of the cycle in a number of cases sufficient for the identification of style and authorship. From this evidence it became certain that a considerable number of the upright designs, attributed by me, as previously stated, to the second Hiroshige, were undoubtedly made during the lifetime of his master and issued from his workshop. These facts place the problem in a different light, and call for consideration accordingly.

The principal series concerned are—taking them in the order of approximate date assigned in the Catalogue of the Memorial

Exhibition—The upright Tōkaidō series, published in 1855 by Tsutaya; "Views of Over Sixty Provinces," published from 1853 to 1855 by Koshihei; the famous "Hundred Views of Yedo," published by Uwoyei from 1856 to 1858; the "Thirty-six Views of Fuji," published by Tsutaya, dated 1858 but not issued till 1859. These are all attributed by the editors of the Memorial Catalogue to Hiroshige I. But we must also bring into view with them the "Hundred Views of Various Provinces," published by Uwoyei from 1859 to 1861 and attributed definitely by the last-named authority to Hiroshige II. It will at once be seen that the whole group relates to a period of about twelve years only, corresponding exactly with that of the activities of Shigenobu, if we accept the statement on page 52 of the Memorial Catalogue, that this man's work " began to be known from 1852." He was then in his 26th year. Prints bearing his own signature (Shigenobu) occur with dates within our period (including some close copies of others, signed Hiroshige, and of similar date). His use of the signature " Second Hiroshige " seems to belong, mainly, to the year 1859, after the death of his master. We are inclined, therefore, to accept the contention that he did not publish, independently, under the name of Hiroshige I during the latter's life-time. And the statements made as to the affection existing between the master and pupil, and the honesty and simplicity of the latter's character, tend in the same direction. It must never be forgotten that the copying of a master's work was an essential part of the education of any artist in Japan.

The question, therefore, resolves itself into the share of Shigenobu in the work produced by the Hiroshige *atelier* during the period from about 1852 to 1865. In round numbers, something like 1,000 prints seem to have been completed during the six years up to the death of Hiroshige I, and several hundred within the next few years after that event, without counting those in collaboration with Kunisada (died 1864) and Kuniyoshi (died 1861). If we credit Hiroshige I merely with the initial design of these prints, it represents an amazing mass of industrious achievement, even allowing for the singular dexterity and speed with which an accomplished Japanese artist places his idea on paper when once he has

visualized his subject. And, as we have noted elsewhere, the making of designs for colour-prints was by no means Hiroshige's only occupation in life. When he went on his many journeys, his principal business seems to have been the painting of screens, theatrical scenery, drop-curtains and the like. He sketched voluminously, it is true ; and we know that his sketches formed the basis of his colour-print designs. Much more than that was, however, involved in the completion of a colour-print. The first idea had to be expanded and translated into a full-sized line-drawing for the engraver— often with an intermediate drawing, carefully thought-out and executed, but not necessarily to scale. The colour-scheme must have been devised—unless, as I am inclined to suspect, it was left very largely, during his later years, to the printers. Proofs marked for colour would require to be prepared to the extent of the dozen, more or less, needed for each composition ; and all the coming and going connected with the business side of the operations must be brought to account. And Hiroshige was a cheerful and sociable soul, who enjoyed life and by no means enslaved himself to his trade.

On the subject of the work of a pupil in a designer's studio Mr. Happer has been so good as to write to me as follows :— "A student . . . means in Japan a kind of apprentice, who has his board and lodging and he is a sort of ' learn pidgin ' as they say in China, i.e. one who looks, listens and learns ; in Japan *Mi-narai* (look-learn). Such an one would naturally spend his time daily in practising and in copying his master's designs. To spend four or five years in his master's studio without issuing any original work would not be unusual when you remember the necessity of sureness of touch, the necessity of having the plan in your head before the brush is put to paper. . . . After the black-and-white impression was ready for filling in the colour-scheme, then Shigenobu might have helped, e.g. to put in the red on the red block, etc. But the Japanese do not consider that collaboration ; any careful child could do it ; they call that *tetsudai*—helping, manual labour, such as any apprentice might be able to do."

Now, with all deference to the opinion of so high an authority, I cannot go so far as Mr. Happer ; for I think the case he states—

and undoubtedly states accurately as a general proposition—is hardly quite applicable to the facts before us. However he began, Shigenobu was more than a *Mi-narai* pupil, by the time he had arrived at the period we are discussing. He was publishing prints under his own name, which, if without the genius of his master or that of the half-dozen living leaders of his school, were, nevertheless, respectable craftsman's work, adequate from the technical point of view. He was an admitted member of the family and must have married the daughter just about this time. But for that alliance, he would have been in business for himself, seeing that he had reached the age of twenty-six. We know that he was a competent painter— by the later Ukiyoye standard ; and I cannot but think that Hiroshige gave him a far larger share in the output of the firm than Mr. Happer suggests.

The undoubted change of style—and, in the aggregate, for the worse—shown in the voluminous productions of Hiroshige in his later years, has been ascribed by one writer to failing powers. I cannot find any evidence of a failure in the physical sense. His death was sudden and not the result of long illness. It occurred when he was by no means an old man by the standard of Hokusai or of his friend Kunisada ; and, up to the last, his popular reputation seems to have been well maintained. Commercialism has also been suggested— in plain English, that he scamped his work in order to exploit the popularity created by his earlier successes. On that point, one may be permitted to quote the opinion of Mr. Minora Uchida—who has, perhaps, investigated the subject as closely as anyone, so far. Mr. Uchida says :—

" It appears that like a true artist, he drew pictures not for the sake of pecuniary gain but solely for the sake of art. Little did he care about his scanty means of living. He was never tired of paying visits to various places far and near in all sorts of weather, especially in rain and snow, day and night, not so much for the purpose of making sketches as for the enjoyment of Nature."

In these words, Mr. Uchida comes, I think, very near to the probable solution of the question.

Let us consider the work of Hiroshige, in relation to that of his

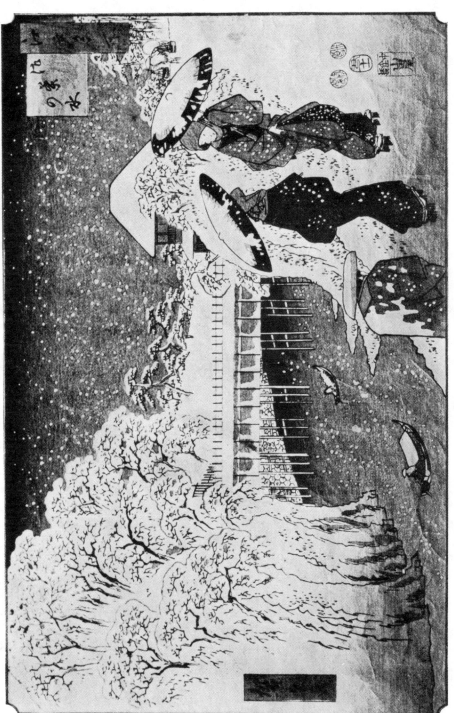

ŌCHA-NO MIDZU IN SNOW.

From a series of "Views of Yedo." *Publisher, Yamadaya.* *Date, Ox Year, 1853.*

contemporary designers of colour-prints. These found their subjects at their doors—the theatres, for sale in the attached tea-houses of which, they made portraits of actors or prints of subjects of the popular dramas ; or the courtesans, whose customers also ranked strongly in their *clientèle*. It all tended to a common round, a narrow and somewhat sordid outlook. But Hiroshige was a wanderer. The fragments that authentically remain of the records of his travels prove how great a share of his inclination was given to his journeys. If ever a man loved the road for its own sake, it was he. And his life is punctuated with long absences from Yedo, of months at a time—even, in one early instance, if Mr. Shōzō Kato's story holds good, for three years. On these journeys he made his exquisite little sketches—he must have done hundreds of them. As his pupils, and especially Shigenobu, the most able of them, became efficient, I suggest that he left the trade side of the concern largely to them. Even his latest work shows, again and again, a breadth of design, of conception, of poetic suggestion that is far from evidencing " failure of powers." The failure, such as it is, is in execution in the filling-in of the details, the loss of human interest in the figures, of delicacy in the *nuances* of the landscape. And it seems to me that these qualities carry on beyond his death—that they are present, in a diminishing scale, in series of prints which no one has yet ventured to ascribe to Hiroshige I. Briefly, then, I conclude that we must give the master credit, for what it is worth, for the whole group of work indicated earlier in this chapter—whether published before or soon after his death. That he was the inventor and only true begetter of this wonderful series of designs which, at their worst, have qualities not yet reached by the best of those artists, whether Japanese or Western, who have tried to follow in Hiroshige's footsteps. And that the decadence is due to the introduction of Shigenobu to a share—perhaps too great—in the working-out of his master's lightly-sketched ideas (*shitazu*). The latter had shown that he was well able to do this much. Hiroshige himself was free to wander ; and, when he died, there remained a quantity of more or less unused material for the pupils to carry on the tradition.

That this is more than a mere conjecture we have at least a fairly

definite indication ; for in the preface to the 8th volume of *Yedo Miyage*, published in 1861, the writer says : " It is now a memorial of him (Hiroshige I) since he is dead, but from sketches left behind are these views reproduced." The work in these later volumes is much inferior to that of those issued during Hiroshige's lifetime ; and it cannot be assumed that these inferior prints " reproduce " the Master's drawings in the sense that they are facsimile copies. Volume 8 is perhaps by Shigenobu ; the rest are built up, by a designer of little skill—Hiroshige III—from sketches such as we have already referred to and seem to indicate the method by which the abler Shigenobu may have arrived at the prints of the debatable period.

A brief note may be added as to prints undoubtedly done by Shigenobu. The earliest dated examples we have noted belong to the year 1852, as previously mentioned ; but specimens (with figure subjects only and not landscape) are to be found, which one is inclined to place before these. Some are signed Ichiyūsai Shigenobu ; and an example may be mentioned—a 3-sheet print of Raikō in Ōyeyama, published by Fujikei, which bears the inscription " Ichiryūsai's pupil, Shigenobu." Hiroshige's 3-sheet print, " Shichiri-ga hama, with visitors on their way to Enoshima," published by Sanoki, was closely copied by Shigenobu (with the prefix Ichiyūsai) in 1857, and a third version exists which is later and also by him, signed Hiroshige and dated 1860. Each was issued by a different publisher. In the latter year he produced a set of 48 Views of Yedo (Tsutakichi, publisher) ; and, during the period 1859-1861, Uwoyei issued for him not fewer than eighty of a " Hundred Views of the Various Provinces " ; as did Tsutakichi a further 68 sheets of a similar series. He is also to be credited with several sets of Yedo Views— all the foregoing being either full or half-sized vertical prints. His first efforts were in the conventional Ukiyoye style ; and show neither imagination nor other quality of distinction beyond good craftsmanship. He repeats the pose of his figures, without scruple, in different subjects ; and, in this respect, evidently possessed even fewer formulæ than did the generality of his fellows. He must have learned a great deal from his master ; but invention was not

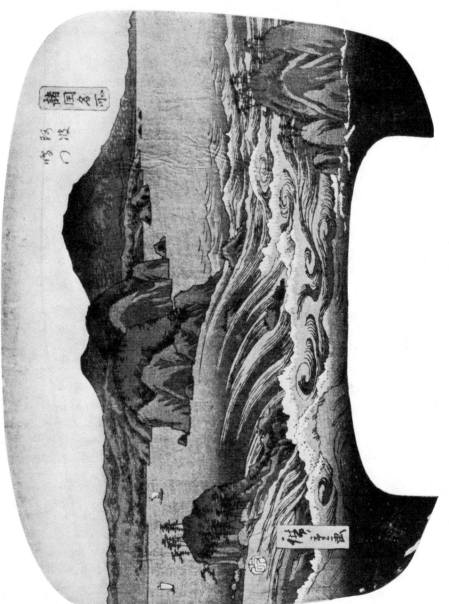

FAN-PRINT (*Uchiwa Shape*).

Awa-no Naruto. The Rapids at Naruto.

thus to be acquired. So long as he had, if our theory is correct, the mass of the first Hiroshige's sketches to exploit, he often produced something fairly creditable ; but when, as in the 3-sheet interior of the " Iwakami Tea-house at Yokohama," a special order of 1860, he is left to his own resources, there is no evidence of the old inspiration—while his not unsuccessful 3-sheet souvenir print, done in 1863 to celebrate the 255th anniversary of the Bungo-no-jō Theatre, Yedo, is a frank return to his earlier conventions. In 1865 he was collaborating—in spite of domestic complications—with his rival in the succession, Shigemasa ; of whom we need only say that his work is unimportant and only illustrates the utter decadence into which the Ukiyoye School fell after the death of its last three leaders, Hiroshige I, Kunisada and Kuniyoshi—a decadence only relieved by the genius of two men who lived too late to have the benefit of the old, beautiful technique—Kyōsai and Yoshitoshi.

In conclusion, I cannot refrain from quoting, at some length, the judgment of Mr. Yone Noguchi on this matter of the several Hiroshige. He says[1] :

I have right here before me the picture called " Awa-no Naruto," which is more often credited to be the work of the second Hiroshige. . . . It is my opinion that there was only one Hiroshige. I say this because in old Japan (a hundred times more artistic than present Japan) the individual personality was not recognized, and when an artist adopted the name of Hiroshige by merit and general consent, it meant that he grew at once incarnated with it ; what use is there to talk about its second or third ? I prefer to regard Hiroshige as the title of artistic merit since it has ceased in fact to be an individuality. . . . And I see so many pictures, which, while bearing his signature, I cannot call his work, because I see them so much below the Hiroshige merit—for instance, the whole upright series of Tōkaidō and Yedo, and so many pictures of the " Noted Places in the Provinces of Japan "—because they are merely prose, and even as prose they often fail. But to return to this " Awa-no Naruto," a piece of poem in picture, where the whirlpools of the strait, large and small, now rising and then falling in perfect rhythm, are drawn suggestively and none the less distinctly. I see in it not only the natural phenomenon of the Awa Strait, but also the symbolism of life's rise and fall, success and defeat.

[1] " The Spirit of Japanese Art," p. 41.

If Mr. Noguchi had been acquainted with the original sketch of the Awa rapids, by the first Hiroshige—one of the most brilliant and exquisite of all his little shorthand notes of Nature—he would not have altered his opinion, though he might have expressed it in other language. For here is the " piece of poem in picture," that the acute intelligence of the poet discerned in the large, somewhat diffuse 3-sheet print to whicn he refers—the essential gem of the superb landscape planned by Nature, but set in a somewhat commonplace environment dictated by commercial requirements and no doubt executed largely by the pupil. I subscribe to Mr. Noguchi's philosophy—if, with some trepidation, I rightly interpret it. And, in this philosophical sense, I am content to say with him, " There was only one Hiroshige."

A brief note only need be given to the other pupil of Hiroshige, Shigemasa. When Shigenobu separated from his wife, she married this man, who always claimed that he was the legitimate Hiroshige the Second. His work was poor and is quite unimportant. He died at the age of 53 in 1894 ; and was therefore only 17 years old at the death of Hiroshige I—too young to have exerted any great influence on the work then being produced. In spite of their matrimonial complications, he is known to have collaborated with his rival on occasion. It is a pity that an authentic account of the whole matter was not obtained from him in time—but no one in Japan then gave much thought to his work. The present Prime Minister of Japan, at a meeting of the Japan Society, in 1895, in the course of a discussion following a paper read by the author, referred " to the fact that the coloured drawings (sic) were only regarded as common prints in Japan. They cost about a penny or three halfpence and were usually bought as presents for children. He was, however, gratified to learn that what in his country they thought lightly of was esteemed and sought after abroad. . . . No Japanese remaining at home dreamt of the complimentary manner in which these little drawings were held by Europeans." Truly, we have moved a little since then !

CHAPTER IV

THE DEVELOPMENT OF HIROSHIGE'S STYLE

STORIES of Hiroshige's early inclination to art were preserved in his family. He is said to have displayed, when a mere child, quite unusual skill in that minor branch of the arts, cultivated to so high a degree among the Japanese—the making of miniature landscapes with coloured sand, small stones and similar material. And it is related that he had a keen eye for anything unusual. In the year Bunkwa 3rd (A.D. 1806) a party of Loo Choo islanders paid a visit to Yedo. Hiroshige, then only ten years old, saw them, was impressed by the unusual dress and bearing of these strangers and made sketches of them which aroused so much attention as to secure a record rare enough in the history of any of these obscure artisans. He seems to have given himself entirely to the practice of art within his limited opportunities. He developed a great admiration for the colour-prints of the first Toyokuni—then at the height of his reputation—which he saw in the print-shops.

At the age of fourteen he had lost both his father and mother ; and, says Mr. Kojima, to distract his mind from his sorrow, he seems then definitely to have decided to embrace an artistic career. As already related he applied to Toyokuni for admission as a pupil, but room could not be made for him. One of the print-sellers befriended him and tried to place him with Toyohiro—who had been Toyokuni's fellow-pupil under Toyoharu, the founder of the Utagawa School. But Toyohiro also refused. Hiroshige, undaunted, made a second application, and in person. He so impressed the artist with his keenness and capability that, this time, he was successful. In Bunkwa 8 (A.D. 1811) Toyohiro took Hiroshige into his house ; and, in the next year, gave him his diploma in accordance with the custom of the craft, endowing him with an artist name embodying one syllable of his own. Mr. Kojima points out that

this occurred after an unusually brief interval of pupilage—three years, at least, being the common term. He suggests, somewhat cynically, that the honour came so soon because it was worth Toyohiro's while to stand well with the *hikeshi-dōshin* fraternity, to which Hiroshige still, nominally, belonged. It is far more likely, in the light of subsequent events, that the reward was gained by sheer merit and assiduity ; for it is also recorded that Toyohiro employed Hiroshige to make sketches for him, sometimes correcting them himself for use, at others developing the idea in his own work. It is possible that some of these have been published, but without signatures. Toyohiro has never been accused of the piracy which is suggested in the case of some other Ukiyoye artists of the time.

The early association of Hiroshige with Toyohiro, instead of with Toyokuni, was probably a most fortunate occurrence for the artist as well as for those who love his work. It were idle to conjecture on what lines he might have gone had he been brought to maturity under the influence of the great theatrical print-designer, with his strong, remorseless design and brilliant colour. Toyohiro's work is cast in a softer mould—not too vigorous to have overwhelmed his pupil, but yet with its own quiet, harmonious individuality that helped without hindering. Moreover, Toyohiro was a very competent painter of flowers and birds, a branch of his own art cultivated with delightful success by Hiroshige from a quite early period of his career. And, short of the revelation that was to come from Hokusai and Hiroshige himself, Toyohiro had not a little skill in landscape, of which a series of *Ōmi Hakkei*—the "Eight Views of Lake Biwa"—may be mentioned as especially significant in choice of subject ; as well as a set of " Views of the Tamagawa " and some others. In any case, the refusal of Toyokuni to take up the young Hiroshige probably saved the latter from falling into the ruck of Ukiyoye figure painters—living on a tradition already wellnigh worn threadbare.

One point more is worth mentioning. Hiroshige considered himself to belong to the Utagawa School. He did not often use this affix to his signature ; but it occurs with sufficient frequency to show that he never abandoned his adherence to the group of which the

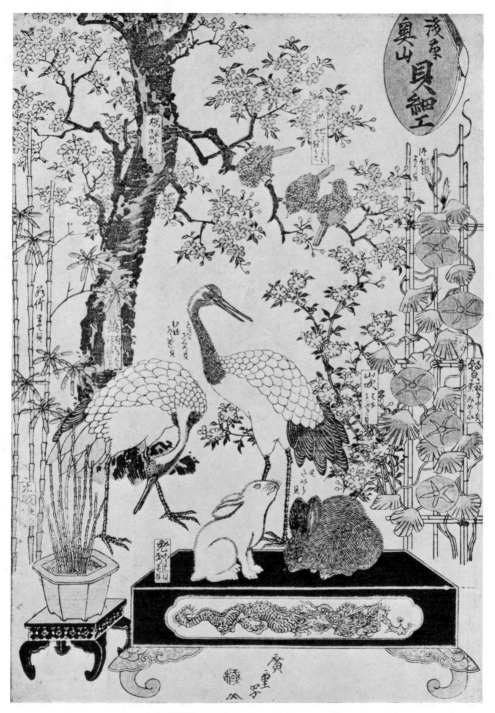

ASAKUSA OKUYAMA KAI ZAIKU.

Advertisement for a Dealer in Shell-work at Asakusa.

two senior artists were among the leaders, and Kunisada and Kuniyoshi the chief of the next generation, his own contemporaries.

Toyohiro died on the 21st day of the 9th month, in the period Bunsei, 12th year (A.D. 1829), at the age of sixty-five—Hiroshige being then thirty-three years of age. He had been Toyohiro's pupil —or, perhaps, disciple would be a better term as applied, at all events, to the later years of the connexion—for more than twenty years ; and it was suggested to him that he should take his master's name, and call himself the Second Toyohiro. This proposition was rejected by him on the ground that his work was not good enough to justify the claim ; but we may suspect the excuse to have been merely a pious tribute to the memory of his master. So long as Toyohiro lived, a visible adherence to the style of that artist would have been expected from the disciple—one calls to mind the wrath of Shunshō, when Hokusai's fertile imagination caused him to break loose from the conventions thus laid upon him. And Hiroshige was, by this time, ripe for independence. His loyalty had, so far, restrained him ; but, while he dutifully retained the name given him by his master, and also that of the Utagawa group, he signalized a new era by the change of a second name, Ichiyūsai, which he had hitherto used, to the Ichiryūsai which forms the basis of the multitudinous and often beautiful seals which decorate so many of his designs.

This name was, in a sense, an inheritance ; and its adoption implied arrival at a full degree of independence. It had been borne by Toyoharu, the founder of the Utagawa School, and by Toyohiro, but each wrote the intermediate character, *ryū*, in a different manner. That of Toyoharu is the equivalent of "dragon," Toyohiro's *ryū* means "willow"—a tree which he was particularly fond of introducing in his designs ; while Hiroshige's *ryū* ("independent") is the simplest and most easily recognizable of all. It is thus a reasonable assumption that most of the first Hiroshige's work with the signature Ichiryūsai belongs to the period terminating with Toyohiro's death. It certainly included a number of *tanzaku, harimaze*, pictures of women in the current Ukiyoye style and generally of no great merit, a few historical subjects and some advertisements for tradesmen.

The colour-prints designed by Hiroshige I appear, in a some-
what general sense, to fall into three groups : the first of which may
be said to comprise his early and tentative experiments in the con-
ventional manner of his contemporaries ; and to terminate, in
approximate date, shortly before his first journey over the Tōkaidō
was undertaken, in 1832. The catalogue of the Memorial Exhibition
places first, in order of date, a 2-sheet print giving a scene from the
play *Momiji-gari*, in which Taira-no-Koremochi is fighting with a
goblin in a wild storm. This print has considerable vigour, but
the figures are lacking in proportion. It is published by Iwatoya,
and may belong to a series of which another example of a theatrical
scene, Ushiwaka fighting with the highwayman Chōhan, is in the
Victoria and Albert Museum, with the mark of the same pub-
lisher and with similar qualities and faults : a criticism which applies
to No. 2 in the Memorial Catalogue, published by Daikokuya.
These earlier prints have the signature in formal characters ; as is
the case with the series *Imayō Kodakara Asobi*, illustrating a mother's
love for her children. This is ascribed by the editors of the catalogue
to about the year 1817 ; and to the influence of Yeizan ; but it
can almost exactly be matched in style by some early prints by
Yeisen.

A series of five subjects entitled *Fūryū Itsutsu Karigane*, also
placed very early in date, seems to be the first bearing the signature
Ichiryūsai Hiroshige ; and two series, each of eight subjects, of com-
parison of women with scenery,. come before a couple of *surimono*,
dated 1820 and 1823 respectively. There are a few other prints of
women and one or two of actors ; but little has yet been recorded
to fill the gap between the years just mentioned and 1828, when a
singularly bad 3-sheet print was designed by Hiroshige and pub-
lished by Yeijudō on the occasion of a festival at the Temple of
Kwannon at Asakusa in 1827—apparently his first effort in this
dimension. In the foreground we see dumpy female figures in the
manner of Yeisen, and men closely imitating that of Toyokuni I ;
with a complete failure in related composition. It is difficult to
account for the defects of this production. No question can be
raised as to its authenticity ; but it is far inferior to the dated

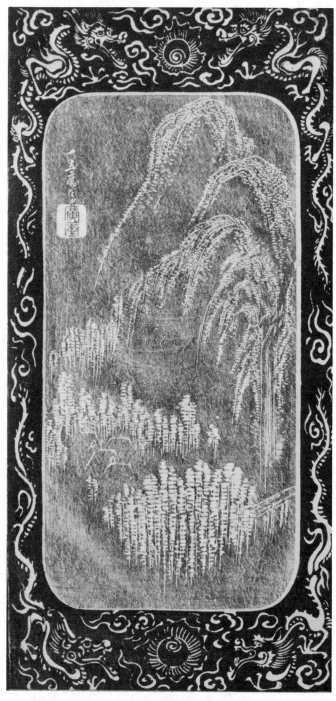

MOUNTAINS, PINES AND WATERFALL WITH A BORDER OF
DRAGONS AND SACRED JEWELS, IN CHINESE STYLE (BLACK-
AND-WHITE).

Signed, Ichiryūsai. *Seal*, Hiroshige.

surimono and to other prints, ascribed by Japanese authority to a considerably earlier period.

In this first group should also be placed a set of three advertisement designs for a dealer in inlaid shell-work which are quite well executed and adequate in colour. All three are in the Victoria and Albert Museum. A set of " Beauties of the Four Seasons " and a portrait, in character, of the actor Kikugorō, may also be referred to ; and we then come, suddenly, it seems, and almost inexplicably, to the evidences of the true greatness of the artist—his second period, from about 1831 to 1850—the period of the real Hiroshige.

The note of introduction to this phase is to be found in a few " Views of Yedo," signed Ichiryūsai Hiroshige, and probably done about 1830 ; and some prints, rather in the style of Shunsen, which are otherwise remarkable only in that they seem to be the first bearing the signature *Ichiryūsai* (Memorial Catalogue, 24, 25). But we then have the superb *kakemono-ye*, untitled, but known as the " Kiso Snow Gorge," or " Fujikawa River in Snow." In this one sees, perhaps more clearly than in any other work of the artist, the influence of the old Chinese ideal which was surely one of the factors in the formation of Hiroshige's style ; and inspired, it is suggested, by the paintings of the greatest of the Japanese painters of the aristocratic school who practised it, Sesshiu. Paintings by old masters— both Chinese and Japanese—had already been popularized in Japan by the books of wood-cut reproductions (or, rather, interpretations), cheap, but beautifully done, which began to appear in the eighteenth century and were much used by artisans of every class. However this may be, the " Snow Gorge " is one of the great landscapes of the nineteenth century. To the simple line and wash of the master with whom we have ventured to make a comparison, Hiroshige's technical skill, and the process at his command, enabled him to add a wonderful suggestion of colour and atmosphere—to reinforce the cold philosophy and abstract idealism of the source of his inspiration with an illuminating and convincing touch of Nature—and yet without any banal descent to the petty details of so-called realism. Whether, at this time, he had actually visited the scene we do not know. It is more than likely.

With the " Snow Gorge," in essential spirit, we would class two sets of prints which may be a little later in date, but, in one case, illustrating a theme of some significance—a set of *Shokoku Meisho* " Views of the Provinces," three subjects on each sheet, published by Kinkōdō, and another series, *Wakan Rōyei Shū*, " Virile Poems of Japan and China," issued by Jōkin, and including another version of the " Snow Gorge," as the first-named does of the equally famous *Saruhashi* or Monkey-Bridge, of which Tsutaya published the *kakemono-ye* generally accepted as a masterpiece, in rank equal to the great picture of the Fuji River rapids. The author, while cordially acknowledging a great admiration for the " Bridge," cannot quite go so far. The mass of rock on the left seems to have tired the artist ; and his original sketch of the subject, which we reproduce, is much more convincing and satisfying as it stands. This print can be given a definite date, for the Kōshū Diary, in which he records what, from his language, must have been his first visit, is of a journey made in 1841. Perhaps popularity was already beginning to tell.

We have, however, been tempted a little too far in our summary ; for, before the execution of the First Tōkaidō, and by way, so to speak, of interlude, the artist made a considerable number of prints of a special class—the *tanzaku* or poem-cards—long, narrow compositions, each with a spray of flowers and a bird, butterflies or something of the sort ; without, as a rule, background or suggestion of landscape —each having an ancient poem so written and incorporated in the composition as to form a charming element of the design. Beautiful as they are, the immediate purpose they were intended to fulfil is not clear unless it was to accompany gifts—the ceremonial giving of which is one of the chief ingredients of Japanese etiquette. To the author, it seems that in this exercise, Hiroshige perfected his style to a not inconsiderable extent. The fine treatment of natural form, the constant searching after variety both of detail and of arrangement, must have been all to the good. With these in his mind, he applied the form to landscape in the brilliant " Yedo Views of the Four Seasons," published by Kawashō, who also was responsible for many of the *Kwa-chō* (Bird and Flower) *tanzaku*

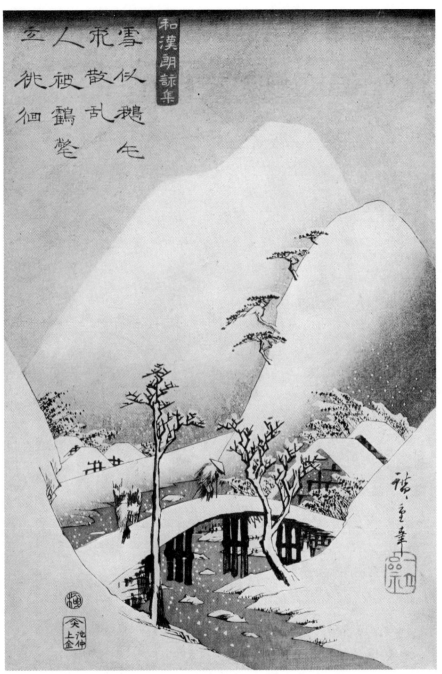

WAKAN RŌYEI SHŪ. CHINESE AND JAPANESE POEMS.

A Mountain Stream in Snow. *Seal*, Ichiryūsai. *Publisher*, Jōkin.

(See color plate B.)

—and this little series is one that no collector would wish to be without.

Two other *tanzaku* of larger *format* must be mentioned, for they also are of the most tender beauty. Hiroshige apparently contemplated a series of " Twenty-eight Moonlight Views." What he might and could have done with so inviting a subject can hardly be imagined. If the quality of the only two known, the " Bow Moon " and the " Moon behind Maple Leaves," may be taken as a standard, this series would have ranked almost as his finest work in pure landscape. The Chinese influence is still perceptible, but subordinated to the personal qualities of the artist ; and, in the former, the author dares to assert that Hiroshige has endowed his admirers with a treasure greater, more artistic, more essentially poetic altogether, than the " Monkey-Bridge," which—perhaps on account, in some degree, of its dimensions—has obscured its fame. And the composition is perfect—as Mr. Noguchi finely says : " What a pictorial contrast in these walled crags on either side, with the ghostly pilgrim of Heaven between. And, again, how the poem inscribed on the top keeps a balance with Hiroshige's signature below on the left. This lovely rhythmic performance in art of balance is so old in the pictorial kingdom of the East : our Japanese artists, indeed all of them, have the secret of it in their blood hereditarily." The " Monkey-Bridge " is but a grandiose version of the " Bow Moon." The moon has become full, indeed, but the virgin beauty of the earlier vision remains immaculate and unassailable in our memories.

Then came the revelation of the great Tōkaidō. Mr. Uchida no doubt had this series immediately in his mind when he said that " Hiroshige was the only Japanese painter who proved himself an absolutely faithful interpreter of the native scenery." That is entirely true—perhaps more true for us even than for the Japanese. For Hiroshige, in these designs, does verily interpret Nature, but in terms, not of the old Chinese philosophy, but of common humanity. He gives us what any man may see, when the artist has once opened his eyes. There are those who despise, or affect to despise, a plain statement in pictorial art ; who twist and entangle and obscure their artistic message with the convolutions of their own warped

" individualities." The Tōkaidō prints, and those to be grouped therewith, have nothing of this decadence. They tell their tale in the language of the etched landscapes of Rembrandt, of the paintings of Hobbema, of Constable.

Hiroshige has now learned his lesson. The dominant influence is, henceforth, that derived from his own observation, with just a leaning towards his far-off Chinese ancestry in art. All artists work in conventions, the alphabets of their language ; but he, still cherishing a few of the old, brought them into combination with new elements. For the idealized landscape of his predecessors, he gives us the real variety of his own country ; for the sage of the Chinese seated in contemplation, we have the wayfarers and denizens of the great roads. Instead of a remote and impenetrable suggestion of reverence and awe, there is the cheery hint of good-fellowship—you would not hesitate to pass the time of day with the people in Hiroshige's pictures. He draws temples; but they are the temples to which he and his fellows went happily as to a club or festival : and, breaking away from Far Eastern tradition to an extent, to us inconceivable, he depicts the inns and their staffs and clients. These are the marks by which Hiroshige is to be separated out from other Japanese artists. One great, perhaps greater, man, Hokusai, had, in his own highly individualistic manner, done something of the sort ; but he gives us Hokusai always, and Hokusai only. Yeisen may, as Hiroshige's partner in one enterprise, claim some small share in the achievement. But in respect of the qualities we have tried to enumerate, Hiroshige is in a class by himself. Carlyle would probably have called him a prophet !

It is this gift that he reveals in the First Tōkaidō, the Kisokaidō, the earlier Yedo Views and the like. The three great *Hakkei* are on a somewhat different plane of pure landscape ; but, apart from these and the few prints to be classed with them, the series we have just named constitute the body of work by which Hiroshige makes his mark. The period during which this high standard was maintained covers roughly about twenty years. Almost all the landscapes issued within it, other than *tanzaku*, are horizontal; though, for its excellence, we would include in this group the delightful little half-plate " Thirty-

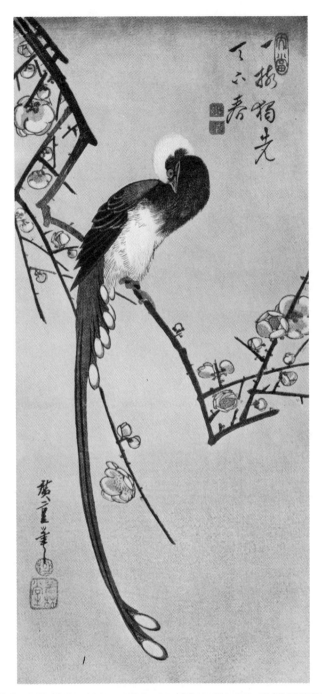

LONG-TAILED BLUE BIRD ON BRANCH OF PLUM TREE
IN BLOSSOM.

Seal, Jakurindō.

(See color plate C.)

six Views of Fuji," published by Sanoki in 1852. But this date, in other respects, marks the period, if not of his own decline, most certainly of a considerable falling off in the quality of the majority of the publications of his remaining years, the causes of which are discussed elsewhere in this volume.

Two salient characteristics of his last period are to be noted— a wide adoption of the vertical form of composition and changes in the method of treating the figure. To these must be added a decided inferiority of colour—which is now more opaque, and less harmonious generally ; the good blue remains, but greens and reds and yellows have sadly deteriorated, while the delicate half-tones of earlier work are rarely to be seen. The changes in the figure are in two curiously opposed directions. Either he has moved towards the old Ukiyoye convention in which the figure is the leading constituent of the design ; or it becomes subordinated almost out of sight, losing every bit of human interest except as suggesting the bare existence of life in the scene. In the first class, it is often gracefully drawn and well placed in its way ; a reversion, apparently, to memories of his early training under Toyohiro. One does not suggest that these things are, by any means, to be found in all the prints of the period. There are many fine compositions, bearing indisputable dates, to be placed therein. But the general level is down ; and a change of style is so marked and occurs so frequently as to give at least *prima facie* grounds for the theory that here was engaged another man. That question is considered in Chapter III ; our business in this place is only to note the change.

A word, in conclusion, may be spared to the humorous subjects and caricatures. Hiroshige had a keen sense of humour, and his prints of this class are well worthy of an attention they have not yet received. He was addicted to the making of little comic poems on all sorts of occasions, in which the inveterate habit of punning practised by the Japanese in this branch of their literature is a factor, putting them, as a rule, almost entirely beyond our comprehension. Of broad farce, together with more than respectable landscape, the unfinished illustrations to the Yajikita story, the " Humorous Adventures of Two Travellers on the Tōkaidō," are an excellent

example. Only seven of them are known. He had quite a reputation as a writer of comic poems and used the *nom-de-plume* of " Tōkaidō Utashige." His book illustration calls for careful study. Most of the volumes are dated, and one can therefore follow his style to some extent therein from his first work of this kind, issued about 1816 onwards. For his last period the *Yedo Miyage* is particularly valuable, inasmuch as it ranges from 1850 to its completion by his pupils in 1867.

There is no definite trace of European influence in Hiroshige's work. His cloud-form is derived from Nature and is free, on the one hand, from the old conventions, used by some of his fellows to eke out their design ; and, on the other, from the curly cumuli of Hokkei and other pupils of Hokusai.

Generally speaking, cloud drawing was originally resorted to exclusively for the purpose of making possible the omission of some parts of the scene depicted. The device became conventionalized and ultimately even abused, taking the form of parallel bars with rounded ends placed arbitrarily athwart the design. Hiroshige used the morning and evening mists of his native land to assist in producing effects of distance and aerial perspective ; but he never carried this device so far as to obstruct or diminish his representation of the sentiment, if not altogether of the actual facts of Nature. With him, it was an element in that fine simplification of a subject which is one of his greatest artistic qualities. The rainbow occurs in two or three prints, and he experimented with reflections and shadows. The best-known example of the latter is reproduced herein (Plate facing p. 68). These things may be said to have been suggested by Western practice, but are surely such as might well have been reached by independent observation.

A well-known writer on the subject suggests that this influence became manifest in the later work of Hiroshige in the form of attempts at perspective, and implies that it was then something of a novelty. As a matter of fact, the elements of perspective were known to the Ukiyoye Masters ; or, at all events, had been promulgated so conspicuously as to be easily available for their use, nearly a century earlier, by the efforts of that interesting character, Shiba

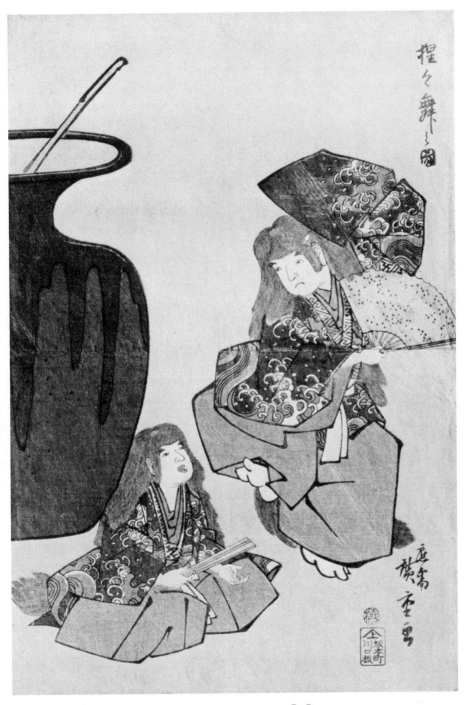

SHŌJŌ MAI-NO DZU. THE SHŌJŌ DANCE.

Signed, " Motome-ni-ōzu (*special order*) Hiroshige Gwa." *Publisher,* Kawaguchi.

Kokan, the self-confessed forger of Harunobu's prints, and the only member of his school, of importance, to use copper-plate engraving. He acquired these accomplishments from the Dutch—other than the habit of forgery, of which those enterprising merchants are not accused. Prints made in perspective were a recognized, though not popular, class, and were known as *Ukiye*—floating pictures. One does not remember any notable specimens from the brush of Toyohiro ; but Toyoharu, the leader of the Utagawa group to which Hiroshige was proud to claim adherence, was responsible for several which have perspective sufficiently accurate for all the ordinary purposes of a painter ; and Hiroshige, without quite formally tying himself to its rules, certainly shows, in quite early work, that he was well able to avail himself of this device at need. His management of aerial perspective and of distance is masterly ; and the way in which he diminishes his roads as they go back from a foreground, proves his ability in this respect.

On the general question of his style it is of interest to note that a distinguished Japanese art critic, Mr. Sawamura Sentarō, claims Hiroshige as one of the most distinguished of the followers of Buson, a famous poet and painter of the eighteenth century. The grounds of this claim are of great interest, and, if rightly interpreted, should at least assist us in our endeavour to arrive at a full understanding of the work of the great designer of landscape colour-prints. Yosa Buson was born at Kema, in the Province of Settsu, in 1716, but was taken, when still a child, to Yosa in Tango, where he was brought up, and from which he adopted one of his pen-names ; his family name being Taniguchi. He afterwards lived at Yedo, where he studied poetry under Hayano Hajin ; but most of his life was passed at Kyōto, where he died on the 25th day the 12th month, A.D. 1783, in his sixty-eighth year. Buson made a great reputation as a writer of *Haiku* poems—exquisite little 3-line verses of seventeen syllables in all. In this respect, moreover, he broke away from the formalism that, in his time, fettered the practitioners of this particular school of poetry. He not only varied the metrical arrangement of syllables, so as, from the Japanese point of view, to secure a more forcible and vigorous effect ; but especially he went to Nature for his subjects

and also invested them with human interest. It is not easy for us to realize even a fragment of the infinite implications of the little verses in which the cultured Japanese take delight. No one but an Oriental can hope to go far on the path of contemplative thought inspired by such a hint as in a typical example which we quote in Mr. Sentarō's translation :

Ah me !
Yon bunch of tender leaves
Bright in the window's light.

He once observed, says an authority, that all he had in this world was the art of painting and poetry, for he had no family, no relatives, no friends, no estate—a saying which may give a slight clue to the inwardness of the poem just quoted. In his painting " he laid stress more on indication than on actual representation." Yet many of his earlier pictures seem to have been over-elaborate and confused ; and it was only in his last few years that he reached, in the eyes of critics of his own country, his greatest merit. Mr. Sentarō says : " But Buson drew inspiration directly from Nature and then idealized what he had thus observed. Hence his paintings are always fresh and original. He did not, however, literally follow Nature ; in fact he rose above Nature. And this is why his pictures are so inconceivably animated, so strikingly bold and unaffected. In trying to arouse the imagination of the beholder, he always exerted an influence over him such as is commonly exerted only by realism. . . . In other words, as he in the rôle of an objective poet selected from Nature the elements essential to exciting the interest of the reader, so he did the same thing in his pictorial art."[1] One remembers Whistler!

The influence exerted on the art of Hiroshige (who, let us not forget, was also a poet of sorts) by that of Buson was philosophical rather than technical—a matter of principles and inspiration rather than of practice. Buson never broke entirely away from the fetters of Chinese classicism, in his technique. His composition never attains the simplicity and concentration of that of Hiroshige. His " landscapes always remind us of scenery in China." Whereas

[1] *Kokka*, Vol. xx, p. 170.

Hiroshige, with a technique ruled and, from our point of view, purified by the limitations of the process for which he worked, derived his objective inspiration from the scenes of his own country as observed by himself—though the principles that ruled his choice of subject and the idealism that underlay them were doubtless on the same lines as those of his master. Buson was a leader of reform both in his poetry and his painting. When Hiroshige abandoned the traditions of the Ukiyoye painters of women and actors in favour of landscape, he laid the foundations of a school of art whose teaching has already gone far beyond the limits or the vision of the Japanese of his day.

CHAPTER V

THE TŌKAIDŌ SERIES

OF the many great roads in Japan, that best known, by repute, to Europeans is the Tōkaidō, running from the seat of the old executive government of the Shōguns at Yedo—the modern Tōkyō—to Kyōto, formerly the residence of the Mikado. And it is mainly to the work of Hiroshige that this fame is due.

The road is not old as age is counted in Japanese history. It formed part of a system inaugurated by Tokugawa Iyeyasu (A.D.1542–1616), when, in 1603, he became, for all practical purposes, the ruler of Japan, and, taking the office of Shōgun, made Yedo the seat of his government. From the Nihon-bashi, the great bridge over the Sumida River, just opposite the palace of the Shōgun, roads radiated throughout the principal island of the Japanese Empire, and from this point all distances were measured. Moreover, the new constitution of Iyeyasu demanded an annual visit to Yedo from all daimyō ; and twice a year, coming and going, the main roads were passed and repassed by their processions, splendid in equipment and in strength according to their degree. In the old days, it is said that the *cortège* of one of the leading princes numbered as many as 20,000 men, who carried out the journey with almost regal ceremonial. For such, arrangements were made a month or so in advance. The posting-houses had to be warned and provision made for the accommodation of parties that often exhausted all the resources of the neighbourhood. The advent of a great daimyō was heralded by advance notices, so that the way should be clear and no inferiors should hamper the course of his magnificence. As he approached, all traffic had to give way, and other travellers, if still on the road, were required to prostrate themselves while he passed. Anyone failing in this homage was remorselessly cut down by the swordsmen forming the escort.

44

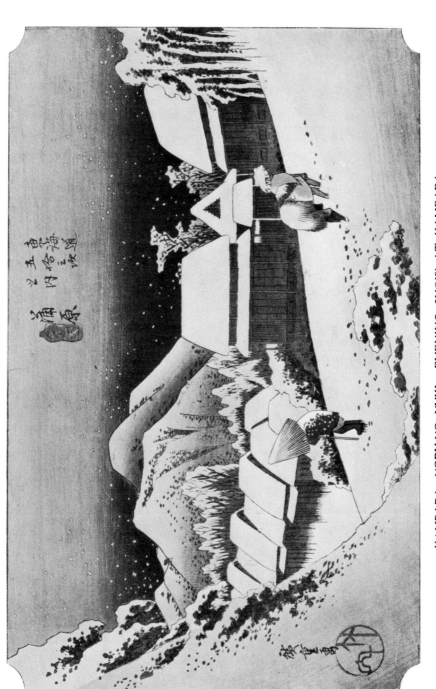

KAMBARA, YORU-NO YUKI. EVENING SNOW AT KAMBARA.

No. 16 of the First Tōkaidō Series.

(See color plate D.)

Of the five main highways radiating from Yedo, the Tōkaidō was perhaps the chief. By this route came all the great nobles from the western provinces as well as the normal traffic between the two capitals Kyōto and Yedo. Thousands of pilgrims used it ; for the old Japanese were addicted to pilgrimage often on small excuse. Engelbert Kaempfer,[1] who twice made the journey between 1690 and 1692, gives an interesting account of the Tōkaidō, which, so far as one can judge, might well apply to the conditions which Hiroshige experienced in his first journey over it. He records a procession of one of " the Princes and Lords of the Empire " in detail, describing the order of march, the post-houses and inns, and the pine-trees that bordered the road from end to end (until, in an excess of enthusiasm for the newly-introduced telegraph poles, the Japanese began to cut them down—a vandalism happily checked by the efforts of European residents). Kaempfer notes the distance marks, and the sign-posts which so often appear in Hiroshige's prints and are so wisely used by him as elements in his composition. " At the end of every tract, province or smaller district, a wooden or stone post, or pillar, is set up on the highway, with characters upon it, showing what provinces or lands they are, which there bound upon one another, and to whom they belong." He describes the great litters, in which persons of high degree were carried by six or eight coolies ; the difficulties of the fords and especially that over the Ōigawa—the subject of several of Hiroshige's designs. He admires the roads, " so broad and large that two companies, tho' never so great, can conveniently and without hindrance pass by one another." The pilgrims to Isé, which all Japanese formerly tried to visit at least once in their lives, those to the thirty-three Temples of Kwannon, the beggars and the travelling nuns all receive due mention, with, on the whole, singular accuracy. And it is not entirely superfluous to point out that this extraordinarily detailed report, made by a European observer before the end of the first hundred years of the Tokugawa regime of strict enclosure, appears to be applicable in every detail to the conditions that Hiroshige must have experienced when he first went up from Yedo.

[1] " History of Japan," London, 1727–1728.

These conditions no longer exist. The railways and the trend of Western civilization have diverted the teeming traffic from the old Tōkaidō road. Many of its fine old trees are gone, and the way is no longer swept and sanded to be made fit for the journey of a great lord. Perhaps motor-cars sometimes rush along it. But it is to our artist that not only Japan but Western civilization will have to turn for a picture of one of the most romantic of the world's great highways—and it is a universal disaster that the great earthquake and fire of 1923 have destroyed his personal records—at least in great part. For many of his diaries were sacrificed in that enormous tragedy.

On the old highway there were fifty-three recognized halting-places or stages, and these, with the starting-point at the Nihonbashi—the Japan Bridge—at Yedo and the finish at Kyōto, make up the fifty-five subjects commonly found in the series of Views of the Tōkaidō, as published by Hiroshige and other colour-print artists ; though one or two additions or reductions in number may sometimes be found. Each of these places had its story, legend, or other title to fame. Indeed an early guide-book to the road, the *Tōkaidō-Meisho Zuye*, published in 1797, and illustrated by Tosa-no Kami Mitsusada and other artists (of whom Keisai Masayoshi is the only one known to us), runs to six substantial volumes. The illustration of the subject was not confined to wood-cuts. It is of not too rare occurrence on *inrō*, those charming little lacquer medicine-cases which make so strong and so justifiable an appeal to the collector ; and examples exist of the whole fifty-three stages being symbolically illustrated on the surface of a small cylinder as a rule not exceeding four inches in height. These, however, do not come into our story ; but it is of some interest briefly to note some of the subjects popularly associated with the stages of the Tōkaidō road, and these will be found, in their respective places, in the full list of the Stations given in the catalogue.

Hiroshige was not the first colour-print artist to illustrate the Tōkaidō. It may have some significance that one such series was produced by his master Toyohiro : though no suggestion can be made that the latter's treatment of this subject in the least influenced

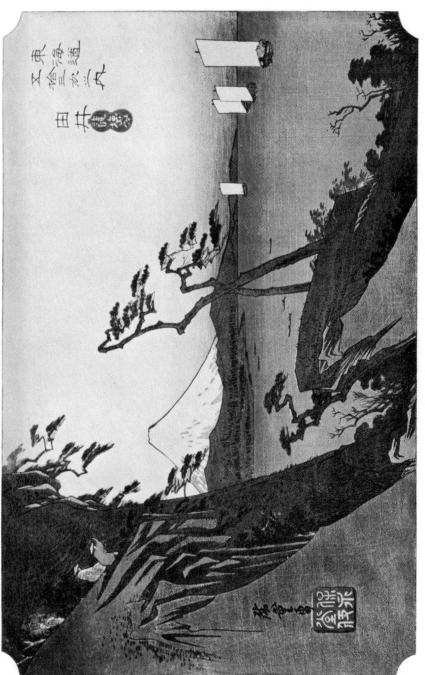

YUI, SATTA PEAK.

No. 17 of the First Tōkaidō Series. Seal, Hoyeidō.

(See color plate E.)

his far more distinguished pupil. So far as regards the actual subjects, one is immediately struck, in comparing the various series published under the artist's name, with the diversity of treatment of particular stages. Only in a few instances, in each set, can the subject be said even remotely to correspond, in a topographical sense, with that adopted in other views of the same stage ; and still more rare is it to find a replica of an earlier design in any of the later series. This fact alone bears strong testimony to the position of Hiroshige in Japanese pictorial art, the traditions of which, derived from or at least influenced by the Chinese, tended to insistence on a stereotyped formula, even as applied to landscape. Hiroshige was hampered by no such limitations. He catered for the masses at a time when independence of thought was already in the air. He derived his material in the first instance from actual observation, and, in this case, where there would seem to have been every inducement to present the particular scenes which, by tradition, were those to which the attention of travellers was inevitably directed, he broke away to give to them an astonishing variety of theme, even to the entire exclusion, at times, of the topographical point of view. In this respect, his independence of convention had far more significance in Japanese eyes than it would convey to Western critics.

The Tōkaidō road is 514 kilometres in length and traverses the provinces bordering on the southern coast of the island until, near Yokkaichi, it strikes inland by way of Kameyama and Ōtsu, passing the southern end of Lake Biwa, to Kyōto. Over and over again it comes within sight of the open sea or of the shores of one or another of the almost land-locked bays which fringe the rugged coast. These glimpses of salt-water gave Hiroshige some of the greatest of his opportunities—in colour, in contrast with precipitous cliffs or distant mountains, in the sentiment which seafaring always suggests, expressed in the coming and going of the little coastwise sailing vessels of which he made such splendid use in his compositions. It is not too much to say that herein lies much of the surpassing charm of this great series.

Hiroshige's first journey over the Tōkaidō took place in 1832, and the set of prints was completed and had been published certainly

before the 1st month of 1834, when a second edition was issued in book-form by the publishing house of Takenouchi-Hoyeidō. It consists of 55 prints—one for each of the stations, or recognized halting-places, one for the starting-point, the Nihon-bashi, or Japan Bridge, in Yedo, and one for the end of the journey at Kyōto. An additional print entitled *Tōkaidō no Uchi Yenoshimaji*, with the sub-title *Shichiri ga Hama*, giving a view of the beach at that place, was published by the same firm, and has been thought to have been intended for an addition to the original series, but there seems no definite evidence for the conjecture beyond a similarity of *format*. Later editions of the main series show, in a number of instances, variations in the blocks, no doubt due to damage or wear and tear, and a suggestion has been made that these variations are partly due to partial destruction by fire. So far, however, there is no case of a print which has been entirely re-cut. The engravers were extra-ordinarily clever in carrying out alterations in a design by cutting out a damaged or rejected portion and plugging the block, or inserting fresh wood on which the correction could be made. Most of the variations occur in the earlier numbers—from No. 10 onwards there are very few. But, in later editions, there is generally a sad falling off in printing, especially in regard to the distribution of colour ; and the lines are blurred, as might be expected in view of the soft nature of the wood used.

There is a consensus of opinion that this series made Hiroshige's reputation in Japan. They were not his first essays in landscape. He had already published a number of " Views of Yedo " and at least two series of the " Eight Views of Lake Biwa " (*Ōmi*). Moreover, the editors of the Catalogue of the Memorial Exhibition place, in order of date, before the Tōkaidō, the superb *kakemono-ye*, the " Snow Gorge," and the exquisite " Yedo Views of the Four Seasons " (elsewhere referred to in this volume) as well as many of his " Flower and Bird " prints, and the two extant examples of a series entitled " Twenty-eight Moonlight Views." They prove that his genius and technical skill were fully developed, even before he chose the old road for his great enterprise. These were notable efforts, already very far removed from the stereotyped conventions of his predecessors.

OKITSU.

No. 18 in the series of "Views of the Tōkaidō." *Publisher,* Marusei.

But, in face of Nature, the art of Hiroshige, in essential principles, now, at a bound, progressed beyond the limits of his school to a degree that is not easily to be realized by Western students. One must not forget that Hokusai had already issued his own " Thirty-six Views of Mount Fuji " (completed about 1829). In those superb designs he had not merely used both Nature and Humanity but had translated them with almost overwhelming force into terms of his own supreme and separate individuality. There is no echo of Hokusai in Hiroshige's Tōkaidō. The latter, indeed, translates Nature, but faithfully—indeed with magnificent and compelling truth—and only into the perfectly selected conventions of his technical process. His characters, the wayfarers that he saw and sketched on the journey, are not merely incidents in a pattern but entirely human—the life of the road. Almost always, they are men and women more or less of his own social class, touched off with not a little kindly humour. In Hokusai's landscape we admire the skill of the artist ; in that of Hiroshige, the beauty and truth of the scene.

It has been said that Hiroshige joined the mission to Kyōto in a minor official capacity. It has even been assumed that he was formally employed as an artist to make a record of the journey—as Western painters have sometimes been associated with State progresses. Japanese students no longer accept either version. Hiroshige's connexion with the fire-police gave him the opportunity of joining the party—as an obscure plebeian of no particular import-ance. Is it not sufficiently significant that he practically ignores the ceremonial side of the procession ? Now and again you get a few banner-bearers—their poles were useful in composition—or a distant view of the litters and other paraphernalia, for the same reasons. But the dignitaries themselves do not appear ; and in many of the prints we find only the ordinary traffic of the road—such persons as those of whom the artist in his note-books records his meetings and partings, his likes and dislikes. It was a new thing for an artist in Japan to take this point of view, however natural it may appear in our eyes. At last, the Japanese themselves have realized what it meant. No wonder Mr. Yone Noguchi says, " He is, in truth, the only one native and national artist of Japan."

A singular quality of the series is its high level of artistic merit. One may have preferences; and such masterpieces as the " Rainstorm " at Shono (46) ; " Clear Weather after Snow " at Kameyama (47) ; " Evening Snow " at Kambara (16) ; and the " Throwing-away-the-Brush Peak " at Sakanoshita (49) are among those which would probably come near the head of a list in popular favour. But not one of the fifty-five is lightly to be discarded ; not one but would have earned high praise for the artist were it standing alone. Moreover, one cannot fail to appreciate the variety of subject and of composition. Later, the artist showed a tendency to favour certain basic lines ; for instance, a bold curve in the centre, with high ground on either side, and a distant view in the gap. He never repeats himself in the First Tōkaidō, and, as far as the series goes, he gives us just that much of the infinite variety of Nature.

Hiroshige made several other sets of Tōkaidō Views—some of them being half-plate size. A list of the most important is given on p. 53. From the artistic point of view the *Reisho* (formal) set is the most important—so-called from the fact that the title is in formal characters on a label. It is also known by the name of the publisher, Marusei. It contains some very good designs, several of which are strikingly original in composition. This series is rare, and seems to exist only in good and early state ; a circumstance accounted for by a story that the blocks were destroyed by fire before many impressions had been printed. The British Museum contains a considerable number, but not, at the time of writing, a complete set. Three series of the *harimaze* prints (for cutting up) are also noted. These consist of a number of separate designs printed in groups of four or five on vertical sheets of the ordinary size. The subjects are by no means always landscapes; but, more often, symbolical of the stories and legends associated with the different stations of the great road. Many of them are of great ingenuity and beauty, and they are often met with in their separate form. We have included in the catalogue the full detail of the subjects of a late Tōkaidō series, in which Hiroshige collaborated with Kuniyoshi and Kunisada (signing, Toyokuni), for the reason that these supply a whole range of the subjects

associated with the Tōkaidō, and are of interest on that account. The stories told are, it must be remembered, such as would have been well known to every Japanese ; and with their habit of symbolism, it only required what must often seem to us to be a far-fetched allusion, to bring these fragments of old history and legend instantly and completely to the mind of the beholder. This association of ideas must always be reckoned with in the art of the Far East. It underlies what we might think to be mere realism, perhaps imperfectly expressed, but taking on an entirely different aspect when interpreted with full knowledge of what it is intended fully to convey. In this sense also should be considered the *Sō-hitsu* (two-brush) set, by Hiroshige and Kunisada, dated from 1854 to 1857, issued in the latter year by the publisher Maruya Kiūshirō, and engraved by Yokogawa Take.

It will not be inappropriate to conclude this chapter with a note on one of the two books dealing with the Tōkaidō, by Hiroshige. The text is an example of a practice common in this country during the seventeenth and eighteenth centuries and followed also in Japan, of prefacing a work with gratulatory epistles or addresses written by literary men with some claim to the attention of the public. Indeed, it is not unknown in our day. Moreover, the preface has its interest; and the turn of phrase, admirably translated, holds a kindly savour of its own.

Tōkaidō Fūkei Dzuye

Translation of Preface to Vol. I.

Travelling is one of the greatest pleasures. Every year have I wished to start on a tour, but my daily duties have not yet allowed me to realize my desires. This work is by the famous artist Hiroshige; in careful detail are views of over fifty villages (stations) between Kyōto and Yedo ; the well-known seas and mountains, Mt. Akiha of Ōmi Province, Hōraiji Temple in Mikawa, and the various routes leading to the Sacred Shrine of Isé. Looking at these pictures is even greater pleasure than travel itself ! Those who have never travelled will find instruction [in these pages] while those who have

visited these places will be vividly reminded of them and their associations. Ignorant as I am of drawing, I dare say that with dark and light shades of ink, its fragrance and beauty, this work is not inferior to the work of any old master.

This by :—Ryūkatei Tanekadzu, *Spring*, 1851.

Rear Word, at Back of Vol. II.

These words are for the teacher Hiroshige :—

Leaning on my desk and looking at the first drafts [originals for the blocks] I find the Pine Forests of Hodogaya, the plum thickets of Sugita, the sea-girt shores of Kanazawa and Kamakura, the mansion of Kagekiyo, Hōrai Temple, Atsuta Temple, Yokkaichi, the clear water of Isuzu River, Asama Mountain, and [Husband and Wife Rocks of] Futami-ga Ura.

Towards the Western Capital [Kyōto] are Higashi Yama, Kiyomizu Temple, ending with Sanjō Bridge.

The brush with great speed covers one hundred *ri*.

Like a fox borrowing the mane of a lion, I have the honour of placing this rear word to end the book—on a rainy day at the beginning of Spring, 1849.

This by :—Tanekadzu, at the north window of the house styled Ryūkatei.

(The " rear word " should have been the preface. Written after seeing the original drawings, it seems to precede by two years the preface written at the time of publication.)

The advertising page at the back reads :—

Tōkaidō Fūkei Dzuye ; Zen Pen (1st Vol.) Go Hen (2nd Vol.) complete.

Script for preface and descriptive text by Ryūkatei Tanekadzu.
Engraved by Yoshida Torakichi.
Kayei 4th year (1851) Wild Boar, early Spring, issued.
Tōto (Eastern Capital), Plates (publisher) Shōrindō (or Fujio-kaya Keisuke), of Tōri Abura-Chō.

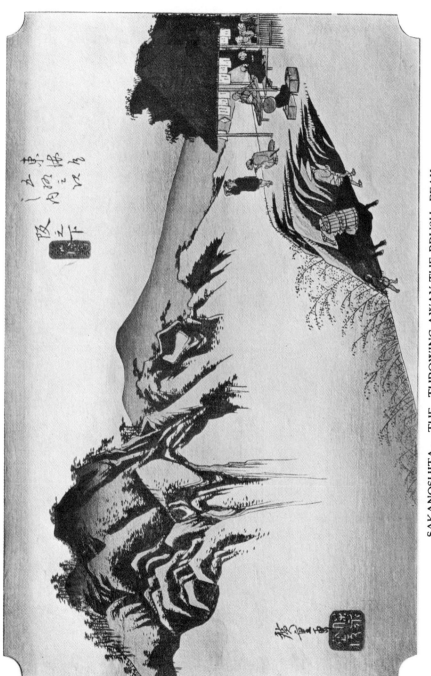

SAKANOSHITA: THE THROWING-AWAY-THE-BRUSH PEAK.

No. 49 of the First Tōkaidō Series.

(See color plate F.)

LIST OF TŌKAIDŌ SERIES

Tōkaidō Gojūsan Tsugi-no Uchi. Publishers, Senkakudō and Hoyeidō. The Great Series. *Ōban Yokoye.* 55 prints.
Completed edition with preface by Yomo-Takimizu, 1st month of Tempō 5, A.D. 1834. Publishers, Takenouchi-Hoyeidō.

Tōkaidō Gojūsan Tsugi. Publisher, Sanoki. *Chūban Yokoye.* Title and 56 prints.

Tōkaidō Gojūsan Tsugi Saiken Dzuye. Scenes with humorous figures. Publisher, Muratetsu. *Ōban Tateye.* Incomplete (about 11 prints).

Tōkaidō Gojūsan Tsugi. Publisher, Tsutaya. *Chūban Yokoye.* 54 prints.

Gojūsan Tsugi. Publisher, Muraichi. *Chūban Tateye.* 56 prints.

Tōkaidō. Publisher, Marusei. The *Reisho* Tōkaidō. *Ōban Yokoye.* 55 prints.

Tōkaidō. Publisher, Hayashi-shō. *Ōban Yokoye.* Incomplete, 6 prints known.

Tōkaidō Gojūsan Tsugi Dzuye Kwai. Publisher, Fujikei. Figures and landscapes. *Ōban Tateye.* Incomplete, " about three-fourths of the series."

Tōkaidō Gojūsan Tsugi Meisho Dzuye. Publisher, Tsutaya in 1855. *Ōban Tateye.* 55 prints.

Tōkaidō Harimaze Dzuye. " Mixed " prints. Publisher, Ibasen. *Ōban Tateye.* 12 sheets.

Tōkaidō Harimaze Dzuye. " Mixed " prints. Publisher, Senichi. *Ōban Tateye.* 14 sheets.

Tōkaidō Gojūsan Tsugi Harimaze Dzuye. " Mixed " prints. Publisher, Yamaguchi. *Ōban Tateye.* 15 sheets.

Tōkaidō Gojūsan Tsugi. Publisher, Yesaki (or Yetatsu). Small *Ōban Yokoye.* 55 prints.
Later edition with 4 designs redrawn. Publisher, Yamadaya.

Tōkaidō. Publisher, Aritaya. *Ōban Yokoye.* 4 subjects on each of 14 sheets.

Tōkaidō. Publisher, Yamashō. *Ōban Yokoye.* 8 subjects on each of 7 sheets.

Tōkaidō Gojūsan Tsugi Tsuzukiye Fūryū Jimbutsu Shinkei. Publisher, Muraichi, in 1852. Known as the *Jimbutsu* (mankind) set. *Chūban Tateye.* 56 prints.

TŌKAIDŌ SERIES BY HIROSHIGE AND OTHER ARTISTS

Tōkaidō Gojūsan Tsui Hodogaya. By H., Kunisada and Kuniyoshi. Publisher, Ibasen. *Ōban Tateye.* 57 prints.

Tōkaidō Meisho Fūkei. By H., Kunisada and others. Publisher, Daikin. *Ōban Tateye.* (Probably) 55 prints.

Sō-hitsu Gojūsan Tsugi. By H. and Kunisada. Publisher, Maruya Kiūshirō, in 1857. *Ōban Tateye.* 55 prints.

CHAPTER VI

THE KISOKAIDŌ ROAD

THE great system of roads organized or reorganized by
Iyeyasu as an integral part of his policy of central control
of the daimyō, included not only the Tōkaidō which has
already been described, but four others of the first rank. The
Nakasendō, or Road of the Mountains of the Centre, which is also
called (and better known to us by the name of) the Kisokaidō,
runs from Yedo to Kyōto, but by a longer and entirely inland route
of 542 kilometres. This road is said to have been made in A.D.
702. Its direction is north-west from Yedo to Matsuida, then west
and south-west across the mountains to Lake Suwa, and south-
west again, by way of Sekigahara, the scene of Iyeyasu's great vic-
tory in 1600 which finally consolidated his power. The road then
approaches Lake Biwa, and dips down to Ōtsu where it joins the
Tōkaidō just outside Kyōto. The Kisokaidō has 69 stations and
the series of prints illustrating it, dealt with in this chapter, consists
therefore of 70, including the universal starting-point—the Nihon-
bashi of Yedo. Only some were done by Hiroshige—the rest
by Keisai Yeisen.

The other main roads are the Nikkōkaidō, of 146 kilometres,
running nearly due north from Yedo to Nikkō by way of Ōmiya
and Utsunomiya ; the Koshūkaidō from Yedo to Kōfu by way of
Hachioji (139 kilometres) and thence through Kanazawa to Shimo-
Suwa where it joins the Kisokaidō. The last of the group is the
Ōshukaidō from Yedo, due north to Asomori through Shirakawa,
Sendai and Morioka (786 kilometres). There are, of course, numerous
other roads of secondary importance—*waki-kaidō*—or side-roads,
which need not be considered for our present purpose. Indeed, so
far as concerns Hiroshige, interest arises almost entirely in connexion
with two only of the above—the Kisokaidō, which supplied him

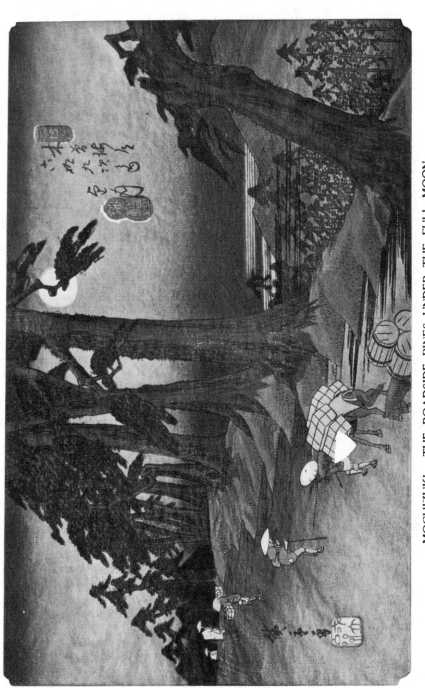

MOCHIZUKI. THE ROADSIDE PINES UNDER THE FULL MOON.

No. 26 of the series of "Views of the Kisokaidō." *Publisher, Kinjudō.*

(See color plate G.)

with material for some of his finest compositions, in the series shared
by him with Keisai Yeisen, and the Koshūkaidō, of which the diary
of his journey has fortunately been preserved in Mr. Kojima's
transcript—though the original perished in the great fire. Of this
we give a translation in Chapter VIII.

The series under consideration, to which collectors have agreed
to refer as that of the Kisokaidō (from the Kiso river which it follows
for part of its course), consists, as previously stated, of 70 prints—one
for each of the 69 stations and one for the starting-point. I have
not, so far, been able to ascertain that any other series of popular
views of this road exists. Kaempfer is evidently referring to it when,
speaking of Ōtsu, near Kyōto—where the Kisokaidō breaks away
from the Tōkaidō—he says of the countryside, " Behind these
mountains [those on the shore of Lake Biwa] there are two very
narrow and troublesome roads over other mountains, over which
some of the Western Princes pass in their Journies to court." The
difficulties of traversing the great mountain range would alone
account for the fact that the Kiso road never had the importance of
its southern rival ; and it will be observed that the daimyō proces-
sion, which occasionally appears to some extent in views of the
latter, is rarely seen in the series now under consideration. Neither
does the Kisokaidō appear in other forms of art, as does the Tōkaidō.
It could not have carried anything like the traffic, either in volume
or in quality, of the latter ; and there are some indications that
views of it never achieved the commercial success of the better-
known series.

It is worth while to analyse briefly, the distribution of subjects
between the two artists engaged thereon. Yeisen is responsible for
the first eleven subjects, and for six of the next twelve. He only did
six more—twenty-three in all, the latest being No.55, " Kōdo," leaving
forty-seven to Hiroshige. There is evidence that the series was begun
in 1835, for one of the umbrellas in No. 1, " Nihon-bashi," is inscribed
" Year of the Sheep " ; and in the opinion of the editors of the
Memorial Catalogue, with which I agree, the prints concluding the
series should probably be dated much later. This authority places
them " from Kashiwabara downwards " (Nos. 61-70) at the end of

the Tempō period (A.D. 1843). Moreover, there was an early change of publisher. The first prints were produced by the Takenouchi Hoyeidō (or Reiganjima Hoyeidō). With Hiroshige's earliest contribution, however, he is joined by Kinjudō (also called Ikenaka Iseri, Ikenaka being a contraction of his address, Ikenohata-Nakachō), and most of the remaining prints were published by this man. After the completion of the series Kinjudō acquired all Hoyeidō's blocks and published an edition with his own style and title on No. 1—omitting in every case Yeisen's signature from the prints designed by him. Yeisen died in 1848 ; but it is not clear whether the second (Kinjudō) edition appeared before or after his death—the presumption is in favour of the latter. The editors of the Memorial Catalogue advance the curious theory that " it may be supposed that the publishers omitted the name and seal of the artist (Yeisen) for fear that the original prints would not be acceptable to the public, with whom the newest edition was most popular in those days." Without disputing the statement, one may venture a doubt as to whether even a Japanese artisan public did not understand the difference between a new publication and a reprint of an old one. It has been said that Yeisen's name was omitted because he quarrelled with the publisher. Nothing is more likely than that this eccentric genius should have had an experience which is not altogether unprecedented even in Western literary and artistic circles. The fact that he no longer owned the copyright would not preclude grounds for trouble. He might have objected, not unreasonably, to excessive printing, to paper, to colour-scheme—in the interests of his own reputation. However, our authority does not consider it " likely that the artist's name and seal would have been struck out by the publisher while the artist was still alive."[1] That view is reasonable and must carry weight. But is there not another possibility ?

I suggest that the name and seal of Yeisen were indeed omitted by the publisher of the later editions of his prints because it was thought that the " original prints would not be acceptable to the public "—and, so far, I can agree with the theory of the editors of the Memorial Catalogue. But I also suggest, as a theory not incom-

[1] Memorial Catalogue, p. 21.

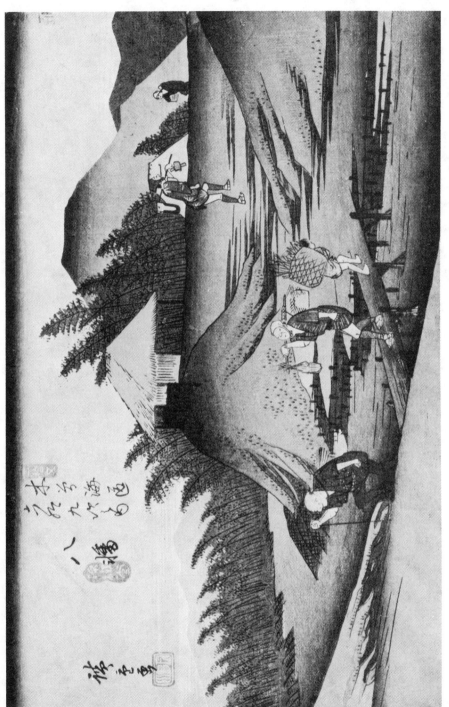

YABATA.

No. 25 in the series of "Views of the Kisokaidō." Seals, Utagawa. Publisher, Kinjudō.

patible with human nature as it sometimes appears in business transactions, that the omission of Yeisen's name was conceived in order to put forward at least an implication that the whole work was by Hiroshige. The latter had made his great success with the first Tōkaidō series, published by Hoyeidō and (at the beginning) by Senkakudō. Hoyeidō was also the first publisher of the Kisokaidō series. The trade-mark of this firm appears on the whole of the first eleven prints—which, we remember, are by Yeisen—as well as on No. 13. In Nos. 15 and 18, we have prints by Yeisen, published by Kinjudō (who had joined Hoyeidō at an early stage), and, in the opinion of Mr. Happer, with titles in Hiroshige's script. All the remaining prints by Yeisen were published by Hoyeidō or by that firm in conjunction with Kinjudō. No. 14 is the only print by Hiroshige with the Hoyeidō imprint and it has that also of Kinjudō in the margin. Surely then, the distribution of the work between the two artists was closely associated with the change of publisher— Hoyeidō being, so to speak, on the side of Yeisen and Kinjudō on that of Hiroshige. On this indication I base my theory—that the Hoyeidō firm thought it would be a good venture to illustrate the Kisokaidō in style uniform with that of their successful Tōkaidō ; that they also entertained the idea of employing an artist of Yeisen's established reputation, by way of not having all their eggs in one basket ; that they failed to get anything more out of that wayward genius than a good beginning and another dozen of subjects— scattered here and there on the programme, and, in two cases, unfinished as regards the writing of the title ; and, finally, that Kinjudō came to the rescue with Hiroshige to complete an undertaking of which Hoyeidō was weary. A Japanese authority states that Yeisen " retired " about the end of Tempō (*c.* A.D. 1843), and this, if true, may account for the whole difficulty.

In this connexion we may make a passing reference to one of those casual and somewhat intangible statements which occur sometimes in the fragmentary " biographies " of Ukiyoye artists, to the effect that Hiroshige was indebted to Yeisen for instruction especially in regard to colour-schemes. So far as we are aware there is no direct evidence of any connexion between the two men before

the initiation of the Kisokaidō series, but such a story may well have arisen out of the mere fact that this important work was begun by the elder artist and handed over to the younger for completion.

There is one further example of collaboration. Probably about the end of the Tempō period (A.D. 1830-1843) the publisher Yeirakuya issued a small work in three volumes, *Ukiyo Gafu*, consisting of small sketches of landscapes, birds and flowers, figures and fish. Of this, volumes one and two are by Yeisen while the third is by Hiroshige ; they are printed with two tints in addition to black, in the style of Hokusai's *Mangwa*. Yeisen, in dealing with landscape, was unequal, or, perhaps, perfunctory. At his best, he reaches a high level. No. 20, " Kutsukake," is one of the best of all the Kisokaidō subjects, and as a representation of torrential rain is not unworthy to stand beside the superb interpretations of this subject by Hiroshige ; while hardly less praise is due to the original and striking snow-scene, "Itabana" (No. 15). But with these and, perhaps, one or two other exceptions, Yeisen's contributions to the Kisokaidō set have not the marked individuality and power of other landscapes by him—such as, for instance, some of the Views of Yedo (of which he did several series), his remarkable series of Waterfalls, etc. In view of the story as to his influence on Hiroshige, it is germane to our subject to point out that Yeisen was, at least, of some importance as a designer of landscapes. Hiroshige's early figure work is decidedly in the style of the elder man ; and, while we do not think, for a moment, that the accomplishment of Hiroshige is, even in part, to be attributed to Yeisen or anyone else, it is more than likely that the latter, or his prints, assisted the designer of the great Tōkaidō series to reach, almost at a bound, the summit of his achievement.

It must be admitted that Hiroshige's contribution to the Kisokaidō is also unequal. The series contains a few of his finest efforts. Two great moonlight scenes, " Mochizuki " (No. 26) and the " Nagakubo " (No. 28) at once demand our admiration. In the latter, and weaker of the two, he gives us an unequalled rendering of the effect of bright moonlight on the river mists, but the amusing little group of children in the foreground insists too urgently on our attention. The low comedy touch, in which Hiroshige constantly

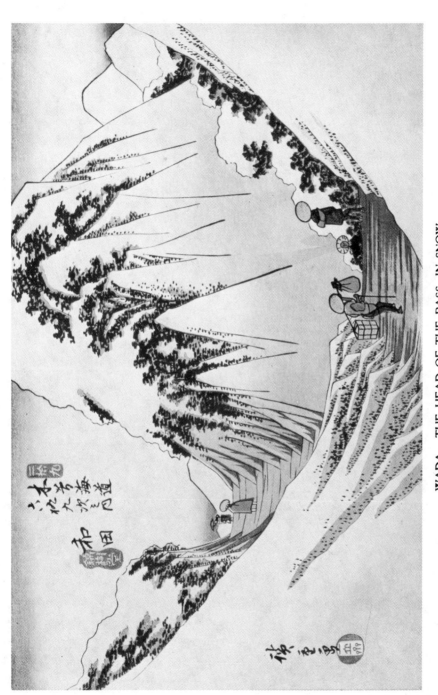

WADA. THE HEAD OF THE PASS, IN SNOW.

No. 29 of the series of "Views of the Kisokaidō." *Publisher,* Kinjudō.

(See color plate H.)

and characteristically delights, is, here, somewhat out of keeping with the note of true beauty and sentiment evoked by the artist's treatment of the main subject. But in the " Mochizuki " there is no dissonance. The great pine trees stand up in the night, on the outward edge of the pass, their limbs and roots grasping the bank with a nervous grip that is almost painful. One, the nearest, is already decaying, and its battered trunk leans outwards over the moonlit ravine towards the eternal hills on the far side of the wooded valley. Along the road, in strong contrast to the guardian pines, toil a few tired wayfarers ; and the story is told. Here is neither comedy nor sentiment. But when Hiroshige worked out this superb and dignified design I must believe that he saw, and intended others to see, a vision of the iron grip laid on the land by the wise old Tokugawa Shōgun. He lived in a time when the seeds of revolution were already well sown and even sprouting. There are no signs of reverence in his versions of the daimyō processions on this and especially on the Tōkaidō road. Iyeyasu's sentinel pine trees were already straining to hold their grip of the land—even beginning to fall.

Of No. 47, " Ōi," Mr. Happer remarks that " there is no finer representation of falling snow in any of his other series " ; and, with the reminder that some few may be worthy to rank with it, we may accept the verdict. But to me, the mere pattern makes an appeal of the strongest—the contrast and harmony of line and mass. And never has Hiroshige carried farther, nor used more brilliantly, his great gift of simplification. There ought to be an example of this print (which is generally found in a condition at least respectable) in every art school in the kingdom.

As in the Tōkaidō, Hiroshige gives us one outstanding example of a subject in thick mist ; but, whereas in that series, the Mishima mists are those of the morning, in the Kisokaidō print, No. 37, " Miyanokoshi," we have, again, a moonlight scene, but of the early evening. These subjects tested the powers and the consciences of the printers to the uttermost. Nothing is more difficult to find than perfect impressions. The values rest entirely on the gradation of colour, and only the very finest work in this respect produces any-

thing but a caricature of the artist's intention. What that was, one can well imagine in either case; but one must confess never to have seen impressions which quite satisfactorily realize two of the most poetic visions in Hiroshige's two most important undertakings.

For the rest, one would note, in the best of Hiroshige's Kiso-kaidō prints, perhaps a greater daring in design—almost reaching violence—not by any means out of harmony with the spirit of the bleak and somewhat unfrequented country traversed at times by the road. Examples of this will be found in No. 29, " Wada," with its sharp and eccentric peaks piled up in snow at the head of the pass; in No. 27, " Ashida," with boldly curving foreground dotted with curious little trees like those in the Noah's Ark of our boyhood, and the angular outline of the far hills in sharp contrast ; in the fallen tree in No. 33, " Motoyama," monopolizing nearly the whole of the foreground. As compared with the Tōkaidō, one notes a change, rather than a development of style. In some respects, the artist shows higher powers ; but if he is, in these instances, more accomplished, one cannot help, frequently, a suspicion that his outlook is also more sophisticated. Indeed, one might wonder at times, how many of the Kisokaidō scenes had been actually sketched—even to the extent of preliminary studies—by Hiroshige. We know that he actually traversed the Kisokaidō road. The Department of Prints and Drawings of the British Museum contains a sketch book (1546), described in detail elsewhere in this volume, including no fewer than twenty-four named sketches of subjects noted by the artist, at stations in the list, of which nine in the series were dealt with by Yeisen. The latter point does not necessarily bear on the question, as Hiroshige sketched everything that took his fancy. Unfortunately the date of the book is not recorded, but from comparison of style with another sketch-book (1548) in the same collection, it need not have been later than 1848 and may have been earlier. The Kiso-kaidō book begins with nine subjects in order of occurrence (with omissions), and although they do not follow this rotation in the subsequent pages, they are so grouped as to suggest things actually seen as he went from one place to another. And there are interesting notes of local costume and that sort of thing ; one with memoranda

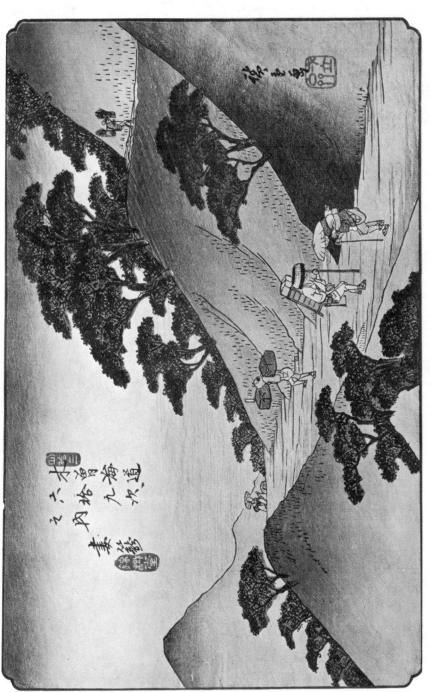

TSUMAGOME.

No. 43 of the series of "Views of the Kisokaidō." *Seal, Kinjudō.*

(See color plate l.)

of colours which indicate that he may have had the designing of prints in his mind.

The lesser popularity of the road, as compared with that of its great rival, would account for the fact that the series was not repeated. A book of popular poems, " *Kiso Meisho Dzuye*," published in 1852, has illustrations by Hiroshige of scenes on the road ; and Mr. K. Matsuki informs me that his collection includes some designs on thin paper for *andon-ye* (festival lamps) of Kisokaidō subjects. There exists also a *kakemono* of one of the stations, Kannonzaka, near Ōta (No. 52). Mr. Matsuki relates that several of the illustrations in the book of poems are topographically correct, from his personal observation, especially those near Lake Suwa and including the Shiojiri Pass—which are dealt with in the British Museum sketch-book.

A third sketch-book (1545) contains a sketch of the " Yenshū Akihasan "—approach to Akiha Temple—one of the prints in the fine " Honchō Meisho " series, which is placed by the editors of the Memorial Catalogue earlier in chronological order than the Kisokaidō series. This corresponds with the actual print more closely than any other of the sketches and must, almost certainly, be considered as the original of it. This book has a drawing of the Nunobiki Waterfall and of the Satta Pass, also forming subjects in the Honchō Meisho. When we find, moreover, that two of the stations of the Kisokaidō " Takamiya " (65) and " Echikawa " (66) come within a few pages, we may perhaps, with an easy conscience, connect these most valuable and charming artistic memoranda with the series of colour-prints.

Mr. Fukuba Toru contributed a *kakemono* entitled " A Scene on the Kisokaidō " to the Japan-British Exhibition of 1910 (No. 282) and Mr. H. Shugio had in the Memorial Exhibition nine small sheets, printed in black on very thin pieces of wood, of a series entitled " Kiso Meisho Dzu " (" Famous Scenes of the Kisokaidō ").

CHAPTER VII

THE OTHER PRINCIPAL SERIES

THE Japanese, following Chinese custom and tradition, have an affection for arranging things in definite categories of fixed numbers. There are many instances of this practice in the work of Hiroshige, other than the sets of prints illustrating the stations on the great roads, the number of which naturally regulated that of the subjects in each case. A conspicuous example of the habit is found in the several series of landscapes, each comprising eight views, and always associated in theme with eight ancient Chinese poems dealing respectively with Evening Snow, the Full Moon in Autumn Twilight, Evening Rain, Temple Bells Ringing at Close of Day, Boats Returning to Harbour, Geese Flying Home, Sunset, and Clearing Skies at Evening after Storm. These eight subjects in themselves might well bring an artist to his best mood, for they represent perhaps the most beautiful phases of Nature—at all events to a class of people whose daily task was onerous enough to inspire an appreciation of the hour of rest.

In view of the Chinese source from which the Japanese directly derived the idea, one might well have expected a formal treatment, but Hiroshige went far beyond those limits. He designed numerous sets of prints embodying the well-known and popular ideas, but placed them in ever-varying setting of different scenes—always instinct with poetic feeling of the highest order. Indeed his three great series of Hakkei—those dealing with the scenery of Lake Biwa (*Ōmi Hakkei*), the neighbourhood of Yedo (*Yedo Kinkō Hakkei*) and Kanazawa (*Kanazawa Hakkei*)—must be placed in the first selection of his work. These were published by Hōyeidō and Yeisendō, by Kikakudō and by Koshihei respectively. The Memorial Catalogue gives an interesting note on the Yedo series ; to the effect that a contemporary poet, Taihadō, employed Hiroshige to depict a set of

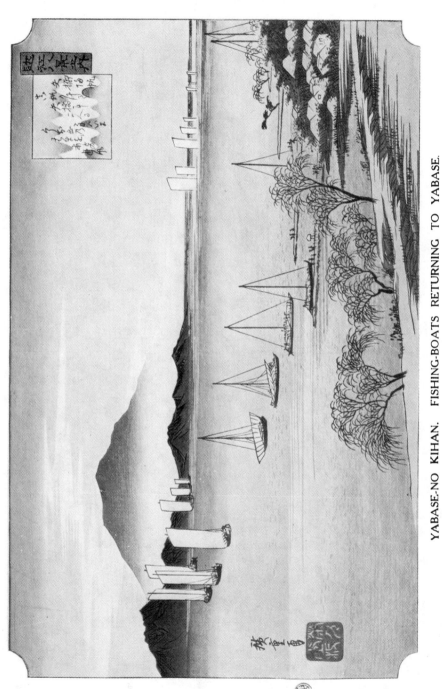

YABASE-NO KIHAN. FISHING-BOATS RETURNING TO YABASE.

From the series Ōmi Hakkei ("Eight Views of Biwa").

(See color plate J.)

scenes chosen by him and some fellow-poets, in order to record their poems ; and some of the prints have, outside the border, the mark *Taihadō-Kaihan* (Prints inaugurated by Taihadō). Each has a poem in three or four verses ; and it is suggested that they were done for circulation among Taihadō's *coterie* of poets—one of those little poetry clubs which form so pleasing a feature in the life of the ordinary folk of the period. The result was, however, so popular that the publisher obtained Taihadō's permission to issue them in the ordinary way to the public, but with only one verse on each. The latter is the edition generally met with, and, even so, is very rare. Examples of the first edition are treasures to be cherished when met with ; none could be included even in the Memorial Exhibition.

These three series represent the high-water mark of Hiroshige's achievement. They are executed with rare delicacy of design and restrained, but exquisite colour. It were hard to choose among so great a wealth of riches : but, of the Biwa series, the cold purity of the moonlight scene at Ishiyama ; the infinite charm and inimitable drawing of the Tama river version of the same theme in the Yedo set ; and the simplicity and humanity of the Shōmyōji "Bells" at Kanazawa, will more than satisfy the most exacting critics. In date of production, they are probably to be placed after the first Tōkaidō, and not later than the beginning of the Kisokaidō sets. Before leaving this group, attention may be drawn to the fan design reproduced in the plate facing p. 92 and described elsewhere (p. 91) ; for it comes very nearly to the style of the best of the three great Hakkei and may even represent the beginning of it.

Probably the earliest set of Ōmi Hakkei is a small vertical set signed Ichiyūsai Hiroshige (Happer Sale, 8). These have only historical interest ; but in a little quarter-plate set of the same subject, published by Senichi (Memorial Cat. 22) the artist already shows the beginning of his power. He published several other small-sized series and at least one full-sized vertical set ; while we have noted about the same number of Yedo (or Tōto—the Eastern capital) Hakkei and two quarter-plate Kanazawa views.

Of views of Yedo, other than the conventional eight, the number is very large. Mr. Happer has identified more than fifty different

series, and a full catalogue of them would alone need a considerable volume. Yedo was Hiroshige's native town, and not only the centre of his own activities, but that of the colour-print industry generally. Probably this art of the artisan did not find the aristocratic atmosphere of Kyōto favourable to its growth; for, although a few series of Kyōto views and other local subjects exist, the number is altogether insignificant in comparison with those relating definitely to Yedo, which was, moreover, the seat of most of the publishers. Ōsaka had, in the first half of the nineteenth century, its own group of designers of colour-prints, but Yedo's supremacy in this respect cannot be challenged. This was natural enough. It was the chief town of Japan for all practical purposes; the seat of the effective government ; the centre of the national life. To Yedo came, every year, daimyō from every part of the country, with their huge retinues of retainers and hangers-on ; and the servants and coolies, as well as the folk of the city, constituted the main support of the colour-print industry. A set of ten, published by Kawaguchi Shōzō (Kawashō), with decorative borders, and signed Ichiyūsai Hiroshige, is considered to be the artist's first undoubted attempts at landscape, pure and simple. They are well drawn and composed, and have a characteristic treatment of clouds in the sky which appears again and again in later prints, and marks his early independence of the conventional bars used by some of his contemporaries and predecessors who had attempted landscape. About this time (1830) he also issued a set of eight and another of twelve views of the capital, four on a sheet (yotsugiri).

Very soon after the publication of the First Tōkaidō, begins a notable series of Views of Yedo in similar format, the number of which has not been exactly ascertained. The issue extended over a period of not less than ten years ; earlier examples having the red stamp of the publisher, Kikakudō, followed by others with the mark Sanoki, a " portmanteau " title derived from his private name Sano-ya Kihei ; but both referring to the same firm. This series contains many fine specimens of the artist's powers. He depicts Yedo and its neighbourhood under every conceivable condition—lonely and deserted scenes, crowded streets, river festivals, flower viewing, temples, rain and

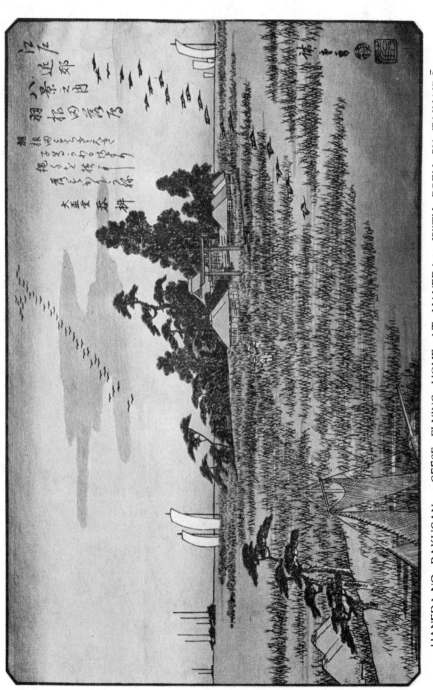

HANEDA-NO RAKUGAN. GEESE FLYING HOME AT HANEDA; WITH POEM BY TAIHAIDŌ.

From the Yedo Kinkō Hakkei ("Eight Views of the Neighbourhood of Yedo").

Publisher, Kikakudō.

(See color plate K.)

snow, day and night—a wonderful panorama of the life and beauty of the Shōgun's capital in the last phase of its existence under the old government. Tōkyō, the modern Yedo, has been ravaged with fire and earthquake; the reforms of Meiji must already have obliterated much of the city that Hiroshige loved so well and painted so faithfully. One wonders whether the historical and topographical value of his prints—he must have made over 400 of this subject alone—has yet been realized by his fellow-countrymen.

To attempt even a brief summary of the many series of Yedo prints is impossible in the space available. We must be content with a mere reference to the series of " Famous Restaurants of Yedo " to the number of thirty and published by Fujihiko ; and pass on to the well-known " Hundred Views," which has something of the character of a memorial to the artist. This unequal but, in mass, remarkable production was issued by the publisher Uwoyei Yeikichiji. It comprises 118 views with the signature Hiroshige; a second version of the " Akasaka, Kiribatake in Rain," signed *Ni sei* (second) Hiroshige and an Index of Subjects (*mokuroku*), making 120 sheets in all. The prints are vertical and of full size ; arranged in four groups relating to the Four Seasons of the Year, and dated in every case. Mr. Happer's note gives the dates of 116, as follows : 1856, 36 plates ; 1857, 70 plates ; 1858, 10 plates. These dates would be those on which the licence of the censor was given approving the design, which was necessary before the blocks could be made. The last of them (excluding the print by Hiroshige II) is within a month of the death of Hiroshige ; so that it is reasonable to assume that the whole of the work, so far as the artist was concerned, was finished before that event. The exception just mentioned is dated 6th month of 1859. Mr. Happer suggests that it was made to fill a deficiency caused by an accident to or loss of the original. It is, however, curious that in this case the later edition did not more closely follow the first design (as in the Tōkaidō series), which is, we think, no more rare than its fellows. Bound sets often have both prints.

The publisher of the " Hundred Views " also produced the memorial portrait of Hiroshige which appears as the frontispiece to

this volume. In the text accompanying this print he only refers specifically to the " Hundred Views " and to a book (in 14 volumes) of comic poems relating to Yedo, of which Hiroshige illustrated thirteen, and Hiroshige II the last. Monsieur C. Vignier finds, in the fact that there is no mention of Hiroshige's earlier and better work in this note, " quelque chose d'étrange et d'absurde." But surely one need not go beyond the commercial point of view for the explanation. The portrait was not a memorial formally devised by a committee of the artist's admirers; and the publisher, making capital out of the death of one of his most successful clients, could hardly be expected to advertise the productions of his rivals in trade. He went further, and published a view of his shop (by Kunisada II) showing the " Hundred Views " on sale.

As stated previously, only one of the " Hundred Views "—and that an additional plate—belongs, by signature, to Hiroshige II. But modern Japanese criticism is inclined to attribute two or three more definitely to the pupil, viz. : " Ichigaya, the Hachiman Shrine " (21), the " Bikuni Bridge " (115), and perhaps another—possibly on account of some accident. The signatures cannot be relied on to prove anything unless it be that the second man had the task of signing a considerable number—whoever made the designs. His authentic signature on the " Kiribatake " is repeated again and again on other subjects—with the exception, of course, of the characters meaning " second." Japanese critics are agreed that he copied his master's signature as well as, to the best of his ability, his style. We give elsewhere facsimile reproductions of the " Kiribatake " signature, and of another print in the series so closely resembling it (and not the only one) as to inspire confidence in anyone not allowing for the Japanese talent for minutely exact reproduction. And it is doubtful if Hiroshige I was so well educated (in literary accomplishment) that his signature can be accepted as an entirely trustworthy guide. Throughout the great range of his work, and over and over again, within particular series, one may find greater variation than appears in the " Hundred Views."

One set of views of Kyōto calls for notice : a lateral series entitled " Kyōto Meisho " and published by Kawaguchi Shōzō, prints

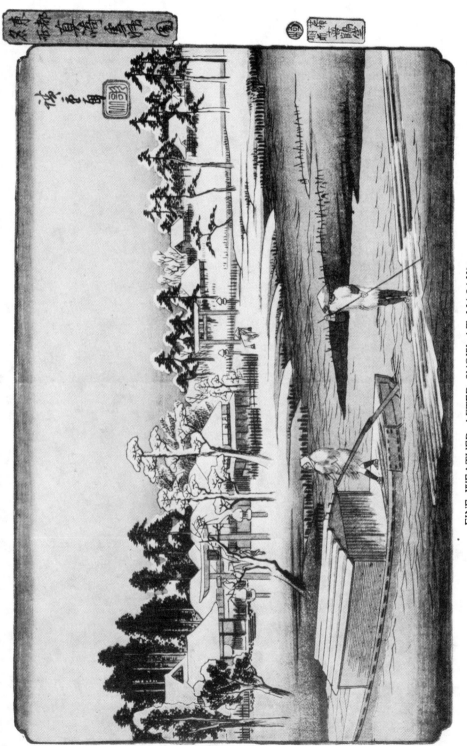

FINE WEATHER AFTER SNOW AT MASAKI.

From a series of "Views of Yedo." *Publisher*, Kikakudō.

bearing one or other of the marks used by this firm—Yeisendō or Kawashō. These are of about the period of the great " Ōmi Hakkei," and include some well-known and beautiful examples of the artist's best period, representing popular resorts of the capital in the Four Seasons of the Year. The " Gion Temple in Snow " and the " Boat on the Yodo River " may be particularly mentioned. In the latter, Hiroshige, perhaps more than in any other of his designs, challenges Hokusai on the latter's own ground.

Going farther afield than the great roads or the two capitals, Hiroshige produced several series of varying importance dealing with scenes in the Provinces. First of these in merit is the " Honchō Meisho," or " Famous Scenes of the Main Island " (publisher, Fujihiko), a lateral series of not fewer than fifteen sheets, of which the " Nunobiki Waterfall " is a strikingly powerful and original composition, comparing most favourably with the treatment of the same subject by other artists. In his last period came the " Views of More than Sixty Provinces," which have been dated from 1853 to 1865 ; though, in the opinion of the writer, 1856 is the latest date mark, and that read as 1865 should be the year of the earlier cycle, 1853. There is little doubt that Hiroshige II must be given a large share in this production. One has only to consider the " Monkey-Bridge " (*Saruhashi*) in this series, side by side with the famous *kakemono-ye* and the first sketch reproduced in this volume, to see how far it is from the originals. Yet there are designs by no means contemptible—only, as in the case of the " Hundred Views of Yedo," the execution leaves much to be desired.

One more group of landscapes must not be forgotten, those inspired by the scenery and legends of the Six Tama Rivers (Tamagawa). The traditional number of " Views " in this case was always six, representing that number of rivers of the same name in different provinces of Japan, each of which is associated with an ancient poem, symbolized in the treatment of the subject. Hiroshige was evidently attracted by this theme—which, indeed, supplied his master, Toyohiro, with material for one of his most successful efforts—and often drew it. The lateral set (*Shokoku Mu-Tamagawa*) published by Tsutaya calls for high praise, and

the element of landscape counts for more in these fine compositions than in the series of narrow upright panels (*chūtanzaku*) for which one must confess a greater admiration. Hiroshige was a great master of the decorative possibilities of this form of panel. The " Koka Mu-Tamagawa was published by Kawashō, who also handled so many of the " Bird and Flower " prints and the exquisite " Yedo in the Four Seasons," and who may have, perhaps, some credit for having inspired this distinctive and most delightful phase of the artist's work.

In the latter series the figure plays an important part, though nothing could be better than the restrained, yet completely satisfying suggestion of landscape in which it is placed. This will be realized by a study of the original drawings for similar subjects which we have been able to reproduce ; the few but telling lines and the massing of the blacks enable one to appreciate the skill of the draughtsman almost better than with the distraction of colour. Hiroshige made other notable sets of like character, in which graceful if not powerful figures are used in combination with his inimitable landscape. Such, for instance, are the " Kokon Jōruri Dzukushi "—" Illustrations of Old and New Ballad Dramas " (Sanoki, publisher), of which fourteen or fifteen have been identified ; the series of sixteen scenes from the great drama " Chūshingura"—that " Story of the Forty-seven Rōnin " immortalized, in Japan, in more than fifty separate plays, and known, surely, to most of those who can read the English language, in the finely told tale, by the late A. B. Mitford (Lord Redesdale), in " Tales of Old Japan." The " Rōnin Crossing the Bridge " in snow is the print in this series that at once leaps to the memory. Hiroshige may not have possessed the power to depict dramatic action that was wielded by Kuniyoshi and a few others ; but when he, as in this print, calls Nature to his aid, he reigns supreme. Nothing could be more impressive than the tramp of the devoted band of followers of a lost lord, bound by their oath of vengeance, over the old bridge, snow-covered and in the silent night.

The tale of the Vengeance of the Soga Brothers furnished Hiroshige with a similar subject (30 sheets) which he also dealt with in the " Chūkō Adanchi dzuye "—" Stories of Revenge inspired by

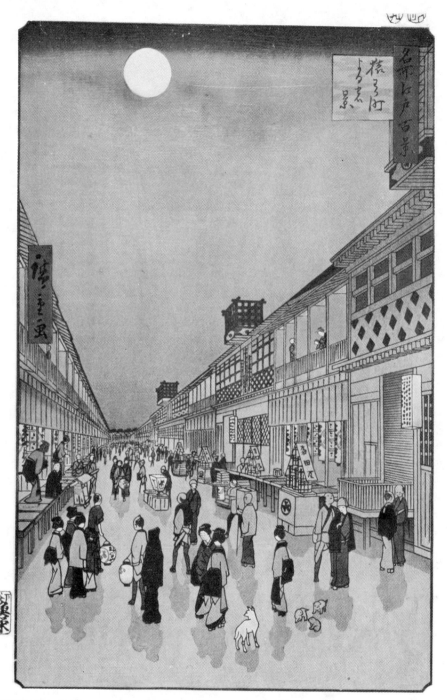

SARUWAKA-CHŌ, YORU SHIBAI. SARUWAKA STREET, YEDO, WITH THEATRES, IN LIGHT OF THE FULL MOON.

No. 90 of " The Hundred Views of Yedo." *Publisher*, Uwoyei.

(See color plate L.)

Loyalty to Parents and Lords." Many of the 3-sheet prints produced during his latter years are of this kind—some entirely the work of, may we say, the Hiroshige *atelier*, others with figures that do not greatly add to their beauty, by Kunisada. A curious set, the main appeal of which will be to the collector rather than to the artist, is entitled " Fuku-toku Kane-no Naruki " (" The Lucky Money-tree that produces Wealth "). At the top of each print is a representation of the " money-tree "—the branches of which are heavily laden with gold coins ; and the subjects represented are industrious women engaged in various occupations (publisher, Aritaya). We have noted thirteen of this set ; probably there are more. One of the industrious ladies is painting her face !

One reverts to pure landscape in referring to the " Views of Mount Fuji." Hiroshige drew Fuji from every possible point of view, and the Peerless Mountain occurs over and over again in his work ; but of the Thirty-six traditional views he seems only to have done two series. The first is a charming set of lateral half-plate views, published by Sanoki in 1852, and giving us perhaps almost the last of the best period of his personal work. The other, a full-sized upright series, with title-page and list of contents, was not issued by Tsutaya until after his death—the date of publication being 6th month, Year of the Sheep (A.D. 1859), while that of the plates is 4th month of the preceding year, 1858. The preface has the inscription *Shodai Ryūsai Hiroshige Ō-i* (relic of the old man, Hiroshige Ryūsai), and states that the plates were received " last Spring " (1858) and carefully published as " an offering of sincere respect to my deceased friend." We have here, therefore, another memorial publication, which, indeed, comes very closely in qualities of design and of execution to the " Hundred Views of Yedo " previously considered. It cannot be compared with Hokusai's masterpiece, published twenty-five years earlier ; yet it has many masterly designs. It must be placed in the group already defined, in which we see the predominant influence of the pupil who must have collaborated in the production.

Before leaving the series of landscape, notice must be given to a set of late 3-sheet prints which have achieved a considerable reputa-

tion—one must think, to some extent on account of their size rather than their artistic value. They form a triad of the favourite theme, " Snow, Moon and Flowers " and comprise, the " Rapids at Naruto," " The Eight Kanazawa Scenes in Moonlight " and the " Kiso Mountains in Snow "; and were published by Tsutaya in 1857. The second is the best—a really good composition with strength and coherence throughout the design. The " Naruto " is weak, and the subject does not lend itself to the chosen dimensions. We have a much earlier drawing by Hiroshige, in one of the sketch-books, which is masterly ; and the fan-print is, in the writer's opinion, far superior to the larger productions. In the latter, one is inclined to recognize, very clearly, the effort and failure of the pupil to rise to the theme propounded by his master, who, beyond setting it, probably took no further share in the execution. The " Kiso in Snow " has much the same defects, but is, in virtue of its mass and colour, more impressive. It is a long way from, and after, its fine prototype. There are, by the way, dangerous copies of each of these prints in existence, to be known by differences in the boat in the one case, and, in the latter, by a variation in the outline of the mountains. In his sale catalogue, Mr. Happer interpreted the seal-date as 1845 ; but we have preferred to follow the editors of the Memorial Catalogue,* who chose, as we think, rightly, the next occurrence of the Snake Year in the cycle, namely 1857.

Two sets of " Uwo Dzukushi," Grand Series of Fishes, were issued, each of ten plates. The earlier series was published by Ycijudō about the same time as the First Tōkaidō appeared ; the second, by Yeijudō and Yamashō about the year 1840. These prints are somewhat rare and have had a vogue out of all proportion to their merits, especially in France. Copies of these, also, must be guarded against.

* On the sixtieth anniversary of Hiroshige's death (September 6, 1917), a great memorial exhibition of his work was held at Tōkyō. The catalogue, extant only in a very limited edition, contains the best list of the artist's work yet published, and is the chief authority for the above summary.

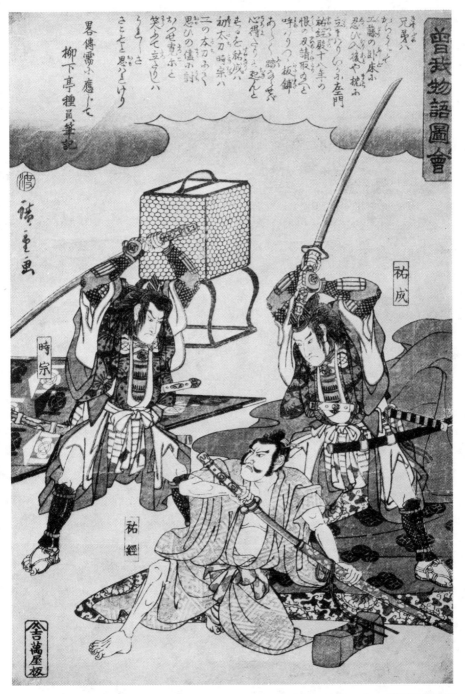

THE SOGA BROTHERS, SUKENARI AND TOKIMUNE, KILLING SUKETSUNE.

Scene from " The Story of the Soga." *Publisher*, Yorozuya.

CHAPTER VIII

HIROSHIGE'S DIARIES

THE earliest in date of the fragmentary diaries still remaining, or of which we have a record, is that of a journey made by Hiroshige over another of the great roads of Japan—that called the Kōshūkaidō and running from Yedo through the province of Kai (Kōshū was the old name in Chinese style) to Kōfu and then by way of Nirazaki and Kanazawa to join the Kisokaidō at Shimo-Suwa. On this expedition the artist " auspiciously started " on the 2nd day of the 4th month in Tempō 12, Year of the Ox (A.D. 1841). He made such good progress as to arrive at his destination, Kōfu, on the evening of the 4th day of his journey—a matter of about 80 miles. It was evidently his first experience of this country. He makes careful notes of the industries practised in the towns and villages through which he passed, and here and there illustrated (in the lost original) his point with sketches. Food is to him a matter of great importance, and the quality of that supplied at his various halting-places is sedulously recorded ; while the attention given to the state of the weather could hardly have been exceeded by an Englishman. The company that he picked up or discarded on the road is duly noted, sometimes with caustic comment ; and the accommodation provided (or refused) at the various inns receives its share of attention—with special reference to quality and cleanliness. At need or on the impulse of the moment he turns a little verse—sometimes, we gather, somewhat *risqué*, but, again, as when crossing the Sasago Pass, altogether simple and charming. And he never fails to write his appreciation of fine scenery, in language to which Mr. Matsuki (to whom I owe the translation following) seems to have done at least adequate justice.

Throughout the diary, the business of making colour-prints is never mentioned. But this journey has special significance to those

who are interested in this branch of his art, for it records his visit to the famous *Saruhashi* or Monkey-Bridge, which provided the subject of one of his greatest and best-known compositions. Moreover, it has the advantage of giving us a date which at all events limits in one direction the period within which this masterly *kakemonoye* must have been produced. As Hiroshige may not have returned to Yedo, at all events to settle down, for a while, it is fairly safe to place the *Saruhashi* print not earlier than 1842. He can hardly have failed, also, to collect much material for the Views of Mount Fuji; for Kōfu is a point from which many excursions can be made affording superb points of view ; and, among them, the descent of the Fujikawa rapids, which, as noted by Mr. Kojima, his sketch-books prove him to have made, as well as a trip to Mount Mitake, once famous for its magnificent temples.

But all this and the sketches resulting therefrom were merely incidental to the main purpose of the journey. The designing of colour-prints was not the only—and, at times, not even the chief occupation of the artist. Hiroshige went to Kōfu, evidently by invitation, for the express purpose of painting " theatre curtains "— those drop-scenes to which the people's theatres of Old Japan attached so much importance. These were sumptuously executed and at great expense ; generally, three or four were displayed in the course of one performance ; and, bearing in mind the strong natural artistic taste of the Japanese people of every class, there is no doubt that they constituted a not unimportant attraction. Hiroshige got into touch with the people he had come to meet, on the first day after his arrival, and met his " committee " two days after. A studio was selected, and he settled down to work, mainly at the curtain, for which he, on April 14th, received a substantial sum in advance of payment (5 ryō in the old coinage may have been about 8 guineas), of which he promptly remitted the greater part to Yedo. He also painted a " Shōki " (the " demon-queller "), 6 feet by 12 feet in size, a banner, 12 feet by 1 foot, for a " Chinese figure," and a number of panels. There seems to be a possible reference to an illustrated book, but that was obviously an affair of small importance at the time.

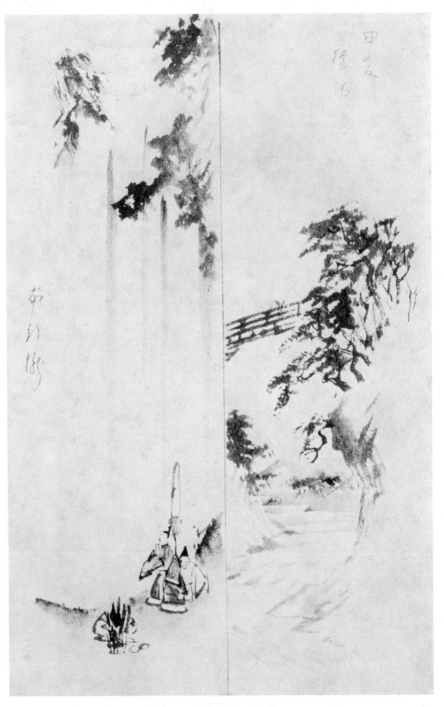

ORIGINAL SKETCHES.

The Nunobiki Waterfall. Saruhashi : The Monkey Bridge.

From a sketch-book in the British Museum.

The second fragment of the diary, in the 11th month of the same year, is also concerned with similar work—evidently a further commission, as it begins with the preparation of a sketch design in ink. This curtain was finished on the 5th day, and a coloured signboard or poster for the theatre begun at once. He finished his theatre-sign next day ; and, on the day after, notes that all painting was completed, made out his bill, sent off his baggage, and drank sake "till late night." His return journey only occupied a few days.

The original note-book covering the last part of this diary has, happily, been preserved. It came into the possession of the late Mr. Wilson Crewdson, who lent it to me for the purpose of my paper on Hiroshige, read before the Japan Society on April 13, 1910. At the sale of Mr. Crewdson's collection it passed into the hands of Dr. Jonathan Hutchinson, who has most kindly placed it again at my disposal. It is a small volume of only 38 pages, roughly put together and bound in paper, filled with charming sketches in ink, of which two examples are reproduced (plate facing p. 122). The script is hastily scribbled at the end, so as, in places, to be hardly legible— but Hiroshige was no scholar and Japanese writers say that he made many mistakes in writing. The translation of this portion (from November 13th onwards) was made by Mr. Hogitaro Inada and Mr. Shōzō Kato. No doubt owing to difficulties of reading the script this version does not exactly correspond with that given by Mr. Matsuki (after Kojima) ; so it has been thought advisable to collate them, the former and more detailed being generally followed. I quote Mr. Matsuki's preface to the Diary in full.

DIARY OF HIROSHIGE, ON TRIP FROM YEDO TO KŌFU

In making this translation of the Diary, I feel it is quite necessary to express our obligations to Mr. H. Kojima, in whose book, " Ukiyoye to Fukeiga " (Ukiyoye and Landscape Pictures), published in 1914, the diary was printed, for the original was destroyed in the great disaster of 1923. It is from this book that the translation is made. It is the sole remaining source. [He did not know of the existence of Dr. Hutchinson's fragment.—*Author's note.*]

In Chapter 24, Mr. Kojima wrote :

The existing diaries of Hiroshige's sketching tours are, as mentioned in Chapter 7 under the title "Sketching Tours among Sea and Mountain Views," one of the travel in Kai province, also called Kōshū, the Kanō-san tour, and the tour around Kominato Tanjoji. The Kai trip diary is the longest and most interesting. In reading this, we see how he delighted in clean and tidy accommodations, how he enjoyed good food and was particular in regard to the quality of the native drink, how simple and unaffected in social relations though occasionally indulging in cynical comments so characteristic of the people of Yedo.

The hand-writing of the diary is freely mixed with the *kana* or native syllabary, which would seem to show that he was not so well-educated in the Chinese character, though this may be due to carelessness, and some parts are not lucid and there are errors in text. As he devoted himself to art studies from boyhood, it may be that he lacked time to cultivate the writing of characters. Still, whatever his faults of style or pen, he shows a close attention to detail.

Personally, I rather like the style shown in his diary, while his penmanship or hand-writing seems strong yet elegant. The Japanese and Chinese poems sometimes written by him on his Bird and Flower prints are in keeping with the artistic composition and are a source of pleasure in complete harmony with the picture.

<div align="right">

K. Matsuki, Tōkyō,
October, 1924.

</div>

HIROSHIGE'S DAILY OF TRIP TO KŌSHŪ

"Note of day to day, April, Tempō 12, the year of Ox. (A.D. 1841) Ichiryūsai."

April 2. Auspiciously started. Cloudy morning, cleared by noon. Left home at *itsutsu* of morning (8 a.m.). From Marunouchi passed through Yotsuya, Shinjiku and made a turn of road at Oiwake. About here the road is pretty bad. Came to Yotsuya-shinmichi, at right there is a road to Juniso, here took a rest. After Ogikubo the road stretches eighteen chō (a little over one mile) to Horinouchi Temple, and tea houses are found on both sides of the road ; rested. In hearing the road to Ōyama of Sagami within 10 chō and a short cut to Futago-no-watashi (the ferry) being near, I, for a fun made this kioka— (popular poem, not translatable).

Went on, villages of Shimo-Takaido and Kami-Takaido, and at Ishihara rested. Through Nunodajiku the landscape was monotonous. A party of three, men and woman from nearabout of Horinouchi became fellow-travellers, not

pleasing. At Fuchujiku visited the Taisha shrine. Two ri to Hino seemed very long way ; took a rest. Crossed Tamagawa by ferry, passed Hinonohara, as going through Hinojiku was joined by a samurai from Suwa of Shinano, took a rest. Passed Hachioji, at Yokaichi tried to lodge at inn called Tokurikiya whose house-mark was like this (sketch) but was refused, so went to the next house by name of Yamakami Jurozayemon. The proprietor was a samurai, being a retainer of Takeda of Kai. Here I met with an elder retired man by name of Suzuki who had much to talk, and heard many interesting stories. By his request composed a kioka of sarcastic nature for him to send to his old love. Having been told that the woman's new patron is a *tabiya* (Japanese sock-maker ; old style *tabi* were provided with cords to tie round ankle) I made the kioka like this,

" The cords of tabi are so firmly tied around your feet, I cannot loosen the tightened root lying in the depths of your heart."

This man resembled much to a kioka composer called Irifune Sendo. For the reward I was treated by him with tea and candy.

April 3. Fine weather. From Sennin street of Hachioji to Santa village the roadsides were hedged with *kenninji-gaki* (special kind of hedge made with split bamboo) and peasant houses looked very clean ; took a rest. The toilet of these houses about here were like this (sketch). From here on, house after house were engaged in weaving industry, making an imitation of Hakata Silk of Chikuzen. Stream was running through village, provided with small water-mill using in hulling rice ; they were like this (sketch).

In village of Konaji there was a tea house, very clean, offering all kind of dishes owing to the employment of a good cook from Yedo. From here a road branches out for 1 ri and 18 chō leading to Takaoyama. Passing Komakino barrier reached to the inn of Komakino, from where was also a short cut to Takaoyama. About here each house was also weaving. From here had another companion of three people from Yedo, on pilgrimage to Minobu, and still another of the hostess of Kashiwaya, the lodging house at Konaji-jiku, making all together five of us ; talked as we went. Begun to ascend Kobotoke Pass. At a tea house took our lunch with vegetable side-dishes which was very poor. Here was the boundary post of Musashi and Sagami. On descending path of the hill was the birth place of Terutehime. Over the valley a little village was visible. At foot of the pass there was a little settling and here we parted with the woman.

Passed Koharu-no-shiku to Yose-no-shiku and at a tea house near the entrance we rested. We ordered some sushi of fresh-water trout and got it after helping to make it. The price was too high because it did not taste good! Making

a short cut was reached the town of Yose, the cut, making the difference of 20 chō from that of main road, was somewhat of hard passing. The Sagami River was slowly running ; crossing the ferry asked the ferry man the name of the river who said "Sakuragawa." Crossing this river twice brought us to inn of Yoshine. This river starts off from skirt of Fuji, so in time of snow melting the volume of the water increases. The villagers say that since the snow resembles the flower, the name of Sakura-gawa derives. (Here he gives a kioka of his own.)

Leaving Yoshinojiku and at entrance of Sekinojiku the place called Umezawa we took a rest. At the house called Komatsuya saw the *stock of male and female principle*, and man and wife rock. Close by was a tea house where served big *manju* (bean-jam bun). After Sekinojiku soon came to Kagamigawa ; the view of the river was fine. Here were three tea houses and those situated toward upper of the river were better. Rested at the middle one, all were feeling hungry and four of us enjoyed fresh trout, *sakura-meshi* (rice boiled with shoyu) and macaroni with saku which was 24 *mon* for 1 go.

Then we came to the guard-house of Suwa, Suwa village, Suwa shrine. The houses from here on were all weaving ; making some silk and cotton cloth. Uyenohara was a very good place ; crossed stream of Tsurukawa, of which was told that in time the water increases, forbidding crossing. The view here was splendid. To Nodajiri went one ri and half, the hill road seemed very long but was charmed with the fine views, making number times of rest. Made lodging at Nodajiri where parted with the three of Yedo. Stopped at the house by name of Komatsuya which was only large and not clean (here he gives another kioka). This evening was aiyado (shared room with some one unknown traveller). In the next room there was a samurai of Kuwana and his family. He, after his family retired, practised the art of *iainuki* (the way of drawing a long sword sitting). First he explained to me his school, telling the name of his teacher. Then explained the way, its form were about like this (sketch). Beside *iai* he showed the way of *tachiai* (facing to foe standing) and some others and then talked much on military pursuits ; about on firing methods and claimed to own one of only two existing secret book on the subject. He also said of having studied astronomy. (Here he gives bill of fare of the supper that night.)

April 4. Fine weather. Left Nadajiri and begun to ascend Inume-toge (pass). The Fuji could be seen as go up the slopy road. At the inn of the pass rested, at tea house called Shigaraki which was opened last March and is run by a man and his wife of Yedo, he used to be a tailor at Shinbashi. Were selling some sweet and all kind of sake and drinks, the shop was comparatively clean.

From Inume to Kami-torizawa the distance of 1 ri and 12 chō was accommodated by horse just returning that way. From Torizawa to Saruhashi was 26 chō, the mountains of Kai were running far and near, some very lofty

with valley deep, the stream of Katsuragawa was pure and clean. The view changed every ten and twenty steps. The charm of the views inexpressible, beyond brush's tempt. From Saruhashi (monkey-bridge) to Komahashi was 16 chō, the road running by a gorge, high peaks of mountain far and near with scattered villages, the view was magnificent. At a tea house of other side of the monkey-bridge took my lunch with trout and vegetable.

At Ōtsuki the road branches out to Fuji. Followed to right descending a slope came to a big bridge, the torrent terrific with rocks of peculiar form. The rocks were towering, thickly wooded ; was completely surrounded with mountains like screen. The view was attractive and also ghastly. The bridge was in decay and a temporal bridge was right by ; in crossing, it came to where the path parted in two, at which I was at loss which one to follow, yet there was no house nor any passing people to inquire about. After standing awhile in a wonder a woodcutter appeared, by whose help I was able to make headway to Shimo-Hanasaki and then to Kami-Hanasaki. At tea house called Kashiku, just before getting to Hatsukari, rested and met with a party off our from Shinagawa of Yedo.

At leaving point of Kami-Hatsukari was a tea house where I ate four sticks of *dango* (dumpling made of rice-flour and four or five of them stuck through a bamboo stick). The hostess of this tea house was native of Yokamachi of Kōfu and had been once to Yedo. Strangely she boiled tea out of *kama* (iron pot) instead tea kettle. One mile to Hinojiku, by ascending Tenjinzaka brought to the village ; then came to Yoshigakubo where was a stone tablet like this (sketch), by going up a little, visited a peasant house called Katsuzayemon and inquired about the deadly poison snake, the old woman came out from interior and told following account—

Some days back, here used to live a wealthy peasant who had a daughter called Oyoshi. She was very beautiful but wicked minded and at last she took form of serpent and lived in a large marsh near about, and night after night would appear tormenting the villagers. The Buddhist priest Shinran happened to come and through his virtue the animal was subdued. The family of Komata still exist in the village, and at a temple of Shinran's sect in Imazawa some two miles away is offering the history printed on paper. This old woman was about seventy-seven or eight, had travelled all alone last year from Zenkōji of Shinano to Yedo, Kamakura, Yenoshima and up to Ōyama. She told many other things and treated us with cakes made from wheat flour.

At Noda-jiku went to Ōgiya for lodging but was refused, stopped at Wakamatsuya. This house was incomparatively dirty, more so than Komatsuya of before ; wall was falling, floor was down, worms were crawling. The straw mats was filled with dust, the *andon* (lighting apparatus) was covered with spider's web and paper broken, the damaged *hibachi* (brazier) and tea cup which was

almost too good for this house. (Here he gives particulars of menu.) To-day occasionally got together with the party of Shinagawa of Yedo but slipped away on account of their being disagreeable.

April 5. Clear weather. Left Kuronoda and begun to ascend Sasago pass. At about half of the way took rest where met with man and woman (they were sister and brother) from Yedo, a man from Kakegawa of Yenshu (Province of Tōtōmi), a party of three, and a Zen priest from Ichikawa of Kōshū, and exchanged words each other. Keeping up the pass came to *Yatate no sugi* (the huge cedar in shape like arrow set up ; this tree appears in Shokoku Meisho Hyakkei by Hiroshige 2nd) standing at left of the path. The woods were thick, sound of raging torrent, songs of different birds were entertaining. The pass was over while enjoying them. As descending made a poem of hokku, " Oh cuckoo, you have made me again stop my foregoing foot to listen to you."

Leaving Tsuruse-noshiku went on 13 chō of narrow hill path and passed Barrier of Tsuruse. The women in party had pass. Here had meal with cooked *yamaudo.* Then went on to field known as Yokobuki at where was joined with a pilgrim party from Yedo. At right was mountain and left ravine ; on high mountain rocks were towering, woods was thick. In front at far distance Shirane-ga-take, Jizo-ga-take, and Yatsu-ga-take's high peaks were visible and the view was superb. Here was a Buddhist temple called Daisenji, on torii at front of the gate was table on which was written " A horse, an ox," did not inquire its meaning. From about here on to Katsunuma was growing the famous grapes, its trellis were seen great deal. This was a long street and stopped at tea house called Tokiwaya where took lunch with the party from Yedo ; the price was very cheap. Here the Yedo party took a road branched off, but met again with the sister and brother of Yedo and the man from Ichikawa. This companions were very amusing. Passed Kurihara and came to Tanaka where was a stone table like this (sketch). The story about the table was as follows :

More than one hundred years ago this village was visited by a flood and placed peoples in a great danger. Man by name of Yasubei who was a leper, had an aged mother in ill and very poor. His wife Okuri scarcely managed to support them. The mother however could not stand, and died. Yasubei said to his wife, " My illness is hopeless, and since it is nature that I can not associate with other people, I had better throw myself in the water and die ; but you are still young and have had no child, so should remain and may be able to get a good suitor." To which the wife answered denying, " Since I have come to this house I never expect to leave undead. If you have thus decided I too will do the same " ; and tying the two bodies together with her obi sunk into the flood.

Her deed was appreciated by the high officials and the monument of this virtuous woman was set up.

Next Shiku was Isawa ; at tea house near the entrance there was a large party of pilgrim from Yedo, very lively. Here I took a drink of *shochu* (alcohol) and a dish of macaroni. In course of conversation I found that the sister and brother from Yedo happen to knew Umekawa Heizo and Onaka of Asakusa. After going through a road bordered with trees, approached to city of Kōfu, where were the remains of Sakaori Shrine. The image of the deity was like this (sketch) ; at Yanagi-machi parted with the companion and at about five p.m. got to the house of Mr. Yeihachi whose house name was Iseya where I made a stay. To-day I had bath and was shaved.

April 6th : Clear weather. In the morning went to the theatre of Kaiyachō and saw two acts of the play called " Date no Ōkido." Then I had to leave on account of a certain business, and at Iseya met with the party of those who looks after stage curtains ; had sake feast with them.

April 7th : Clear weather. In morning saw Sanokawa Ichizo. From the forenoon went to theatre. From a girl I do not happen to know received a gift of tea and candy, and sent her things in return. Saw part of the play of Ōshun and Denbei, also Iroha Shijushichinin ; the curtain was new.

April 8th : Clear weather. In morning baggage arrived. The color of the curtain was selected. The members of the committee were ten ; in evening the respected Mr. Yoshiokaya Kameo came and we talked a long time.

April 9th : Clear weather. The place of studio was decided. From afternoon went to theatre and saw till the last. Then took a walk along street and visited temple Ichirenji ; within the temple ground were Inari and Tenjin Shrine, also archery and restaurant. Was invited to supper by Mr. Tsunezawa at a restaurant front of temple Onkōji.

April 10th : Cloudy. Painted a Shōki in size six by twelve feet. The curtain committee were having feast as inner room, and was invited. At dusk accompanied the respected Mr. Kameo to tea house of Ichirenji and had sake feast, and then inviting priest Sankeu went to another tea house and had jolly time.

April 11th : Cloudy. Had painted on five feet screen. Received two hundred hiki (1 hiki was ½ ryo) for painting Shōki and one dish of broiled eel. In evening had sake feast with Sanokawa Ishizo.

April 12th : Rain. Had painted four fusuma (paper panel of size 3 by 6 feet). A basket of cucumber and a dried Katsuwo were brought from Tsujijin. Enjoyed the treat of buckwheat nudle evening.

April 13th : Clear weather. At house of Tsuchinoya Jumon was a gathering of announcing kioka (popular poem) and attended.

April 14th : Clear weather. Painted two fusuma but not feeling well took rest. Received five ryo as deposit against final fee for painting curtain, and sent four ryo one bu two shu to Yedo (1 bu was $\frac{1}{2}$ ryo, 1 shu was $\frac{1}{8}$ ryo).

April 15th : Clear weather. In morning went to house of Mr. Murata Kohei of Sakanachō, from afternoon went to see procession of Goko festival. The streets of Kōfu were filled with people come out from near about. Felt slightly sick and took some medicine (sketch of festival); in evening went to see theatre there was no seat, but saw two different plays.

April 16th : Fine weather, had shower. Totally recovered from ill feeling. Wrote a little. Murako sent me home-made buckwheat nudles which were very, very good. In evening heard account of the festival, gave some tips to people of festival.

April 17th : Fine weather. Finished painting on fusuma for Tsujiya and sent to them. Tea and candy came. A flag of twelve to one feet was ready to paint Chinese figure.

April 18th : Fine weather. The flag was finished. From after-noon commenced to paint the theatre curtain and worked to evening. Letters from Yedo arrived twice.

April 19th : Fine weather. Despatched letter to Yedo. Painted four fusuma for Murako from whom some *sushi* (rice-ball) came. At dusk had a bath at Tsujiya, also had treat of *soba* (buckwheat nudle), went to theatre in evening and saw three acts of Iwaiburo.

April 20th : Half cloudy. Finished *sumigaki* (design drawn with ink) for the curtain. Also painted Shōki on Chinese cotton cloth. In evening went to Murako and on way back stopped at theatre, when it was over a sake feast was opened at third story.

April 21st : Half cloudy. Ordered a *yukata* (bath robe or retiring kimono) at Tsujiya. Applied colouring to Sanoi (book he was illustrating ?) did some petty work.

April 22nd : Half cloudy. Took a rest.

April 23rd : Half cloudy. Painted Shōki for Tsujiya.

Note by Mr. Kojima :

" From here the diary jumps to November 13th. Whether he had returned to Yedo during this period or remained is not clear. While he was staying in Kōfu it seems that he made the trip ascending to Mitake

THE EVENING BELL AT MIIDERA.

From the series, Ōmi Hakkei (" Eight Views of Biwa ").

and Minobu and shot down the Fujikawa rapid. His sketch book accompanying the diary contains in its end part the picture of the main shrine of Takaozan of Musashi and the Buddhist Temple Kashiozan Daizenji."

Nov. 13th : Fine weather. Made *sumigaki* (black and white design) for curtain. Was invited by Tsujiya for evening. The fish was good but sake and soba were bad, so speedily left at 10 o'clock. Wrote letter to Yedo.

(14*th.* Fine weather. Began to paint curtain, lonesome evening, was invited to Narumiya, the guest was the widow of Yeirakuya of Yokaichi.)

(Above was obtained from other manuscript.)

Nov. 15th : Fine weather. The curtain design was done. Took rest from noon. In evening had sake at Yorozuya's. Just after Yotsu (4 P.M.) begun to stretch another curtain on frame ready for painting, and then again sake feast.

Nov. 16th : Fine weather, then half cloudy. During morning worked a little on curtain. Had sake feast at Narumiya's. With some company went to an eel restaurant with Mansada and Genyemon. In evening all went to theatre and saw two acts of play. This was day of great booze.

Nov. 17th : Fine weather. Commenced to paint theatre's signboard. The screen for Narumiya was done. Worked a little at night. From late evening begun to stretch curtain. Sake feast continued till daybreak, and stayed at his house. During the night, Yeihachi's wife had a child. [Yeihachi was a friend of Hiroshige.]

Nov. 18th : Fine weather. The signboard for theatre was finished with colouring. There was a great feast in evening.

Nov. 19th : Fine weather. In morning finished all painting work. Wrote bill for the curtain. In afternoon had the parting feast with all our circle of friends. After the baggage was sent out from Narumiya's and the Yorozuya [inn] in the evening sake was drunk till late night.

Nov. 20th : Cloudy, snowed little. Left Iseya at about 7 A.M., accompanied Matsumi but parted on outskirts of Kōfu, hurried on alone and at evening at 6 reached Kamihanasaki where stopped for night. This lodging was very good. A man from Shinano was companion for the night.

Nov. 21st : Fine weather. Started about same hour as yesterday. Passed Inume and Shigaraki and rested. Sake and soup was poor. At Uyenohara took rest again, and took lunch. At Yose stopped for night at the Inariya Inn. Had to sleep with two other people as *aiyado*. One was an actor, Tsujiya Hyosuke. Heard the story of Ozawa who attempted a great crime at Uenohara.

Nov. 22nd : Fine weather. Left Yose in morning at 8 o'clock with company of one *aiyado* of the night before. Took rest several times, drinking sake each time but all were bad. By dusk stopped at Matsumotoya front of Myojin Shrine of Fuchū. Sake was very bad.

[He may had reached Yedo next day as the diary end here.]

[*Author's note :*—From November 13th to end, the original fragment is in the collection of Dr. J. Hutchinson, F.R.C.S., who kindly placed it at my disposal. The diary as printed has been collated with Mr. Kojima's version. The titles of the sketches in the volume are printed in Chapter XII.]

The second diary is a brief record of a visit to the neighbourhood of the Kanō mountain, still a favourite locality for excursions from Tōkyō in the springtime, and famous for its flowers and sea-views. Hiroshige went by boat to Kisarazu—steamers run daily at the present time—and made that a centre for several walks, in the course of which he saw two festivals and visited several shrines. This was purely a pleasure trip, for there is no mention of business and he does not even record the making of sketches or poems ; but his reference to the hospitality of Mr. Tsumekura Yahei and the fact that he was pleased that his host's people were " not a bit infected by city style," throws a kindly and illuminating light on the artist's own character. The diary is dated in the Japanese calendar equivalent of March, 1844 ; and, at this point, though again there is no reference in his notes to the making of colour-prints, we get a definite connexion with this part of his business. The collection in the Victoria and Albert Museum contains a view of Kisarazu, a lateral print (*ōban yokoye*) showing two sailing-boats at anchor in the bay, with traffic in small boats between them and the shore. This print is in Hiroshige's middle style, later than that of the Tōkaidō, but earlier than that of the last ten years of his life ; and we can consequently identify the date which it bears, Horse Year, 9th month, definitely as 1846. For the rest, we have the usual reference to his food and drink and " a great spree," with criticism favourable and otherwise of his lodgings. On " an evening of great drink " he " got into bad trouble by stepping into a stream by mistake " ; and, later, had a good passage home.

" Diary, Tempō 15, Year of Dragon, late of March " (1844).

March 23 : In evening left Yedo-bashi by boat. Having no wind, boat was slow. About noon of next day reached Kisarazu.

March 24 : Fine weather and mild. Unexpectedly met with Mr. Uhachi who is dealer in daily necessities. Took rest at house of Mr. Koizumi where I had my lunch. Went on Tsukuma road, looking toward the sea. On the left, the view was fine. Late after-noon arrived at house of Mr. Hayamatsu Seiyemon. In the evening Mr. Shobei came. Had sake feast. From the mid-night the rainstorm raged.

March 25 : Rain ; the storm kept on whole day. Very tiresome.

March 26 : Good weather. Cloudy in after-noon. At house of Mr. Nizayemon was treated with wheat-meal, vegetable soup. In afternoon letter arrived from Yedo.

March 27 : Good weather. Started in early morning to Kanōsan. Mr. Shobei, Yukichi and some others, four in all, were accompanying. Reached there in early after-noon and made for lodging. Went to see festival of Mino-o Tennō. The lodging house was crowded, not having enough beddings, two had to sleep in one bedside *aiyado*. Accompanied with two men of Tomitsu of Bōshū. Sake feast and made a great spree.

March 28 : Good weather. Went to see the shrine festival of Shiratori, where a great throng of shops and people. In returning passed Minami-Koyasu village in which was a mysterious pond called Tsurigane-buchi (haunted pool of sunken bell). Took lunch at tea-house Futakumiya of Kisarazu. The cooking of this house was in bit of Yedo style. Came back to Kutsuma village at nightfall.

March 29 : Good weather. Visited the Shrine of Sakato Daimyōjin of Sakato Ichiba. The view from here was fine. In this mountain there is another noted shrine Togakushi Daimyōjin. At house of Mr. Ishiari Jinzayemon received some hospitality. The house was grand in architecture. Then was invited to another house of Mr. Tsumekura Yahei and had more treat of hospitality. The people of this house were rustic as they could be, not a bit infected by city style, was very pleasing. With companion of Mr. Yukichi got back to Kutsuma in evening ; on the way got into bad trouble by stepping into a stream by mistake. This was an evening of great drink.

April 1 : Fine weather. In early morning left Kutsuma village. Took lunch with Koizumi. From Kisarazu the wind was favourable, making good speed and by dusk reached to Minatomachi of Teppozu. (Yedo.)

The third brief diary begins with another voyage from Yedo to Kisarazu, where again he was afflicted with bad weather. However, he pushes on and after four days arrives at the place of his desire, the Tanjōji Temple of Kominato, where he is joined by one of his friends, Mr. Shobei, whom he met at Kisarazu on his former journey. The Tanjōji Temple is a famous place of pilgrimage for Buddhists of the *Hokke* sect, having been first established in 1286 in memory of the Saint, Nichiren, who is said to have been born here ; but at the time of Hiroshige's visit, in 1852, it must have been almost new, as it was rebuilt in 1846. In this diary he sets forth his admiration of the splendid scenery ; notes several of the treasures in one of the temples, "some of them in very queer style" ; and paints some *kakemono*—the hanging pictures in the form affected mainly by painters of the recognized schools. This is of some interest, if, as one Japanese authority states, it was only in his later years that Hiroshige painted on established lines. Again he expresses his pleasure at the "simple and tasteful" manner of the country-folk. Several times he took to horse to traverse the bad roads, missed his boat at Tenjinsan, was badly advised, with the same result at Kisarazu and was consequently "not in the mood of enjoying" the cherry-blossoms!

HIROSHIGE'S DIARY OF PILGRIMAGE TO TANJŌJI—(The Buddhist temple of Saint Nichiren's birthplace).

(There is no title to this diary by him.)

Feb. 25th. Kayei 5, the Year of Rat (1852). In evening left Yedo-bashi by boat, and at Yeitai-bashi halted waiting for the wind. Early in morning, West-North wind blew and started, but soon the wind ceased. The boat was slow and weather changed bringing a little of rain, causing some disturbance among boatmen. But soon the rain had stopped and wind began to blow, and by late after-noon safely reached to Kisarazu. Rain began to fall again. Took lunch and started for Kanōsan to where arrived at dusk. A man of Nukariya village of Bōshū by name of Kanzayemon and his daughter were room mates. Next day was rainy ; after waiting a while, started. Road was very bad, from place called Seki on the hilly road was particularly hard. At Kōzuka took lunch. Just before reaching to Dainichi parted with Kanzayemon, and became alone. At Dainichi-jiku took horse, and in early afternoon reached to house of Hidaka.

Feb. 28th : Fine weather. Took a day of rest.

Feb. 29th : Visited Tanjōji of Kominato. Hidaka Sobei accompanied. Along the road every places were beautiful view. By the descending road of Shinsaka was a small temple called Asahi-no-mido [The Temple of Rising Sun] where Saint Nichiren is said to have prayed to the rising sun. The view of the sea with hills and islands were simply superb. (Of this view and about cherry-tree at front of Tanjōji temple he gives a poem each.)

March 1st : Visited Kiyozumi temple. Was quite high and engaged a guide ; view was fine, ascended about 1 ri. The front of the gate of the temple is slanting road along which were many restaurants, all of them being rather stylish unusual for such a locality. Within the temple ground were good many cherry trees and all in full bloom. Had a good view of Konpirasan. Here I smoked and rested. At tea house called Masuya took lunch. In the opposite tea house there was a big party of people including some official of locality, much in display. In the main temple there were many *ema* (paintings of votive offering), among them were very old ones of warriors, of Tenjin and Kurumabiki, some of them in very queer style. The houses in this street were mostly making interior fittings. The peasant girls were carrying things on their heads down the hill for purpose of peddling. The custom of old and young seemed quite simple and tasteful. In after-noon returned to Hamaogi. In the evening rice was pounded to make *mochi* mixed with millet and offer to the doll's festival.

March 2nd : Did not feel well in morning. Postponed to start. Painted three rolls for *kakemono.*

March 3rd : Rainy. From the relative of the house a bottle of sake was gifted. Had feast. Painted a little. In evening Tokogen the barber came and had feast.

March 4th : About noon started on horseback. Went on passing Mayebara, Isomura, Namita, Termen, Bentenjima, Shima-no-Nizayemon, Shodayuzaki, Yemi, Wada—all being along the coast, rocks were plenty ; by beach the view exquisite, beyond capability of describing with brush. At Wada left horse and at Matsuda-Yeki lodged at Aburaya, was *aiyado* that night (here he gives two *hokku*—short poems).

March 5th : During morning did some painting. Then by horse went to Nako and leaving horse there visited Kwanzeon. The view at top of the hill was fine. From there lost the way and wandered for one ri. Then hired horse again. The view at Kinonezaka Pass was fine. Lunched and rested at Ichibu-no-shiku, and continued on the horse. The view of Katsuyama was fine, visited temple Rakwanji at Hoda, made lodge for night at Kanaya. Had to share room with six men from Bōshū. The rain kept off till morning.

March 6th : Started without any raincoat. At Tenjinzan no boat could be had, so hurried on to Kisarazu but by question of one second missed boat. Lunched at Isekyu and lodge at Nagasugaya.

March 7th : Half-cloudy. Painted a little. Was persuaded not to go aboard on account of the wind not favourable. Seeing four boats sailing out regretted of not going on. Went to see the cherry blossoms at Yakushido but was not in the mood of enjoying. (Here he give one each of *uta* (poem) and *hokku*, in former expressing his feeling of the occasion.)

There is no description of the 8th. Probably he had sailed on the 8th and safely returned to Yedo.

Mr. Kojima's note.—The above diaries were copied from the copied manuscript biographies of Ukiyoye Utagawa Artists (owned by the library attached to Imperial University Library), and except very slight change of *kana* it is exactly like that of original. Hiroshige's own diary, I was told to be in possession of the Imperial University Library. (This library was completely destroyed with its contents at the fire.—K. M.)

If these fragments throw but little light on Hiroshige's practice of the art by which he is best known, they are not devoid of compensation to the student. For they are singularly human documents. One of the most acute and best-informed of Japanese critics, from both Eastern and Western points of view, Mr. Yone Noguchi, in an essay published ten years ago,[1] asked, " Where is the other artist, East or West, whose life-story is so little known as Hiroshige's ? " In the light of these revelations, the answer must be that there are many such. We can read the man's character very plainly from these casual but intimate jottings ; and the present writer sees therein much that is reflected in his work. He presents himself as a friendly, sociable soul, fond of good company and good food and drink and apt to resent failure in these important matters. His outlook on life is simple and direct ; his appreciation of the beauties of Nature inexhaustible, and not without the humility of an artist who knows his limitations (" the view exquisite, beyond capability of describing with brush "). When work is to be done, it is put through without delay ; and when on the road, he lost no time. He has a keen instinct for a story ; and, at appropriate moments, one of those little poems

[1] " The Spirit of Japanese Art," p. 41, 1915.

in which his class indulged, is easily forthcoming. His tastes and accomplishments are those of the social order to which he belonged ; and, if occasion had arisen, we can well imagine him describing himself, not without pride, in the words of his great contemporary, who claimed the title " Hokusai, Peasant." This must not be forgotten. Hiroshige was an artisan ; and his high achievement, the influence of which has been and still is potent among artists of every degree throughout the sphere of Western civilization, was, in the first place, a message to his own people, of his own degree, unknown to and unaided by aristocratic patronage of any kind whatsoever.

CHAPTER IX

THE FAN COLOUR-PRINTS

ONE of the most characteristic articles of Japanese personal equipment is the fan. Before the change of costume and habits which followed the revolution of 1868, it played a part in the daily or ceremonial life of everyone, rich and poor, from the Emperor and Imperial Court to coolies. It was given as a souvenir to parting guests ; exchanged with the fan of a new acquaintance of distinction ; presented by a bridegroom to his bride ; or to a youth, as a symbol of good luck, on attaining his majority at the age of 16 years. On attaining the honourable age of 77 years, an old man would also be offered fans by his relations, inscribed with the character *ki*, which is composed of the numerals 7, 10 and 7. He also would return the gift in the form of small-sized fans autographed with the same character. Incidentally, it may be remarked that the attainment of this length of years was an occasion for a great family celebration. It was denied to Hiroshige ; but it is for this reason that one finds prints by Kunisada, and in a few cases some in which the second Hiroshige had collaborated, proudly signed by the former, " Made in his 77th year " (1862), and evidently to be associated with the *ki-ju no ga* festival.

Apart from certain classes of fans, such as those used by generals in the field, for religious processions and similar special occasions, the fans in popular use were of two kinds : the folding fan, forming the segment of a circle with the apex cut away, which is also commonly used by Western nations (*ōgi*) ; and the rigid form, also struck from a circle, but with the top and sides cut square and a flattened curve at the base (*uchiwa*). The latter is believed to be of very ancient Chinese origin, and to have been introduced into Japan, through Korea, in the earliest periods of its history. The invention of the former is attributed to the widow of Atsumori,

FAN-PRINT (Ōgi Shape).

Seirō Hanami Ryaku Dzu. Procession of Women of the Yoshiwara viewing the Cherry-blossom.
(See color plate M.)

who became a nun at Kyōto in A.D. 1184, and is said to have devised the folding fan to relieve the father-superior when sick of a fever. The Chinese fan was in common use up to the fifteenth century, when it was generally superseded by the folding form ; but the nineteenth century seems to have seen a reversion to the older type, at all events among the class of people to which the Ukiyoye painters belonged, for a large number of this sort must have been made, judging from the examples still sometimes to be found. These fans were often hand-painted and sometimes elaborately mounted with handles and frames of lacquer and other rich material ; but those with which we are now concerned consisted of colour-prints of the requisite shape and size, on frames made of a single piece of bamboo, the upper part split to form the ribs and stiffened with a bent strip of the same material. Among the Ukiyoye artists who designed colour-prints for this purpose, Hiroshige is pre-eminent ; but Kunisada, Kuniyoshi, and some of their pupils also issued a considerable number, generally in the conventional style of their school. Hiroshige also designed folding fans (ōgi).

These prints are rare ; for it is obvious that most of them, being made for use, must have been easily worn out and destroyed. Yet they are to be picked up, here and there, and well repay the patience of the collector who is content to wait for his opportunities. Often they bear the marks of the ribs, having been removed from their mounts and cherished by someone who appreciated the artistic value of them ; but, now and again, one can find examples free from the marks of usage. That indefatigable collector, Mr. Happer, could include but 9 ōgi and 16 uchiwa in the great collection sold in 1909. Only 10 were exhibited in the Memorial Exhibition. Sir R. Leicester Harmsworth has managed to secure about 18 or 20 ; but it is pleasant to be able to record that no fewer than 130 have been acquired by the Victoria and Albert Museum, so that visitors to London have there, at all events, an opportunity of studying a representative collection of a phase of Hiroshige's work which merits far more attention than it has yet received. For that reason, we have thought it advisable to devote to this subject a larger propor-tion of the illustrations to this volume than might otherwise have

been the case, at the expense of some of the better-known prints which have frequently been reproduced elsewhere.

For to this class Hiroshige devoted some of the best of his talent. The forms alone offer a problem to the designer, which is attractive and calls for a particular effort. But he never fails. The composition is, though restricted in its opportunities by the rigid boundaries of the object, inevitably right and perfectly adapted to its purpose. It implies a concentration of design on a central base, with radiating lines outwards and upwards ; and he either follows or contrasts with these, with a sure instinct that defies criticism. They cover the ground from his best period to the time of his death ; and display an extraordinary variety of treatment—pure landscape in the exquisite, restrained and intensely poetic style of the three great *Hakkei*, the more vigorous method of the First Tōkaidō with its added human interest, birds, flowers, tortoises, and other natural objects ; and a whole series of brilliantly coloured landscapes with the graceful female figures in which he shows, more than in any other of his work, a hint of his inheritance from his master Toyohiro. And a word must be given to the blue prints (*aizuri*), and particularly the brilliant " Fuji " from Schichi-ri Bay reproduced herein and dated 1855—the powers of the man who made this superb design were hardly failing then !

These latter are the work of his later years—perhaps the best of it. But the fans, in date, as well as in style, reflect the whole course of the artist's career. In the class of blue prints, for example, we can refer to an example to be placed even earlier than his first Ōmi Hakkei ; an *uchiwa* design consisting of three smaller fan-shaped compartments with views of Okina-Inari, Myōken and Ryōdai-shi, and published by Marukyū ; while three superb *aizuri*, from the house of Marusei, the " Nightingale, Full Moon and Plum-blossom " and " Cranes and Bamboo "—with which should be mentioned a group of Iris flowers and leaves, in blue, green and purple, belong to the period of the first and best Flower and Bird *tanzaku*. Such as the " Famous Produce of the Tōkaidō " in black and grey only, and the " Famous Flower-gardens of Yedo," will appeal to the collector of curiosities ; but a print like that repro-

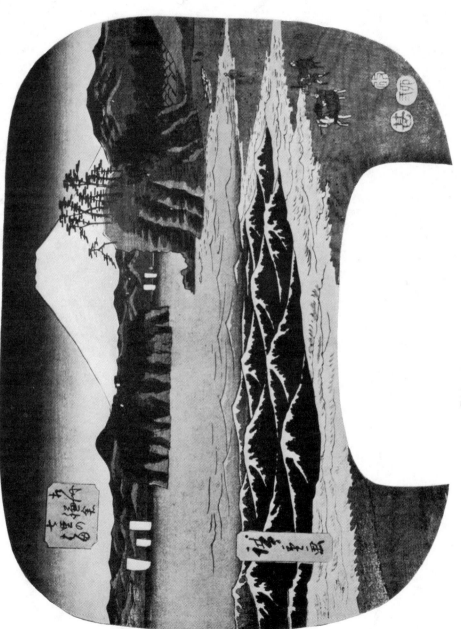

FAN-PRINT (*Uchiwa Shape*).

The Shichi-ri Bay at Kamakura, Sōshu. *Publisher, Marujin.* *Date, Hare Year, 1855.*

duced from the " Eight Views of Post-stations," the Kumagai Embankment with its distant view of the Usui Pass, challenges comparison even with the three great *Hakkei* series and may have preceded them in period. It is singularly restrained and correspondingly effective—but the contrast of the winding embankment through the marshes, perfectly in perspective, with the mass of the mountain, is the sort of success in composition that is only achieved by an artist of the first rank. The key to the design is supplied by a device, easy, natural, and yet absolutely convincing—a veritable epigram of art—just a flight of geese descending into the marshes.

Everyone who has written about Hiroshige has tried to do justice to his rendering of rain. There are many famous examples ; but to those already so well known we must add the fan-print from Dansendō's Kōto Meisho series—"Yeitai Bridge in Evening Rain." Everything is still—under the oppressive, almost perpendicular downpour. The colours are blurred ; the very river seems drenched ; and yet the scene has a beauty all its own. We owe this and another fan to the visit paid by the artist to Kisarazu, as related in the diary printed elsewhere in this volume. While, in contrast with the flowers and birds and landscapes, mention must be made of the boldly drawn and brilliantly coloured " Cock and Hen with Autumn Flowers " (published by Sanoki) ; as strong and virile a piece of drawing as is other of Hiroshige's work tender and delicate. How well, too, he could draw the figure in motion when he chose is demonstrated by the Kishiū Festival dance from the series of " Ancient and Modern Festivals in the Provinces." The young and graceful group of dancers is absolutely alive—here is nothing of the rigid, statuesque convention that fettered his contemporaries of the expiring theatrical school.

CATALOGUE OF FAN-PRINTS

Note :—All are *uchiwa* shape unless otherwise stated. In some cases it has not been possible to do more than give a description of the subject; but it is hoped that this will help in identification. The numbers of the series are generally not known. The subjects given are the only ones so far noted. All are in the Victoria and Albert Museum unless otherwise stated.

YEDO VIEWS

Yedo Hakkei. The Eight Views of Yedo. *Publisher*, Ibasen.
Night Rain on the Sumida River.
Evening Snow at Asakusa.
Sunset at Ryōgoku.
Boats returning to Tsukuda.
Geese alighting at Nippori Marshes.
Weather clearing after Storm at Ocha-no Midzu.
Evening Bell at Uyeno.
Autumn Moon at Matsuchiyama.

Tōto Meisui Kagami. Well-known Water Views of Yedo. *Publisher* Ibasen. Snake Year (1857).
Koganei bank of the Upper Tamagawa River. A woman seated, with gourd-bottle; on far side, cherry-blossom and reflections in river. Fuji in distance to left.
Woman on balcony, in a mosquito net, looking at the mouth of the river, with distant bank and sea. Verse : " Every river flows into the sea."
Upper Kanda River in autumn, with reflections of maple in stream. Back view of woman to left.

Tōto Katsushika Watashiba Dzukushi. Views of the Famous Ferries of Yedo. *Publisher*, Masatsuji. *Engraver*, Mino. Tiger and Snake Years (1854; 1857).
Mimeguri Ferry. Woman on balcony overlooking river, with ferry-boats and full moon.
Nakagawa Ferry. Three women in ferry-boat and man on raft.
Hashiba Ferry. Three women under cherry-tree in blossom, on high ground overlooking ferry.
Ommaya Gashi Ferry. Ferry-boat with three women in moonlight Snake Year (1857).
Niishiku Ferry. Two women on balcony overlooking ferry in snow. (Engraver's seal.)

Yedo Kyūseki Dzukushi. Views of Ancient Places of Yedo. *Publisher*, Marukyū.
The story of Kwannon disguised as a traveller and the old woman and her daughter who used to kill and eat travellers, at the pond of Asakusa.
Legend of Asakusa ; Takenari and Hazinari recovering the golden image of Asakusa in a fishing-net, as revealed to them in a dream.

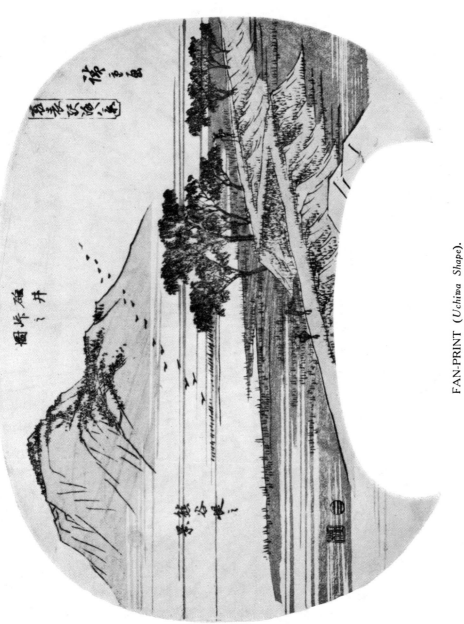

FAN-PRINT (*Uchiwa Shape*).

The Usui Pass and Kumagai Embankment, with geese flying home. From the Ura Omote Yekiro Hakkei ("Eight Views of the Post-Road, in and out").

Yedo Meisho Nenju Gyōji. Various Customs of Yedo at Different Seasons. *No publisher's mark.*

Gathering shell-fish at low tide at Susaki; with three women on a bridge leading to an embankment.

A dancer and two musicians on a balcony overlooking the sea at Takenaga, at night.

Yedo Junan Mitate Gogyō. The Five Elements compared with Views of Yedo. *Publisher,* Marukyū.

Fire—a woman with lantern, and fishermen fishing with fire-buckets, at night.

Water—Ocha-no Midzu, with woman in a boat and man on raft. Bridge in middle distance.

Yedo Meiyen. Famous Flower-gardens of Yedo, with the Flowers for which each is famous. *In black and grey only on red-lined background. Publisher,* Ibasen. *Square* kiwame *mark.*

Tōto Meisho Yuki-no Sankei. Three Snow Views of Yedo. *Publisher,* Ibasen.

Ryōgoku Yukibare-no Tsuki. Full moon after snow at Ryōgoku; women carrying *Oki-kodatsu* (hop-box).

Tōto Meisho Sōmoku Hakkei. Eight Views of Trees and Grasses at Yedo. *Publisher,* Masatsuji.

Shubi-no Matsu at Asakusa River. The pine-tree of Shubi.

Mikayeri Yanagi. Willow-tree, moon and snow; with two women, one with umbrella and one with lantern.

Aoiga Oka. Asi (hollyhock) flowers, waterfall, and three girls with umbrellas. A later edition has different colours and the signature on a white label.

Kinoshitagawa, Kakitsubata. Iris garden with three women visitors on Kinoshita River.

Tōto Meichi Fukei. Views of Famous Ponds at Yedo. *Publisher,* Yamata.

The Shinobazu Pond at Uyeno.

Tōto Meisho (fan-shaped title). **Views of Yedo.** *Publisher,* Marukyū.

Wistaria Gardens at Kameido Temple.

Tōto Meisho. Views of Yedo. *Publisher,* Marukyū.

Women watching the distant fireworks behind clouds, at Ryōgoku, from the *mono-hoshi* (drying tower) of a house.

Takanawa; girls on the beach admiring the evening rainbow. On a notice-board is an advertisement of the publisher, under the name Ibakyū.

Uyeno, Shinobazu-no Ike Hasu-no Hanami. Admiring the lotus-flowers on the Shinobazu Pond.

Tōto Meisho. *Publisher,* Kitamago.

Distant View of Ryōgoku from Ōhashi.

Tōto Meisho. *Publisher,* Yamato.

Takanawa-no dzu. Picture of Takanawa Kameido Temmangū. Kameido Temple, with wistaria garden and bridge.

Shiba-Ura Hinode-no dzu. Sunrise at Shiba-Ura.

Tōto Meisho. *Publisher*, Ibasen. Snake Year (1857).
The Sumida River, both banks, with sailing-boats.

Tōto Meisho. *No publisher's mark.*
Shiba-Ura from Takanawa, with boats at anchor.
Asakusa Kinryūzan Embō-no dzu. Distant view of the Asakusa Temple in time of cherry-blossom.

Yedo Meisho. *Publisher*, Sanoki.
Sumidagawa Yuki-no Kei. Snow on the Sumida River.

Yedo Meisho. Outings of the Year. (*Publisher's mark not given.*)
Ryōgoku boating. *Happer Sale, 347.*

Kōto Meisho. *Publisher*, Dansendō.
Yeitai Bridge, Evening Rain.

Tōto Hakkei. *Publisher*, Fujihiko. *Ogi shape.*
Asakusa, Sunset.
Takanawa, Autumn Moon.
Shinobazu, Geese flying home. *Happer Sale, 333–335.*

Various Views of Yedo (apparently not in series).
Seirō Hanami Ryaku dzu. Procession of Yoshiwara women viewing the cherry-blossom. *Signed*, Hiroshige. *Seal*, Ichiryū. *Ogi shape, aizuri.*
Fishing at night on the Sumida River, with Mount Fuji and Full Moon. *Publisher*, Masatsuji.
Sumidagawa Hashiba-no Watashi Masaki-no Yashiro. Temple of Masaki seen from the Hashiba ferry on the Sumida River, in Spring. *Publisher*, Yamato.

Uyeno, Shinobazu-no Ike. Shinobazu Pond at Uyeno Park. *Publisher*, Yamato. *Signed*, Hiroshige gwa Isse Ichidai. (Hiroshige painted only once in his life !)

Ōkawa Shubi-no Matsu Ryōgoku-bashi Yū Suzumi. The Shubi Pine-tree in the cool of the evening at Ryōgoku Bridge on the Sumida River. *Publisher*, Yamato.

Yeitai-Bashi Yakei. Yeitai Bridge at Night. *Publisher*, Sanoya. *Seal*, Utagawa.

Okina-Inari, Myōken and Ryōdai-shi. Three fan-shaped designs on one sheet. *Publisher*, Marukyū. *Aizuri* (very early).

Sugita-no Ume-Zo-no. Plum-blossom garden at Sugita, with woman leaning on a *kago* in which another is seated ; Fuji in distance. *Publisher*, Sanoya.

Sendagi Hana Yashiki. Sendagi Flower-garden, with women on balcony of a tea-house and lanterns. *Publisher*, Sanoya. Hare Year (1855).

Yotsuya Shinjiku Tsutsumi-no Hana. Cherry-blossom on Shinjiku bank at Yotsuya, with three women on a balcony. *Publisher*, Ibasen. Dragon Year (1856).

TŌKAIDŌ SCENES

Tōkaidō Kawa Dzukushi. River Series of Tōkaidō. *Publisher*, Manjū.

Coolies fording a river; two carrying a woman.

A woman carried across a river in a *kago*.

Passengers crossing a river in ferry-boats; in foreground to left, a boat with two women, one in a pilgrim's hat. *Harmsworth Collection.*

Tōkaidō Meibutsu Dzukushi. Famous produce of the Tōkaidō. Various dishes of food. *Signed*, Ichiryūsai (only). In black and grey—very early.

Yokkaichi. Three women in the cherry-garden of a temple with banner and lantern. In distance, above a bank of mist, a bridge and Fuji. *Publisher*, Sanpei.

KISOKAIDŌ ROAD

Ura Omote Yekiro Hakkei. Eight Views of Post-stations on the Road. *Publisher*, Ibasen. *Square* kiwame *mark*.

Usui Tōge-no dzu, Kumagai Tsutsume-no Kai. View of the Usui Pass and Kumagai Embankment.

KYŌTO VIEWS

Kyō Arashiyama. View of Arashi Mountain from Kyōto. *Publisher*, Yamato.

HAKONE VIEWS

Hakone Shichitō Dzuye. The Seven Hot Springs of Hakone. *Publisher*, Ibasen. 3-block print. *Signed*, Ichiryūsai (only). Two scenes in kidney-shaped compartments; Dōgashima (exterior) and a Bathing-house.

Hakone Shichitō Dzuye. The Seven Hot Springs of Hakone. *Publisher*, Ibasen.

Yumoto; with two women travellers coming up the bank from the river.

Tonosawa; the village at farther end of the bridge with mountains beyond.

Ashinoyu; the bathing-house at night, with three women, one carrying a lantern.

Miyanoshitā; two women on veranda overlooking rapids.

Tonosawa; two women on veranda overlooking rapids, with maid bringing food.

Yumoto; geisha dancing in tea-house. One of "Three Styles of Amusement." (Hiro. *seal.*)

Kiga; two women on seat drinking tea; bridge over rapids, left.

Hakone Shichitō Meguri. Seven Hot Springs of Hakone. *Publisher*, Ibasen. *Aizuri.*

Kiga; village with bridge over stream among mountains.

Hakone Kojō Fuji. Fuji from Hakone Lake. *Publisher*, Kinzō. (?)

Tonosawa; Village on farther bank at end of plank bridge, with mountains. *Publisher*, Marujin. Hare Year (1855).

VIEWS IN THE PROVINCES

Shokoku Meisho. Famous Views in the Provinces. *Publisher,* Yamato.
Shimofusa Province. Chōshi beach; with cliffs, and Fuji in distance.
Suruga Province. Tago-no Ura. The beach, with Fuji beyond the bay.
Kyōto. Arashiyama in time of cherry-blossom, with three women crossing bridge.
Awa-no Naruto. The rapids at Naruto.

Shokoku Meisho. *Publisher,* Marukyū.
Yamato Province. Yoshino River with noble on a balcony admiring cherry-blossom.

Shokoku Meisho Dzuye. *Publisher,* Yamajō. Dragon Year (1856).
Musashi Province. Kanazawa with three ladies (two on a veranda overlooking the
river).
Ōsaka. Sumiyoshi. A houseboat with three women and temple-lantern ; the bay
in distance.

**Meizan Dzukushi Shokoku Jukkei. The Ten Famous Mountains of the
Provinces.** *Publisher,* Ibascn.
Ishiyama, with two women looking at Lake Biwa, Sanuki, Zodzusan (mountain).

**Shokoku Kokon Sairei Dzukushi. Series of Ancient and Modern
Festivals in the Provinces.** *Publisher,* Yamato.
Kishiū Waka Gosaishiki. The Festival of Kishiū.

Bōsō Meisho. Kiyozumi Mountain, in Boshiū Province, with women on balcony.
Publisher, Masatsuji. Rat Year (1852).

Uraga Bay in Sōshū Province ; with ships at anchor and tall trees on high
ground to left. *Publisher,* Marujin. Hare Year (1855). *Aizuri.*

Kai, Kawaguchi Kosui-no dzu. The river entering the lake at foot of Fuji,
at Kai. (*No publisher's mark.*)

Sunshū Mio-no Ura Fūkei. View of Miyo-no Ura in Sunshū Province. (*No
publisher's mark.*)

Kadzusa Kisarazu Kaijo-no dzu. The sea at Kisarazu in Kadzusa Province.
(*No publisher's mark.*)

Oyama Waterfall in Sagami Province. Waterfall to left, with large lamp and
two travellers. *Publisher,* Marujin. Hare Year (1855). *Aizuri.*

Miyo-no Matsubara in Suruga Province. Two women overlooking
Kiyōmigaseki, with Fuji in distance. *Publisher,* Sanpei. Rat Year (1852).

Būshū, Kanazawa Suzume-na-Ura ; with fishermen throwing a net, and two
women in boat. *Publisher,* Sanoya.

Kataura-no dzu. Women gathering shell-fish at Kataura. *Publisher,* Fukusendō.

Zōzu Mountain at Sanuki ; with three women on high path near a pine-tree,
overlooking valley with bridge and river. *Publisher,* Igeta Hisa (?). Dragon
Year (1856).

Enoshima Island, with boats on shore. *Publisher,* Marujin. Hare Year (1855).
Aizuri.

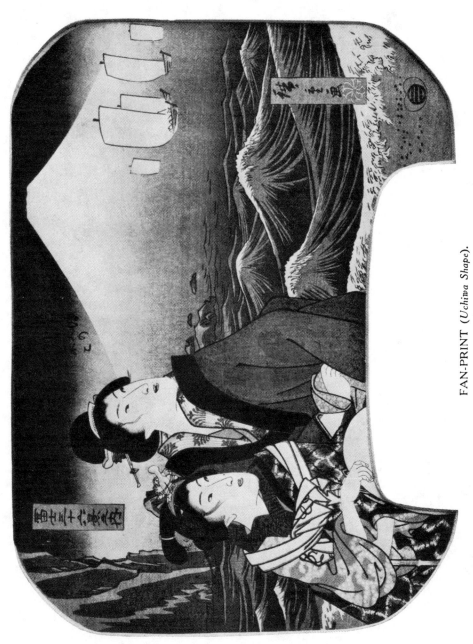

FAN-PRINT (*Uchiwa Shape*).

Enoshima. From a series of " The 36 Views of Fuji." *Publisher*, Ibasen.

Sōshu, Kamakura Shichiri-no Hama. Fuji from Shichi-ri Bay, Kamakura. *Publisher*, Marujin. Hare Year (1855). *Aizuri*.

Owari Atsuta Shichiri-no Watashi. Shichi-ri Bay with women walking on beach. *Publisher*, Sanpei. Rat Year (1852).

VIEWS OF FUJI

Fuji Sanjū Rokkei-no Uchi. The 36 views of Mount Fuji. *Publisher*, Ibasen.

Enoshima Sōten-no Fuji. Fuji at dawn from Enoshima.

OTHER LANDSCAPE SERIES

Three Snow Views. (*No publisher's mark*.)

Kanda Myōjin Yuki-no Ashita. Snow in early morning at Kanda Temple; woman on balcony with broom.

Yedo Meisho Mitate San Kō. The 3 Luminaries of Sun, Moon and Stars compared with Views of Yedo. *Publisher*, Ibasen. Dragon Year (1856).

Susaki Hatsuhinode. Sunrise at Susaki; two women walking on embankment, with other people watching sunrise.

Ryōgoku Tsuki-no Sugata. Ryōgoku by moonlight; woman on balcony overlooking river.

Yanagijima Hoshi Matsuri. Starlight festival at Yanagijima. Woman, half-length, on balcony overlooking river.

Meisho Hana Kyōdai. **Flower series of various places.** *Publisher*, Sanpei. Dragon Year (1856).

Gotenyama, Cherry-blossom; two women near a cherry-tree and a pine overlooking the sea.

Ōzawa, Peach-blossom (*momo*); two women seated on river bank, with blossoming trees, and Fuji beyond.

Komurai, Plum-blossom; three women on bank of pond, with plum trees, hill, and tea-house on farther bank.

Two girls at a table, one seated to left, in a cherry-blossom garden, on bank of a river with a man punting; Fuji in distance. *Harmsworth Collection*.

FLOWER AND BIRD SERIES, WITH POEMS

Publisher, Matsubaradō (or Fujihiko, the alternative name) on gourd-shaped seal. *Ōgi shape*. (*Happer sale* 327–332.)

Mandarin Ducks and Bamboo in Snow.
Iris and Cuckoo.
Passion Vine and Sparrow.
Birds and Wild Cherry.
Wild Camellia and Red-bill.
Butterfly and Pæonies.

FLOWER, BIRD AND FISH SUBJECTS

Fūryū Shiki-no Ikebana. Flower arrangements of the Four Seasons. *Publisher*, Marukiken.

Autumn. Chrysanthemum, with *kakemono* and full moon.

Winter. Narcissus and *Sazankwa* flower, with *kakemono* of river, with ducks, in winter.

Children with *Kare* **(flat) Fish on Beach ;** with woman and basket of shell-fish and distant boats. (*Very early, in style of Yeisen. No publisher's mark.*)

Stork and Iris. (*No publisher's mark.*) *Harmsworth Collection.*

Two Tortoises in Water. (*No publisher's mark*). *Aizuri.*

Cranes and Bamboo. *Publisher*, Marusei. *Aizuri.*

Nightingale, Full Moon and Plum-blossom. *Publisher*, Marusei. *Aizuri.*

Cock, Hen and Basket. *Publisher*, Marusei.

Cock and Hen with Autumn Flowers. *Publisher*, Sanoki.

Masts of Ships, Cuckoo and Full Moon, with the famous poem, *Hitokoye wa Tsuki ga Naitaka Hototogisu. Publisher*, Yamato.

Pier of a Bridge, with reflection of Full Moon in the Water and Poem by Toshishige, " The Autumn Moon is as clear as parents' understanding of their children." *Publisher*, Aritaya.

SUBJECTS FROM STORIES

Genji Setsu Getsu Kwa. Series of Snow, Moon and Flower pictures from the Story of Prince Genji. *Publisher*, Ibasen. Tiger Year (1854).

Saga, with Prince Genji and a lady in a boat, viewing the cherry-blossom.

Kyōdai Monogatari Dzuye. Series of Ancient Stories. *Publisher*, Masatsuji.

Minamoto-no Hikaru in a boat, and full moon.

Soga Monogatari. Shōshō, on a balcony, watching the departure of Soga-no Gōrō, in Snow.

Uchiwaka Dzuye. Scenes in the Life of Uchiwaka. *Publisher*, Ibasen.

Uchiwaka and a Lady in a garden by moonlight, a house with lights to right, at Yahagi-no Shuku.

Chūshingura Hakkei. The Eight Scenes of the Chūshingura (Story of the Forty-seven Rōnin). *Publisher*, Ibasen. (On the same lines as Ōmi Hakkei, etc.)

Yama Michi-no Yo-ame. Night rain on the mountain, with Yoichibei and Sadakuro.

Toritsugi-no Banshō. Evening bell at Toritsugi; with Rikiya and Konami in the house of Wakas-anosuke.

VARIOUS SUBJECTS

Onna Sanjū Rokkasen-no Ūchi. The 36 Famous Poetesses. *Publisher*, Yamato.

Ono-no Komachi, seated.

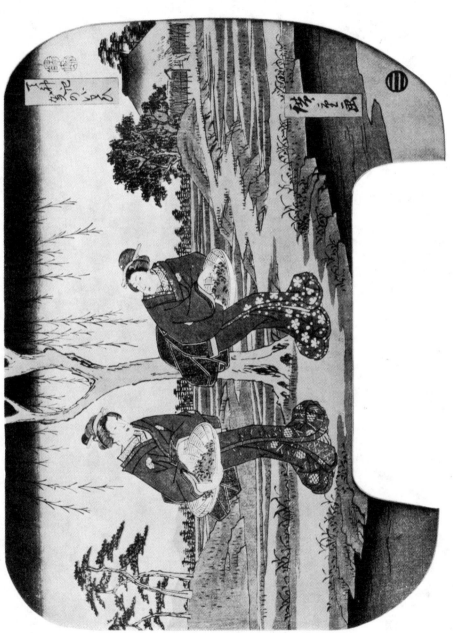

FAN-PRINT (*Uchiwa Shape*).

Tenjin Ki Gano Iwai. Gathering fallen leaves for a Birthday Ceremony, referring to a story of Sugawara Michizane.

Meiyo Shokunin Zukushi-no Uchi Horimono. Series of Famous Craftsmen. *Publisher*, Marukyū.

Hidari Jingoro, the sculptor.

Oroku Kushi. Oroku, the first maker of wooden combs.

Gorō Masamune, the swordsmith.

Kaichō Asa Mairi-no Dzu. Morning excursion to the ceremony of " Opening the Curtain " at a Buddhist Temple. *Publisher*, Marukyū. Tiger Year (1854). *Inscribed*, Shin Pan (*New block*).

Mitate Sambaso. Women compared with the Sambaso Dance. By Hiroshige, Kunisada and Kuniyoshi. *Publisher*, Ibasen. *Engraver*, Take. Hare Year (1855).

Woman, half-length, holding small lacquer box, with pine-branches, on pink ground. (By Hiroshige.)

Woman, half-length, holding up *kimono*, with pine-branches, on pink ground. (By Kunisada.)

Woman, half-length, holding *biwa* fruit, with pine-branches, on pink ground (By Kuniyoshi.)

UNSIGNED, BUT ATTRIBUTED TO HIROSHIGE I

Fuji seen above a Row of Pine Trees. *Publisher*, Yamato. (In blue and black only, no key-block.)

Fuji from the River at Matsuchiyama. *Publisher*, Yamato.

The Miryakodori ; 3 *chidori* on stream with reeds, symbolizing the Sumida River. *Publisher*, Yamato. (In black and white only.)

Kikyō Flower and Ayu Fish. *Publisher*, Marusei.

Iris (in blue, green and purple). *Publisher*, Marusei.

Shinagawa Shore with Stalls and Swimmers carrying a Kōshi towards the Boats. *Mark unknown.*

Nikkōzan Kegon-no Takei. Waterfall of Kegon at Nikkō. *Mark unknown.*

Būshū, Kanazawa Suzume-ga-Ura ; with fishermen in foreground and Fuji in distance to right. *Mark unknown.*

Convolvulus, Pink and Iris, with hanging lamp suspended from bamboo support. *Mark unknown.*

Biwa (loquat) Fruit and Hōzuki. *Mark unknown.*

Hollyhock. *Mark unknown.*

Red Plum-blossom, Chrysanthemum and Flower-basket. *Mark unknown.*

CHAPTER X

SURIMONO

A FORM of colour-print which differs considerably from the ordinary productions was made only for special occasions ; and not, as a rule, either issued through publishers or sold broadcast to any purchaser who came along. To these is given the name *surimono* (literally, " thing printed "), and although the majority might be described as New Year cards, they were also done to announce or celebrate other particular festivities or events ; such, for instance, as a change of name, as when Kunisada took the name of his master, Toyokuni, on the 7th day of the New Year, 1844, and circulated a portrait of himself among his friends. Actors adopted a similar procedure ; and a successful meeting of clubs of poets would likewise be recorded in a charming little print, exquisitely executed on special paper, often embellished with *gauffrage* (blind printing) and a liberal use of metallic tints, gold, silver or bronze. Surimono date back well into the eighteenth century, but the first half of the nineteenth century was the period when most of them came into being ; notable artists who distinguished themselves in this class of work being Hokusai and his pupils, of whom Hokkei and Gakutei were the most prolific and successful, while Shunman also calls for mention. Most of the other designers of colour-prints, however, indulged in this luxury, either on their own account or when commissioned by patrons ; and a very considerable number are signed by men—probably amateurs or comparatively unknown painters—who had no definite connexion with the Ukiyoye School. The circumstances attending the production of surimono account for their rarity. Only small editions could have been made ; and though a collector may easily expect to gather a fair number of specimens, it will be found extremely difficult to obtain particular examples. Hiroshige did not altogether neglect

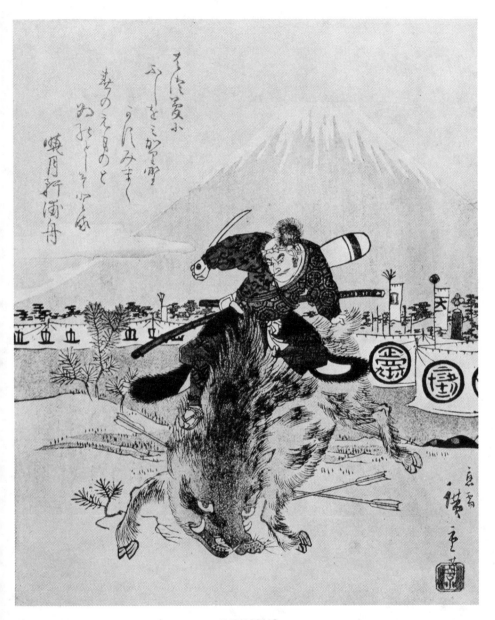

SURIMONO.

Nitan-no Shirō killing the Wild Boar at the Foot of Mount Fuji.

Signed, "Special order, Hiroshige."

Seal, **Ryūsai.** A *Dai-Shō* Calendar for the Year, 1851.

this form of colour-print. Mr. Happer, after the most diligent search, was only able to account for " less than ten "; but to this small number we are able to add to a very limited extent.

In *The Far East* of December 20, 1913, he describes in detail and illustrates six surimono by Hiroshige I in his possession. Five of these are what he conveniently terms "abbreviated calendars," that is, they give a list of the long (*dai*) and short (*shō*) months, of 30 and 29 days each respectively, into which the old Japanese year was divided. Mr. Happer points out that, as the allocation of the *dai* and *shō* months varied in different years, some sort of guide was necessary—thus the second month of the year was *dai* in 1844 and *shō* in 1846. Each of these prints is something of the nature of the puzzle pictures which have been popular in recent years in this country, the numerals indicating the category to which the various months belonged being ingeniously concealed in the design. It also frequently occurs that the year of the zodiacal cycle is indicated in the design of surimono, either directly by the introduction of the appropriate animal, or by way of allusion. Hiroshige has adopted this device in each of these cases, as will be seen from the descriptions in the catalogue (page 105). They can be certainly identified as having been made for the years 1841 (Ox), 1844 (Dragon), 1845 (Snake), 1846 (Horse), and 1847 (Sheep). To these we can add examples in the collection at the Victoria and Albert Museum for the years 1849 (Cock), 1851 (Boar), and 1858 (Horse) ; as well as a further specimen signed *Ni sei* (Second) Hiroshige, for the year of the Sheep, viz. 1859. The distribution of dates over this period suggests that Hiroshige made one of these calendar-surimono for each year, as a regular practice ; and probably left either a design or an uncompleted commission which, for one year at all events, was carried out by his principal pupil. The execution of the latter is inferior to that of the undoubted work of the master ; the signature corresponds closely to that on the extra print signed " Second Hiroshige " in " The Hundred Views of Yedo." The seal is " Ryūsai."

In addition to the calendar-surimono, we have notes of a few others. The Memorial Exhibition contained two only, dated respectively 1820 and 1823 ; the former a commission from the

great actor Ichikawa Danjiūrō. Mr. Happer reproduces in the article previously mentioned a finely drawn print of which the subject is a couple of horses and autumn grass, with a charming poem suggesting that the waving of the *susuki* grasses in flower, like the beckoning of graceful slender hands, summons the prancing colts at pasture on the moor. The Victoria and Albert Museum also contains an undated surimono of rather unusual proportions, representing water-plants and a water-spider, signed " Ryūsai " and with the seal " Hiroshige," which is too good to be the work of the pupil ; and in Messrs. Sotheby's sale of January 29, 1923, two more were catalogued, one of which is the most elaborate that has yet come to our notice, and is also the only one of which we have been able to note two examples. This is of such interest as to call for detailed description. It represents the Goddess Benten seated, clad in rich robes and with a remarkable head-dress in which a *torii* is conspicuous. In her left hand she holds the sacred jewel that she is about to place on a pictorial diagram, divided into compartments each of which has one of the emblems of good luck. On the other side of the diagram is a seated child dressed in the Chinese manner, waiting, evidently, for the goddess to reveal the fortune of the New Year by putting the jewel on one of the emblems. On the outside of the diagram are the characters *Sugoroku*, the name of the game so popular still with the Japanese; and the whole is evidently a symbolical treatment of this subject. The title is " The *Sugoroku* of Good Fortune." It is signed by Hiroshige with the circular script seal of the Utagawa. The signature is in one of his earliest styles; and the prominence given to Benten in the design suggests that it was made either for the year of the Dragon or that (the next in succession of the Japanese cycle) of the Serpent. Benten is often represented with the Dragon ; but in some localities she is particularly associated with the Serpent ; and it is on the day of the Serpent specially that her temples are visited. It is probable, therefore, that this surimono was made for the year either of the Dragon or of the Serpent ; and the *torii* suggests a choice of the latter, perhaps with reference to the famous temple of Enoshima, on the island which she is said to have raised from the waves in the sixth century. This,

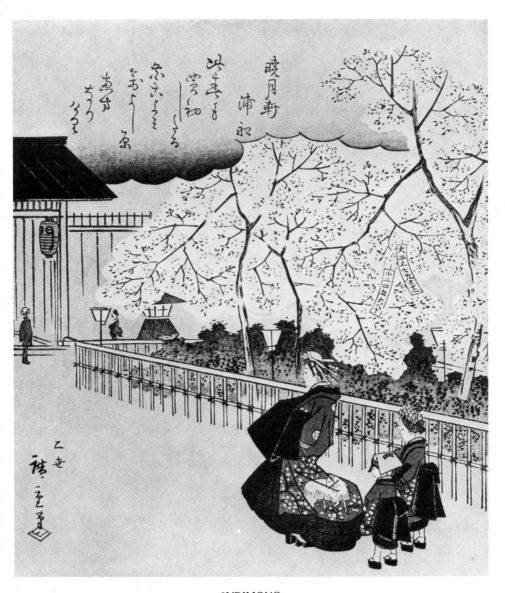

SURIMONO.

A Woman and her Attendants approaching the Gate of the Yoshiwara.

Signed, Second Hiroshige.

Seal, Hiro. A *Dai-Shō* Calendar for the Year, 1859.

taking into account the style of the signature, would mean that the print was made either in 1821 or 1833. The former is too soon for the Utagawa seal to have been used ; and we may therefore accept the latter, particularly as it was the first year of a sexagenary cycle also indicated by the Serpent.

Hiroshige also made a set of prints in surimono style, " put on sale," says the Memorial Catalogue, " in the form of a roll consisting of 12 sheets to be used for writing letters. Almost all of these prints on letter paper were used by nobles and dignitaries and men of taste ; and, consequently, there remain very few of them now." Each is oblong, and measures 7½ by 20 inches. There is no publisher's mark, but the blocks were in existence at the time of the exhibition and showed them to have been issued by the Wakasaya. The 12 prints consist of views of the following places : Giōtoku, Tamagawa, Gotenyama, Matsudo, Nakagawaguchi, Susaki, Koganei, Kaianji, Yūhigaoka, Azuma, Takata, Hagidera.

Mr. Happer has also described, in a recent number of *The Far East*, a class of prints of the Tōkaidō which have considerable personal interest ; these are small, 5½ by 3½ inches only, in size ; and each has a design by Hiroshige, with a little landscape in a fan-shaped compartment, appropriate emblems of the various stations, etc. They were made as *Juda*, the cards used by pilgrims to be affixed to some part of the shrine or temple visited by them ; and it appears that Hiroshige himself—an inveterate wanderer—belonged to a " Pilgrims' Club," the Hakkaku Kai, in a roll of members of which is his *nom de plume* as a poet, Ichiryūsai Utāshige. The prints are of the date 1841 ; and it is curious to observe that each has an advertisement " Sen jo kō " of a " Fairy Perfume " sold by a well-known dealer, Sakamoto, who seems also to have belonged to the club. The same advertisement has been noted on other Tōkaidō prints ; so it may be assumed that Hiroshige was not averse to a commercial transaction of a sort with which we are familiar. Though not surimono, these were prints made for special occasions and are therefore noted here.

The Victoria and Albert Museum also possesses original designs by Hiroshige I for surimono, of unquestionable authenticity and

belonging to his best period, representing two tortoises in a stream with water-weeds and having the Utagawa seal as well as the usual signature, hydrangea blossom and dragon-fly (signed " Ichi-ryūsai Hiroshige " and with the " Hiro " seal) and Shūkaido flower and grasshopper. These themes were favourites with the artist—they occur on fans, as well as in *tanzaku* form and in his drawing-book for children (*see* page 112). As studies from Nature it is diffi-cult to praise them too highly. The suggestion of form, of colour, of movement and natural life—it is little more than suggestion—is perfect ; and the impression of truth and beauty is conveyed to the beholder more surely and more completely than could have been effected by the most laborious manipulation of the artist's tools.

CATALOGUE OF SURIMONO

1. The Famous Actor Ichikawa Danjiurō on the Stage at the New Year. Dated Bunsei, 3rd Year (A.D. 1820). Memorial Cat. 7.

2. A Watch. Dated Bunsei, 6th Year (A.D. 1823). Memorial Cat. 8.

3. Benten playing at *Sugoroku* with a child. *Signed*, Hiroshige. *Seal*, Utagawa ring.

4. Two horses and *susuki* grass. *Signed* Tanomareta (*by request*) Hiroshige. *Poem* (*Uta*) *signed* Emma.

> *Aki no no no*
> *Maneku obana ni mura garite*
> *Isami tachi taru*
> *Maki no waka goma.*

(*Translation*) :

> Flowers of the grass
> Beckon with graceful, slender hands
> The dancing colts
> That range over the autumn moor.

Probably for Horse Year, 1846. Happer, "The Far East," pl. VI.

5. A courtesan passing the Kadomatsu (young pines before the house door) at the New Year Parade. *Signed*, Hiroshige. *Seal*, Mimasu (?).

Note :—The above, described as from a set with a red sign *No-ichi*, in Messrs. Sotheby's Sale of 29th January, 1923.

6. Arrow-head leaves and blossom with a water-spider ; and poems by many poets. *Signed*, Ryūsai. *Seal*, Hiroshige. 7¾ x 11½ inches.

DAI-SHŌ SŪRIMONO

7. An ox laden with bundles of fire-wood, on which is seated a peasant girl smoking a pipe ; and plum tree in blossom. *Signed*, Hiroshige.
 For Ox Year, 1841. *Dai* numerals on tree—*Uru*, 3, 4, 6, 8, 10, 11. *Shō*, on ground and representing grass, 1, 2, 5, 7, 9, 12.
 Happer, "The Far East," pl. III.

8. A pair of dragons rising from the waves. *Signed*, Hiroshige. *Seal*, Ichiryūsai.
 For Dragon Year, 1844. *Dai*, on right dragon, 1, 2, 4, 6, 8, 10, 12. *Shō*, on left dragon, 3, 5, 7, 9, 11. Happer, *ibid.*, pl. IV.

9. A garden, with pine and plum trees, thatched pavilion and rising sun seen beyond the gate. *Signed*, Mitoshi Hiroshige. *Seal*, Ichiryūsai.
 For Snake Year, 1845. *Dai*, on roof, 2, 4, 5, 7, 9, 11. *Shō*, on doors, 1, 3, 6, 8, 10, 12. Happer, *ibid.*, pl. I.

10. Fuji seen, rising above the clouds, between two overhanging peaks, crowned with pine trees ; between them is a man leading a horse along the road on the left

of a river. On the right bank, beyond the cliff, are the roofs of a village among trees. *Signed*, Uma no shō haru Hiroshige. *Seal*, Ichiryūsai.

> For Horse Year, 1846. Numerals are on tree trunks, *Dai*, on right, 1, 3, 5, 6, 7, 9, 11. *Shō*, on left, 2, 4, *Uru*, 5, 8, 10, 12. The 5 seems plainly visible on both sides—apparently an error of the artist.
>
> Happer, "The Far East," pl. V.

11. The Ship of Good Fortune (*takara-bune*), a spit of land with pine trees, sails of distant boats, with Fuji and the Rising Sun. *Signed*, Hitsuji toshi Hiroshige. *Seal*, Ko kwa Shi Riaku Reki.

> For Sheep Year, 1847. *Dai*, forming the character *Takara* on sail of ship, 1, 3, 6, 7, 9, 10, 12. *Shō*, forming distant sails, 2, 4, 5, 8, 12.
>
> Happer, *ibid.*, pl. II.

12. Young Girl holding a *Yema* (temple picture), with cock and hen as a votive offering—standing under a plum tree in blossom. *Signed*, Moto me ni ō dzu (*special order*) Hiroshige. *Seal*, Ryūsai.

> For Cock Year, 1849. *Dai*, on Cock, 2, 3, 5, 7, 9, 12. *Shō*, on hen, 1, 6, 8, 10, 11, the frame of the picture forming 4.

13. Nitta-no Yoshiro killing the Wild Boar at the foot of Fuji, and a camp enclosure. *Signed*, Moto me ni ō dzu Hiroshige. *Seal*, Ryūsai.

> For Boar Year, 1851. *Dai*, 2, 3, 5, 8, 10, 12. *Shō*, 1, 4, 6, 9, 11. The 7 is in a separate circle to right.

14. Yama Uba carrying *bendai* (New Year's ornament for good luck) and Kintoki on a hobby-horse. *Signed*, Moto me ni ō dzu Hiroshige. (*No seal.*)

> *Dai*, on red label, 2, 5, 8, 9, 11, 12. *Shō*, blue label, 1, 3, 4, 6, 7, 10.

Note :—The poems on the last three are signed Giō-getsu-ken Ura-bune.

15. Oiran, with Ram on her *kimono*, walking towards the gate of the Yoshiwara in the season of cherry-blossom. *Signed*, Ni sei (second) Hiroshige. *Seal*, Hiro.

> For Sheep Year, 1859. *Dai*, on right label hanging on cherry-tree, 1, 3, 7, 9, 11, 12. *Shō*, on left label, 2, 4, 5, 6, 8, 10.

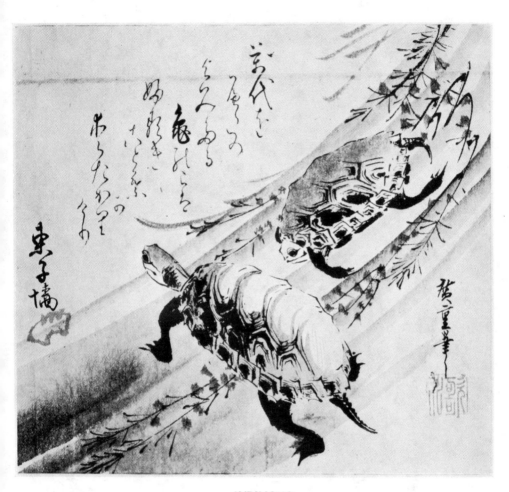

SURIMONO.

Original design. Tortoises and Water-weeds. *Signed*, "Hiroshige fude." *Seal*, Utagawa

CHAPTER XI

ILLUSTRATED BOOKS

HIROSHIGE illustrated about thirty books. The earliest is entitled "Kando Chiyuzō," and contains illustrations of Chinese Heroes, coloured but in simple style, which the editors of the Memorial Catalogue ascribe to the year 1816. Two years later he did the plates of one of three volumes of humorous poems, "Kyōka Murasaki no Maki," which is of interest not only because the other volumes were illustrated by Hokkei (the pupil of Hokusai) and Tōshū, but because therein his eight contributions are signed "Ichiryūsai Hiroshige" with a character *yū* appearing on some of his earliest colour-prints (which can thus be dated), but soon abandoned for a *yū* written differently but with the same pronunciation. His remaining book illustrations appeared at intervals of a year or two throughout his career ; and, as many are dated, the collector would be well advised to acquire them for the purpose of studying the development of his style and signatures. As already indicated, Hiroshige was very fond of making poems, and especially those of a humorous or satirical nature (*kyōka*) ; and a considerable proportion of the books are of this kind. One of these is devoted to the Tōkaidō ("Tōkaidō Meisho Dzuye," published in 4 volumes, in 1849), and another to the Kisokaidō (3 volumes, 1851). In the latter year Kinshōdō issued another Tōkaidō book, "Tōkaidō Fūkei Dzuye," in 4 volumes. The Memorial Catalogue refers to a Collection of Comic Poems on all classes of Society ("Kyōka Yamato Jinbutsu"), in 7 volumes, as "beautifully coloured," but the author has not seen it. One might hazard a guess—or perhaps a wish—that the illustration therein of an "Old Man Painting" (Plate 264 of the Catalogue) was a self-portrait—as, indeed, might well be the "Old Man enjoying Sake," a *kakemono* with a comic poem by that Taihaidō Donshō who commissioned the "Yedo Kinkō

107

Hakkei." The reproduction in the Catalogue, No. 285, certainly suggests it.

Two other of the illustrated books have unusual interest, namely, " Yedo Miyage " (Souvenirs of Yedo), issued between 1850 and 1867 by Kinkōdō ; and a little copy-book for children, " Tebiki Gusa," from the Iseya firm in 1849. The first began as a series of 4 volumes only, distinguished by the names of the Four Winds, instead of by numbers, in the first edition only ; later editions have the usual numeration. Each of these is dated 1850. Two additional volumes (undated) were then added to the scheme, the 6th having a synopsis of the contents of the whole set as it then stood. After an interval, apparently, the series was further extended by a 7th volume, the work of the First Hiroshige, but also without a date ; but it was not until 1861 that volume 8 appeared, with a tribute to the memory of the master and a plain statement that the plates were based on sketches left by him—valuable evidence as to the accuracy of the suggestions already put forward in this book on the subject of the relationship between Hiroshige and his pupils. This, which is unsigned, was probably done by Shigenobu. Volume 9 appeared in 1864, with Shigemasa's signature ; and the series was concluded in 1867 by the same man, under his name Risshō. There is a considerable falling off in the style of the last three as compared with that of the first volumes. Shigemasa, claiming the title of Second Hiroshige, is very proud of having depicted " even the foreign military exercises "—at that time the most potent and disturbing factor in Japanese politics. Each of the volumes is furnished with a preface, written, with one exception, by literary men engaged for the purpose. These are of such interest that we have thought it well to give the translations following.

YEDO MIYAGE

(Translation of Prefaces)

Vol. I. In olden time, during Horeki era (1751-63) one hundred years ago, appeared the original " Yedo Miyage," first illustrated by Nishimura Shigenaga, succeeding volumes by Suzuki Harunobu. They were much liked, and in fact were called the origin of picture books. Unfortunately, one year, during a fire, the blocks and all [the edition ?] were turned to ashes. Sad indeed the loss ! for not only did they show the then

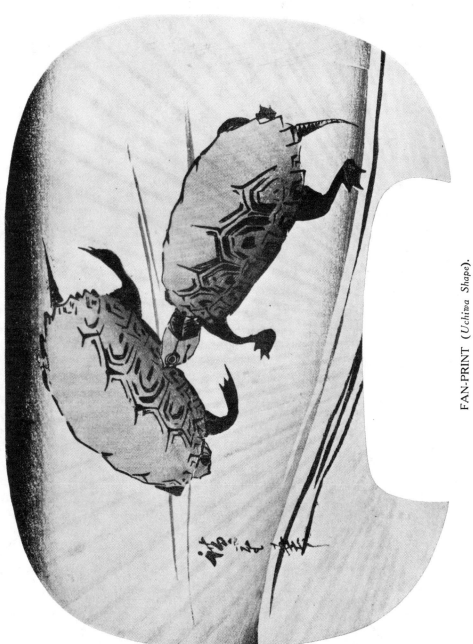

FAN-PRINT (*Uchiwa Shape*).
Tortoises in Water.

prosperity of the Eastern Capital, but also portrayed ancient customs. But the famous places still remain, though changed by lapse of years ; and on careful consideration, the book-seller Kinkōdō has brought out this (as it were) revival of the edition, illustrated from life by Hiroshige at the publisher's request. They will be a valuable present to take to distant or even foreign countries, and it is interesting to compare the modern with the old.

Now, on the eve of publication, by request, with hasty brush I write these few lines as preface.

Kanoye Inu—Dog Year (1850).—*Early Autumn. KINSUI CHINJIN, Writer.*

Vol. II. [The translation is difficult, as there is a play on words, an allusion to a poem in which the poet writes of the Eastern Capital as being in a vast moor (*No*), the moon rising in Musashi Moor (*No*) and setting in *No*, the capital.]

When rain falls on Musashi No not all the ground is wet, for vaster than the rain-cloud are the grounds of No [the Capital]. No longer the No of the poet, more numerous are the houses than the rushes of the fields. In some places the streets are wide, but in general, the moon (now) rises between roofs, and sets between roofs,—so populous is the city, so great has it become.

The inhabitants both young and old enjoy the constant changes (and growths) and the new interesting places.

Hiroshige, selecting the best scenes, with his exquisite touch has so wonderfully portrayed the city, that his pictures seem better even than the real sights ! If one has never seen Yedo, to look at this book is sufficient :—the best *miyage* this to take home or abroad.

Kanoye Inu—Dog Year (1850)—*on a Summer Day. SHOTEI GIYOFU, Writer.*

Vol. III.—Different provinces differ as to the character of their famous places :—in Yamato there are old historical places, likewise in Yamashiro surrounding Kyōto the ancient seat of royalty, but in Yedo increased civilization increases the number and variety of interesting spots.

In the Ise Monogatari, a poem runs :—*Miyoshi no no tanomu no kari :—*" Beseeching the wild geese of Miyoshi Moor " ; I am told that is near Kawagoe, but this is known only to few, because they are far from Yedo.

You easily see the growth near you : Buddhist and Shintō temples—magnificent buildings multiply and add to the wealth and power of the city. Witness Tairei Kinryūzan and Sano Kanda, temples.

Already have the first and second volumes appeared ; now that the third is ready for publication, by request, I have let my brush write this preface.

Kanoye Inu—Dog Year (1850)—*Middle of Autumn. KINSUI DŌJIN, Writer.*

Vol. IV.—This work has now reached its 4th Volume. All views are drawn with fidelity to nature, with exact truth. Of course rather freely and unskilfully, but it may amuse children or serve as lesson books. Landscape foliage and letterpress are treated in a sketchy manner : were I to put in everything minutely, the scenes would be crowded with people, and some places would look like a well-used ant-track. In future volumes will be depicted fine temples, types of people, stories, warehouses and shops, presented as if actually before you. Criticize the work if you like, but I trust you will desire it and purchase it !

Written in Kanoye Inu—Dog Year (1850)—*Beginning of Winter.*
ICHIRYŪSAI HIROSHIGE.

Vol. V. Many are the noted places and sights of Yedo, more than a hundred, and yet varying view points increase the number, but it is unnecessary to enumerate all and the many temples. In all seasons are they depicted, to suit all tastes. Hiroshige's relation of the far and near (perspective), the relative sizes of houses, horses, and people (sometimes mere dots), are very accurate and unmistakable. So faithful and forceful are his pictures that strangers will see it just as if they dwelt in the Capital.

Written by :—KINSUI CHINJIN. (No Date.

Vol. VI. [After referring to plays, and music, the writer says :] Hiroshige Daijin, depicts landscapes, grass, trees, birds and animals so faithfully, that on looking at the views one seems to be alive amidst them all.

This completes 6 Volumes written at the request of Kinkōdō, by : *SHOENSHU ZINBAIGEN. (No date.)*

At the end of this Volume is a synopsis of contents of the 6 Vols. as follows :

Vol. I. Many noted places of Yedo, to show to strangers its many beauties, hence entitled *Yedo Miyage*—Souvenir of Yedo—a revival after a hundred years [of the old title in new form]. Beginning at the South East, round by Yatsumi Bridge, both banks of the Sumida River, as far East as Yanagi Island, the Hall of the 500 Disciples of Buddha —all are faithfully depicted by Ichiryūsai.

Vol. II. Yedo Miyage, by Ichiryūsai. Continuing the series in Vol. I, beginning with Fukagawa Hachiman (Temple), via Shin Ōhashi to Tsukudajima, where fisher-folk with blazing braziers at the bow attract the fish, as described in the poem : *Shirauo-bune Takuya Kagarino Nami wo Yaku Kiyomi Gaseki!*—(" Where is it that the braziers of the whitebait fishers seem to burn the waves ? 'Tis at Kiyomi Cape ! ") As of old, when the poem was written, there is no view like it yet ! The plum-trees of Ōmori and Kameidō fill its pages with perfume. There is nothing better as a Souvenir.

Vol. III. Continuing the series, we here have Tama River, where cloth is washed, Rokugō River, Haneda Ferry, Ikegami Temple, the evergreen Chiyo Pine, Wild geese flying across Kasumi Gaseki, etc., etc.

Vol. IV. In this Vol. are all the places noted for Cherry-blossoms : Kawaguchi Ferry, and the many scenes near Ōji, many Cascades, Snow Scenes, all depicted in up-to-date views.

Vol. V. From Nihon-Bashi the centre of the city, round by Tori Chō, with Mitsui's Store, Spring Scenes, Summer Cooling, and Famous Gardens, as far as Negishi, etc., etc.

Vol. VI. Famous Temples, Places of Amusement, Boats (hundreds of them in the river), both sides of the Yanagi-Bashi tea-houses, etc., etc. Such opulence and beauty is not to be seen in Korea or China !

Vol. VII Preface reads : " Once a mulberry patch, now a sea "—truly in this change-able world nothing remains immutable ! As the poem says, " A deep pool may change to the rapids of a river." When this work was planned the Six Volumes were thought to contain all the views, but now not only going thirty miles outside of the city, but old places changed require new pictures, so faithfully drawn that everyone at once recognizes the localities. The artist wields the brush of great achievement !

Written by KINSUI DŌJIN. Seal : SHOTEI. (No Date.)

Vol. VIII. Ichiryūsai Hiroshige was a noted pupil of Toyohiro, the Ukiyoye-shi (painter). He originated his own style, and depicted landscape, flowers and birds, instead of real (or classical Kanō) pictures, for which his name is renowned. Why did not Heaven grant him longer life ? To die only a little over 50 ! This series of *Yedo Miyage*, the work of years, used as presents to far-off places, with Volume added to Volume has now extended to 8. It is now a memorial of him (since he is dead), but from sketches left behind are these views reproduced. On my own behalf I beseech the patronage of the rich, the princely, that they procure the work to look at from time to time, in different seasons, for their amusement.

Dated : Kanoto Tori. Middle Autumn (1861). *Written by SHOTEI USŌ.*

Vol. IX. [On title page are two signatures : *Hiroshige fude* and *Shigemase fude*, the latter perhaps the signature of the *vignette*].

Everyone likes pleasant things ; the one who does not is unique. Yedo is a great city, full of noted places and brilliant scenes. All who see it wish to relate its wonders. Words or letters cannot describe its beauties ; nothing is better (for that purpose) than pictures. A few years ago the Master Ichiryūsai was asked to prepare pictures for 10 Volumes. This is the 9th. Vol. X is almost ready for publication in a few days. The series is in fact a biography of the artist in brush-work. Whoever sees the series, enjoys the sights as if he were actually among them.

Kinoye Ne (1864). *Composed by YANAGI NO MON SHŪJIN SHUNSUI.*
Calligraphy by CHIKIDO.

Vol. X. Great is Yedo ! Views in the Four Seasons. This is the final one of 10 volumes. As a great poet, Bashio, said : *Yukimi ni korobu tōkōrō made.*—(" In viewing snow—watch it till it has all fallen." [i.e. get the whole set from start to finish.] " After the snow has stopped the earth is like silver.") Whoever loves pictures, this book will be found the best to give them. The *Second Hiroshige* Risshō is certainly successful in his brush-work—we see even the foreign military exercises. Kinkōdō may well be proud of *Yedo Miyage.*

Hinoto U (1867). *Composed by YAURA ITSUJIN.*
Calligraphy by RIŪSŌ CHUIN.

The second of the books here mentioned is the first volume of a projected series which does not seem to have been continued. It was issued by Iseya in 1849 and consists of 36 pages of colour-prints of flowers and fishes, with one landscape, put forth specific-ally as copies for the use of children. It was always customary for Japanese children to be taught drawing from copies. Dexterity with the brush was the object sought for ; and extraordinary skill was attained in this respect. But the wonderful drawings of plant and animal forms which have captured the admiration of Western educationists, and have been made the subject of so many senti-mental sermons on the advantages of studying Nature, were all done

in this way—from copies of drawings by long-forgotten artists handed down from generation to generation. Japanese art students did not go to Nature. The fact that Hiroshige did so, stamped him, in the eyes of the elect, as a somewhat vulgar revolutionary. However, he made this small contribution to the process—and, perhaps, abandoned the competition with stereotyped formulæ in despair. The Victoria and Albert Museum is so fortunate as to possess the whole of the original drawings for the printed book—that is, those first studies from which the engraver's clean drawings have been made. They include an interesting statement of some of the principles which underlay his methods, written by himself on the several pages. He, at all events, would send the children to Nature, " adding slightly an artistic idea in the brush-work "; and the " ideal treatment " is to be based on the " accurate copy." The reference to the Japanese equivalent of the pencil—the " Yakifude "—is also of interest. It is tantalizing that we have not his second volume, dealing with landscape. The author has never seen it; and Mr. H. Shugio, a keen student of Hiroshige's work, who has specialized in the collection of his books, was only able to describe the first volume in the Memorial Catalogue. The translation of the artist's notes which follows was made by Mr. H. Inada.

YEHON TEBIKI GUSA (*A Drawing-book of Plant Form*)

1849—Publisher, Iseya.

Introduction. The way to paint pictures is to copy from Nature, but adding slightly an artistic idea in the brush-work. The publisher has asked me to publish my pictures of grasses, flowers, fishes, etc., which I have painted for amusement. I have accepted his offer and now issue this book, for the purpose of giving hints to children who wish to paint, though they have not yet begun to paint regularly in classes. Those grasses, trees, fishes, etc., which are not illustrated in this volume will be published later in successive volumes. *Signed,* Ichiryūsai.

(1) Accurate copy of Fukujusō, with the same drawn in *Sō-hitsu* or quick brush-work style. In the case of quick brush-work painting, each petal should be painted in this manner with one stroke of the brush.

(2) Accurate copy of Sakurasō. There are several kinds of this plant, here the easiest one is chosen for children. Also an ideal treatment of the same. The flower to be

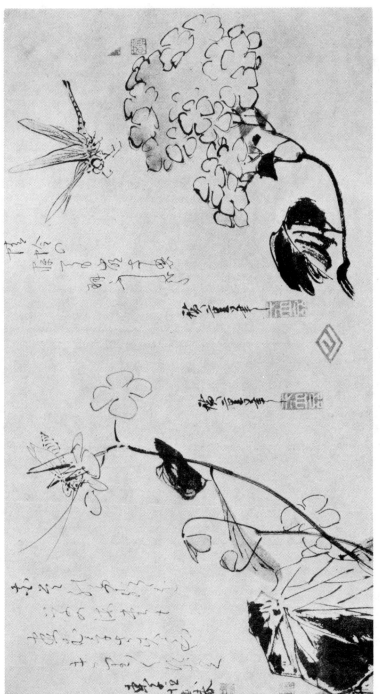

ORIGINAL DRAWINGS.

Kirigirisu on Shūkaidō Flower. Dragon-fly and Hydrangea.

Signed, Hiroshige. *Seals,* Ichiryūsai, Hiro.

done in pink colour, each petal with two strokes of the brush, the leaf in green or grey with a few strokes of the brush and the lines or nerves to be drawn afterwards.

(3) Himeyuri (lily) and Sumire (violet) accurately drawn with brush-work drawing of the latter.

(4) Ajisai (hydrangea) drawn accurately and also in brush-work style.

(5) Wistaria as above.

(6) Iris.

(7) Peony.

(8) Na no Hana (rape).

(9) Giboshi, the mauve colour of which is seen in May to June and looks like a kind of lily. Also Suge, a sort of rush.

(10) Kikyō, single and double. Light purple with white lines.

(11) Asagao and Hirugao (convolvuli).

(12) Fuyo (hibiscus) painted accurately.

(13) Susuki, autumn grass in brushwork style.

(14) Shūkaido (begonia) and Mizuhikigusa in both styles.

(15) Suisen (narcissus) in both styles.

(16) Rice and Karukayaso drawn in both styles.

(17) Chrysanthemum and Hiōgi in both styles.

(18) Cherry-blossom to be painted with white and pink. There are many different kinds, the one illustrated only gives a general idea. The petals are generally irregular. One must not draw flowers in too regular a form.

(19) To draw a Tai fish quickly. First draw the upright lines with *Yakifude* [i.e. stick of soft wood burnt at the top and used instead of a pencil before the Meiji period]. The head to take $\frac{1}{4}$ of the space, 2/4 for the body and $\frac{1}{4}$ for the tail, an extra $\frac{1}{8}$ being taken for the ends of the tail. Next draw the horizontal line and fix the proportion of the eyes, mouth and fins. The proportion differs in different fish as illustrated afterwards. Accurate drawings of Tai fish and Hōbō.

(20) Akauwo (red fish). Proportion: $\frac{2}{7}$ for head, $\frac{4}{7}$ for body, $\frac{1}{7}$ for tail. Fine scales all over the body. Also Tai fish in brush-work style.

(21) Aji fish. Proportion: $\frac{1}{4}$ for head, $\frac{3}{4}$ for body. Drawn in both styles.

(22) Mother of pearl oyster and Sayori fish. These do not require diagrams. Drawn in both styles.

(23) Ayu (mountain trout). Proportion in 5 except the tail. Drawn in both styles.

(24) Tobiuwo (flying fish) Minokasago, and Hirame (sole).

(25) Fugu (poison fish) and Mouwo. Proportion: $\frac{1}{5}$ for head, $\frac{4}{5}$ for body. Fine scales. Drawn in both styles.

(26) Carp—scales to be painted with black and grey, shaded somewhat darker on the back, then apply light yellow.

(27) Proportions for carp: $\frac{3}{4}$ for body, $\frac{1}{4}$ for head. The head to be divided into 4 parts as shown. Central line of scales is divided to make 36 principal scales. Drawn in both styles.

(28) Katsuō. Proportions in 4 parts, the tail having two. These fish are in many colours, namely red, black, brown, etc. Drawn in both styles.

(30) Crab. Drawn in both styles.

(31) Lobster and shrimps. Drawn accurately.

(32) Lobster and shell-fish in brush-work style.

(33) Tortoises. Drawn in both styles.

(34)
(35) }In landscape painting there is also proportion to be explained in the next volume. [The illustration is a fine view of Fuji seen from the flat land at its feet. The drawing is in line only; but the published print is in full colour.]

(36) Dried fish hanging on a tree. *Signature*, Ichiryūsai, *seal*, Hiroshige.

TŌKAIDŌ FŪKEI DZUYE

Hiroshige published, in 1851, a set of Tōkaidō Views in book form, to which reference is made on pp. 51–2 and a translation given of the preface, etc.

CHAPTER XII

SKETCH–BOOKS AND DRAWINGS

THE sketches and notes and studies—the *memoria technica*—of any considerable artist have a charm which often surpasses that of the finished work. In this matter the painter holds a large advantage over those who ply the other arts. The poor scribe is, of all, shackled hardest by the necessary tricks of his trade—though one thinks, wistfully, of such easy freedom as that of Herrick, and of those who made the Greek Anthology, and of all the writers of verse that ever were native to Japan. In this last innumerable company was Hiroshige. When a subject appealed to him he might make a little poem, a few lines—three or four or five in the popular manner; or a drawing done with hardly more strokes of the brush or the charred stick which did the work of our pencils. Hiroshige, in literary mood, was something of a wit; and apt, reading between the lines of his diaries, to be caustic at times. No doubt his restless brush expressed itself in like manner ; but the few fragments that remain of the drawings he made of scenes that demanded to be drawn and would not be denied, suggest only the most intense feeling for the veritable spirit of Nature. They are slight—in the sense that they evince a most severe economy of labour ; but no one may give them any term implying triviality. For the draughtsman who can, in so few strokes, give a perfect impression of a landscape with a horizon fifty miles away, or the gates of a mighty temple, or of a mere pot or two, or a girl's head-dress, with equal genius and facility, is in the first rank of his craft—and Hiroshige did these things and more.

His method of work may be concisely stated, so far as can be gathered from the specimens available for study. The beginning of a design was a sketch in black-and-white, small in size, and done either in wash or bold line. This gives the pith of the matter. Its

composition is always perfect, and seems to have been instinctive—an integral part of his genius—for no corrections are to be found at this stage. In his notes on the original sketches for the " Yehon Tebiki Gusa," printed elsewhere, he distinguishes between the "accurate copy " and the " quick brushwork." His sketches belong to the latter category. These were followed by a draft of the design fo a colour-print, of which a good example is to be seen in the 3-sheet drawing of a " Street Scene at Akibana, Yedo," exhibited with the set of tools and materials for the process of Japanese colour-printing, at the Victoria and Albert Museum ; and in the designs for a set of " Views of the Tamagawa " illustrated in this volume. Corrections are now made where necessary, not by rubbing out, or the use of body-colour as with us—Japanese paper does not lend itself to the former—but on thin paper pasted over the original. Probably a drawing in this stage might go at once to the engraver, to be laid on the block and cut up in the course of engraving ; but it may be that where extra care was being taken a fair copy would have been made for this purpose. It is the later stages of the operation that Hiroshige may have, during his last period, handed over to his pupil.

That excellent publication the *Kokka*, which, in respect of its illustrations is superior to any periodical produced in this country, has reproduced at various times drawings by Hiroshige in what one might call a painter's style—having no apparent connexion with the production of a colour-print. Among them are a number of Tōkaidō scenes. The Victoria and Albert Museum possesses a set of such drawings, one of which we reproduce (Plate facing p.120), of great power and interest. He also in his later years painted a few *kakemono* (hanging pictures) in form corresponding to the works of the recognized schools of Japanese painting. The finest of these is, no doubt, the " Daimyō Procession " in the Imperial Museum at Tōkyō ; and it is significant of the awakened interest of the Japanese in their great landscape artist that it is chosen as one of the few illustrations of Japanese painting to illustrate the Guide Book of the Imperial State Railways of Japan. There is a fine reproduction in the *Kokka*. But it is to the early sketches that the artist will turn. These are

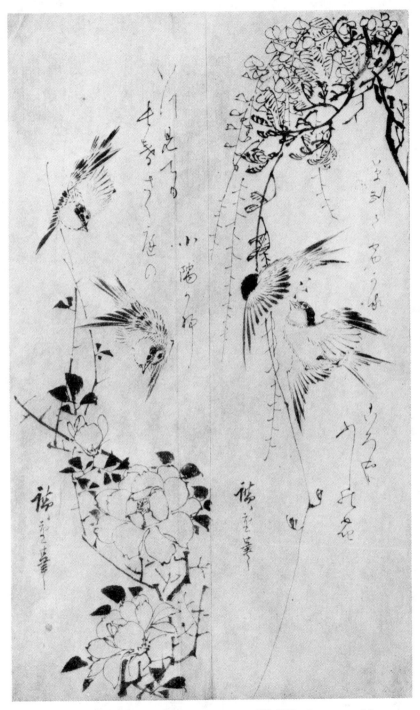

ORIGINAL DRAWINGS FOR *TANZAKU* (poem-cards).

Sparrows and *Sazankwa* Flower.　　　　Swallows and Wistaria.

gems of the first water and of infinite variety. Fortunately, in view of the destruction caused by the fire and earthquake at Tōkyō, we have a share of them, and so placed as to be easily accessible to students—a matter for which we are indebted to Mr. Arthur Morrison, who obtained them from Japan and made it possible for them to be added to the national treasures of this country.

The Department of Prints and Drawings of the British Museum contains four small volumes of original sketches by Hiroshige (Arthur Morrison Collection, Nos. 1545-8) which are of much importance, as they, in many instances, furnish a record of the artist's personal observation of many scenes, afterwards embodied in some of his best-known prints. These books are all of the same size, $9\frac{1}{4}$ by $6\frac{1}{2}$ inches, outside measurement ; and, with the exception noted below, are in strong line, vigorously drawn and, in most cases, with a brief note of the name of the place in Hiroshige's own script. They contain no information in diary form. One only is dated—Kayei 1st year (A.D. 1848) ; the others appear to be perhaps somewhat earlier, and are certainly not much later. They afford incontestable evidence that Hiroshige actually visited the scenes recorded in series where we have hitherto had no definite proof of the fact ; and also of his method of work. Straining after analogies is an attractive but dangerous pastime ; yet it may be permitted to suggest that these first-hand notes, afterwards used with such admirable results, may be compared with the mass of similar work by our own great landscape painter, J. M. W. Turner, bequeathed by him to a nation that has hardly yet begun to appreciate their splendid artistic and educational value.

A detailed examination and comparison of these sketch-books, with the large number of prints involved, is impossible within the limits of this volume ; but the following indication of their contents may serve as a guide to students, who will find that such research will well repay their efforts. The sketch-books are not paged; but the references given in the list are to the numbers of folios in each, counting from the right. It should also be understood that references are only to the locality and not, unless expressly stated, to particular prints ; for it must not be assumed that those relating

to particular stations on the Kisokaidō necessarily imply that the actual sketch is reproduced in the corresponding series of prints, but only that it was made at the place indicated. Explanatory notes added to the transliteration of the script are given in brackets.

B.M. 1545. Morrison Collection. In many instances, more than one subject appears on each page.

1. Banshu (Harima Province) Ishi-no Hōden.
 Ōi (gawa) Shima (da). [*Tōkaidō*, 24. The Shimada bank with Fuji and setting sun.]
 Kana (ya). [*Tōkaidō*, 25. Opposite bank of the Ōi river.]
2. Seto. Abe (kawa). Fuji kawa (38). Kiōmi. [All on the Tōkaidō.]
3. Yahagi (bridge). [*Tōkaidō*, 35, Yoshida.]
4. [No title. Avenue of pines with temple lanterns. For Yenshū Akihasan— Entrance to Akihasan Temple. *Honchō Meisho.*]
5. Yokkaichi (44). Kuwana (43). Miya (42). [Three successive stations on Tōkaidō.]
6. [Cooking clams, etc., typical of Kuwana, Tōkaidō.]
7. Nunobiki-no Taki, Ōto-Kodake. [The "male" waterfall at Nunobiki, Settsu Province.]
8. [Perhaps Nara.]
9. [No title.]
10. Futami, Isé. [The Rock and Village. The subject is in Tsutaya's "36 *Views of Fuji.*"]
11. Asakuma-Toge, Chaya. [Tea-house at Asakuma Pass on road to Futami.]
 Akō (in) Arima (province). [Associated with *Chūshingura.*]
12. Tempōzan, Kōzu-no Miya. Naniwa (=Ōsaka).
13, 14. Kōzuke. [*60 Provinces.*] Shirako. Kambegawa.
15-17. Bizen. [*60 Provinces.*]
18. Takasago Ura. Muro-notsu. Ai-oi-no Matsu. [Harima Province.]
19. Suma (beach). Akashi. Hyōgo. [Harima Province.]
20. [Harima sketches.]
21. [Kiyomidzu Temple, *Kyōto Meisho.*]
22. Shimabara [*Kyōto Meisho*]. Naniwaya-no Matsu. Sumiyoshi [both *Naniwa Meisho*].
23. Shimabara [*Kyōto Meisho.*] Demi-no hama [*Honchō Meisho*]. Gōjō [bridge, Kyōto].
24. Marugame [Sanuki Province]. Dankin-no Hana. [Bizen Province.] Maiko Hama. [Harima Province.]
25. Kitano (Temple). Maruyama. Ōtsu. [Kyōto.]
26. Chiōin. [Temple, Kyōto, and local costume.]
27. Ishiyama [*Ōmi Hakkei*]. Kusatsu, Oiwake [*Tōkaidō*, 53 and *Kisokaidō*, 69]. Echikawa [*Kisokaidō*, 66].
28. Karasaki. [Pine tree and Temple. *Ōmi Hakkei.*]
29. Ōtsu [Courtesan quarter. *Tōkaidō*, 54.]
30. Miidera Temple. Ishiyama Temple. Seta (Evening). [*Ōmi Hakkei.*]
31. Takamiyajima. Takamiyakawa. [*Kisokaidō*, 65.] Echikawa [*Kisokaidō*, 66.]
32. Musa [*Kisokaidō*, 67.]

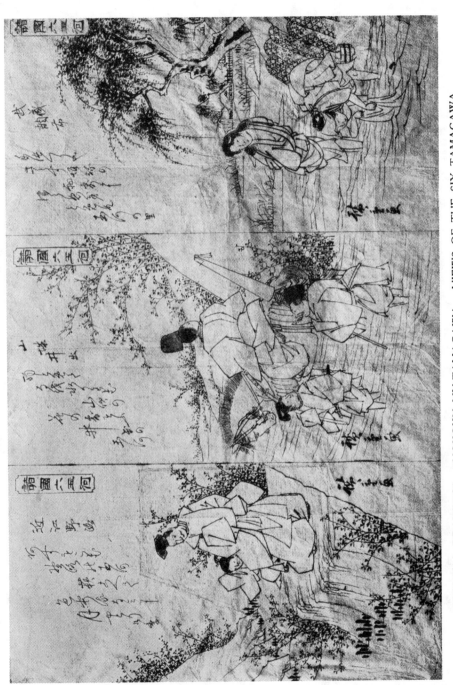

ORIGINAL DRAWINGS : SHOKOKU MU-TAMAGAWA. VIEWS OF THE SIX TAMAGAWA.

Noji in Ōmi.　　　　Ide in Yamashiro.　　　　Chōfu in Musashi.

B.M. 1545. Morrison Collection (*continued*)—

33. Saikawa. Araikawa. [On Kisokaidō.]
34. Tenryūgawa [*Tōkaidō* and *Kisokaidō*].
35. Uji bashi [Yamashiro Province.]
36. Ai-no-yama, Ise. Sunshū [= Suruga] Fuchū.
37. Satta. Yui [*Tōkaidō*, 17]. Okitsu [*Tōkaidō*, 18].
38. Hommoku Jūnytensha [Yokohama].

B.M. 1546. Morrison Collection. [In this book are many drawings of scenes on the Kisokaidō. Those marked *Y* refer to Stations of which the prints were made by Yeisen.]

1. Itabashi-eki, Tateba. [Resting place at Tateba. *Kisokaidō*, 2. *Y.*]
 Toda-no Watashi. [Ferry-boat at Toda, Warabi Station. *Kisokaidō*, 3. *Y.*]
 This sketch has also short poems on a journey to the Kisokaidō, of which the following are two.

 > *Sake Kumite medetaku*
 > *Hana-no Wakare Kana.*

 > Drinking sake, happy farewell of the flower.

 > *Kashimadachi Okurite Kokoni*
 > *Kiso-no Eki*
 > *Yagate Medetaku Kaeru Tōkai.*

 > I am leaving to begin a journey
 > On the Kisō Road,
 > Soon shall I joyfully return to the Eastern Sea (Yedo).

2. Ōmiya Shiku Musashi Ichi-no Miya Hikawa Daimiōjin. [The famous Shintō Shrine of Hikawa. Ōmiya Station. *Kisokaidō*, 5. *Y.*]
 Kumagaya Tsutsumi Arakawa. [Embankment at Kumagaya. *Kisokaidō*, 9. *Y.*]
 Fukaya Irikuchi. [Entrance to Fukaya. *Kisokaidō*, 10. *Y.*]
3. Shinmachi Shiku ; Shinryūkawana, Karasugawa. [*Kisokaidō*, 12.]
 Honjō Irikuchi. [*Kisokaidō*, 11. *Y.*]
4. Kuragano. [*Kisokaidō*, 13. *Y.*]
 Kumagai Renshōbō. [Portrait of Renshōbō, the name taken by Kumagai Naozane when he became a priest and whose shrine is here.
 Kisokaidō, 9. *Y.*]
5. Saruga Banba Toge (Pass). [*Kisokaidō*, 63.]
6. Suwa-no Kozan [Fish, produce of Lake Suwa]. Shin [= Shinano Province].
 Suwa Kono Dzu. [*Kisokaidō*, 30.]
7. Shin Hakke and Take [Peak and a Castle].
8. Shojiri Toge. [Shojiri Pass. *Kisokaidō*, 31. *Y.*]
9. Myōgi San Embō. [Distant view of Mount Myōgi, Matsuida, *Kisoka'dō*, 17.]
 Nakano Take Embō [Distant view of Nakano Peak].
10, 11. Chikumagawa Watashi. [Ferry on the Chikuma River—a fine 2-page drawing.]
12, 13. [Studies of country folk on the Kisokaidō.]
14. Shinshū [= Shinano Province] Zenkōji.
 Sarashina.

B.M. 1546. Morrison Collection (*continued*)—

15. Surikugi Toge Yori Biwa-ko. [Lake Biwa from Surikugi Pass.]
16. [Studies of country folk; one sheet marked for colour, " grey," " green," etc.]
17. Kashiwabara Shiku. [Shops for *moxa* treatment. *Kisokaidō*, 61.]
 Akasaka Irikuchi. [Entrance to Akasaka. *Kisokaidō*, 57.]
18. Tarui. [*Kisokaidō*, 58]. Myeji. [*Kisokaidō*, 56.]
 Samegai. [*Kisokaidō*, 62.]
19. Ikao Tojiba. [Hot springs at Ikao, near Karuizawa. *Kisokaidō*, 19.]
20. [3 views, unnamed.]
21. Amba. [The village, inscribed " Boundary of the Provinces of Mino and
 Ōmi.] Imasu. [*Kisokaidō*, 60.]
22. [Unnamed.]
23. Ōta. [*Kisokaidō*, 52.] Unuma. [*Kisokaidō*, 53.]
 Kanō. [*Kisokaidō*, 54.]
24. Kōdo-no Watashi. [Ferry at Kōdo. *Kisokaidō*, 55. *Y.*]
 Maid carrying water in pails with a yoke.
25. Shinshū Jino Jimbutsu. [Local costume of Shināno people, a *kago*, farmer,
 pony with firewood, etc.]
26. Nakatsugawa. [*Kisokaidō*, 46.] Ōi. [*Kisokaidō*, 47.]
27. Jū-San Toge. [Pass between Ōi and Ōkute [*Kisokaidō*, 48.]
28. Ōta-no Watashi. [Ferry at Ōta. *Kisokaidō*, 52.]
 Kwannonzaka Yori Chōbō. [View from Kwannon Hill.]
29. Shimo-no suwa. [*Kisokaidō*, 30.]
30. Tsuma-ko. [For Tsumakome. *Kisokaidō*, 43.]
 Magome. [*Kisokaidō*, 44. *Y.*] Ochiai. [*Kisokaidō*, 45.]

B.M. 1547 (Morrison Collection).

1-8. [Various sketches, unnamed.]
9. [Sketch of Rapids at Awa-no Naruto.]
11. Suwō, Kintai-bashi. [60 *Provinces.*]
12. [Unnamed.]
13. Sumi [= black ink].
14. Sai [= colour]. Jū-san Toge. [The Jū-san Pass.]
15. Ōtagawa. [*Kisokaidō*, 52.]
16-18. [Unnamed.]
19. Haruna-no Uchi. [Snow at Haruna. 60 *Provinces.*]
20. Uchū. [Also marked " Rain "—but no rain has been drawn.] Kirihari.
 [Fine Day after Mist.]
21. [Girl and Full Moon. Signed, Ryūsai.]
 Sagabori Setchū. [Snow at Setchū.]
22. Futami-ga Ura, Asakuma Yama Hana. [Flowers at Asakuma Mountain.]
23. [The Courtesan Takao and Cuckoo.]
24. Yoshiwara Tsukiyo-no Hana. [Moonlight at Yoshiwara. *Tōkaidō*, 15.]
 Dōsho Nihon Tsutsumi-no Yuki. [Snow on the embankment at the same
 place.]
25. Myō-no Matsuwara Kiomigaseki.
26. Shinobazu Ūchū-no Hana. [Flowers at the Shinobazu Pond in rain. *Tōto
 Meisho.*]
 Kōzuke [Province] Muchū-no Hana. [Flowers in Mist at Muchū.]
27. Meguro, Chiyogasaki. Dōsho, Chiyogaiki. [*Tōto Meisho.*]

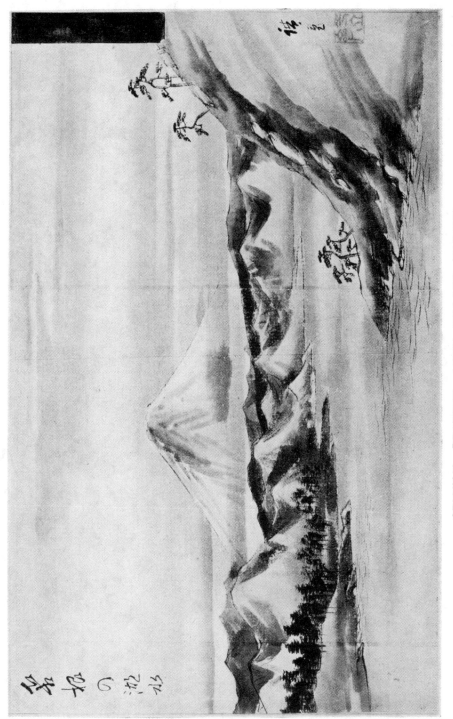

ORIGINAL DRAWING: VIEW OF LAKE HAKONE.

B.M. 1547. Morrison Collection (*continued*)—

28. Tsunohazu Jū-ni-sō-no-ike.
 Dōshō, Ōdaki Take (Waterfall).
29. Ōjitaki-no Gawa. Ōji, Ōtonashigawa, Ōdaki.
30. Gotenyama, Yoru-no Hana. [Flowers at evening at Gotenyama. *Tō.o Meisho.*] Takanawa, Yuki-no Asa. [Snow at Takanawa. *Tō.ō Meisho.*]
31, 32. [Fuji and Cherry-blossom from the Sumida River.]

B.M. 1548 (Morrison Collection). Nos. 1-13 are in wash, lightly tinted in places with red and blue. The rest are in line.

1. Takanawa, Asukayama. [*Tōto Meisho.*]
2. Sumidagawa [in snow]. Ryōgoku [in moonlight—both *Tōto Meisho*].
3. Yoshiwara Nihon Tsutsume. [Yoshiwara embankment in rain. *Tōkaidō,* 15.] Gotenyama. [*Tōto Meisho.*]
4. Sanyabori-yori. Mimeguri Susaki.
5. Takanawa. Sumidagawa. [*Tōto Meisho.*]
6. Tsukudajima. Asukayama Urate [Back view].
7. Ryōgoku [with Fireworks]. Susaki. [*Tōto Meisho.*]
8. Matsuchiyama. Gotenyama. [*Tōto Meisho.*]
9. Tonegawa. Kōzuke, Nakanoyama.
10. Kai, Saruhashi. [Sketch for the famous " Monkey-Bridge." *See plate, facing p.* 72] Nunobiki-no Take. [Nunobiki Waterfall—so called from its resemblance to stretched linen. *See plate, facing p.* 72.]
11. Mio-no Matsubara. Hakone, Shiraito-no Taki. [Waterfall "like silk."]
12. Kōzuke, Haruna San. [*60 Provinces.*] Mino, Ōtagawa [*60 Provinces.*]
13. [Unnamed, Fuji from Ryōgoku.]
 Sun [= Suruga] Satta-no Yuki. [Snow at Satta, *Tōkaidō,* 17.]

[On the latter page is the following inscription : " Kayei 1st [1848] Monkey Year, drawn in Summer. Shin [= Shinano] Sakata-no Byōbu [note for distance]."]

14. Tōto, Gotenyama. [*Tōto Meisho.*] Hakone, Shiraito-no Take.
15. Tamegawa. Yamato, Tatsuta. [With maples.]
16. Kazusa, Kurodo-no Ura. Kyō, Arashiyama.
17. Ban [= Harima], Maiko [Beach]. Bu [= Musashi]. Kanazawa. [Sketch for one of the *Kanazawa Hakkei.*]
18. Sun [= Suruga], Fujikawa. [*Tōkaidō,* 38.] Tōto, Matsuchiyama. [*Tōto Meisho.*]
19. Kaianji. Gotenyama. [*Tōto Meisho.*]
20. Mimeguri Tsukiyo-no Yuki [Moonlight and Snow]. Imada-no Hotori.
21. Sumidagawa. Konodai.
22. Kyōto, Arashiyama Sakura. [*Kyōto Meisho.*] Kyōto, Momiji. [*Kyōto Meisho.*]
23. Yoshinogawa. Katsuragawa.
24. Schichirigahama. Enoshima.
25. [Unnamed : Enoshima.] [Lake View (?) Hakone.]
26. Koganei. Tamagawa. [*Yedo Kinkō Hakkei.*]
27. [Unnamed—Cherry-blossom on a Beach, and Fuji.]
28. [Unnamed—Sailing-boats, and Sea View with Setting Sun.]

The British Museum also contains an album consisting of 10 double-page folios, drawn full-size for lateral prints and (9) lightly tinted with red and grey wash. These would be completed designs from which probably a fair copy would be made for the engraver. (Size 11$\frac{15}{16}$ by 14$\frac{1}{4}$ inches.) They are late in style, signed " Hiroshige," and sealed " Ichiryūsai," the subject being (1) Plum garden at Kameido, (2) Viewing Cherry-blossoms at Mukōjima, (3) Imado from Mukōjima in Spring—almost exactly reproduced in the " 36 Views of Fuji "—(4) Tamagawa, (5) Tanabata Festival, (6) Shinagawa beach in Autumn Moonlight, (7) Yanagi Bridge in Autumn Moonlight, (8) Maple Viewing at Ōji—this is labelled *Fuyu* (Winter) in error for *Aki* (Autumn), and (9) Ferry-boat at Hashiba in Winter. The last drawing (10) is fully but badly coloured, and is inferior to the rest. It represents Snow on the Sumida River, from the Imado Tea-house, and is signed " Hiroshige " but not sealed. All must belong to Hiroshige's latest period.

The Diary already referred to as belonging to Dr. J. Hutchinson is written on the last two pages of a volume similar to those in the British Museum, 7$\frac{3}{4}$ by 5 inches in size and containing 38 pages, of which two are blank and the first has only an inscription, " Memories of Travel." The rest (except for those previously mentioned) are filled with sketches, roughly but most vigorously drawn and annotated with names and memoranda in Hiroshige's writing. The following is a detailed account of the contents :—

PAGE

1. Title. Memories of Travel.
2. (Blank.)
3. Taiko Iwa. Rock called Drum Rock.
4, 5. Mitake Michi, Gedō-no-hara, Kōshū. Devil's Plain on the way to Mount Mitake, Kōshū or Kai province. The rock on the summit of the mountain is called Katana nuki-ishi. (2-page.)
6, 7. The view continued from No. 2 (2-page).
8, 9. Kurakake Iwa. Saddle Rock (2-page).
10, 11. Zō-ga-hana. Cliff called Elephant Trunk (2-page).
12. Mitake Ōmon. Great Gate, Mitake.
13. (Blank.)
14, 15. Place called Kajikazawa on the bank of the River Fuji, on the way to Mount Minobu. Two houses on the hill are tea-houses. There is an inn in the town. The whole way from this town to Mount Minobu has most beautiful scenery.

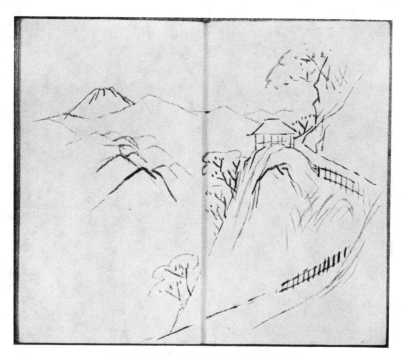

THE BACK OF MOUNT FUJI.

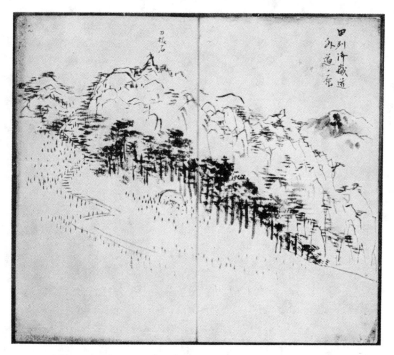

THE DEVIL'S PLAIN NEAR MOUNT MITAKE.

From original sketches in the collection of Dr. Jonathan Hutchinson, F.R.C.S.

CHAPTER XIII

HIROSHIGE AND WESTERN ART

N O Japanese artist has exercised so direct an influence on the modern art of Europe and America as Hiroshige. Hokusai evokes the warmest admiration in our painters ; but none has tried to tread in his footsteps. One may see more than a trace of the manner and methods of Utamaro in Beardsley and his little school of imitators—in the slender, exquisite line curving voluptuously to express the very quintessence of sensuality. But, so far as we were concerned, the tale was soon told, and hardly an echo of it remains. It has been far otherwise with the characteristic art of Hiroshige. When he—or another—wrote the little poem that appears on his memorial picture, his words held an unimagined truth. Hiroshige has veritably come to the West. His spirit, working in our painters and designers, has taught them indeed to view our scenery in a new light. We take the verse, as Noguchi writes, with " Western seriousness." It is not so much that he and his work have been " interpreted and reconstructed by a new understanding," as that he has opened the door to new interpretations and reconstructions of our own art. In this untrodden path Whistler led the way ; and it is therefore to the consideration of Hiroshige's influence on that very great pioneer that we must first give attention.

In 1858, the year of Hiroshige's death, Whistler was in Paris and published his first etchings, the " French Set." In or about that year also he painted " At the Piano," and shocked the critics by much of that beauty of arrangement and spacing he was said, later, to have learned from the Japanese. But Hiroshige does not come into the story, as generally told, till far later. It was not until 1872 that Whistler began his series of *Nocturnes*. Mr. Joseph Pennell, an acute and enthusiastic critic, has a few words on this

series which we may venture to quote. He says (in his admirable "Life" of the great American artist) :

"Whistler was the first to paint the night. The blue mystery that veils the world from dusk to dawn is in the colour-prints of Hiroshige. But the wood-block cannot give the depth of the darkness, the medium makes a convention of the colour. Hiroshige saw and felt the beauty, and invented a wonderful scheme by which to suggest it on the block, but he could not render the night as Whistler rendered it on canvas."

It would have been more accurate to say that Hiroshige did not do so ; and a wider acquaintance with Hiroshige's work might have modified Mr. Pennell's views as to Hiroshige's night scenes. But on the main point we are in agreement, even up to Mr. Pennell's categorical assertion that "Whistler never imitated the Japanese in their technique." He may have absorbed a hint or two in regard —as Mr. Pennell points out—to minor details, perhaps even more than that writer admits in respect of composition, particularly the high point of view. But all the time the comparison is between things not in the same category ; and, personally, the present writer sees only superficial resemblances in execution.

Of course, the direct challenge is in the famous " Nocturne, Blue and Gold—Battersea Bridge." The old wooden bridges of Japan supplied Hiroshige with many subjects. He gives them to us in almost every possible aspect ; and notably at night, in moonlight or with falling fireworks (the " Falling Rocket " was another of Whistler's *Nocturnes*). His treatment of silvery moonlight perhaps comes nearest to that of Whistler in the exquisite " Nagakubo " (No. 28 in the Kisokaidō series). But there is no evidence that Whistler had seen very much of Hiroshige's work at a date when few people in the West knew anything about Japanese art or colourprints in general, or Hiroshige in particular. Rossetti, we know, acquired some in Paris about the years 1862 and 1863. The author has seen them, for they passed as a whole into the hands of the late W. M. Rossetti, who was kind enough to afford an opportunity for examination. They were mainly 3-sheet battle-pieces and illustrations of legends by Kuniyoshi and his pupils ; with a very few landscapes by Hiroshige from " The Hundred Views of Yedo " and

series of that period. The late Mr. Thomas Armstrong, who was in Paris about the same time, then made his first acquaintance with them, and, no doubt, Whistler shared in the new discovery. Indeed, in "The Gold Screen"—one of the pseudo-oriental group painted in Chelsea in 1863–1865—he actually reproduces a print from the "More than Sixty Provinces" series. But the prints he cherished through all the vicissitudes of his stormy life, which were in his possession when he died, did not include a single landscape. They were mainly by Kiyonaga, and all by artists of that period and in that manner.

Beyond the similarity of subject, the "Old Battersea Bridge" has nothing in common with Hiroshige's work that might not have been arrived at by an artist of similar tendencies and independence of the traditions of his environment. There is no question of "influence"; but much kinship in essentials. Whistler—again to quote Mr. Pennell—"never gave up, he developed rather, what he always spoke of as the Japanese theory of drawing. . . . Few painters understood better than he did the art of selection, and here again Hiroshige and the other Japanese had been of use to him. He went to Nature for the suggestion, the motive." Again, "The long nights of observation on the river were followed by long days of experiment in the studio"; and, in the notorious trial, one of the ridiculous points alleged against him was that he only took two days to paint his masterpiece! Mr. Pennell is absolutely right on all but one detail—a thing which really does not matter. For one may be permitted to doubt whether Whistler knew, till long after he had arrived at his way of working, that it was, in essentials, the same as that of Hiroshige. The case seems one of *post hoc, ergo propter hoc.*

However, one must, and cheerfully, give Whistler the credit of having been the interpreter to the West of artistic principles that, anyhow, were those of Hiroshige. The results need not be expounded in detail. Indeed, it were difficult to do justice to the far-reaching and potent effect of the new vision opened to us by these two great men. Since the colour-prints have been known to artists generally, their direct influence cannot be denied.

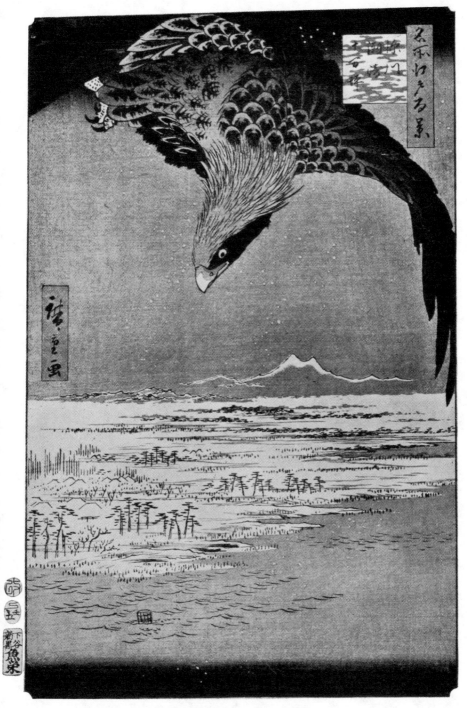

JŪMANTSUBO IN SNOW.

From " The Hundred Views of Yedo." *Publisher*, Uwoyei. *Date*, Snake Year, 1857.

On a lower plane of art, one of the most conspicuous instances of the application to Western uses of the root principles, if not quite of the technical methods, of the Japanese colour-printers is to be found in the modern development of the poster. This influence was displayed first of all in figure-subjects, and France led the way ; for the early posters of Steinlen, Balluriau, Ibels, Grasset, and Toulouse-Lautrec had much of the clear and dramatic statement of subject, in terms of definite outline and flat planes of colour, which are characteristic of the Ukiyoye work generally. Perhaps the earliest poster of note in England which can be referred to the same source is the remarkable advertisement of Mr. Shaw's *Arms and the Man* made for its first production at the Avenue Theatre by Aubrey Beardsley. This must be placed among the pioneer work of the great advance that has since taken place in the artistic merits of our posters ; a movement which was further promoted by the admirable work of the Beggarstaff Brothers (Messrs. James Pryde and William Nicholson), Dudley Hardy, and Mr. Hassall. We cannot claim these as coming specifically within the sphere of influence of Hiroshige ; but later productions, and notably the remarkable series published under the auspices of Mr. Frank Pick, for the Underground Railways, contain many examples of a successful treatment of landscape, in which the spirit of Hiroshige is manifest. The outburst of this sort of advertisement in which other railway companies have indulged during the last year or so, is also to be considered in this category; so far as regards those (and the best of them) which are not merely feeble versions of formal painting. Hiroshige has taught at least some of our poster designers the virtue of simplicity; and how to select the essential features of a great landscape and interpret them in terms easily to be understood by the people. His fine vision and essential poetry constitute the hall-mark of his own great individuality, and are not shared by any imitator or student. We have, unhappily, nothing to correspond with the rich symbolism and traditional philosophy and allusiveness with which the presentment of a Japanese landscape, by a great Japanese artist, is replete. But, at least, we have been able to learn a lesson, by no means of little value, and thereby to brighten our dingy stations

and hoardings in a way unthought-of thirty years ago. To Hiro-
shige we owe the scenes of sea-coast and mountain and picturesque
countryside that play so large a part nowadays in our poster-panorama.
But I think that no one yet has dared to advertise a rainy day.

The curious thing is that the Japanese rarely advertised in this
manner. Hiroshige himself made a few prints as advertisements :
but not, we think, as posters. The Japanese theatre poster—many
examples of which he certainly executed—was a large painting or
writing : in the former case, crude in design and coarse in techni-
que ; in the latter, often with that intrinsic beauty which belongs to
Japanese and Chinese calligraphy and arranged with the natural taste
which seems to be inseparable therefrom. But Hiroshige was not a
skilled writer, and we can ascribe to him no share in this kind of
artistic achievement.

In another direction, his influence was more immediately exerted
on a modern movement of considerable importance, which seems
now to be well established, namely, the making of colour-prints by
Western artists in a technical method practically identical with that
of the Japanese. In this country the pioneers of a remarkably
interesting and successful experiment were Mr. J. D. Batten and
Professor Morley Fletcher, working together ; who, after surmount-
ing many difficulties, at last prevailed so far as to give us some good
colour-prints which not only have considerable merit of their
own, but were a source of inspiration to many students eager to
attempt a method of wood-cut printing capable—as proved by the
Japanese—of most beautiful results. Messrs. Batten and Morley
Fletcher, it should be recorded, worked without the assistance of
Japanese instructors, and even, at the outset, with no more help
than could be derived from the first published account of the pro-
cess, published in the transactions of the Smithsonian Institute by
Mr. Tokuno, and reprinted in an early number of *The Studio*. The
somewhat more detailed description published by the author in
Japanese Illustration, and the writings of Professor William Anderson
and Professor Rein, comprised the body of information then avail-
able. However, the seed was sown, and the technical exhibit of a
complete set of blocks, each with a proof, tools, and materials,

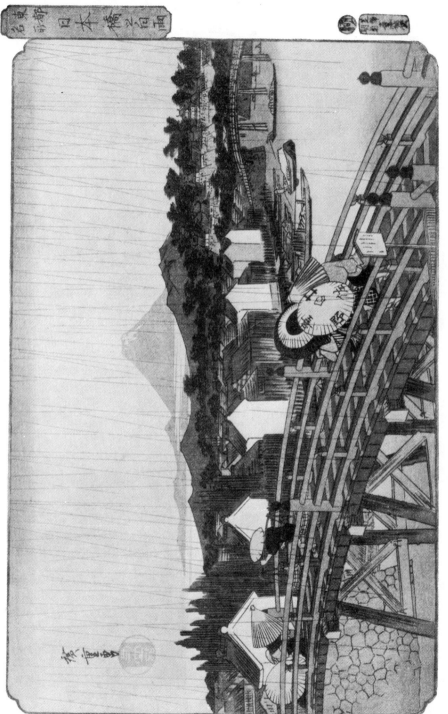

THE NIHON-BASHI, YEDO, IN RAIN.

From a series of "Views of Yedo." *Publisher,* Kikakudō.

arranged by the author in the Department of Engraving, Illustration, and Design, of the Victoria and Albert Museum, made the path easier for the increasing number of artists inclined towards the venture.

On the Continent Mr. Emil Orlik, of Prague, was one of the first and most capable of the leaders of the new movement. He learnt his method in Japan ; and we believe that Frau Brinckmann (Fräulein Minna Hahn), of Hamburg, also had the benefit of Japanese instruction in her own country. Good work has since been done in France and in the United States ; and there is now a considerable body of artists engaged, more or less, in producing creditable prints from wood-blocks in the Japanese manner. Mr. William Giles, one of the most ingenious and persevering of them, has not been content to restrict himself in this respect, and has devised technical methods of his own, from the original starting point, of great value and interest, and involving the use of metal plates. But probably not one of these would deny a great debt due to Hiroshige. He taught his Western disciples to see landscape and flowers in terms of the colour-print. It cannot yet be said that any one of them has come within measurable distance of his own supreme position. Not so easily can a tyro perfect himself in craftsmanship such as that inherited by the Japanese artisans from generations of artistic ancestors. And our people do not undergo, and probably never will undergo, the surrender of body and soul to training in one specific handicraft which formed the basis of the craftsman's education in old Japan. Even were it possible, one may doubt, unhappily, whether a bare living is now to be gained in that way —in the West. Our arts were nurtured mainly on the direct patronage of the aristocracy—as, indeed, were most of the arts of Japan. We are now traversing a period of uncertainty and difficulty, in which commercialism is a potent factor. Perhaps we may dare to look forward, in our more healthy moods of optimism, to a time when our own democracy shall develop and generously maintain its graphic arts, as did what Noguchi finely calls the " proud plebeianism " of old Japan, which counted Hiroshige in its ranks, perhaps, even in his own day, not without some honour.

CHAPTER XIV

A JAPANESE APPRECIATION OF HIROSHIGE

I AM permitted to quote—as a not unsuitable conclusion to this book—an appreciation of Hiroshige by a Japanese writer, Mr. Sotaro Nakai. It appears, in language not without an eloquence of its own, to define the position of the great artist, in terms which a Western critic could hardly expect to have at his command ; and from a point of view somewhat deeper and more philosophical than the technical aspect which necessarily appeals to us. It calls for no comment beyond an expression of warm thanks for so illuminating an exposition.

HIROSHIGE AND YEDO'S CIVILIZATION. By SOTARO NAKAI

Yedo's civilization was the civilization of men. The Yedo people tried to find all the pleasure of life in the congregation of men. In their eagerness to drink deep of the fountains of pleasure they did not mind ruining themselves in the theatres and gay quarters. Artists also tried to seek the beauties of art in men. This was palpably wrong. Art that lost Mother Earth to follow frivolity must be considered as a deplorable art, for artifice, however elaborate the painting, is not comparable to the beauties of Nature.

It was Ichiryūsai Hiroshige who discovered the "lost earth" in the midst of this general decadence of art and instilled a new life into art. Why was Nature lost in the growth of art in Yedo ? The civilization of Yedo had grown with the city as a centre. In other words, its civilization had been nurtured by the citizens who sought the beauties and pleasures among themselves, and so it is not surprising that the provinces of art and literature should be confined to these limits. Yedo's civilization was essentially that of the common people whose destinies were swayed by the development of the city. The admiration of the city in which they lived and

their pride in it was never absent from the minds of the Yedo people. There is a more potent reason why the Yedo people sought their pleasures among men. At that time the common people of Yedo held the power of finance in their hands, and money was their life and soul : yet they never hesitated to spend money like water. What was the reason ? At that time the common people suffered from all the tyranny and oppression of the Tokugawa Government, but they dared not raise a finger against the tyrants, for it meant an instant extinction. Their pent-up feelings found a safety-valve in pleasure-making that money could buy. It is not surprising in such circumstances that theatres and gay quarters should have made wonderful development, and the last vestige of Nature was swept away from the art and literature of Yedo. It was evident, however, that men could not wallow for ever in the mire of sensualism, and the day of awaking must arrive sooner or later.

It was Hiroshige who first discovered the " lost earth " in the midst of general degeneration. It is true that Seikaku and Ikku in literature, and Harunobu, Toyoharu, Kiyonaga, Utamaro and Hokusai in art, tried to depict Nature to a more or less extent, but none penetrated deeper into their objective than Hiroshige did.

Hiroshige's Art.—The truth is that the people had become tired of too much artifice in the civilization of Yedo, and of art and literature without any genuine spirit. Since the Kwansei era the Tokugawa Government repeatedly issued orders aiming at checking the luxurious tendencies of the people, without much effect. During the Tempō era, Mizuno Echizen no Kami issued another order in which he enjoined on the people the necessity of thrift and saving. From this time on the people gradually began to incline more in favour of steadier and simpler life, and this tendency in popular taste must not be lost sight of in the study of such popular art as Ukiyoye.

At first Hiroshige used to paint human figures, but later he became conscious that this was not his mission, and the growing popular demand brought him nearer to Nature. Early in the Tempō era, Hiroshige joined a party dispatched by the Tokugawa Government for the purpose of presenting horses to the Emperor

in Kyōto, and journeyed along the Tōkaidō. The trip proved an eye-opener to the master in more senses than one. When Nature was spread before the artist in all its splendour, the artistic instincts dormant in the inner recesses of his mind began to move with restless activity, and his delight and amazement were no doubt boundless. He was struck by a new inspiration owing to the beauties of Nature and the secrets of earth which he had hitherto failed to discern, and determined to dedicate his life and art to Nature. Hiroshige was brought from darkness into light and into a wider, prettier new world from the narrow confines of art in which he used to move. It is not surprising that the master should be filled with a newer and greater inspiration. The result was the production of " Tōkaidō Gojūsan Tsugi," " Kyōto Meisho " and " Ōmi Hakkei."

From this time on Hiroshige travelled far and wide throughout the country delineating Nature in all its moods and aspects. He travelled over the quiet, lonely roads of old Japan seeking subjects for his pictures, and when the night fell he relished and refreshed the artistic impressions obtained during the day under the rushlight of an obscure inn.

Hiroshige approached Nature with unadorned simplicity and artless truthfulness ; and herein lies a clear distinction between his productions and those of Hokusai and Toyoharu. Some artists in their attempt to interpret Nature in her true aspects got hold only of her outer shell, and so their productions are necessarily superficial and defective. Hiroshige's attitude in depicting Nature, however, is honest, straightforward, and simple, and the result is wonderfully effective. His paintings, however, are not free from tones of loneliness, humour, melancholy and resignation, which were evidently derived from the world in which he lived. Especially loneliness and resignation were the prevailing feelings of the Yedo people at that time. The oppression of the Bakufu as exerted on the common people was so severe and relentless that they had to live in constant fear and trepidation of the powers that be, and the feelings of loneliness and melancholy were bred in their minds in process of time. They had no courage even to vent their grievances aloud, much less to protest the wrongs inflicted on them ; they merely mur-

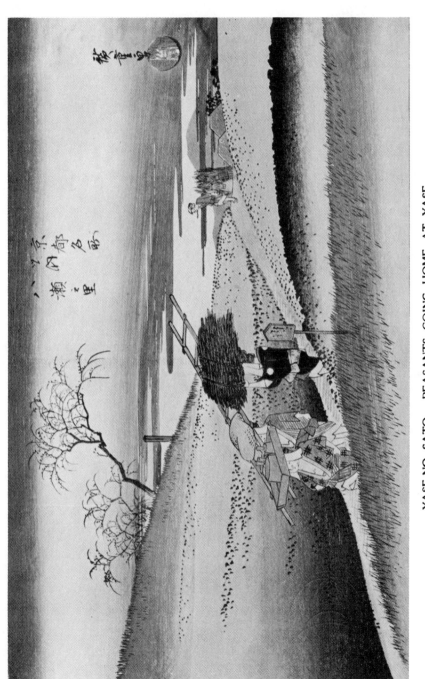

YASE-NO SATO. PEASANTS GOING HOME AT YASE.

From the series of "Famous Views of Kyotō."

(See color plate N.)

mured their complaints and resigned themselves to fate. This is the reason that tones of loneliness and melancholy are discernible in some of Hiroshige's productions.

He avoided depicting the noise and bustle of life, but took delight in delineating such a scene in which a spring day is brought to a close amid the flying flakes of cherry-blossoms and the distant sound of a temple bell. It must not be thought, however, that these tones pervade all of Hiroshige's paintings. In some of his productions light humour and vivacity sparkle like gems, such as the scenes at Goyu and other places in his Tōkaidō paintings. In any interpretation of Hiroshige and his art the witty and humorous side of his nature must not be lost sight of.

Most of Hiroshige's art gives one an irresistible feeling of loneliness, and especially he seemed to have taken delight in depicting pilgrims and other travellers hurrying to their inns over the roads in the setting sun. It is, however, noticeable that even in lonely surroundings there exists in Hiroshige's works a warm, admirable harmony between man and Nature that is pleasing. This effect is strikingly evident in the painting in " Kyōto Meisho " and " Naniwa Meisho."

Hiroshige treated men as part of Nature and brought men and earth into a perfect harmony. This is what makes his art particularly valuable. The study of Hiroshige's painting will convince one that human figures in his productions stand in such perfect harmony with their surroundings that they are present as part of Nature without the slightest marring effect. Thus men have been enabled to return to earth from which they had sprung, discarding resplendent artifice.

Hiroshige's portrayal of landscape scenery is simple, straightforward, and emotional. He had the knack of vividly bringing home to the mind of an onlooker the beauties of Nature which, though he might have seen for many years, he failed to appreciate. Hiroshige's art is so popular in conception, soft in symmetry, and so charming and enticing in effect, that one gets a feeling on studying his paintings as if one were sleeping in his mother's arms to the tune of a nursery song.

Even in the Ukiyoye prior to Hiroshige there are some who delineated independent landscape scenery. Among these may be mentioned "Ōmi Hakkei" by Kitao Seibi, "Noted Places in the Tōkaidō" by Toyohiro, and "Ōmi Hakkei" by Kiyonaga. The effects by these artists, while no doubt excellent in their way, lack the sincerity to penetrate deeper into the secrets of Nature as compared with the productions of Hiroshige. The "Noted Places in Yedo for Twelve Months," by Utamaro, may be said to be merely the product of imagination, and there are no traces of sincerity as landscape paintings. Hokusai, who was a contemporary of Hiroshige, may be described as a better and more serious landscape painter than Utamaro. Hokusai, however, resorted to too much art in his work, and cannot be considered as a simple, honest painter of Nature. Hiroshige himself pointed out this tendency in Hokusai's art in the preface to his "One Hundred Views of Fuji," published in the 6th year of Ansei.

In short, Hiroshige's painting may be said to be entirely free from artificial ornaments, and he effectually succeeded in resurrecting the earth lost owing to the peculiarly tantalizing civilization of Yedo. Quiet melancholy and serene loneliness are the predominant features of Hiroshige's paintings, but they are judiciously interspersed with light humour and sparkling wit.

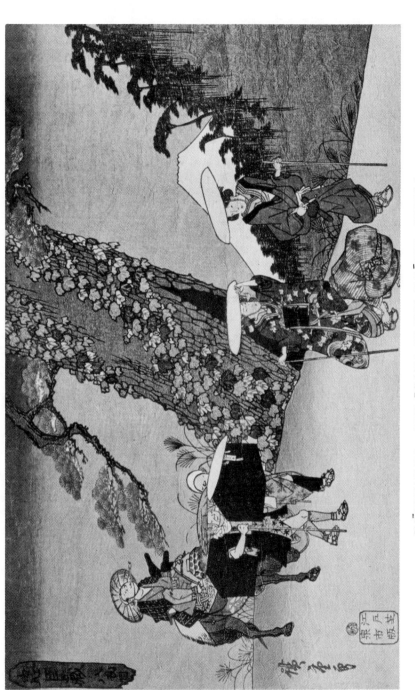

CHŪSHINGURA ; THE DRAMA OF THE 47 RŌNIN SCENE 8.

Publisher, Senichi.

(See color plate O.)

CATALOGUE

Note.—A complete catalogue of the prints signed Hiroshige would be an almost impossible task. They must number several thousands and are now scattered all over the world. The catalogue of the Memorial Exhibition consists of 233 titles, ranging from single prints to that of "The Hundred Views of Yedo" (120); and Messrs. Sotheby, Wilkinson and Hodge's sale catalogue of Mr. J. S. Happer's collection (compiled by himself) runs to 732 lots including a few books, original drawings and work by the pupils. The excellent catalogues of sales since held by Messrs. Sotheby, Wilkinson and Hodge constitute a most valuable series for reference, and, if collated, would cover much of the ground; and the various catalogues issued in Paris by MM. Vignier and Portier, in which Mr. Inada has had a share, must also be mentioned. The published catalogue of Japanese Prints in the British Museum (by Mr. Laurence Binyon) and the MS. catalogue of the collection in the Victoria and Albert Museum have the advantage that the student can refer to the actual prints; but neither of those collections, important as they are, can yet be said to be fully representative even of the artist's best work in its best condition.

In the following catalogue an endeavour has been made to indicate, in more or less detail, those series which may be expected to come into the hands of the average private collector; and to supply a basis on which a fuller and more detailed catalogue may yet be built. It does not pretend to be exhaustive or to include the many "states" which, with more or less justification, may be evolved by minute examination. Mr. S. Tuke, in a paper read before the Japan Society, and Mr. W. H. Edmunds, in the *Burlington Magazine* (vol. xl.), give good indications to the student who desires to pursue this line of research.

For the sake of convenience of reference, the Tōkaidō series of titles are printed together and also several other groups. The general series is believed to be approximately in chronological order.

TŌKAIDŌ GOJŪSAN TSUGI-NO UCHI

Fifty-three Stations on the Tōkaidō. A set of fifty-five (including prints for the starting-point at Yedo and arrival at Kyōto). *Publishers*, Senkakudō and Hoyeidō for the greater part of the 1st edition, which was finished by the Hoyeidō firm alone. The series was completed in the 1st month of Tempō 5 (1834) and then republished in book form by Takenouchi-Hoyeidō. *Engraver*, Jirobei; *Printer*, Heibei (see No. 36). Prints on crêpe paper are to be met with.

1. Nihon-bashi, Yedo. Asa-no Kei. The head of a daimyō's procession crossing the bridge, with two porters carrying red boxes, followed by two standard bearers. On left six street hawkers; two dogs to right. Sky with clouds. *Seals*, Ki-Kaku and Takenouchi.

1a. Gioretsu Furude. Another version with different blocks, chiefly in colour scheme of green, purple, black and red. Foreground filled with street hawkers,

women, children, etc., and two puppies near the centre. Buildings redrawn. No clouds. *Seal*, Take.

Prints have been noted also with three and two seals.

2. Shinagawa. Hinode. Dawn. A procession starting up the village street to right from the shores of the bay; six figures only—with two bowmen and two porters. Four ships with sails set, one under the bank and a group at anchor to left. *Seal*, Senkakudō, Hoyeidō.

2a. Another version. **Shoko Detachi.** Ten figures, including two with match-locks, in the procession. Boats at anchor varied, the mast of that under the bank rises above the nearest sailing-boat. *Seal*, Takenouchi. Another print has two seals.

2b. Another state of 2a, without the cloud block and with one seal only.

3. Kawasaki. Rokugō Tosen. A ferry-boat crosses the river and is awaited by a group of travellers and a pack-horse. To left a man is poling a timber-raft. Beyond clumps of trees is a village with thatched roofs; and Fuji is seen to right with bars of red cloud near its base. *Seals*, Senkakudō, Hoyeidō.

3a. Another version. The man on the raft has been removed and Fuji is in outline only and without key-block. The cottages in the centre are redrawn with tiled roofs and the centre figure in middle distance, near the shop, is altered. Two seals.

4. Kanagawa. Kure-no Kei. The village street rises steeply to left with a string of travellers, two of whom are accosted by women who try to drag them into the tea-houses. In the bay, a sailing boat at anchor, towards which goes a skiff with two men; also five small boats and in distance to right five boats sailing. Cloud in sky to left. *Seal*, Hoyeidō.

4a. Another version. Entirely redrawn, the roofs flatter; no skiff; cloud to right instead of left; posts at edge of water in foreground. *Seal*, Takenouchi.

5. Hodogaya. Shinkame Bashi. Travellers crossing, from right, a wooden bridge at the end of which are tea-houses and the village stretching to right. Beyond tree-clad hill; distant mountains to right. *Seal*, Senkakudō, Hoyeidō.

5a. Another state. The distant mountains to right omitted.

6. Totsuka. Motomachi Betsudō. At the veranda of a tea-house to the left a man dismounts from his horse, a maid-servant to left; a woman and coolie to right. In centre a milestone, *For Kamakura turn to left*. On right a porter arrives across a wooden bridge. Beyond the stream, houses, pine trees and a palisade. The sky printed with striations. Hill in distance to left. *Seal*, Tsuruki Takenouchi.

6a. Another version. Entirely redrawn. The man is now mounting; the front of the tea-house is boarded in and the hill beyond has gone. The houses are fewer in number, less varied and surrounded with clumps of bamboo. A low hill and pine-wood in middle distance, sky gradated only. *Seal*, Takenouchi.

7. Fujisawa. Yugyōji. The temple is on a hill in middle distance rising above the village. In the foreground a *torii* and near, three blind men facing a stream over which a bridge, left, leads back to the houses. *Seal*, Hoyeidō.

8. Hiratsuka. Nawate Michi. The Nawate Highway, with a few single pine trees, zigzags across rice-fields. Beyond a round-topped hill to left, craggy mountain to right and Fuji seen, white, between them. On the road a coolie running to right passes two travellers. *Seal*, Hoyeidō, Senkakudō.

9. Ōiso. Tora Ga Ame. The village is on left turning round the flank of a hill, among pine trees. To right the sea beyond a bank also fringed with pines. Travellers, one mounted, enter the village in heavy rain. Five beehives in foreground. *Seal*, Takenouchi.

10. Odawara. Sakawaga. Travellers fording the Sakawa River, in the middle o. which is a litter. Beyond rice-fields and mountains rising high to right; at their feet the castle. Two coolies only on the near bank, and the outlines of the distant hills sharp and abrupt. *Seal*, Hoyeidō.

10a. Another version. (? 1st state.) Two coolies and two travellers on the near bank. The distant mountain to right conical with a notch on its right side.

10b. Another version. Three coolies and two travellers on near bank. Distant hills rounded, one now appears behind the tree in middle distance and another on extreme left below the seal of the artist.

10c. Another version. Similar to 10b, except that distant mountains now have four main peaks instead of being rounded.

11. Hakone. Kosui. On the right of the lake is a group of wild and precipitous cliffs, that in the centre, of many colours. The heads of pilgrims are seen in the pass on its right. To left are foot-hills beyond the lake over which is the white peak of Fuji. *Seal*, Hoyeidō.

12. Mishima. Asakiri. Heavy morning mist. In centre, a group of travellers, one mounted and one in a litter, are passing the entrance to a Shintō temple. Other travellers, houses and trees dimly seen in the mist to right and in distance. *Seal*, Hoyeidō.

13. Numazu. Kikure. The full moon rising in the centre, over the village towards which three pilgrims pass along a road bordering the river, one with a grotesque mask distinctive of pilgrims to the Shintō Shrine of Kompira in the Province of Sanuki. On left bank of the stream, thick pine-woods. *Seal*, Hoyeidō.

14. Hara. Asa-no Fuji. Fuji rising from a group of lower peaks on the far side of rice-fields—its cone going above the upper line of the frame-line. In the foreground, two women and a porter pass along the road to left; two cranes stand in the rice-field. *Seal*, Takenouchi.

15. Yoshiwara. Hidari Fuji. A horse with three women in a balanced saddle and led by a man pass along the road, raised and edged with pine trees. To left the cone of the distant Fuji; to right, peaks of other mountains. *Seal*, Hoyeidō.

15a. Another version. Entirely redrawn. Title is now across the cone of Fuji and the larger seal is above the trees on left instead of below the signature as on 15. No signature.

16. Kambara. Yoru-no Yuki. The village occupies the middle distance ; to left a steep tree-clad slope ; beyond, trees and mountains, in the foreground the road slopes upwards to right with three peasants. All in heavy snow, which is still seen to fall against the dark background. *Seal*, Takenouchi.

An impression has been noted without the seal below signature ; the sky varies in different prints.

17. Yui. Satta Mine. On left steep crags with pine-trees and three travellers ; in centre the trunks of two pine trees cross above flat-topped rocks. Below and to right is the bay with four sailing-boats and beyond the white cone of Fuji flecked with grey on its lower slopes. *Seal*, Hoyeidō.

18. Okitsu. Okitsukawa. Two wrestlers crossing the stream, one in a litter and one mounted. To left rocks and pine trees ; in the distance is seen the sea with sails of boats, beyond pine trees in a marsh. *Seal*, Tsuruki Takenouchi.

Great variations of colour in different prints.

19. Yejiri. Miho Embo. In the foreground the roofs of houses, beyond which is the bay with two groups of boats, some with sails, low spits of tree-covered ground jutting out into the sea, and mountains to left in distance. *Seal*, Hoyeidō.

Variations of colour in different prints.

20. Fuchū. Abekawa. In right foreground women are carried across the ford ; to left coolies lead a pack-horse and others carry loads. Beyond the farther bank, great hills stretch away to the distance right and left. *Seal*, Hoyeidō.

21. Mariko. Meibutsu Chaya. The tea-house occupies the right foreground. Within, two travellers are having a meal, waited on by a woman with a baby on her back. Behind is a hill and on each side plum trees in blossom, that to left showing white against the graded pink of the sky. Another traveller walks away left. *Seal*, Tsuruki Takemago.

Many variations of colour.

21a. Another state. Without the horizontal lines of shading printed in green.

22. Okabe. Utsu-no Yama. A torrent rushes down the pass between over-hanging hills, that on the right with trunks of pine trees. On the path bordering the stream are peasants bearing bundles of wood, etc. *Seal*, Senkakudō.

Differences of colour have been noted, e.g., the left hill greenish yellow in one print, and olive green shading into brown in another.

23. Fujiyeda. Jinme Tsugitate. A group of coolies changing horses and packs outside the inn, on the platform of which, to right, is seated an attendant. *Seal*, Tsuruki Takemago.

24. Shimada. Ōigawa Shungan. A procession of travellers crossing the first arm of the ford of the river Ō-i from right to left. The chief retainers of the daimyō are waiting their turn on the shore of the near bank. *Seal*, Hoyeidō.

25. Kanaya. Ōigawa Engan. The travellers crossing the farther portion of the ford on the river Ō-i. A daimyō's litter is supported by a large group of coolies ; a light bridge is over the last arm of the river, and mountains fill the distance. *Seal*, Takenouchi.

26. Nissaka. Sayo-no Nakayama. The mountain path crosses the foreground and ascends steeply between pines to right. On it are travellers, some gazing at a great boulder " said to commemorate the murder of a woman whose ghost led to the discovery of the murder" (see p. 159). In the gap to left peaks of mountains. *Seal*, Tsuruki Takemago.

27. Kakegawa. Akiha-San Empo. To right Mount Akiha rises beyond rice-fields and mist. In the foreground a trestle-bridge on which travellers are saluting a priest who crosses from left. A kite is flown from left and another has broken loose. *Seal*, Hoyeidō.

27a. Varied printing. The water under the bridge is blue, with reflections ; the sunset glow is orange, and the mountain-top, grey.

28. Fukuroi. De Chaya. Wayside tea-house to left with travellers and maid boiling a large kettle over a fire the smoke of which shows blind tooling ; behind is a large tree; to right a signpost on which is a bird and roofs of a village ; in centre, rice-fields. *Seals*, Senkakudō, Hoyeidō.

29. Mitsuke. Tenryūgawa. On the near arm of the river, right, two ferry-boats are beached, one with two boatmen. On the far side of the sand bank, more ferry-boats with travellers. Beyond, tree-clad hills appear in the mist. *Seal*, Hoyeidō.

30. Hamamatsu. Fuyugare. In centre of foreground a group of peasants with a fire at the foot of the trunk of a huge tree. Beyond, rice-fields in snow and the village and castle to right. *Seal*, Hoyeidō.
Many variations of colour in different prints.

31. Maisaka. Imaki Shinkei. Imaki Point, a group of rugged peaks juts out from right to centre. Beyond it to right the white cone of Fuji. Around the rocky shore are small fishing-boats. To right in foreground the sails of three boats and stakes to left. *Seal*, Hoyeidō.

32. Arai. Tosen. A ferry-boat, with peasants crossing from left. In centre, a daimyō's boat, screened, with badges and crest. Beyond the water the village amid pines and mountain peaks in the distance to right. *Seal*, Takemago.

32a. Another state. The garment of the left boatman has a diaper pattern. Green generally substituted for purple in colour-scheme.

33. Shirasuka. Shiomi Zaka. The sea with sails is seen in the dip between two hill-sides each with pine trees, just below which appear the heads of badges of a daimyō procession. Below, the beach, with fishing nets drying and boats off the shore. *Seal*, Hoyeidō.

33a. Another state. The red printing omitted from fishing nets on beach and from faces in the procession.

34. Futakawa. Saru Ga Baba. To left a tea-house with sign, at which a traveller has just arrived ; three musicians in centre pass towards it. Beyond is a great slope, with young pine trees, and beyond are flat fields, dotted with pines. *Seal*, Hoyeidō.

35. Yoshida. Toyokawa Hashi. Toyokawa Castle to right, with scaffolding and painters at work. To left the trestle-bridge crosses the river to the village ; beyond, mountain peaks. *Seal*, Hoyeidō.

36. Goyu. Tabibito Tome Onna. The village street in the twilight. In centre, elderly maid-servants are struggling for possession of travellers. To left in an open tea-house, a traveller prepares to wash his feet. On its walls are the names of Jirobei, engraver; Heibei, printer; and Ichiryūsai, designer. On a large circle, that of Takenouchi, *han*, the publisher. *Seal*, Takenouchi.

36a. Another state. The name of Takenouchi omitted. Street printed throughout in green.

37. Akasaka. Ryosha Shofu. Interior of an inn. To left a guest reclines and a maid brings his meal on two stands—other servants are in waiting. To right two geisha arrange their toilet. In the centre of the courtyard, a large sago-palm and stone lantern. *Seal*, Hoyeidō.

38. Fujikawa. Bōbana. Villagers bowing down as the head of a daimyō procession reaches the entrance to the village. On either side of the road, walled bank with trees and bamboos. Below in centre, rice-fields. Sky with rich yellow clouds. *Seal*, Takemago.

38a. Varied printing. The sky deep purple.

39. Okazaki. Tenshin-no Hashi. A daimyō's procession crossing a trestle-bridge over the river from left to right. Beyond is the village, castle, a group of low hills and a mountain with rounded summit. *Seal*, Hoyeidō.

40. Chiriu. Shuku Uma Ichi. The horse-fair. Groups of horses tethered in long grass. In centre a tall tree with crowd of horse-dealers at its foot and a few buildings. *Seal*, Hoyeidō.

40a. Variation of printing. The grass is greenish-blue instead of apple-green.

40b. Addition to design of a whale-back hill.

41. Narumi. Meibutsu, Arimatsu Shibori. One side of the village street with two shops for selling stencilled fabrics for which the neighbouring village of Arimatsu was famous. Over the nearest is the cipher of Hiroshige. Along the road to right pass a woman in a litter with two women attendants, another woman riding a led horse, and a porter. *Seal*, Hoyeidō.

42. Miya. Atsuta Jinji. Two teams of men, each with one horse, hauling festival cars (not in the design) from right. To right part of a *torii* ; to left a building outside which are two fires, and people watching. *Seal*, Takenouchi.

43. Kuwana. Shichi-ri Watashi Guchi. Two sailing-boats, with sails partly lowered, entering the inlet on the farther side of which is Kuwana Castle. Other sailing-boats out at sea to right. *Seal*, Hoyeidō.

43a. Another state. Without the heavy shading on the waves in the foreground.

44. Yokkaichi. San Chō Kawa. A high wind blowing from right across the marsh. To left a peasant, cloaked, on a trestle-bridge ; another races along the causeway to catch his hat which has blown off. In centre a willow tree bending to the wind; left, roofs of cottages and masts of boats. The bow of a punt in the foreground. *Seal*, Hoyeidō.

45. Ishiyakushi. Ishiyakushi-ji. The village temple among trees at the foot of a hill. beyond which rise the rounded summits of another range. Porters pass along a causeway towards the left ; two more are working in rice-fields to right of the causeway. *Seal,* Hoyeidō.

> Mr. Happer notes that the blue hill in the background is missing in some prints.

46. Shōno. Haku-u. In driving wind and rain, three coolies with a litter mount the steep hill-side ; two more hurry downwards to right. On the umbrella of one of these are the characters *Takenouchi han* and *Gojūsan tsugi.* Beyond are the roofs of houses, bamboos bending to the wind, and the tops of two lines of trees dimly seen through the rain. *Seal,* Hoyeidō.

46a. Another state. The characters no longer appear on the umbrella. The colour varies in different impressions. In the later there is no green over the bamboos to right of the hill-side.

47. Kameyama. Yukihare. The whole scene is deep in snow, with steep hill-sides to right, snow-laden trees and a procession climbing up to the castle. Below is the village and a fine rose-coloured glow to left. *Seal,* Hoyeidō.

48. Seki. Honjin Hayatachi. The courtyard of an inn at which a daimyō is resting, screened with hangings bearing his crest. Lower, servants preparing to start, before dawn ; to left a group of them adjusting hats, etc. ; farther back, others receiving a samurai. On the lanterns held by one of these is Hiroshige's cipher.

49. Sakanoshita. Fude Sute Mine. To right a tea-house with guests on the edge of a precipice. Two visitors gazing across the chasm at the wild group of peaks, with waterfalls, opposite. Beyond, the double summit of another range.

50. Tsuchiyama. Haru-no Ame. A daimyō procession crossing a bridge over a torrent, in heavy rain, towards a village, left, screened by a row of trees. *Seal,* Hoyeidō.

51. Minakuchi. Meibutsu Kampyō. In the foreground, to left, two women are preparing sliced gourd (*kampyō*), a third has a baby on her back. In the centre is a tree and beyond is the village amid bamboos, with palisades on which sliced gourd is hanging. High mountains in background.

52. Ishibe. Meġawa Sato. To left a large inn, trees, decorations, etc., with groups of travellers starting along the road to right. Beyond, distant mountains rise above bars of mist. *Seal,* Hoyeidō.

> The printing of the mist and distant hills varies considerably.

53. Kusatsu. Meibutsu Tateba. A large tea-house with travellers eating rice-cakes which are being made under the veranda. In the foreground two litters, one open and the other closed, both carried by coolies. *Seal,* Takemago.

54. Ōtsu. Hashirii Chaya. Three bullock carts, one with bales of rice, the others with charcoal (?), come down the street from right to the tea-house on left, in front of which is a fountain with coolie filling buckets. In centre, pine trees rise above the bamboos, etc. A green hill faintly outlined in distance. *Seal,* Hoyeidō.

54a. Another state. The green hill no longer appears.

55. Kyōto. Sanjō Ōhashi. The long trestle-bridge, with people crossing, covers the foreground. Beyond, the city lies along the river bank at the foot of a range of many-peaked hills and, beyond, a mountain range. *Seal,* Hoyeidō.

Tōkaidō-no Uchi Enoshima-ji. (The way to Enoshima from the Tōkaidō.) Shichiraga Hama. The Shichi-ri Beach. The beach curves boldly round from left to right, and again to left past crags crowned with trees, towards the wooded island. Travellers scattered along the beach which skirts the spurs of low, wooded slopes. *Seal,* Takenouchi-Hoyeidō.

Note.—This print is thought to have been made as a supplement to the foregoing Tōkaidō Series; but it is more in the style of the Honchō Meisho. In the many other Tōkaidō Series Enoshima does not occur.

TŌKAIDŌ GOJŪSAN TSUGI

The 53 Stations of the Tōkaidō. A set of 55. *Publisher,* Yezakiya (Yetatsu). Known as the *Gyōsho* Tōkaidō from the style in which the title is written. Ōban Yokoye (7¾ by 12½ inches). A 2nd edition published by Yamadaya.

1. Nihon-bashi. A party with a *kago* on the bridge. In foreground to left a coolie carrying two tubs on a yoke, and a dog; to right, a group of four men. Foreground spotted with large stones.

1a. 2nd ed., three girls to left in foreground. (Yamadaya.)

2. Shinagawa. Tea-house with two travellers to left; woman and three upturned punts, right; boats in middle distance.

3. Kawasaki. Subject of First Tōkaidō (3), much varied. Two ferry-boats; Fuji in middle distance.

4. Kanagawa. Road in foreground with three travellers right, and two porters left ; two pine trees, centre. Village left, sailing-boats right.

5. Hodogaya. Bridge with three travellers crosses middle distance: tea-house with three lanterns, left.

6. Totsuka. Road with mounted traveller and woman in litter descends between slopes of hills, two pine trees right, one left. (2nd ed.)

7. Fujisawa. Road with travellers in foreground; bridge left; *torii* with tablet right; and milestone.

8. Hiratsuka. Road with pack-horse and three coolies halted on bank of stream : ferry-boat left ; Fuji, left of centre, rises above trees left, and peaks, right.

9. Ōiso. Five daimyō retainers with insignia on road in foreground; two old pine-trunks, and mountains beyond the sea.

10. Odawara. The ford is to left; pine trees on each side of road in right foreground; mountains occupy whole distance.

11. Hakone. Coolies pass to left along boulder-strewn road, between slopes of mountains; on right slope great boulders and four pine trees; below, milestone.

12. Mishima. The village seen in cup formed by tree-clad slope, right, and tea-house, left, peaks beyond. In centre, two samurai with umbrellas arrive.

13. Numazu. Silkworm culture house, left, with man changing trays; in foreground, three travelling musicians and boy, between two pine trees; peaks in distance.

14. Hara. Fuji rises above frame-line to left, beyond river and bars of mist; travellers pass along road in foreground, with trees, and two cottage-roofs, right.

15. Yoshiwara. Shop, right, with jars, peasant-hats, umbrellas, etc., two travellers standing, another seated drinks sake; Fuji rises left beyond flat ground and trees.

16. Kambara. Three pilgrims and a willow tree on road to left; Fuji rises in right centre beyond other peaks, mist and river.

17. Yui. Porters with packs and a litter cross to left, over trestle-bridges over a creek, towards a pine-clad hummock and the village.

18. Okitsu. The road is to right with travellers, one mounted, passing trunk of a great pine tree; the bay to left, with two sailing-boats in distance.

19. Yejiri. Snow. The road with travellers passes trees to village, left; rice-fields and trees, right.

20. Fuchū. On either side of the road a (?) rice-cake shop; pilgrims (one with the mark of the Kompira Shrine) and other travellers in road, centre; beyond, trees, fields and river.

21. Mariko. Tea-house with plum-blossom, hanging sign and two travellers and a waitress, to left; to right, roof of a house, with red and white plum-blossom.

22. Okabe. Tea-house at summit of the pass, with a seated traveller and waitress; coolies arrive from right. On the other side of the chasm, precipitous tree-clad slopes and peaks beyond.

23. Fujiyeda. Travellers crossing a stream; the village beyond to left, and mass of trees to right.

24. Shimada. A samurai with attendant, crossing a trestle-bridge, a peasant going the other way. Beyond, the river embankment, a stack of the rafts used by coolies; Fuji in middle distance beyond trees.

25. Kanaya. A daimyō procession carried across the river by coolies; to right a wrestler, seated on a litter, also crosses; beyond, green slopes, right, and peaks, left.

26. Nissaka. The ghost-stone is to left of centre foreground; two travellers to right of it; another in a litter, and a woman to left, behind the crossed trunks of two pine trees; beyond, the river and green hills.

27. Kakegawa. Road in foreground with travellers passes a *torii* with tablet; on either side a stone lantern and a pine tree.

28. Fukuroi. The road goes away from the centre, between pine trees and rice-fields; travellers coming and going.

29. Mitsuke. Two ferry-boats with passengers in foreground, a third in middle distance; beyond, green fields, trees and peaks.

30. Hamamatsu. Three peasants in foreground, one seated ; beyond, ancient pine trees on the shore, and sailing-boats at sea.

31. Maisaka. Two sailing-boats, one arriving with half-lowered sail, to left ; to right, three coolies with package on the shore. Beyond, to right, Imaki Point, with sailing-boats in distance to left.

32. Arai. Five country boats with grass roofs under sail. Beyond, a line of low peaks.

33. Shirasuka. The road winds steeply up the hill to right where a group of travellers are resting ; at foot of the slope a pine tree and standing figure ; three sailing-boats in distance, left.

34. Futakawa. The tea-house with two signs is in centre, with travellers sitting, standing and passing ; to right, two bushy trees ; beyond, right and left, green slopes with young pines.

35. Yoshida. Foreground, a bridge with four travellers ; beyond the river, Toyokawa Castle amid trees and to its left two mountains rise above the mist.

36. Goyu. The village street with travellers who are accosted by female servants from rival tea-houses ; left, a tea-house with two maids seated on a bench ; right, the roof of another tea-house.

37. Akasaka. Night scene, with full moon ; along the road, between three pine trees in centre, are travellers with lanterns, two running with dispatches ; beyond, a range of peaks.

38. Fujikawa. Travellers pass along the steep street, ridged with stones ; left, two shops with notices ; right, roofs of two houses.

39. Okazaki. The bridge crosses foreground from right to left, with travellers, a woman riding under an umbrella, etc., and a man with banner ; beyond, the castle to right, and mountains to left.

40. Chiriū. The road winds from left and turns sharply to right, between the trunks of two great pine trees, at the feet of which travellers are resting, two more lighting pipes.

41. Narumi. The textile shop to right with a customer, porters passing and three women to left.

42. Miya. A *torii* to left, and three travellers on the shore ; sailing-boats in centre and distance left ; right, trees on a green bank and three masts over them.

43. Kuwana. Composition resembling that of First Tōkaidō (43). A country boat lies up at the foot of steps leading to a *torii* right ; left, another puts out to sea with half-raised sail.

44. Yokkaichi. To left, a tea-house with hanging decorations (some with badge of Hiroshige) ; *torii* and lantern centre ; beyond which, to right, is a pack-horse with three riders.

45. Ishiyakushi. Snow scene ; travellers, one mounted on road in foreground ; to left, group of pine trees ; right, hills rise over roofs of houses. Great flakes of snow against dark ground.

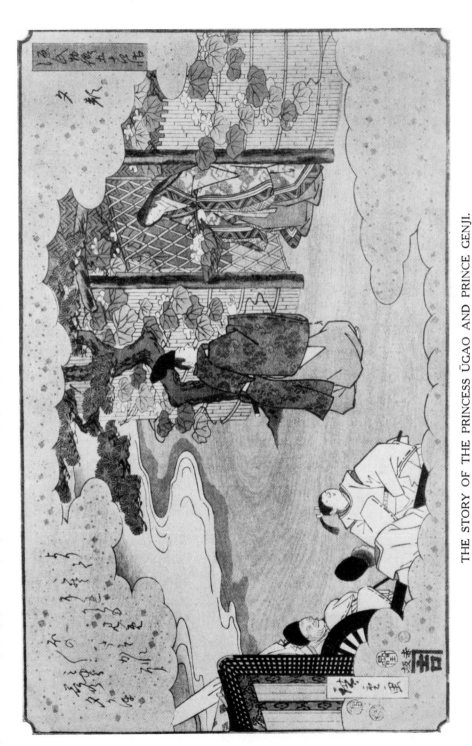

THE STORY OF THE PRINCESS ŪGAO AND PRINCE GENJI.

From "The 54 Scenes from the Story of Genji." *Publisher*, Isekane. *Date*, Rat Year, 1852.

46. Shōno. The barrier, left, with official examining papers ; right, a group of coolies with pack-horses.

47. Kameyama. Coolies with slung packages coming down the road from right between trunks of great pine trees ; left, distant hills with pine trees.

48. Seki. At the open front of the tea-house a traveller bathes his feet ; another is being received at the door ; an aged maid-servant accosts a passer-by.

49. Sakanoshita. Three travellers seated on two benches at the tea-house and admiring the view, another standing ; a servant brings two cups of tea on a tray ; left, peaks and waterfall seen above mist.

50. Tsuchiyama. Rain ; the head of a daimyō procession wading through a torrent ; right, a pine tree growing from a cleft in the rock ; left, mountain peaks.

51. Minakuchi. Cottage, left, with a man beating straw for hats, etc., a straw-worker inside, and trunks of two great pine trees near. In the street, to right, a group of travellers.

52. Ishibe. A group of travellers at the entrance to a palisaded wall ; in centre, a signpost and two pine trees.

53. Kusatsu. The road in foreground, with three travellers, one carrying an empty litter, also a pine tree, and cherry and plum trees in blossom ; beyond, the river and distant mountains.

54. Ōtsu. The tea-house, right, with travellers resting, baggage with *mon*, signboard, and decorations ; to left, sailing-boats and hills beyond.

55. Kyōto. Bridge in left foreground, with seven travellers, one bearing a straw crate on his head ; beyond the river, to right, is the city at the foot of wooded slopes.

TŌKAIDŌ GOJŪSAN TSUGI

The 53 Stations of the Tōkaidō. A set of 56 with title-page. *Publisher,* Sanoki. Chūban Yokoye. On each print is a comic poem (*kyōka*) ; hence known as the " Kyōka Tōkaidō."

Title-page. Design of chrysanthemum and *kiri* flowers on purple ground with title on square of blind-printed pattern and signature on tall, narrow panel, each with cloud-pattern in yellow and blue.

1. Nihon-bashi. The bridge with a daimyō procession runs across the foreground. To left, the outline of Fuji rises above red bars of mist.

2. Shinagawa. The village street, seen from above, is in the foreground ; beyond it, to right, a point with houses and trees juts out into the bay ; boats at anchor, left, and on the sky-line two sailing-boats.

3. Kawasaki. In foreground, to left, a shop and group of trees ; beyond is the river with ferry-boats and a sailing-boat in the centre ; in distance, trees above mist and houses, right.

4. Kanagawa. The road runs upward, to left, towards a tea-house and trees ; right, is a man with performing monkey near a shelter ; beyond, the sea with four sailing-boats, and headlands, right.

5. **Hodogaya.** In foreground, right, a tea-house with lanterns and coloured decorations; three great trees and hills beyond.

6. **Totsuka.** The road, with dispatch-runner, passes between green slopes with pine trees (three and four) on either side; beyond, in centre, the roofs of the village and distant hills.

7. **Fujisawa.** The *torii* and temple lantern are to left, on the farther bank of the stream, crossed by a small bridge, right, the village is in middle distance and beyond, to left, rise two mountain-peaks above the mist.

8. **Hiratsuka.** In the foreground, the river with two ferry-boats; left, the village with three trees; in the distance, right, the outline of Fuji.

9. **Ōiso.** The village is in foreground on a shore fringed with pine trees. On the farther bank, to right, stretches a chain of mountains.

10. **Odawara.** The road bends from right to left and again to right with three tall pine trees and four travellers in foreground. On the shore, beyond, fishermen are hauling in their nets.

11. **Hakone.** Night. The road, paved with great boulders, runs steeply upward to left, with two travellers in litters and men carrying great torches. On either side, rocks with scattered pine trees.

12. **Mishima.** Snow. A torrent, crossed by a bridge runs through the village, standing amid snow-laden trees. Beyond, in centre, the outline of Fuji.

13. **Numazu.** The road runs along the foreground; to right, a tea-house and trees. Beyond, rice-fields and mist above which rise rugged peaks, right, and Fuji with the dragon-cloud partly seen, to left.

14. **Hara.** The road in foreground with three houses and a group of tall trees. To right, beyond the rice-fields and mist, part of the group of peaks seen in No. 13; with Fuji encircled by the dragon-cloud in the centre, rising above the top of the panel (as in other views).

15. **Yoshiwara.** The road, with tall pine trees, goes away from the foreground to left; beyond, in left centre, is the outline of Fuji.

16. **Kambara.** The road with houses and a traveller in a litter passes between green slopes with, on the right, a great pine tree; other trees more distant and the snow-clad peak of Fuji beyond to right, with shaped clouds.

17. **Yui.** Travellers crossing the river by rude trestle-bridges joining up an island; beyond, to right, a round-topped hill with scattered pines and the village partly seen at its foot.

18. **Okitsu.** Ford over the river; in the foreground, to left, coolies are taking travellers upon their shoulders. Beyond, a group of round-topped wooded hills with rocky sides.

19. **Yejiri.** The road in foreground; to right, two great trees and a row of houses; to left, round-topped hills, with Fuji rising above clouds.

20. **Fuchū.** Moonlight, buildings to left, with closed screens; many persons of various sorts in the street, which leads to a palisade and gate with willow trees, right. Above is the full moon.

21. Mariko. The tea-house with travellers resting and refreshing is to right, one near a great tree, displaying colour-prints of actors and landscapes. To left, near a wall of masonry, is a pack-horse.

22. Okabe. The road passes between steep slopes with scattered pine trees; to right is a tea-house and beyond peaks of mountains seen against white clouds.

23. Fujiyeda. Travellers fording a stream; to right, an unused plank bridge. The village near the centre in a gap between dense woods.

24. Shimada. A daimyō procession crossing the river; in the foreground, to right, two great litters carried by many coolies. Beyond, low hills rise above the mist, and the outline of Fuji is seen far away towards the left.

25. Kanaya. Coolies gathered around a party of travellers on the bank of the river, with rafts and baggage. To left, a line of trees and above them, distant hills.

26. Nissaka. Coolies with slung baggage descending the pass. On either side steep green slopes, partly wooded, and four houses to right.

27. Kakeǧawa. The bridge, with pilgrims, crosses from the right, towards a *torii*, temple lantern, trees and roofs of buildings to left; to right, distant mountains.

28. Fukuroi. The road with five tall pine trees passes from left to right, to left is a small hut; the village, with woods beyond, is to right.

29. Mitsuke. The road descends between green slopes, with pine trees (one and two) on either side towards a ford. In the centre is a mounted traveller, and roofs of two houses to right in foreground.

30. Hamamatsu. Travellers pass along the road, in foreground; on the far side is a row of houses among trees; and, beyond, to right, the castle.

31. Maisaka. In the foreground, two country sailing-boats; beyond, a wall of mountain-peaks, with scattered pine trees, to right, below.

32. Arai. On the quay, to left, a curtained rest-house, with daimyō insignia in a rack, and a few pine trees; to right, a group of retainers have landed from a boat; sailing-boats and distant mountains to right on farther shore.

33. Shirasuka. The road passes to left from a shelter in the centre; on its right side is a row of old pine trees. Beyond, the sea and sailing-boats to right in the distance.

34. Futakawa. A rain-storm; travellers running for shelter towards a workman's shed to left; in centre, a tall pine tree; beyond, to left, wooded slopes of a hill; purple clouds above.

35. Yoshida. The bridge, with travellers, one mounted, crosses the left foreground towards the village. Beyond the river, with boats, the castle rises above trees, right.

36. Goyu. Three pairs of coolies, carrying slung baggage with decorations, cross a bridge towards the right. The village is to left, and in the centre a green mound with a group of willow trees.

37. Akasaka. On the road from the village, with pine trees on either side, a man leads a horse.

38. Fujikawa. Snow-scene, with falling snow. A horseman passes through deep snow towards the village on right. Trees on either side of the road.

39. Okazaki. The bridge crosses from left to right; below are a country boat and a timber-raft; the castle is on the farther bank to right, with a group of distant mountains in the centre.

40. Chiriū. To left, a group of tea-houses with bamboos behind them; the inhabitants making obeisance to a daimyō procession arriving from the right.

41. Narumi. The shops, displaying textiles, are left of the road; on the right in foreground is a green hill with a few pine trees.

42. Miya. On a quay, to right, a *torii*; to left, on other side of the entrance to the harbour, a part of the castle. Country boats are at anchor near the quay.

43. Kuwana. Shops on left side of street with hanging signs, etc.; in foreground, right, part of a roof and a group of travellers below.

44. Yokkaichi. The bridge, with pilgrims, runs from left towards the village amid blossoming plum and other trees, to right.

45. Ishiyakushi. A group of travellers with baggage-coolies halted outside an office for examination of passports, on left.

46. Shōno. In foreground, coolies running with a traveller in a litter; in centre, a clump of trees on a green mound. Beyond, rice-fields, the village and trees, and distant mountains; clouds in sky.

47. Kameyama. The road, with pilgrims and bordered with pine trees, leads up from centre of foreground to the gate of the castle, left; behind, the profile of a high peak.

48. Seki. The reception of a daimyō's procession at a tea-house, right, draped with curtains having his badge. In left foreground, two of his banner-bearers and two attendants with his robe-chests.

49. Sakanoshita. Travellers admiring the view from the edge of a cliff, with pine trees, left; on the far-side of the chasm, the group of peaks and waterfall.

50. Tsuchiyama. The head of the pass, with four cloaked travellers; left, a steep hill-side; right, a group of peaks with distant blue mountains in profile.

51. Minakuchi. The street, with travellers forcibly accosted by women attendants from the tea-houses on the far side of the road, with advertisements. Trees beyond the houses.

52. Ishibe. Interior of a tea-house, with red *prunus* in centre of garden-court; right, a visitor with attendants; left, two men in bath-room.

53. Kusatsu. On the far side of the street, shops with coolies resting and purchasing; in left foreground, part of a roof and trees.

54. Ōtsu. The quay-side, with houses, left, and boats at anchor; on the farther shore, distant mountains.

55. Kyō (to). The bridge goes back, in violent perspective, from the centre of the foreground, towards the city on the farther bank of the river; beyond is a wooded range, with a high mountain range in distance.

56. Kyō (to) Dairi. View of the palace at Kyōto, with Court nobles and attendants, left.

TŌKAIDŌ GOJŪSAN TSUGI

The 53 Stations of the Tōkaidō. A set of 54. *Publisher,* Tsutaya. Chūban Yokoye.

Note :—Shimada (24) and Kanaya (25) are combined in one scene. Late editions occur, printed in coarse, thick colour. The famous points of view are indicated by names on labels.

1. **Nihon-bashi.** Two litters borne by coolies, left; other porters and fire-ladder, right.

2. **Shinagawa.** Daimyō procession crossing the shore from left; boats anchored in the bay.

3. **Kawasaki.** Two loaded ferry-boats; people with umbrellas waiting on near bank, right.

4. **Kanagawa.** Four tea-houses with yellow roofs and two great pine trees, left; the sea to right.

5. **Hodogaya.** Travellers crossing bridge towards the left; two-branched tree in foreground.

6. **Totsuka.** Stream right; beyond it, the road with a litter and porter, willow and two pine trees; village to left.

7. **Fujisawa.** Village street with travellers; two trees in foreground, and stone pillars; right, tea-house with decorations.

8. **Hiratsuka.** Similar view to that in First Tōkaidō; rough shelter and travellers resting, right.

9. **Ōiso.** Coolies with litters and packs come along winding road on right; the bay to left.

10. **Odawara.** The ford in foreground; pines and mist in middle distance.

11. **Hakone.** Four travellers on boulder-strewn road in a gap in the pass; beyond, the sea and mountains.

12. **Mishima.** Three houses to left, with small trestle-bridge in foreground; beyond, pine-trees, cherry-blossom and the peak of Fuji.

13. **Numazu.** To right, a tea-house; centre, two pines, signpost, etc.; travellers and porters on the road. On the left, mountains seen above the mist slope upwards sharply.

14. **Hara.** Road with travellers in foreground; three pine trees, left; Fuji in snow, right centre, rises above the top line of design; around it a wreath of white cloud (dragon symbol).

15. **Yoshiwara.** Road with pedestrians bends sharply to left between three pine trees; Fuji to left; village to right.

16. **Kambara.** River with three boats and four men on near bank; beyond, mountains rise above mist, with Fuji to right.

17. **Yui.** Tea-houses at foot of a pine-clad cliff, to right; the sea with three boats, left.

18. **Okitsu.** Three aged pines, right; left, a led horse, with brushwood and mountains rising above the village on far side of the bay.

19. **Yejiri.** Four travellers caught on a bridge in heavy rain and wind; the village on farther bank, left.

20. **Fuchū.** Tea-house right; a group of trees in the centre, and beyond, the river and low hills.

21. **Mariko.** Snow. The village, among trees is in centre at foot of the left of two great hills.

22. **Okabe.** Travellers cross the pass in dip between steep slopes with pine trees; beyond, roofs of houses and distant mountains.

23. **Fujiyeda.** Travellers fording a stream; in right centre a large willow tree.

24. 25. **Shimada and Kanaya.** A procession of travellers fording the Ōigawa, of which the opposite banks are seen, rising to distant mountains.
 Note :—The inscriptions in bottom right corner (Shimada) and top left corner (Kanaya) indicate that this scene covers two of the usual Views.

26. **Nissaka.** The mountain path ascends to left; on it is the famous boulder, with a group of travellers and two great pines. Distant mountains, right.

27. **Kakegawa.** To left, a *torii* and temple lantern, with five travellers on the road. Rice-fields and distant mountains seen beyond three great pines.

28. **Fukuroi.** Road in foreground with travellers cooking, etc.; rice-fields and distant mountains seen beyond one large and two small pine trees in centre.

29. **Mitsuke.** In foreground the river with three ferry-boats being punted; beyond, wooded banks.

30. **Hamamatsu.** Travellers making a fire by the road-side; beyond, the sea seen through pine trees.

31. **Maisaka.** Imaki Point to right; eight sailing and two small boats are shown.

32. **Arai.** Three country sailing-boats in foreground; others in distance to right; to left, distant mountains.

33. **Shirasuka.** The sea is seen in the dip between two hills with pines, similar to the view in First Tōkaidō but with a few travellers on the road instead of the daimyō procession.

34. **Futakawa.** The village in foreground; to left, a tea-house with tall pine tree; hills with scattered pines rise beyond rice-fields.

35. **Yoshida.** The bridge crosses the river from left to right; on the far bank, to left, is the castle.

36. **Goyu.** Night scene; a corner of the village street with women trying to draw travellers into their tea-houses.

37. **Akasaka.** Night scene with crescent moon; travellers with lanterns on the road.

38. **Fujikawa.** The village of thatched houses slopes up the hill to left; the road is stepped with large stones; to right, a high hill.

39. **Okazaki.** The bridge crosses in middle distance; to left, women washing on the bank with big umbrellas.

40. **Chiriŭ.** The horse-fair. Groups of horses in long grass with dealers, stalls, etc. To left, the trunks of two tall willows; three more on slope of hill to right.

41. **Narumi.** A row of shops in background; the road, with travellers, bends round from right to left.

42. **Miya.** A *torii* to left, beyond it the angle of a castle; road with travellers in foreground; country boats, right.

43. **Kuwana.** Two sailing-boats, with sails partly lowered, entering the inlet; the castle to right; in foreground, two men and a woman near the upright of a *torii*.

44. **Yokkaichi.** In centre, a *torii*, two temple-lanterns and two pine trees; buildings on either side.

45. **Ishiyakushi.** The walled entrance to a village, with houses seen in centre through the opening; in foreground, the trunk of a tall tree, signposts, etc.

46. **Shōno.** Coolies with baggage resting; to right, an office with officials examining papers.

47. **Kameyama.** View from above of inn buildings with curtain having a daimyō badge, and a procession starting. To right, a party of samurai being received by the host near foot of tall tree.

48. **Seki.** In centre, a group of trees on a hillock; beyond is the road with a daimyō procession.

49. **Sakanoshita.** The rest-house with travellers admiring the view is in the foreground; beyond, the hills and waterfall occupy the centre of the distance.

50. **Tsuchiyama.** Driving rain; the torrent is crossed by a trestle-bridge, with three travellers. Beyond, in centre, a rounded hill with pines.

51. **Minakuchi.** Large two-story inn seen from the garden, with palm, lantern, ornamental stones, etc.

52. **Ishibe.** To left, the inn as in first series but with only one tree. In right foreground, roofs of cottages and plum-blossom.

53. **Kusatsu.** Travellers wading across a winding stream; the village in middle distance; trees on sky-line right and left.

54. **Ōtsu.** Coolies with baggage on the quay-side; to right, a lighthouse; country boats in the bay and distant mountains beyond the town on the farther bank.

55. **Kyōto.** The bridge crosses from left to right in foreground; beyond, the town stands at foot of wooded slopes and distant mountains in centre, with a flight of birds.

[TŌKAIDŌ] GOJŪSAN TSUGI MEISHO DZUYE

The 53 Famous Views. A set of 55. *Publisher,* Tsutaya. *Seal date,* Hare Year (1855). Numbered plates. Ōban Tateye. Also, printed from the same blocks, an edition on crêpe paper.

1. **Nihon-bashi.** The bridge in middle distance; beyond it a row of nine ends of buildings in white; Fuji on sky-line, left. In foreground, a street seen in a break of conventional cloud.

1a. Another state. Without shading on the peak of Fuji.

2. Shinagawa. The town on shore of the bay, seen from edge of a cliff with pine and cherry trees. Outside the harbour breakwater a row of boats at anchor, right.

3. Kawasaki. In the foreground, a country boat and timber raft on the river; to right, a trestle-bridge. Beyond the far wooded bank are banks of mist above which is the snow-streaked cone of Fuji.

4. Kanagawa. A tea-house balcony, with lanterns, right, overlooks the bay with country boats; the full moon above.

5. Hodogaya. In foreground, tea-houses with lanterns and coolies resting; in centre, rice-fields between ranges of low hills with a few tall pine trees.

6. Totsuka. In foreground, three peasants working in rice-field in dip between rocky slopes. The road with pine trees in centre; beyond it, right, the snow-clad peak of Fuji seen through trees.

7. Fujisawa. In foreground, the road with travellers and tall pine trees; beyond, left, the peak of Fuji rises over the trees.

8. Hiratsuka. The foreground almost bare with three pines to right, ferry-boats on the river in middle distance; beyond, the village and trees, left, with the peak of Fuji rising to left of a green ridge.

9. Ōiso. A hill-side with pines and memorial-stones; below, to left, a small shrine; beyond, the bay and a range of mountains.

9a. Another state without the brown printing on the shrine and left roof in foreground.

10. Odawara. In foreground, roofs of houses, three pine trees and two rows of fishermen hauling on ropes of a net. Beyond, the sea with sailing-boats and mountains, right.

11. Hakone. Night. To right, a steep road with stone wall, rows of stones, three pine trees and coolies, two of whom carry torches, overhangs a torrent; on the far side, a mountain with three pines in silhouette.

12. Mishima. The *torii* with a single pine tree to left; to right, a row of shops, etc., with passers-by.

13. Numazu. Snow; the stream is crossed by two trestle-bridges, on one of which are two travellers. The outline of Fuji to left.

14. Hara. In the foreground, the road with travellers and village, left; beyond the fields and low hills with scattered pines, the cone of Fuji rises above the top of the panel.

15. Yoshiwara. In foreground, fishermen in boats on edge of a marsh, with a group of pines in centre, and flight of birds; above rises the peak of Fuji.
Note :—In some prints the striations on Fuji are in blue instead of grey.

16. Kambara. A tea-house on either side of the head of a steep road with travellers arriving; below, the river with boats. On the far bank a green hill with scattered pines.

17. Yui. The road winds steeply up-hill to left; in foreground are the crossed trees appearing in the First Tōkaidō scene. Below to right, the bay with rocks and surf; Fuji, snow-clad, seen through the trees on the cliff.

18. Okitsu. Coolies carrying travellers and baggage across the river; on the far bank, tree-clad cliffs, the village to left, and wooded mountains beyond.

19. Yejiri. In foreground, two nets drying and two punts on the beach; beyond is the river with boats, and above, in distance, to left, Fuji rises above the clouds.

20. Fuchū. Night scene. The gate of a group of buildings, with left, a mounted traveller. In the distance a range of hills above banks of mist, and the crescent moon.

21. Mariko. On the left a tea-house with travellers refreshing; also colour-prints hung up of two actors, the Nihon-bashi, Fuji and another. To right, other shops, etc. Travellers, one mounted, pass along the road above a tall tree on which rises a green hill with scattered pines.

22. Okabe. A few travellers pass up the gorge to a small rest-house in centre. On either side, on the heights, are three pine trees; and beyond, a round-topped mountain rises above clouds.

23. Fujiyeda. Travellers fording the river, on the right bank of which are two willow trees.

24. Shimada. A daimyō procession fording the river; in the foreground, a rough plank bridge; in distance, wooded hills and mountains rising above them.

25. Kanaya. The ford seen from the top of a steep road with tree-clad banks on either side, and a mounted traveller ascending. In the far distance, the white cone of Fuji.

26. Nissaka. The road, bordered with trees, ascends steeply towards the right from a tea-house on left in foreground. Beyond the chasm to left of the road is a high range of mountains. The famous stone does not appear.

27. Kakegawa. Travellers fording the river in two places; on a mound to right in the bend, a group of trees; on the farther bank, cliffs with wooded summits. Beyond, in distance, a round-topped mountain.

28. Fukuroi. Peasants at work in rice-fields, with three pine trees and distant village and hills. Two men on road to right fly a large kite and another is also in the air.

29. Mitsuke. Pine trees, travellers and a tea-house in foreground; beyond, the river with islands and boats, and mountains in the distance.

30. Hamamatsu. The famous old pine tree to right on the shore, with surf; to right, a daimyō with attendants viewing it.

31. Maisaka. The rocky promontory is on the right of the upper part of the design; sailing-ships and small boats below it; and a line of posts across the bottom right corner of the panel.

32. Arai. The village and temple overlooking the sea, seen from the green hills above; a line of boats stretches across to the far shore, where Fuji rises above the nearer mountains.

33. Shirasuka. The road climbs to the right with travellers and scattered pine trees. Below to left is the beach, with boats, nets, etc., and distant mountains on the sky-line beyond the sea.

34. Futakawa. To left of the road, in foreground, are two shops with signs inscribed. Large trees in centre. Behind rises a green hill with scattered pines and distant mountains.

35. Yoshida. The bridge, with head of a daimyō procession crosses the foreground ; beyond is the river with boats, a belt of pines, and the castle and distant mountains rising above mist.

36. Goyu. The river winds past willow trees ; in foreground, three travellers and two children fishing. Beyond, mountains with pine trees at summits, and Fuji seen above in the centre.

37. Akasaka. The road, with signposts and tall pine trees, winds through rice-fields to the village on right. In foreground a man is beating a lad with a stick. Above is the crescent moon.

38. Fujikawa. Snow scene, with falling snow. The village and stream are in middle distance. In foreground, a large tree and a peasant with straw coat standing near and travellers descending. In the distance, the white form of hills, without outlines.

39. Okazaki. The bridge goes across the panel from upper left to right. In foreground, below, a man is washing down a horse on the near bank. Beyond, woods and distant mountains ; the castle to right.

40. Chiriū. Two ancient and distorted pine trees, with travellers by the wayside ; to right, a marsh.

41. Narumi. To left, a tall rack with dyed cloths hung up to dry ; and beyond, a large pine tree. The village, with shops on the far side of the road, to right.

42. Miya. The right part of a tall *torii*, in foreground to left. In centre, a group of men and women on the quay, with boats beyond.

43. Kuwana. A large country sailing-boat with a group of passengers in centre ; near it a small fishing-boat. The castle on shore to right.

44. Yokkaichi. Trestle-bridge, with coolies, in foreground ; the village to left. Beyond, pine trees and the masts of shipping, and the sea with a group of sailing-boats and birds.

45. Ishiyakushi. In foreground, a stream draining from rice-fields ; to left, a tall cherry tree in blossom ; to right, two peasants, *torii*, etc. ; the village and hills in middle distance.

46. Shōno. Coolies with baggage decorated for a festival on the road ; beyond, three great pine trees, rice-fields and distant hills.

47. Kameyama. A thunderstorm, heavy clouds, rain and lightning, peasants on the steep road, edged with pine trees and leading to the castle.
Note :—Remarkable attempt to produce effect of lightning with white lining to cloud.

48. Seki. The road with buildings on either side runs from left to right, on edge of a precipice, with *torii* temple lanterns and steps downward. In distance double-peaked mountain-top, birds, and sky with zigzag clouds printed.
Note :—Rare attempt at printed clouds.

49. Sakanoshita. The road, right, leads up to a cave in which three Buddhas are seen ; in centre is the torrent—a succession of waterfalls, with steep cliffs and scattered pine trees on either side.

50. Tsuchiyama. A samurai with three women and three banner-bearers on the near bank of a rocky stream ; beyond which is a little shrine in a pine wood and hill with clouds over-printed.

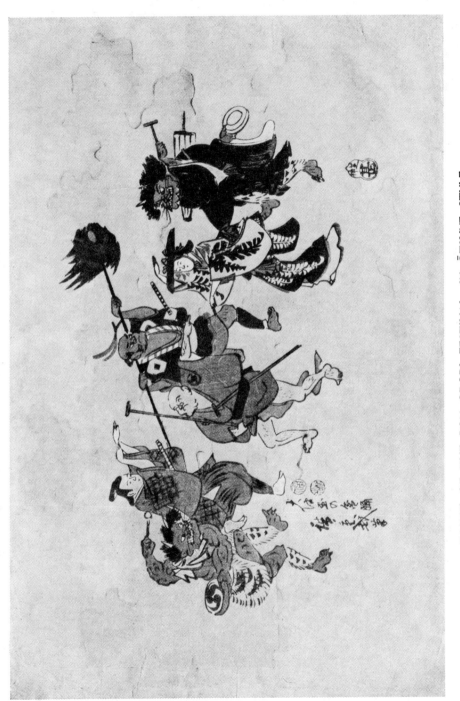

DANCE OF THE BON ODORI FESTIVAL, IN ŌTSUYE STYLE.
Signed, "Hiroshige Gi Hitsu" (humorous drawing). *Publisher,* Marujin.

51. Minakuchi. Peasants, a pilgrim, etc., on road to right of a small stream, with trees on each bank; to right, huts; beyond, high hills.

52. Ishibe. The two-story tea-house, with guests, etc.; in the garden to left, a stone lantern.

53. Kusatsu. In foreground, six country sailing-boats near the piers of the harbour; in the distance, other sailing-boats and a range of mountains, with castle, right.

54. Ōtsu. The terrace of a temple, with cherry trees in blossom and eaves of the building, left; in distance, Fuji rises beyond the water with sailing-boats, and low hills.

55. Kyōto. The bridge crosses the foreground; in middle distance a great bank of pink mist partly obscures the city on the farther bank; above it is a green hill with trees.

OTHER TŌKAIDŌ SERIES

Marusei Tōkaidō. A set of 55. *Publisher*, Marusei. Ōban Yokoye.

Note :—As it has not been found possible to have access to a complete series, details are not given. A considerable number are described in the British Museum catalogue. Titles are in red frames, with plate-number and sub-title in black; the title being written in *reishō* character; hence the set is also known as the "Reishō Tōkaidō."

Hayashi Tōkaidō. Six of a set (unfinished). *Publisher*, Hayashi-shō. Ōban Yokoye.

Note :—Title also in *reishō* character. The following subjects only are known—Nihon-bashi (1), Shinagawa (2), Kawasaki (3), Fujisawa (7), Ōiso (9) and Hakone (11).

Fujikei Tōkaidō. About three-fourths of a set (unfinished). *Publisher*, Fujikei. Ōban Tateye. Figures and landscapes.

Muraichi Tōkaidō. A set of 56. *Publisher*, Muraichi (1852). Chūban Tateye.

Tōkaidō Gojūsan Tsugi Saiken Dzuye. Views of the Tōkaidō with humorous figures. About 11 of a set (unfinished). *Publisher*, Muratetsu. Ōban Tateye.

Aritaya Tōkaidō. A set of 56. *Publisher*, Aritaya. Four scenes on each of 14 sheets.

Yamashō Tōkaidō. A set of 56. *Publisher*, Yamashō. Eight scenes on each of 7 sheets.

Jōkin (miniature) Tōkaidō. A set of 60. *Publisher*, Jōkin. Twenty scenes on each of 3 sheets.

Note :—In order to complete the sheets, views of Kamakura, Kanazawa and Enoshima are inserted after Totsuka (6) and 2 of the Eight Views of Ōmi after Kusatsu (53).

The Harimaze (cut-up) Tōkaidō series are catalogued under that heading on page 187.

SŌ-HITSU GOJŪSAN TSUGI

The 53 Stations of the Tōkaidō by two brushes (i.e. Hiroshige and Kunisada). *Publisher*, Maruya Kishirō; *Seal*, Kochōrō Toyokuni (Kunisada); *Engraver*, Yokogawa Take. Plates sealed: Tiger, 7, 8, 12 (1854). Hare, 4, 8 (1855). Snake, 4 (1857). Published in 1857.

1. **Nihon-bashi.** Boy playing with toy.
2. **Shinagawa.** Jōro at her toilet.
3. **Kawasaki.** Straw-braid curio maker.
4. **Kanagawa.** Spearman.
5. **Hodogaya.** Ise Mairi—boy pilgrim.
6. **Totsuka.** Hotel maidservant.
7. **Fujisawa.** Terute-hime leading her husband Oguri to Kumano Spring, to cure poisoning by robbers.
8. **Hiratsuka.** Hotel maidservant.
9. **Ōiso.** Soga-no Jūrō and Toragōzen (geisha), " Soga Brothers' Vendetta," time of Yoritomo.
10. **Odawara.** Yumoto hot springs.
11. **Hakone.** Crippled Katsugoro and his wife Hatsuhana searching for their enemy. (Ashikaga period.)
12. **Mishima.** Mishima no-o-sen (a female brave).
13. **Numazu.** Igagoye—Jūbei and father Heisaku.
14. **Hara.** Shirozake (sweet white sake) seller.
15. **Yoshiwara.** Saigyō Hōshi. Priest of period of Yoritomo.
16. **Kambara.** Tourist and inn maidservant.
17. **Yui.** Miyagino and Shinobu taught fencing by the famous master Yiu to avenge their father's death.
18. **Okitsu.** Amma.
19. **Yejiri.** Hagoromo.
20. **Fuchū.** Picking tea-leaves.
21. **Mariko.** Dumpling seller.
22. **Okabe.** Okabe no Rokuyata—one of Yoshitsune's braves.
23. **Fujiyeda.** Crossing the River Ōi.
24. **Shimada.** Traveller.
25. **Kanaya.** " Asagao Nikki "—Asagao in search of her lover.
26. **Nissaka.** Umegaye begging to help her lover, Kagesuye, of Yoritomo's army.
27. **Kakegawa.** Country children.
28. **Fukuroi.** Pilgrims.
29. **Mitsuke.** Tenryugawa Ferry.

30. **Hamamatsu.** Riding.
31. **Maisaka.** Blind minstrel woman.
32. **Arai.** Fortune-teller.
33. **Shirasuka.** Jiraiya—robber-chief.
34. **Futakawa.** Ghost.
35. **Yoshida.** Oran-no-kata—"immoral lady."
36. **Goyu.** Yamamoto Kansuke and Naoye Yamashiro-no Kami (counsellors of war of 350 years ago.)
37. **Akasaka.** Manzai, after Itcho.
38. **Fujikawa.** Tourist.
39. **Okazaki.** Jōrurihime and Ushiwaka trysting secretly.
40. **Chiriū.** Narihira travelling to the East.
41. **Narumi.** Drama. Tanyemon.
42. **Miya.** Kagekiyo, Yoritomo's assassin.
43. **Kuwana.** Otohime (Princess of the Dragon Palace) and Urashima.
44. **Yokkaichi.** Drama; Norikyō.
45. **Ishiyakushi.** Benkei ordered by Yoritomo to behead Yoshitsune's wife, slew his daughter instead—"Horikawa Youchi."
46. **Shōno.** Travellers.
47. **Kameyama.** Akahori Midzuyemon, the villain of a vendetta story.
48. **Seki.** Semi-maru (blind biwa-player).
49. **Sakanoshita.** Akogi-no Heiji and Jirozō, from the play *Akogi ga ura*.
50. **Tsuchiyama.** Gompachi escaping from the prison *kago*.
51. **Minakuchi.** Nunobiki, from the play *Seisuiki*.
52. **Ishibe.** Ohan (15 years) and Chōyemon (over 40) loved and died together.
53. **Kusatsu.** Sasaki and Tanimura—characters in a play.
54. **Ōtsu.** Kuronushi.
55. **Kyōto.** Muromachi Shogun.

TŌKAIDŌ GOJŪSAN TSUGI HODOGAYA

The traditions and historical characters associated with the Stations of the Tōkaidō. A set of 57. By Hiroshige, Kunisada (*signed* Toyokuni) and Kuniyoshi. *Publishers*, Ibasen, Ibakiū and others. Ōban Tateye.

1. **Nihon-bashi.** Geisha of the fish market.

2. **Shinagawa.** Story of Hirai Gompachi and Komurasaki at Suzuga mori. Gompachi murdered travellers for their money.

3. **Kawasaki.** Nitta Yoshioki advancing to Yedo with his victorious army is treacherously waylaid and drowned at Yaguchi-no Watashi.

4. Kanagawa. Urashima-Zuka. Mound to commemorate the adventures of Urashima Taro, the Japanese Rip Van Winkle. Picture represents girl fishing. No connexion with the story.

5. Hodogaya. Shinozuka Hachirō telling the story of the death of Nitta Yoshioki to Yura Hyōgo and his wife, followers of Ashikaga.

6. Totsuka. (H.) Goten-jō-chū (daimyō maid) admiring scenery. With Fuji, etc.

7. Fujisawa. Oguri Kōjirō, paralysed by poison given by an enemy—taken by his faithful wife Terute-hime, bathes and is cured in the Kumano Gongen (shrine) waterfall.

8. Hiratsuka. (H.) Formerly the river was known as Sagamigawa, but in 9th year of Kenkyū—12th month, Minamoto-no Yoritomo attended a festival here. His horse, scared by a thunderstorm, ran into the river and was drowned, and the river's name was thereafter Banyū.

9. Ōiso. Soga-no Jurō, while bent on avenging his father's death, stayed in the house where his enemy was being entertained, and became enamoured of an *oiran*—Tora. After the execution of Soga, Tora became a nun—dying at 71 years of age.

10. Odawara. Yoritomo (Minamoto) when a youth was in exile at Izu. He fell in love with the daughter of Ito the Governor, and courted her secretly. The father tried to kill him, but he escaped.

11. Hakone. After eighteen years of waiting and hardship, Soga-no Gorō and his brother took vengeance on Kudo Suketsune for their father's murder.

12. Mishima. (H.) Festival of the Temple to Oyama zumi-no Mikoto (erected Tenkyō 10) on January 6th. Dancers carry farming tools and kitchen utensils.

13. Numazu. Poem has a punning play on words :—" Travellers here make a long stay and it is just as hard for them to move on as if they were in a swamp."

14. Hara. (H). Taketori, cutting bamboos, found a fairy child who grew to be a beautiful woman courted even by the Emperor. Finally she disappeared, leaving behind her a letter of thanks and a magic powder which would make the old man immortal. He, however, mourned her loss, and not wishing to live without her, threw the medicine on Fuji and burnt it. To this day there is a crater emitting smoke,—hence " Fuji " is sometimes written *Fu shi*—" no death."

15. Yoshiwara. Divided by the Fujikawa were encamped the rival hosts of Heike and Genji. The water birds at night made such a noise that the Heike host fled, thinking themselves attacked by a stronger force.

16. Kambara. Here died Jōruri-hime, who for love of Yoshitsune followed him until worn out. Ōtsu—another girl—wrote a life of Jōruri in twelve volumes and set it to music—thus reviving music. The girl in the picture is studying the life of Jōruri-hime.

17. Yui. Noted for view of Fuji, also for the Awabi shell gatherers.

18. Okitsu. On the coast here is the celebrated Tago-no ura (beach), the subject of a poem by Yamabe-no Akahito.

19. Yejiri. (H.) Noted for Hagoromo-no Matsu, the pine on which an angel left her feather coat. It was taken by a peasant, and in order to regain her coat, the angel became his wife—until she was able to get her coat and fly away. Fuji in distance.

20. Fuchū. (H). Noted for tea-picking. The river is the Abegawa.

21. Mariko. (H.) Tegoshi—eastern part of Mariko, is where Taira-no Shigehira, a captive on his way to Kamakura, was entertained by Yoritomo, a daughter of the chief officer of Tegoshi. Senju-no Mae sang and danced before Shigehira. After Shigehira was executed at Kamakura she took the veil at Zenkōji.

22. Okabe. Here is a large cat-shaped rock among the pine trees. The legend is that an old wild cat lived here, who in the form of an old woman did evil to travellers. At death it turned to stone.

23. Fujiyeda. Kumugai Jirō became pious under Hōnen Shōnin and took the (priest) name of Renshō Hōshi. Once stopping for a night at this place, he borrowed *ichi kan mon* (ten sen), promising to pay on his way back to the capital, and repeated a prayer of blessing ten times, upon which ten lotus-blooms appeared in the pond. When, returning, he paid his debt, the flowers shrivelled and died. Afterwards he made the place a temple.

24. Shimada. Crossing the Ōi River.

25. Kanaya. (H.) The Ōigawa. Poem. " Even the girls of Shimada on arriving here write home of their safe crossing the river."

26. Nissaka. A samurai left home, going East (to Yedo). His wife, impatient for his return, went out to meet him on the lonely mountain path, where a robber assaulted and then killed her. Dying, she gave birth to a child. Kwannon (whom the mother devoutly worshipped) cared for the child, and the ghost-mother nourished it. The husband on his return, anxious for his wife, heard the child crying, and was thus led to it, and the mother's ghost related to him all that had befallen her. A stone commemorating this event is called the—Yo-naki-ishi—" Night Crying Stone."

27. Kakegawa. Here lived a famous smith Shimosaka-no Kaji (smith), so-called because when forging a sword for the Emperor, and cooling it in the river, a piece of straw floating with the current on reaching the blade floated against the current— hence the name *Shimo* (down) *saka* (contrary), a name then given to the sword and taken by the smith. This sword became the property of the Aoye family. Once it was stolen, and Fukuoka Mitsugi learnt from a letter where the sword was.

28. Fukuroi. Here Hōnen Shōnin saw in a dream a beautiful woman clad in scales, who said she had drowned herself and had been turned into a dragon in the Sakura-ga-ike, but her life was one of torment because of the little worms in between the scales, and besought his prayers for her relief. The priest did as requested, and soon after a dragon appeared on the surface with its scales all removed and a smooth skin.

29. Mitsuke. (H.) Yoritomo wishing to know the length of life of cranes, set many cranes free at this place, with date tags on their legs. Long were they seen, even to this day they say ! Mitsuke means " finding out." A group of peasants attacked by a tortoise : a parody on the story.

30. Hamamatsu. Taira-no Shigemori, stopping here on his way to Kamakura as a captive, was entertained with song and dance by a daughter of Kumano, who was in love with Munemori Shigemori's brother.

31. Maisaka. A captain watching the sky at night.

32. Arai. Traveller at an inn writing his diary. A famous poem refers to this place—" Mist hiding the view of the bridge and pine trees."

33. Shirasuka. (H.) Yoritomo always stopped here on his journeys, and geisha amused him. Among them was one especially favoured by him, who, on his death, became a nun.

34. Futakawa. (H.) Hizakurige; Kitahachi and Yaji at the inn at Futakawa frightened by clothes taken for a ghost. (Story of the humorous adventures of two travellers on the Tōkaidō.)

35. Yoshida. Noted for the jorōya; a jorō soliciting a samurai.

36. Goyu. Yamamoto Kansuke with his wife lived in retirement here, studying military tactics. A powerful daimyō, Takeda Shingen, came here and besought his services as adviser. After twice refusing he accepted.

37. Akasaka. (H.) Dajō Daijin Fujiwara Moronaga was in exile here. He was a famous biwa player; wandering at Miyaji Yama, admiring the maples, the goddess of water appeared to him as a mark of appreciation of his genius.

38. Fujikawa. Fujikawa Mizuyemon killed Isogai Heidayu, taking the precious sword called *Naga Mitsu*, and fled. Heidayu's son tried to take vengeance, but losing his sight was killed by Mizuyemon. Another son finally took vengeance.

39. Okazaki. (H.) At Yahagimura, near here, is the tomb of Jōruri-hime, daughter of the chief officer of the *mura* (district), with whom Ushiwaka (Yoshitsune), stopping here on his way North, fell in love. After his departure she followed him —dying at Kambara.

40. Chiriū. Ariwara-no Narihira composed at Yatsuhashi the famous poem " Kakit-subata."

41. Narumi. Women making *Narumi shibori* (a variegated dyed cloth), for which Arimatsu, in this province, is celebrated.

42. Miya. A woman named Fuji, whose husband was away in Ōshu, died of grief at his absence. On the husband's return he went to a priest, who gave him incense, and whenever he burnt it he could see his wife.

43. Kuwana. A sailor named Jūzō for many years never sailed on the 31st December. Once he had to sail on that day, when a great storm arose, and a huge monster appeared and asked Jūzō if he was afraid. Jūzō said " No," and the monster disappeared.

44. Yokkaichi. Oft-times in summer the opposite shore appears in a mirage. The natives call it the procession of Daijingu at Isé, going to visit the god at Atsuta.

45. Ishiyakushi. In the woods opposite the town is a cherry tree called Yoshitsune Sakasa Zakura (inverted cherry). Once Noriyori (brother of Yoshitsune) passing here, and calling to mind that near here was the birthplace of the noted horse Ikezuki, planted his horse-whip, which grew into a large cherry tree.

46. Shōno. This was the birthplace of the horse Ikezuki, which was presented by an officer of this place to Shōgun Yoritomo, in obedience to a vision of Kwannon. It was then given to Sasaki, and on it Sasaki was the first to cross the Ujikawa at that famous battle.

47. Kameyama. (H.) Gennojō on a mission of vengeance left his wife here. One night she dreamed that Gennojō returned in fine array. The next day came news of Gennojō's death at the hands of the murderer of his father. She then became a nun.

48. Seki. (H.) An *oiran* of Takasu asking Ikku Oshō for instruction.

49. Sakanoshita. (H.) A younger brother of Tenchi Tennō, desiring to escape military service in the Otomo war, stayed here, and was given the beautiful daughter of the old man with whom he stayed. After the young prince became Tennō a shrine, Suzuka, was erected for the worship of the old man.

50. Tsuchiyama. Abe-no Takamaru of Ōshu rebelled against the Emperor Kanmu. Tamura Shōgun, at the Emperor's command, and by the aid of Kwannon, killed Takamaru. Later, at Suzukayama, near here, he put down a band of robbers, believed by the people to be devils (*oni-no kami*). The picture shows Tamura guided by the goddess to the sleeping robber chief.

51. Minakuchi. At Takashima, near here, lived a strong girl named Ōiko. Her farms were deprived of water by her neighbours, but she dammed up a stream with an enormous stone which all the farmers could not remove. On apologizing to her, she easily removed the stone.

52. Ishibe. A jorō at her morning toilet. There is a saying that a man, though *ishibe* (strict and rigid as a stone), will be led astray by a woman, if she but have the opportunity.

53. Kusatsu. At Seta-no Kurahashi, near here, a dragon in the shape of a woman appeared to Hidesato, beseeching him to kill a monstrous serpent on Mt. Mikami. This he did, and was afterwards feasted at the dragon's home (*ryūgu*) and given handsome presents.

54. Ōtsu. (H.) Matahei lived here. So lifelike were his paintings that they actually came to life. The picture shows his wife amazed at his paintings, in Ōtsuye style ; and an actor with two brushes.

55. Kyōto. (H.) Sanjō-no Ōhashi—the busiest part of the city.

Note :—Some texts are not explanatory. They are *Kyōka* (*kyō* = crazy, *ka* = poem), a form of verse to which Hiroshige was very partial. The prints by Hiroshige are marked (H.).

KISOKAIDŌ ROKUJŪ TSUGI, BY HIROSHIGE AND YEISEN

The 69 Stations of the Kisokaidō (road). A set of 70. *Publisher* (1st edition), Takenouchi-Hoyeidō (first part) and with Kinjudō (completion) ; later editions (Kinjudō). *Engraved* by Matsushima Fusajirō ; *Printers*, Surikō Matsumura Yasugorō *and* Onajiku Kameta Ichitarō (*see* No. 34). Ōban Yokoye. No censor's seals.

1. Nihon-bashi. (Yeisen.) Early morning after snow. The rising sun is dimly seen through clouds. To right, three coolies push a heavily laden vehicle over the

bridge. In centre of foreground on an umbrella is the name of the publisher, Reiganjima Takenouchi. To left, fish-hawkers and snow-covered roofs stretching away into the distance. *Signed*, Keisai Yeisen. Plate number " 1."

1a. A later state. Without the rising sun. The umbrella inscribed " Ikenaka Iseri " (for Ikenohata-Nakachō, the address of the publisher, Iseri Kinjudō), and Sheep Year with number (? Go Sen). On another umbrella is the publisher's mark. Without artist's signature. *Seals*, Takenouchi, Hoyeidō.

Note :—Sheep Year may be 1835 or 1847. The editors of the Memorial Catalogue assume it to be the former ; but, as this is not a first edition and the name of the artist is omitted, it seems more likely to be 1847.

1b. Another state. With " Nakabashi Yamashō-ban " on the umbrella.

Note :—The Memorial Catalogue states that " more than three " revisions exist.

2. Itabashi. (Yeisen.) Travellers on the road at the entrance to a village. To right, a smith is shoeing a horse. In centre, a stone with inscription. The village to left. Unsigned. *Seal*, Hoyeidō. Publisher's mark on the horse's pack, and plate number " 2."

Note :—Probably 2nd edition ; but the 1st has not been seen.

3. Warabi. (Yeisen.) The ferry over the Toda River with passengers and a horse. Above, a flight of cranes. To left, other passengers waiting on the river bank. Unsigned. *Seal*, Hoyei[dō], and plate number " 3."

Note :—Probably 2nd edition.

4. Urawa. (Yeisen.) At the bend in the road is a man with pack-horse going left and another man and a porter going towards the village to right. To left is the smoking peak of Mount Asama. Unsigned. *Seal*, Hoyeidō, and plate number "4."

Note :—Probably 2nd edition.

5. Ōmiya. (Yeisen.) Travellers pass along the road, in the foreground, with cherry trees in blossom. To left is a memorial stone with inscription, " Under a shelter." Beyond are rice-fields with Fuji seen in the distance. Unsigned. *Seals*, Hoyeidō (Takenouchi), and plate number " 5."

Note :—Probably 2nd edition.

6. Ageo. (Yeisen.) To left is a rest-house with white and red signboards ; in front, peasants are winnowing rice. *Seal*, Takenouchi, and plate number " 6."

Note :—The inscriptions are as follows :—1st to right, Iseri (publisher) ; 2nd, Kamo Dai Miōjin (name of temple) ; 3rd, Iseri ; 4th, Kamo, etc. ; 5th, *Seal*, Kiwame ; 6th, Iseri.

7. Okegawa. (Yeisen.) To left, a peasant's cottage, in which the man is lighting his pipe. Outside his wife, who is husking rice, looks up at a traveller who asks the way. To right, a man on horseback looks out over the rice-fields. Unsigned. *Seal*, Hoyeidō, and plate number " 7."

Note :—Probably 2nd edition.

8. Kōnosu. (Yeisen.) Fuki-age (erupted Fuji). Travellers pass along the zigzag path from left to right. In the background, Fuji rises white above bars of mist, against a blue sky. *Signed*, Keisai gwa. *Seal*, Hoyeidō, and plate number " 8."

8a. Another state. Without signature. *Seals*, Hoyeidō, Takenouchi.

9. Kumagaya. (Yeisen.) The road, banked high, winds down from the right to a rest-house in left foreground, near which is a horse with publisher's mark of Kinjudō on pack, and a litter in the road. Near the house is a lantern with advertisement of Ankoro (sweetmeats) and Udon (macaroni). Unsigned. *Seal,* Hoyeidō, and plate number " 9."

Note :—Probably 2nd edition.

10. Fukaya. (Yeisen.) A group of girls, outside a tea-house with lantern at night, the one to left holding a lantern. To right are other people seen only in silhouette. Unsigned. *Seal,* Hoyeidō. On lantern—Take (for Takenouchi). Plate number " 10."

Note :—Probably 2nd edition.

10a. A later impression. With less contrast in light and shadow.

10b. Third edition. No distinction of light and shadow. Mr. Happer says, " The houses in the distance do not appear."

11. Honjō. (Yeisen.) Crossing the Shinryū River. The near arm of the river is crossed from right to left by a trestle-bridge over which goes the procession of a daimyō. At its near end is a stone lantern. The village is on the farther shore of the second arm of the river on which are ferry-boats. Beyond is a range of mountains in three groups, brilliantly coloured and with over-printing. Unsigned. No seals except plate number " 11."

Note :—Probably 2nd edition.

12. Shinmachi. (Hiroshige.) The narrow and shallow river winds from left to right with a bridge on which are two travellers. In centre, the bank crowned with a group of pines. To left on farther bank, a coolie with packs and two other travellers; beyond, the blue peaks of a range of mountains seen against a golden glow with purple and orange clouds in the sky. *Signed,* Hiroshige. *Seal,* Ichiryūsai, Kinjudō, and plate number " 12."

12a. Without the clouds in upper left corner or the seal Ichiryūsai.

13. Kuragano. (Yeisen.) The Torigawa River. In the centre, a group of children playing near a sluice. To right, a woman washing pots, watched by another on a veranda under an awning. On the farther bank, the village right; and a group of green hills left. *Signed,* Yeisen. *Seal,* Takenouchi, Hoyeidō, and plate number " 13."

13a. Another edition, without signature.

13b. Another edition, without clouds to right of sky and with pattern of lines on woman's kimono and extra work on trees in background.

13c. Another edition, without signature or seals.

14. Takasaki. (Hiroshige.) The village, on left bank of the Karasu River, is in centre. Beyond is a group of lofty mountains in blue. In foreground, a small rest-house, left; and two beggars, one with a fan, accosting two travellers on the highway. *Signed,* Hiroshige. *Seals,* Ichiryūsai, Hoyeidō, and plate number " 14."

14a. Later edition. The flesh of one traveller and of the two beggars from the same block as the picnic set, seen between the screens of the rest-house.

15. Itahana. (Yeisen.) Deep snow. The road runs along the farther bank of a torrent, with weather-beaten pines on either side, and travellers in snow-covered cloaks passing to and fro. Unsigned. *Seals*, Iseri, and plate number " 15."

Note :—Mr. Happer notes that the title is " in Hiroshige's script," using the character *Kai* instead of the more correct *Gai*.

Probably 2nd edition.

16. Annaka. (Hiroshige.) The pass, with head of a daimyō's procession, rises steeply towards the left, with rest-houses, three on the left side and one to right. A steep bank with budding plumtrees goes away upwards to right. *Signed*, Hiroshige. *Seals*, Ichiryūsai, Kinjudō, and plate number " 16."

Note :—In late prints, the colour on the hills is not graded.

17. Matsuida. (Hiroshige.) The road, with travellers, winds steeply upwards to right. Near the crest is a wayside shrine with votive flags, between two great pine trees. To left, a hill, with two pines, rises sharply, and in the gap are seen the peak of Myōgi-san. *Signed*, Hiroshige. *Seals*, Ichiryūsai, Kinjudō, and plate number " 17."

18. Sakamoto. (Yeisen.) The village, through the street of which runs a stream crossed with planks, is at the foot of a great round-topped hill. Sunset glow and distant mountains to left. Unsigned. *Seal*, Iseri, and plate number " 18."

Note :—In his note to Lot 419 (Sale Cat.) Mr. Happer was disposed, with some reserve, to attribute this to Hiroshige. It is now generally given to Yeisen.

Probably 2nd edition.

19. Karuizawa. (Hiroshige.) Night with two fires of burning weeds. At one in the road, near the foot of a tree, a traveller stoops to light his pipe, while another, mounted, gets a light from the pipe of his companion on foot. Beyond to right is the village with rice-fields and mountains in distance to left. *Signed*, Hiroshige. *Seal*, Tōkaidō, Takenouchi, and plate number " 19."

The lantern is inscribed Iseri and the girth has the mark of Kinjudō.

Note :—Mr. Happer draws attention to the seal " similar in sound to the name of the series which brought him fame." The *Dō* means " halt " instead of " road " or " highway," a punning adaptation.

19a. Later edition. Without the seal of Takenouchi.

Note :—Later prints vary in colour and in contrast of light and shade.

20. Kutsukake. (Yeisen.) Pack-oxen and travellers caught in a driving storm of wind and rain. *Signed*, Yeisen. *Seals*, Hoyeidō, Takenouchi, and plate number " 20."

20a. Another edition. Without signature or Hoyeidō seal.

20b. Later edition. Without signature, seals, or number.

21. Oiwake. (Yeisen.) Mount Fuji in warm brown streaked with red with sparse trees and deep clefts. At its feet a pack train toils upward to the left. On the horse-trappings are the marks of the publishers, Takenouchi and Kinjudō. *Signed*, Keisai gwa. *Seal*, Takenouchi, and plate number " 21."

21a. Another state. With additional block of heavy rain, and unsigned. Illustrated in B.S. Miller Sale Catalogue, Plate XIII.

Note :—Mr. Happer considers this to be the first state, but the absence of the signature suggests that it is later, as in the British Museum Catalogue.

21b. Another state. Unsigned and with heavy streaks on Fuji, and no rain.

21c. Another state. The block washed to imitate rain but not printed in lines; the trees re-worked in dark masses. *Seals*, Kiwame, Take.

22. Odai. (Hiroshige.) Four pilgrims, one with a banner, near a winding stream amid autumn grasses (*susuki*) and a young maple tree. To left a range of mountains rises above the mist. *Signed*, Hiroshige. *Seal*, Ichiryūsai, Kinjudō, and plate number " 22."

23. Iwamurata. (Yeisen.) A group of blind masseurs fighting. To left, one seated at foot of a tree; to right, a dog, howling; mountains in the distance. *Signed*, Keisai. *Seal*, Takenouchi, and plate number " 23."

23a. Another state. Unsigned, the mountains, stream, etc., blue.

23b. Another state. Unsigned, without the blue block.

24. Shionada. (Hiroshige.) A rest-house, with a group of coolies, near a large tree to left. In foreground, three coolies go towards it; beyond is the river and distant mountains under a deep orange glow. *Signed*, Hiroshige. *Seals*, Ichiryūsai, Kinjudō, and plate number " 24."

24a. Another state. With pale yellow only on sky and rest-house, the coolie in rain-cloak, etc., banks of river light grey and no green in tree.

25. Yawata. (Hiroshige.) Early morning, peasants crossing a stream by a foot-bridge. The stream winds to left and then backward, with grey bamboos on its bank. In centre, a thatched shelter and mountains in distance to right (blue) and left (grey). *Signed*, Hiroshige. *Seals*, Utagawa, Kinjudō, and plate number " 25."

26. Mochizuki. (Hiroshige.) Moonlight; the road with travellers stretches upwards to left, bordered with great pine trees, through the branches of which is seen the full moon. To right, the tops of trees in a ravine and mountains beyond. *Signed*, Hiroshige. *Seals*, Ichiryūsai, Kinjudō, and plate number " 26."

26a. Another state. The trees printed in light and dark red.

27. Ashida. (Hiroshige.) The road, with travellers and bordered with bushy-topped trees, is seen in an abrupt dip of a green hill, to left. Beyond are mountains, sharply drawn in flat planes. *Signed*, Hiroshige. *Seals*, Ichiryūsai, Kinjudō, and plate number " 27."

27a. Another state. Deeper colour and without the seal, Ichiryūsai.

28. Nagakubo. (Hiroshige.) The full moon on the river, with travellers crossing a trestle-bridge and mountains looming through the mist beyond. On the near bank, children playing with dogs and a man leading a horse, on the cloth of which is the publisher's mark, a great tree and a house with bamboos to right. *Signed*, Hiroshige. *Seals*, Ichiryūsai, Kinjudō, and plate number " 28."

28a. Another state. The distant mountains are not seen to right of the central tree.

28b. Another state. The mountain range does not appear.

Note :—This print, in Mr. Oscar C. Raphael's collection, is in such fine condition and so sharply printed as to go far to justify the assumption that it is the first state. It is unusual for a block to be added and difficult to see a reason for it in this instance. On the other hand, the wear of the block shown as between 28 and 28a might have

given a reason for cutting the worn part away altogether. There are, however, no signs of wear in Mr. Raphael's print, and the order in which editions are here placed is given with all reserve.

29. **Wada.** (Hiroshige.) The road with travellers is seen between steep, snow-covered slopes and peaks with some green foliage. *Signed*, Hiroshige. *Seals*, Ichiryūsai, Kinjudō, and plate number " 29."
Note :—The highest pass on the road, 5,300 ft.

30. **Shimosuwa.** (Hiroshige.) The rest-house on Lake Suwa, where there are hot springs. To right, a party of travellers at a meal, with screen patterned with the publisher's mark. To left, a man in a bath. *Signed*, Hiroshige. *Seals*, Ichiryūsai, Kinjudō, and plate number " 30."

31. **Shyojiri.** (Yeisen.) Lake Suwa, frozen and crossed by travellers. To right, the road rises steeply upwards. On the farther shore are snow-covered mountains with Fuji in the distance. On horse-cloth, the mark of the publisher, " Take." *Signed*, Yeisen. *Seals*, Takenouchi, Hoyeidō, and plate number " 31."

31a. Another state. Unsigned and with mark of Kinjudō on horse-cloth.

32. **Seba.** (Hiroshige.) The full moon seen through the budding branches of willows on the bank of a stream, on which one man is punting a flat-bottomed boat and another a timber-raft. Blue sky with remains of sunset glow. *Signed*, Hiroshige. *Seals*, Ichiryūsai, Kinjudō, and plate number " 32."

32a. Another state. Without the tree on the horizon behind the roofs, etc.

33. **Motoyama.** (Hiroshige.) A great pine tree has fallen across the road and is supported with trestles ; beneath it sit two sawyers, near a fire. *Signed*, Hiroshige. *Seals*, Ichiryūsai, Kinjudō, and plate number " 33."
Note :—Later editions have the tree in red instead of brown.

34. **Niekawa.** (Hiroshige.) An inn with travellers refreshing and resting. In front a coolie unloads a horse, on the cloth of which is the number of the plate, " 34." The inn-signs bear the inscriptions as given below. *Signed*, Hiroshige. *Seals*, Ichiryūsai, Kinjudō.

Inscriptions on the signs of the inns :—1, Hanmoto Iseri (publisher), twice ; 2, Dai kichi ri ichi (prosperous shop brings good luck) ; 3, Senjoko, Kyōbashi, Sakamoto (scent advertisement) ; 4, Matsushima Fusajirō tō (name of engraver) ; 5, Suriko Matsumura Yasugorō (name of printer) ; 6, Onajiku Kameta Ichitarō (name of printer).
Note:—This is the only case in this series where a name of engraver or printer is given.

35. **Narai** (Yeisen.) The shop at the foot of the Torii Pass where are sold *Oroku Kushi* (boxwood combs invented by a woman called Oroku). Outside is a group of coolies and to left, distant mountains seen across the ravine. *Signed*, Yeisen. *Seals*, Takenouchi, Hoyeidō, and plate number " 35."

35a. Another state. Unsigned.

36. **Yabuhara** (Yeisen.) The Torii Pass, with two travellers resting and admiring the view, and two women carrying firewood. To left a pine tree, well, and inscribed stone. Across the ravine are the peaks of a group of mountains. *Signed*, Yeisen. *Seal*, Hoyeidō, and plate number " 36."

36a. Another state. Unsigned.

37. Miyanokoshi. (Hiroshige.) The river bank with trees seen in silhouette through the mist, under a full moon. In the foreground to left, a peasant family cross a plank bridge. *Signed*, Hiroshige. *Seals*, Ichiryūsai, Kinjudō and plate number " 37."

37a. Another state. The trees to left, and posts of the bridge in green instead of grey, and the upper outline of the bank behind the family is not seen.

38. Fukushima. (Hiroshige.) The entrance to the town between high fenced walls at night. Through the gate is seen the guard-house, with publisher's mark on the curtain. Travellers come and go. *Signed*, Hiroshige. *Seals*, Ichiryūsai, Kinjudō, and plate number " 38."

In margin, combined *Seal*, Kiwame, Take ; Kinjudō, *Seal*.

39. Agematsu. (Hiroshige.) The waterfall to left comes away in a torrent over which is a trestle-bridge with two travellers and a peasant with firewood. To right curious rocks are seen against an orange sky. *Signed*, Hiroshige. *Seals*, Utagawa, Kinjudō, and plate number " 39."

39a. Another state. Without the grey over-printing on the rocks to right.

40. Suhara. (Hiroshige.) A rain-storm. Coolies rush for shelter to a hut near trees, right. A mounted traveller and one on foot are seen in silhouette to left. *Signed*, Hiroshige. *Seals*, Ichiryūsai, Kinjudō, and plate number " 40."

41. Nojiri Inagawa Bridge. (Yeisen.) The high-pitched bridge with masonry piers spans a torrent between precipitous banks. To left is a steep flight of steps leading to a shrine, and blue peaks beyond. *Signed*, Keisai. *Seals*, Takenouchi, Hoyeidō, and plate number " 41."

41a. Another state. Unsigned ; the mountain to left of shrine is grey and has only one peak.
Note :—Later editions have differences in colour.

42. Mitono. (Hiroshige.) In the foreground, peasants in *susuki* grass. To right, a path winds upwards to two *torii*, with cherry-blossom beyond. Village roofs to left. *Signed*, Hiroshige. *Seals*, Ichiryūsai, Kinjudō, and plate number " 42."

43. Tsumakome. (Hiroshige.) The road with travellers passes between sharply defined successive slopes. The second hill on the right is crowned with trees. To left, a high peak. *Signed*, Hiroshige. *Seals*, Ichiryūsai, Kinjudō, and plate number " 43."

44. Magome. (Yeisen.) The road with three travellers winds sharply to left, on the side of a steep cliff with waterfall and trees, where is a peasant riding on an ox. In the distance is a range of mountains with " wrinkles " finely drawn, high above the roofs of the village. *Signed*, Yeisen. *Seals*, Takemago (Takenouchi Magome), Hoyeidō, and plate number " 44."

44a. Another state. Unsigned. The " wrinkles " no longer appear on the mountains, which only extend, on the right, to the first tree. A double-peaked mountain in blue has been introduced right.

45. Ochiai. (Hiroshige.) A daimyō procession straggles down from the village, past a range of low, green, wooded hills, to cross a stream in foreground. In the distance a range of blue hills. *Signed*, Hiroshige. *Seals*, Ichiryūsai, Kinjudō, and plate number " 45."

46. Nakatsugawa. (Hiroshige.) The road, with travellers, crosses a little stream in foreground, and winds back, through rice-fields, to the village at foot of a hill, beyond which are peaks of distant mountains. To left, two willow trees. *Signed,* Hiroshige. *Seals,* Ichiryūsai, Kinjudō, and plate number " 46."

47. Ōi. (Hiroshige.) Heavy falling snow, through which a group of travellers make their way. On either side, the trunk of a great pine tree ; beyond, the summits of snow-covered hills. *Signed,* Hiroshige. *Seals,* Ichiryūsai, Kinjudō, and plate number " 47."

Note :—The sky is sometimes blue as above, or grey as in other impressions seen.

48. Ōkute. (Hiroshige.) Two wood-cutters ascending the pass. To left jagged rocks protrude from the hill-side on which are a few pines standing up against the evening glow. Beyond, a low green hill with mountain ranges in the distance. *Signed,* Hiroshige. *Seals,* Ichiryūsai, Kinjudō, and plate number " 48."

49. Hosokute. (Hiroshige.) The road rises upwards steeply under the trunks of two great pines, leaning towards each other. Below is the village, and in the distance many mountain peaks. *Signed,* Hiroshige. *Seals,* Ichiryūsai, Kinjudō, and plate number " 49."

50. Mitake. (Hiroshige.) A tea-house with inscribed sign, at the head of the pass, with travellers resting, and one tying his shoe ; left, a woman washing at a stream. In the distance to right, the outline of the mountain Komagatake. *Signed,* Hiroshige. *Seals,* Ichiryūsai, Kinjudō, and plate number " 50."

Inscription on the Lantern, *Go-shintō* (Temple-lantern) and *Mitake Yama* (name of place). On the *Shōji, Kichinyado* (poor man's inn).

51. Fushimi. (Hiroshige.) The road runs along the foreground, with travellers including two retainers of a daimyō with insignia, strolling musicians, etc. In the centre is the trunk of a great pine tree, with other travellers resting and eating at its feet. Beyond rice-fields are distant mountains and pines. *Signed,* Hiroshige. *Seal,* Kinjudō, and plate number " 51."

52. Ōta. (Hiroshige.) On the near bank of the river travellers wait for the ferry, which is in mid-stream. To left, three pine trees ; to right, on far bank, hills and trees above a bank of mist. Sky pink with sunset glow. *Signed,* Hiroshige. *Seals,* Ichiryūsai, Kinjudō, and plate number " 52."

53. Unuma. (Yeisen.) The Castle of Unuma is to right overlooking the Kiso River. On the far side, a range of mountains, with rice-fields in middle distance. Unsigned. *Seal,* Hoyeidō, and plate number " 53."

Note :—Probably 2nd edition. A later edition has rice-fields in dark instead of light green, and distant hills in reddish-brown instead of grey.

54. Kanō. (Hiroshige.) A daimyō procession coming from the Castle of Nagai Hizen-no Kami (right), with peasants making obeisance. On the far side of the road, rice-fields and scattered pines. *Signed,* Hiroshige. *Seal,* Kinjudō, and plate number " 54."

55. Kōdo. (Yeisen.) Fishing by night with cormorants on the Nagara River. In the foreground the boat, with a flare, has two fishermen, one holding strings of five cormorants (four only seen), the other about to fill his pipe. Other boats, tree-clad

slopes and mountains in the distance. *Signed*, Yeisen. *Seal*, Hoyeidō, and plate number " 55."

55a. Another state. Without signature or seal. The water printed without gradation.

55b. Another state. Without signature or seal. Water partially gradated. Outlines have disappeared from distant hills, which appear as if printed from one block.

56. Myeji. (Hiroshige.) On the right a traveller asks the way from a farmer who is going home from work ; near is a bamboo grove and two trees of wild camellias in bloom. The village is in the distance to left, beyond the river and low-lying ground. *Signed*, Hiroshige. *Seals*, Ichiryūsai, Kinjudō, and plate number " 56."

57. Akasaka. (Hiroshige.) To right, an arched bridge, with travellers, over the River Ai ; beyond is the village seen through budding trees. *Signed*, Hiroshige. *Seal*, Kinjudō, and plate number " 57."

58. Tarui. (Hiroshige.) Rain ; the head of a daimyō procession emerges from an avenue of pines. On either side of the road is a colour-print shop, that to left with the mark of the publisher Kinjudō on the shutter. Outside each, villagers are making obeisance. *Signed*, Hiroshige. *Seals*, Ichiryūsai, Kinjudō, and number of plate " 58."

Note :—The prints shown in the shops include both figure subjects and landscapes. Among the latter a view of Fuji is in that on the right.

59. Sekigahara. (Hiroshige.) To right, a tea-house with a maid waiting on two guests ; another has just dismounted outside. The road bends back between three trees, with another tea-house farther on to left. *Signed*, Hiroshige. *Seals*, Tokai, Kinjudō, and plate number " 59."

60. Imasu. (Hiroshige.) To left, the road is bordered with shops for hats, sandals, etc., with signs and a signpost. To right is a tree near the corner of another house. The road dips sharply in centre, with view of distant plain and hills. *Signed*, Hiroshige. *Seals*, Ichiryūsai, Kinjudō, and plate number " 60."

61. Kashiwabara. (Hiroshige.) The tea-house Kame-ya—" The House of the Tortoise "—with visitors, a grotesque, big-headed, seated figure, miniature mountain, view of the garden and picture of Benkei. In front, two coolies with letters have halted. *Signed*, Hiroshige. *Seal*, Kinjudō, and plate number " 61."

62. Samegai. (Hiroshige.) In the centre is a great tree, near which are two daimyō retainers ; on their backs is the mark of the publisher. To right the hill-side rises, with a seated traveller at foot of the slope ; to left is the village with trees and distant mountains. *Signed*, Hiroshige. *Seals*, Ichiryūsai, Kinjudō, and plate number " 62."

63. Banba. (Hiroshige.) The entrance to the village street which bends to right between shops and tea-houses—one with the mark of the publisher. Near a stone wall to left stands a group of coolies with horses. In the distance a high green hill. *Signed*, Hiroshige. *Seal*, Kinjudō, and plate number " 63."

64. Toriimoto. (Hiroshige.) To left, on the steep side of a hill near the top of the Suribari Pass, a tea-house with travellers resting, and a few pines. To right, the roof of another building. From the terrace is a view of the river, lake and distant mountains. *Signed*, Hiroshige. *Seals*, Ichiryūsai, Takenouchi, and Kinjudō, and plate number " 64."

65. Takamiya. (Hiroshige.) In the foreground, two women carrying straw bundles, between trunks of two great trees. Below, the trestles of a destroyed bridge on the dried-up bed of a stream ; the village amid trees ; and distant mountains rising above mist. *Signed*, Hiroshige. *Seals*, Ichiryūsai, Kinjudō, and plate number " 65."

66. Echikawa. (Hiroshige.) In the foreground, a woman leading an ox, two pilgrims and a man with two children ; a plank bridge, on trestles, with travellers, crosses to left, and beyond, distant mountains rise above the mist. *Signed*, Hiroshige. *Seals*, Ichiryūsai, Kinjudō, and plate number " 66."

67. Musa. (Hiroshige.) A bridge formed with planks across two moored boats crosses the stream towards a small toll-house ; beyond are rushes and a row of trees. *Signed*, Hiroshige. *Seals*, Ichiryūsai, Kinjudō, and plate number (in error) " 66."
Note :—The Memorial Catalogue places " Musa " as No. 66 ; but we have preferred Mr. Happer's order, which is supported by the Japanese pagination of a contemporary album (of second editions) in the Victoria and Albert Museum.

68. Moriyama. (Hiroshige.) On the far bank of a stream is the road with a row of houses, shops, etc., one with the mark of the publisher. Beyond, above cherry trees in blossom and pines, is the summit of a green hill. To left, on near bank, cherry-blossom, etc. *Signed*, Hiroshige. *Seal*, Kinjudō, and plate number " 68."

69. Kusatsu. (Hiroshige.) In the foreground, a group of travellers with a woman crossing a little stream by a plank. The roofs of the village are seen in middle distance, with trees on each side and beyond. Above rises the silhouette of distant mountains. *Signed*, Hiroshige. *Seals*, Ichiryūsai, Kinjudō, and plate number (in error) " 68."

70. Ōtsu. The street rises towards the foreground, between shops and inns with signs. To left is a bullock-cart ; to right, three women travellers ; and beyond, Lake Biwa with sailing-boats and distant mountains. *Signed*, Hiroshige. *Seal*, Kinjudō, and plate number " 70."
Note :—At Ōtsu, the road joins the Tōkaidō (Station No. 54). The Kisokaidō series does not include the point of arrival, Kyōto—ten miles distant.

GENERAL SERIES

Mother and Child. From a series representing a mother's love for her children. In style of a series by Keisai Yeisen, about 1817. Ōban Tateye.

Fūryū Itsutsu Karigane. The Five Refined Beauties. *Publisher*, Iwatoya. *Signed*, Ichiryūsai Hiroshige. Ōban Tateye.
Note :—The signature is written with an early form of the character *yū*, afterwards changed to another form written differently but pronounced in the same way.

Soto To Uchi Sugata Hakkei. Eight views of scenery compared with women.
Four sheets each with two views. *Publisher*, Yeijudō. Ōban Tateye.
Kōshi-no Yau, Evening Rain (Outdoor) ; and Magaki-no Seiran, courtesan offering a pipe to her lover (Indoor).
Rōka-no Bosetsu, Evening Snow on a Veranda (Outdoor) ; and Zashiki-no Yūshō, woman going to bed and summoning her servant by clapping the hands (Indoor).

Soto To Uchi Sugata Hakkei, *continued*—

Tampo-no Rakugan, wild geese homing, and a *kago* hurrying on the road (Outdoor); and Kinuginu Bansho, woman awakening from sleep (Indoor). Yanagibashi-no Shūgetsu, girls on a jetty pulling a boat (Outdoor); and Kuake-no Kihan, geisha warming her hands over a charcoal fire (Indoor). *Note :*—The outdoor subjects are in circles.

Bijin Fūzoku Awase. Comparison of Famous Beauties. A series. *Publisher,* Iwatoya. Ōban Tateye.

Yedo Jiman. Pride of Yedo. A series. *Publisher,* Kawashō. Ōban Tateye.

Jūrō Sukenari. The actor Kikugorō in a character from the Drama. *Publisher,* Kawachō. Ōban Tateye.

Imayo Gosekku. The Five Festivals of the Year. A set of 5. *Publisher,* Yamachō. Ōban Tateye.

Geisha seated near a blue bowl with a biwa. Above is a pattern of sake bowls floating on a stream—a favourite pastime. *No title or publisher.* Ōban Tateye.

Tōto Meisho Nenjū Gyōji. Views of Yedo with Beautiful Women. A series. *Publisher,* Marujin. Ōban Tateye.

Kai Sai Ku. Shell-work plates. Set of designs of shell-work made for a dealer, Oku Yama, Asakusa, Yedo. A set of 3. " Special Order." *No publisher's mark.* Ōban Tateye.

Tōto Meisho. Famous Views of the Eastern Capital (Yedo). A set of 8. Ōban Yokoye.

Susaki Yukino Hatsuhi. Susakai, New Year's Sunrise after Snow.
Shibaura Shiohigari-no dzu. Shell-gathering at Shibaura.
Shinyoshiwara Asazakura-no dzu. Morning Cherries at Yoshiwara.
Gotenyama-no Yūzakura. Twilight Cherries at Gotenyama.
Masaki Boshun-no Kei. Late Spring at Masaki.
Sumidagawa Hazakura-no Kei. Cherries in leaf on the Banks of the Sumida.
Tsukudajima Hatsu Hototogisu. First Cuckoo of the Year at Tsukudajima.
Shinobugaoka Hasuike-no dzu. Lotus Pond at Shinobugaoka.

Note :—These prints, which were issued by Kawaguchi-Shōzō, 4-chōme, Ginza, Yedo, are each signed Ichiyūsai Hiroshige. They show a very free and yet careful brush-work. They are perhaps the author's first landscape paintings. From the tone and style, it appears that they were produced in the first year of Tempō (1830). The first prints have decorative borders, but these borders are omitted in later editions.

Ryōgoku no Yoizuki. Twilight Moon at Ryōgoku Bridge.

Takanawa no Meigetsu. Full Moon at Takanawa.

Views of Yedo. A set of 10. Chūban Tateye. *Publisher,* Yeijudō.

Ōmi Hakkei. Eight Views of Ōmi (Lake Biwa). Blue prints in a circle with decorative border. Chūban.

Tōto Hakkei. Eight Views of the Eastern Capital (Yedo). Yotsugiri Jigami gata (Folding fan-shaped quarter plates). 8 sheets in a set. *Publisher,* Shimizu.

Ōmi Hakkei. Eight Views of Ōmi. Yotsugiri Yokoye. 8 sheets in a set. *Publisher* Senichi. The above prints and the following set are early landscape prints signed " Ichiyūsai Hiroshige " instead of " Ichiryūsai Hiroshige," and were produced before 1832.

Yedo Jūnikei. Twelve Views of Yedo. Yotsugiri Yokoye. 12 sheets in a set.
Nihon-bashi Yukihare. Sunrise in Snow.
Gotenyama-no Hana. Cherries.
Asukayama.
Sumidagawa. The Sumida.
Dōkanyama Shita. Foot of Dōkan Hill.
Susaki Shiohi. Shell-gathering at Susaki.
Takanawa. Moon at Takanawa.
Tsukudajima. Incoming Boats at Tsukudajima.
Ryōgokubashi Shita. Moon at Ryōgoku.
Nakasu-no Kei. View of Nakasu.
Uyeno Shinobazu. Shinobazu Pond, Uyeno.
Yoshiwara Tambo. Evening view of Rice-fields near Yoshiwara.

Tsuki Niju Hakkei. Twenty-eight Moonlight Scenes. *Publisher*, Kikakudō. Only two of this series have, so far, been found.
Yumihari Zuki. The Bow Moon.
Hagoshi-no Tsuki. The Moon seen through Maple Leaves.
Note :—The Memorial Catalogue states that these were published by Jakurindō. The examples in the Happer Sale, that of the " Bow Moon " catalogued by MM. Vignier and Inada, and those in the Victoria and Albert Museum have the mark " Kikakudō " (Sanoki) ; so possibly the Memorial Catalogue is in error. An interesting experiment was made by the late Mr. Wilson Crewdson, who had the second of the series enlarged to 3 ft. by 1 ft. 2 in., a stencil cut, and used for printing cloth. Specimens are exhibited in the Victoria and Albert Museum.

Shiki Kōto Meisho. Famous Views of Yedo in the Four Seasons. A set of 4. *Publisher*, Kawashō. Chū-tanzaku.
Haru Gotenyama-no Hana. Cherry-blossom in Spring at Gotenyama ; with a woman preparing *dengaku* (bean-cakes).

> *Poem :—What can be more sweet ?*
> *A windless day—*
> *Perfume and hue of blossoms !*

Natsu Ryōgoku-no Tsuki. Full Moon at Ryōgoku Bridge in Summer. A melon-seller.

> *Poem :—Where do the fireworks glitter on high—*
> *The meeting and parting crowd pass on ?*
> *'Tis Ryōgoku Bridge.*

Aki Kaianji Momiji. The Autumn Maples at Kaianji.

> *Poem :—The Maples dyed by Autumn*
> *Make a fine brocade—*
> *There is neither warp nor woof !*

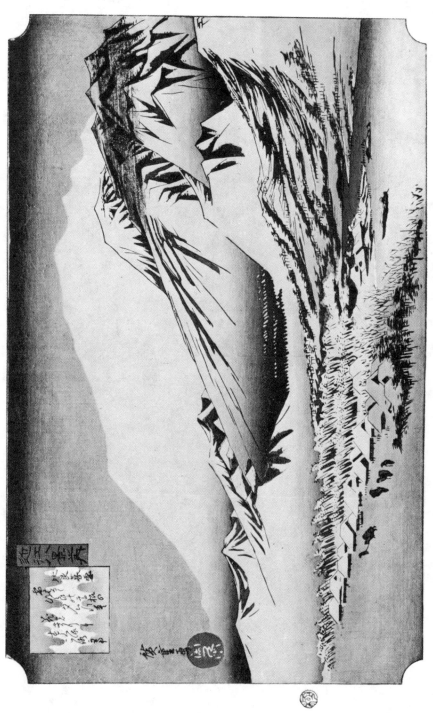

EVENING SNOW AT HIRA.

From the series Ōmi Hakkei ("Eight Views of Biwa").

(See color plate P.)

Shiki Kōto Meisho. Famous Views of Yedo in the Four Seasons, *continued*—
Fuyu Sumidagawa-no Yuki. The Sumida River in Winter Snow. A timber-raft.

> *Poem :—The snowflakes fall and float*
> *On the Sumidagawa tide—*
> *I think of the Miyakadori dancers.*

Yedo Kinkō Hakkei-no Uchi. Eight Views of the Neighbourhood of Yedo.
A series of 8. *Publisher*, Kikakudō. Ōban Yokoye.

Koganei Yūshō. Sunset at Koganei. Old cherry trees in blossom on the banks of a narrow stream spanned by a bridge.

Ikegami Banstro. Evening Bells at Ikegami. The temple, at the head of a steep flight of steps, in a wood.

Haneda Rakugan. Geese Flying Home at Haneda. A temple in a clump of trees on a little bank in the midst of the marshes.

Shibaura Seiran. Clearing Weather at Shibaura. Two boats at anchor off Shibaura.

Azumi Mori Yau. Evening Rain at Azumi-no Mori. A little shrine seen in thick woods beyond a narrow path through rice-fields.

Asukayama Bosetsu. Evening Snow at Asukayama. Peasants with a pack-horse in a snowstorm at the foot of the Asuka hill, famous for cherry-blossom.

Giōtoku Kihan. Two fishing-boats with large striped sails and other boats returning to harbour.

Tamagawa Strugetsu. Autumn Moon at Tama. The full moon above a willow tree on the bank of the river with a boat and fishermen.

Note:—The first edition has, in the upper part of each print, a poem in 3 or 4 verses by Taihadō. Some are stamped in the margin Taihadō-Kaihan (" Prints originated by Taihadō "). Later editions have only one verse.

Ōmi Hakkei-no Uchi. Eight Views of Ōmi.

Seta-no Sekishō. Sunset at Seta.
Karasaki-no Yau. Evening Rain at Karasaki Pine Tree.
Yabase-no Kihan. Fishing-boats sailing back to Yabase.
Katata-no Rakugan. Geese Homing at Katata.
Ishiyama-no Shūgetsu. Autumn Moon at Ishiyama.
Hira-no Bōsetsu. Evening Snow at Mount Hira.
Awazu-no Seiran. Weather Clearing after Storm at Awazu.
Mii-no Banshō. Evening Bell at Miidera (temple).

Note :—These are the famous Eight Scenes on the shore of Lake Biwa. Each has an appropriate poem in a square at the corner. *Publishers*, Hōyeidō and Yeisendō. Ōban Yokoye.

Kyōto Meisho. Views of Kyōto. A set of 10. *Publisher*, Yeisendō. Ōban Yokoye. (Published about A.D. 1835.)

Yodogawa. Passenger boat on the Yodo River in moonlight.
Shijō Gawara Yūsuzumi. The cool of the evening—the river bed at Shijō.
Gionsha Setchū. Gion Shrine in snow.
Yase-no Sato. Spring scene at Yase.
Arashiyama Manka. Cherry-blossom on the banks at Arashiyama.
Kiyomidzu. Cherry-blossom in the grounds of Kiyomidzu Temple.
Kinkakuji. The Temple.
Tadasugawara-no Yudachi. Shower at twilight, Tadasugawara.

Kyōto Meisho. Views of Kyōto, *continued*—

Shimabara Deguchi-no Yanagi. Moonlight scene at the gate of the " Licensed Quarter," from which a jolly roysterer is being assisted home.

Tsūten Kyō-no Kōfu. Merrymaking beneath the maple trees at Tsūten Kyō.

Tōto Meisho. Famous Sights of the Eastern Capital, Yedo (Tōkyō).

Masaki Yukihare-no dzu. Clearing weather after snow at Masaki.

Ryōgokubashi Nōryō. People enjoying the evening cool and watching the display of fireworks, in boats at Ryōgoku.

Fukagawa Tomigaoka Hachiman. Tomigaoka Hachiman Shrine, Fukagawa.

Kameido Umeyashiki-no dzu. Plum Garden, Kameido.

Shiba Atago Sanjō-no dzu. Top of Atago Hill, Shiba.

Asakusa Kinryuzan Toshinoichi Gunshū. Year-end Fair at Asakusa Park.

Meguro Fudō Mōde. Pilgrims at the Fudō Shrine, Meguro.

Uyeno Shinobazu-no Ike. Shinobazu Pond, Uyeno.

Asukayama Hanami. Cherry-viewing party at Asukayama.

Takanawa-no Yūkei. Twilight view of Takanawa.

Gohiakurakan Sazaidō. The Sazaidō containing the Five Hundred Images of Buddha.

Ochanomizu-no dzu. Scene of Ochanomizu.

Tagata-no Baba Sannōmiya. Sannō Shrine, Tagata-no Baba.

Surugachō-no dzu. Surugachō Street.

Susaki Shichigari. Shell-gathering at Susaki at low ebb.

Gotenyama Yūkyō. Picnic at Gotenyama.

Yushima Temmangū. Temman Shrine at Yushima.

Ōji Inari-no Sha. Ōji Inari Shrine.

Uyeno Tōyeizan-no dzu. View of Tōyeizan at Uyeno.

Shiba Zōjōji-no dzu. Court of the Zōjōji Temple, Shiba.

Shiba Akabanebashi-no dzu. Akabane Bridge, Shiba.

Kanda Myōjin Higashizaka. Higashizaka leading to the precincts of the Kanda Myōjin Shrine.

Matsuchiyama-no dzu. View of Matsuchiyama.

Tsukudajima Irifune-no dzu. Boats entering Tsukudajima.

Shiba Shimmei Keidai-no dzu. Precincts of the Shimmei Shrine, Shiba.

Nichōmachi Shibai-no dzu. Theatre hall at Nichōmachi.

Kameido Fuji-no Hana. Wistaria at Kameido.

Yanagishima Myōkendō. The Myōkendō Temple at Yanagishima.

Azuma-no Mori. Woods at Azuma.

Susaki Benten Keidai. Precincts of the Susaki Benten Shrine.

Shinobazu Benten Yashiro. Shinobazu Benten Shrine.

Sumida Tsutsumi Hanami-no dzu. Cherry-viewing parties on the banks of the Sumida.

Tsukiji Gomonzeki Sama. Tsukiji Monzeki Temple.

Takanawa-no dzu. View of Takanawa.

Nippori. View of Nippori.

Ōji Takinogawa. View of Takinogawa.

Asakusa Kinryūzan Monmaye. The front gate of the Kinryūzan Temple, Asakusa.

Ekōin Keidai Sumō-no dzu. Wrestling matches in the precincts of the Ekōin.

Note :—The foregoing are from a series issued continuously from 1833 to 1843. First editions have the red stamp of the publisher Kikakudō; later prints, a

black stamp of Sanōki. Both represent the same firm, the former being the trade name, and the latter a short form of the publisher's personal name, Sanoya Kihei. The monogram, Sanoya, occurs elsewhere. Prints with the abbreviated form of the private name of this publisher are the later. All are Ōban Yokoye in size.

Kōto Meisho. Views of Yedo. Chūban Yokoye. 10 sheets in a set. *Publisher,* Kikakudō.

Nihon-bashi Setchū. Clearing Weather after Snow at Nihon-bashi.
Shiba Atagoyama. Atagoyama Hill, Shiba.
Ryōgoku-no Hanabi. Fireworks, Ryōgoku.
Uyeno-no Hanazakari. Cherry-blossoms at Uyeno.
Takanawa-no Yūkei. Twilight scene at Takanawa.
Shiba Shinmei Sairei. Festival of the Shinmei Shrine.
Shiba Zōjōji-no dzu. Shiba Zōjōji Temple.
Yoshiwara Yozakura. Evening Cherry-blossoms, Yoshiwara.
Nichōmachi Kaomise. Play-hall, Nichōmachi.

Kōto Shokei. Views of Yedo. A set of 8. *Publisher,* Kawashō. Ōban Yokoye.

Yoroi-no Watashi. Ferry-boat at Yoroi.
Shiba Shinsenza-no dzu. Shinsenza Street, Shiba.
Toranomon Soto-no dzu. Outside the Toranomon Gate.
Ōhashi Nakasu-no dzu. Boat sailing along Nakasu.
Sakurada Soto-no dzu. Outside the Sakurada Gate.
Hibiya Soto-no dzu. Outside the Hibiya Gate.
Yamashita Gomon-no Uchi. Inside the Yamashita Gate.
Sumida-gawa Hashiba Watashi-no dzu. Sumida River, Ferry Landing.

Honchō Meisho. Famous Sights of the Main Island. A set of 15. *Publisher,* Fujihiko, or Matsubaradō. Ōban Yokoye.

Sunshū Fujikawa Tosen-no dzu. Fujikawa River, ferry boats.
Sunshū Kiyomi ga Seki. Kiyomiga Seki Beach.
Sesshū Nunobiki-no Taki. Nunobiki Waterfall.
Yenshū Akihasan. Approach to the Akiha Temple.
Satta Fuji. Fuji Yama viewed from Satta Pass.
Sōshū Shichirigahama. Shichirigahama Beach.
Sōshū Enoshima Iwaya-no dzu. The entrance of a cave at Enoshima Island.
Shinshū Sarashina Tagoto-no Tsuki. Reflected moon on paddy-fields at Sarashina.
Sanshū Hōraiji Gyōjagoi. Men climbing a cliff at Hōraiji, Mikawa Province.
Ōsaka Tenpōzan. Merrymaking on board a boat at Tenpōzan, Ōsaka.
Hakone Tōjiba-no dzu. Watering-place at Hakone.
Bushū Kanazawa Fūkei. Sights of Kanazawa, Musashi Province.
Ama-no Hashidate. One of the three famous scenes of Japan.
Settshū Sumiyoshi Demi-no hama. Sumiyoshi Beach at Demi.
Banshū Maiko-no hama. Maiko Beach, Harima Province.

Naniwa Meisho Dzuye. Views including gay quarters of Naniwa (ancient name of Ōsaka which is now used only in poems). A set of 10. *Publisher,* Yeisendō Ōban Yokoye.

Anryū machi Naniwaya no Matsu. Famous pine at Naniwaya, Anryū machi.
Imamiya Tōka Ebisu. Ebisu Shrine, a festival.
Junkei machi Yomise-no dzu. Night stalls on Junkei Street.

Naniwa Meisho Dzuye.　Views of Naniwa, *continued*—

Zakoba Uoichi-no dzu.　Fish-market at Zakoba.

Dōjima Kome Akinai.　Rice-market at Dōjima.

Sumiyoshi Gyōden-no Saishiki Dengaku-no dzu.　Sacred Dance at the Sumiyoshi Shrine.

Tenjinyama.　Tenjin Shrine.

Dōtonbori.　Pleasure resort.

Kukenchō.　Gay street.

Shinmachi Hachikenya.　River boat landing-place.

Kanazawa Hakkei.　Eight Views of Kanazawa.　*Publisher*, Koshihei.　Ōban Yokoye.

Koizumi-no yau.　Evening Rain at Koizumi.

Seto Shūgetsu.　Autumnal Moon at Seto.

Uchikawa Bosetsu.　Evening Snow at Uchikawa.

Hirakata-no Rakugan.　Geese Flying Down at Hirakata.

Nojima-no Yūshō.　Sunset at Nojima.

Ottomo-no Kihan.　Boats sailing back at Ottomo.

Susaki-no Seiran.　Clearing Weather at Susaki.

Shōmyōji-no Banshō.　Vesper Bells at the Shōmyōji Temple.

Shokoku Mu-Tamagawa.　Six Rivers named Tamagawa in the various provinces.　*Publisher*, Tsutaya.　Ōban Yokoye.

Note :—These six rivers named Tamagawa are noted not for their size but for their popular poetical associations.　This series comes next to the foregoing Eight Views of Kanazawa in splendour.

Settsu Kinuta-no Tamagawa.　Two women pounding cloth by the stream in the moonlight at Kinuta.

Musashi Chōfu-no Tamagawa.　　　Yamashiro Ide-no Tamagawa.

Mutsu Node-no Tamagawa.　　　Ōmi Noji-no Tamagawa.

Kii Kōya-no Tamagawa.

Nihon Minato Zukushi.　Famous Harbours of Japan.　A set of 10.　*Publisher*, Marusei.　Ōban Yokoye.

Sōshū Uraga.　Uraga in snow; now famous for the visit by Commodore Perry's expedition.

Tōto, Nakasu Mitsumata.　　Ōsaka, Ajikawa guchi,　　Chōshū, Shimonoseki.

Yedo, Teppōzu.　　　　　　Tōto, Yedo-bashi.　　　　Sunshū, Shimizu Minato.

Tōto, Shinagawa.　　　　　Sanshū, Marugame.　　　Banshū, Muronotsu.

Tōto Meisho.　Famous Views of Yedo.　*Publisher*, Kawashō.　Ōban Yokoye.

Tōto Meisho.　Famous Views of Yedo.　*Publisher*, Matsubaradō, Chū-tanzaku.

Tōto Meisho.　Famous Views of Yedo.　*Publisher*, Fujihiko.　Chū-tanzaku.

Asakusa Kinryūzanka-no Uchū.　Asakusa Temple by the side of the Sumida in rain.

Nihonbashi-no Setchū.　Nihon-bashi ; Sunrise after Snow.

Asukayama Shita.　View of Rice-fields at the foot of Asukayama.

Ryōgoku-no Hanabi.　Fireworks at Ryōgoku.

Matsuchiyama-no Yukihare.　Snow-mantled view of Matsuchiyama in Clearing Weather.

Tsukudajima-no Oborozuki.　Tsukudajima Isle in the Moonlight.

Uyeno Kiyomizudō.　Kiyomidzu Temple at Uyeno.

Tōto Meisho. Famous Views of Yedo, *continued*—
Sumidagawa-no Watashi. Ferry-boats on the Sumida.
Susaki Shiohigari. Shell-gathering at Susaki.
Shinobazu-no Ike. Benten Shrine in Shinobazu Pond.
Umeyashiki-no Manka. Plum Garden.
Aoizaka. Scene at Aoizaka.
Ochanomizu. Rivulets running far below cliffs at Ochanomizu.
Kameido-no Fuji-no Hana. Wistaria at Kameido.
Setchū Shinobazu-no Ike. Shinobazu Pond in Snow.

Shiba Hakkei. Eight Views of Shiba, Yedo. *Publisher,* Echizenya. Ōban Yokoye.
Gotenyama-no Rakugan. Geese flying down at Gotenyama.
Akabane-no Yau. Evening Rain at Akabane.
Takanawa-no Kihan. Boats sailing back at Takanawa.
Atagoyama-no Bosetsu. Evening Snow at Atago Shrine.
Tamachi-no Shūgetsu. Autumn Moon at Tamachi.
Shinmei-no Yūshō. Sunset at Shinmei Shrine.
Shirokane-no Seiran. Weather clearing at Shirokane.
Sanyenzan-no Banshō. Vesper Bells at Sanyenzan Temple.

Tōto Meisho Sumidagawa Hakkei. Eight Views of the Sumida in Yedo.
Publisher, Sanoki. Aiban Yokoye.
Mimeguri-no Bosetsu. Evening Snow at Mimeguri Shrine.
Masaki-no Yau. Evening Rain at Masaki.
Mokuboji Shūgetsu. Autumn Moon at Mokuboji Temple.
Imado-no Yūshō. Sunset at Imado.
Matsuchiyama-no Seiran. Weather clearing at Matsuchiyama.
Kinryūzan-no Banshō. Vesper Bells at Kinryūzan (Asakusa Temple).
Azumabashi-no Kihan. Boats sailing back at Azumabashi.
Hashiba-no Rakugan. Geese flying down at Hashiba.

Yedo Kōmei Kwaitei Dzukushi. Grand series of Famous Tea-houses in Yedo.
A set of 30. *Publisher,* Fujihiko. Ōban Yokoye.
Note :—The names of the tea-houses are given in brackets.
Mokuboji Yukimi. Mokuboji in Snow. (Uyekiya.)
Yanagi-bashi Yakei. Evening Scene at Yanagi-bashi. (Manpachi.)
Susaki Hatsuhinode. Snow at Susaki in the first sunrise of the year. (Musahiya.)

Shiba Shinmeisha Uchi (Shatetsu-rō).
Nihon-bashi (Kashiwagi).
Asakusa Kaminarimon Mae (Kame-ya).
Honjō Komme (Ogura-an).
Hakusan Keiseiga Kubo (Daisen).
Yanagishima-no dzu (Hashimoto).
Yushima (Matsu Kane-ya).
Shinyoshiwara Yemonzaka Nihon-zutsumi (Harima-ya).
Shitaya Hirokōji (Oike).
Fukagawa Hachiman Mae (Ushio-mura).
Mukōjima (Daikoku-ya).
Mimeguri-no Kei (Toyoha-ya).
Zōshigaya-no dzu (Myōga-ya).

Imadobashi-no dzu (Tama-Shō).
Ryōgoku (Aoyagi).
Ryōgoku Yanagibashi (Ōno).
Ikeno Hata (Hōrai-ya).
Daisenji Mae (Tagawa-ya).
Kameido Uramon (Tama-ya).
Ōji (Ōgi-ya).
Ryōgoku Yanagi-bashi (Umegawa).
Mukōjima-no dzu (Hira-Iwa).
Fukagawa Hachiman Keidai (Niken Jya-ya).
Ryōgoku Yanagi-bashi (Kawachi-ya).
Ushijima (Musashi-ya).
San-ya (Yaozen).
Sumidagawa Hashiba Watashi dzu (Yanagi-ya).

Kokon Jōruri Dzukushi. Grand series of Old and New Dramatic Songs. A set of not less than 15. *Publisher*, Sanoki. *Engraver*, Fusajiro.

Chūshingura Hachidamme.

Gonpachi Yume-no Dan.

Chūshin Kōshaku Yukifuri-no Dan.

Himekomatsu Nenohi Asobi Shima Monogatari.

Katsuragawa Renri-no Shigarami Michiyuki.

Meiboku Sendaihagi.

Kagamiyama Kokyō-no Nishikiye.

Chūshingura Sandamme Michiyuki.

Karukaya Sōmon Tsukushi-no Iyetsuto.

Seishū Akogigaura Hamabe.

Somemoyō Imose-no Kadomatsu.

Sekinoto-no Shita.

Hiragana Seisuike.

Yoshitsune Senbon Zakura.

Keisei Koibiaku Ninokuch Mura.

Tōto Kyūseki Dzukushi. Yedo in Legend and History. A Series. *Publisher*, Wakasaya. Ōban Tateye.

Chūshingura. The Drama of the 47 Rōnin. A set of 15. *Publisher*, Izumiya Ichi, Shiba, Yedo (Senichi). Ōban Yokoye.

Soga Monogatari Dzuye. The Story of the Revenge of the Soga Brothers. A set of (?) 36. *Publisher*, Dansendō. Ōban Tateye.

Tōto Hakkei. Eight Views of Yedo. *Publisher*, Fujikei. Chūban Yokoye. Margins outside the border of each print are coloured light green.

Nihon-bashi-no Yau. Evening Rain at Nihon-bashi.

Asakusa-no Bosetsu. Evening Snow at Asakusa.

Ryōgoku-no Yūshō. Sunset at Ryōgoku with Fireworks

Uyeno-no Banshō. Vesper Bells at Uyeno.

Takanawa-no Kihan. Boats sailing back at Takanawa.

Susaki-no Seiran. Weather clearing at Susaki.

Sumidagawa-no Shūgetsu. Autumn Moon above the Sumida.

Shinobazu-no Rakugan. Geese Homing at Shinobazu.

Fuji Sanjū Rokkei. The 36 Views of Mount Fuji. A set of 36. *Publisher*, Sanoki, in 1852. Chūban Yokoye.

Tōto Ryōgoku-bashi Shita.

Kinegawa Tanbo.

Sagamigawa.

Yeitai-bashi, Tsukudajima.

Kōnodai.

Kazusa Tenjin-yama Kaigan.

Ōmori Nawate.

Kai Suga-yama Ura.

Shinano Suwako.

Suruga Fujinuma.

Tamagawa.

Fujikawa.

Inume Tōge.

Sumida-dzutsumi.

Musashino.

Nihon-bashi.

Ōyama.

Tanabata Matsuri.

Sagami Shichiriga Hama.

Surugadai.

Koganei-dzutsumi.

Satta Tōge.

Tago-no Ura.

Hakone-yama Kosui.

Kanagawa Kaijō.

Izu Kaihin.

Tōto Aoyama.

Asukayama.

Honmoku Kaijō.

Kisarazu Kaijō.

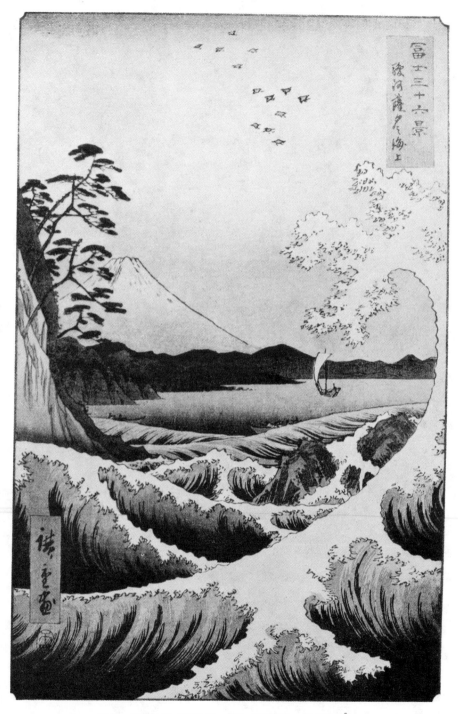

THE GREAT WAVE AT SATTA, SUNSHŪ.

From a series of " The 36 Views of Fuji." *Publisher*, Tsutaya. *Date*, Horse Year, 1858.

Fuji Sanjū Rokkei. The 36 Views of Mount Fuji, *continued*—

Chiyogasaki.
Nokogiri-yama.
Ōtsukihara.
Yamashita-chō Gashi.
Suidō-bashi.
Kazusa Kanōzan Toriizaki.

Sankai Mitate Zumō. Wrestling Matches between Mountains and Seas. "Where land and sea are locked as in a wrestler's bout." Ten each of Mountains and Harbours. *Publisher*, Yamadaya, in 1858 (Year of Horse). Ōban Yokoye.

Mountains.

Bizen Yugayama.
Echigo Kamewaritōge.
Sanuki Zōzuzan.
Settsu Arimayama.
Echizen Yunootōge.
Awa Kiyozumiyama.
Kazusa Kanōzan.
Sagami Ōyama.
Harima Tatsuyama.
Etchū Tateyama. (This one only was published by Marujin.)

Harbours.

Settsu Ajikawaguchi.
Kazusa Kisarazu.
Harima Muronotsu.
Bizen Tanokuchi.
Echizen Mikuni.
Echigo Niigata.
Etsuchū Kokubu Minato.
Awa Kominato.
Sagami Uraga.
Sanuki Marugame.

Letter-paper Series. A set of 12.

These are printed in *surimono* style, but were put on sale in the form of a roll consisting of 12 sheets to be used for writing letters. Almost all of these prints on letter-paper were used by nobles and dignitaries and men of taste, and consequently there now remain very few of them. Each of the 12 sheets is oblong, measuring 7½ in. by 20½ in. The prints bear no stamp of publisher, but by the proofs taken from key-blocks, now in existence, it has been made clear that they were published by the Wakasaya.

Giōtoku Shiohama-no dzu.
Tamagawa-no Sato.
Gotenyama-no dzu.
Matsudo-no Sato.
Nakagawaguchi-no dzu.
Susaki Yuki-no Asa.
Koganei-no Kei.
Kaianji-no Momiji.
Yūhiga Oka.
Azuma-no Mori.
Takata-no Baba.
Hagidera.

Fuji Sanjū Rokkei. The 36 Views of Mount Fuji. A set of 36 plates and title-page. *Publisher*, Tsutaya. Ōban Tateye. *Engraver*, Horichō. *Dated*, Horse 4 (A.D. 1858).

Title-page.
Fuji from :—
1. Yasuda Beach.
2. The Bank of Sumida River, Yedo.
3. Kōnodai on the River Tone.
4. Shiwojiri-Tōge, Shinano.
5. Ocha-no Mitzu, Yedo.
6. Shichirigahama, Sagami.
7. Ichikoku-bashi (bridge), Yedo.
8. Lake Suwa, Shinano.
9. Misakagoye, Kai.
10. Koganei, Musashi.
11. Noge, Yokohama, Musashi.
12. Tōkaidō (Hidari Fuji).
13. The Mountains in Izu.
14. Rokusozan, Kazusa.
15. Hommoku, Musashi.
16. Ryōgoku, Yedo.
17. Miwo-no Matsubara, Suruga.
18. Sagami River, Sagami.
19. Surugachō, Yedo.
20. Tamagawa, Musashi.
21. Meguro, Yedo.
22. Zōshigaya, Yedo.

Fuji Sanjū Rokkei. The 36 Views of Mount Fuji, *continued*—
Fuji from :—

23. Asukayama, Yedo.	30. Kuroto-no ura, Kazusa.
24. Satta Beach, Suruga.	31. Koganegahara, Shimōsa.
25. Miura, Sagami.	32. Tsukuda, Yedo.
26. Enoshima, Sagami.	33. Inume Tōge, Kai.
27. Hakone Lake, Sagami.	34. Ōtsuki-no-hara, Kai.
28. Sukiyagashi, Yedo.	35. Futami ga ura, Isé.
29. Ōi River, Suruga.	36. Koshigaya, Musashi.

Sumida Tsutsumi Yamiyo-no Sakura. Three women on the banks of the Sumida on a night in spring. Sammai-tsūzuki. *Publisher*, Iseichi.

Sumida-no Ryō Tsuki-no Yen. Three women enjoying a small feast in an upper room of a house on the banks of the Sumida under the full moon. Sammai-tsūzuki. *Publisher*, Marusei.

Mutsu Adachi Domeki-Yeki Hakkei-no Dzu. Eight views of Domekiyeki, Mutsu Province. Sammai-tsūzuki. *Publisher*, Yamato.

Meisho Yedo Hiakkei. "The Hundred Views of Yedo, Famous Places." 119 sheets in album with MS. preface (five pages, dated for 18 July, 1860), 14½ by 9¾ (including margins). 1856-1859. *Publisher*, Uwoya Yeikichi, Shitaya, Yedo (Uwoyei). Ōban Tateye.

The complete series (except title-page) by Hiroshige I, as issued in 1858 (or early in 1859), together with the new print (No. 19) by Hiroshige II substituted for No. 18 (original No. 48) in a later edition. The oval date-seals in the top or left margin of each print indicate that the blocks were cut between March, 1856, and November, 1858—that for the substitute print in July, 1859. In the list of contents included in the title-page, the prints are arranged according to the seasons : thus, Spring, original Nos. 1-42, Summer 43-72, Autumn 73-95, Winter 96-118. [In the descriptions following, the original series numbers are given in square brackets.]

N.B.—The year quoted as "Dragon" began on February 6, 1856; "Snake," January 26, 1857; "Horse," February 14, 1858; "Sheep," February 3, 1859.

1. [3] Yamashita Street, Hibiya, Soto-Sakurada. Dated *Snake year, 12th month.*
2. [21] Shiba, Atago Hill. (The Messenger to the Bishamon Temple.) Doubly dated : *Snake, 8th month*, and *Ansei IV* (1857).
3. [1] The Nihon-bashi and Yedo-bashi (bridges). *Snake*, 12.
4. [62] Yatsumi-no Hashi (bridge). *Dragon*, 8.
5. [66] Kōjimachi, Soto-Sakurada, Benkei-bori (moat). *Dragon*, 5.
6. [2] Kasumigaseki. *Snake*, 1.
7. [113] Aoi-Zaka (hill) outside Tora-no Mon (gate). *Snake*, 11.
8. [112] Atagoshita, Yabu-kōji (street). *Snake*, 12.
9. [79] Shiba, Shimmei, Zōjōji (temple). *Horse*, 7.
10. [49] Akabane, Pagoda of the Zōjōji. *Snake*, 1.
11. [22] Hirō-o, Furu River. *Dragon*, 7.
12. [25] Meguro, Moto-Fuji (the real Mount Fuji). *Dragon*, 7.
13. [84] Meguro, Jiji-ga-chaya (tea-house). *Snake*, 4.
14. [23] Meguro, Chiyogaiki (lake). *Dragon*, 7.
15. [111] Meguro, Taiko-bashi ("drum-bridge"), evening. *Snake*, 4.

Meisho Yedo Hiakkei. "The Hundred Views of Yedo, Famous Places," *cont.*—

16. [26] Hakkei-zaka (hill), Yoroi-kake-matsu (pine tree). *Dragon,* 5.
17. [85] Kinokuni-zaka (hill), Tame-ike (canal). Akasaka in distance. *Dragon,* 4.
18. [48] Akasaka, Kiribatake ("Paulownia plantation"). *Dragon,* 4.
19. [Substitute for 48] Akasaka, Kiribatake, in rain, evening. *Signed,* Hiro-shige II. *Sheep,* 6.
20. [65] Kōjimachi, Itchōme. Sannō-no matsuri (festival). Procession of festival cars. *Dragon,* 7.
21. [41] Ichigaya, Hachiman (shrine). *Horse,* 10.
22. [64] Tsunohazu, Kumano-jinsha (twelve shrines), commonly called the Twelve Tō (pagodas). *Dragon,* 7.
23. [86] Yotsuya, Naitō-shinjiku (street). *Snake,* 11.
24. [42] Tamagawa (river), flowers (cherry-blossom) on the embankment. *Dragon,* 2.
25. [87] Inokashira-no-ike (lake), Shrine of Benten. *Snake ?,* 4.
26. [110] Senzoku-ga-ike (pond), Kesakake-no Matsu (pine-tree). *Dragon,* 2.
27. [115] Takata-no Baba (race-course). *Snake,* 1.
28. [116] Takata, Sugatami and Omokage bridges, with gravel-bed (*jariba*). *Snake,* 1.
29. [40] Sekiguchi, house of the poet Bashō. *Snake,* 4.
30. [18] Ōji, Inari-no Yashiro (shrine). *Snake,* 9.
31. [88] Ōji, Taki-no Kawa (river of the fall). *Dragon,* 4.
32. [19] Ōji, Otonashigawa (river); dam, commonly called Ōtaki ("Big Fall"). *Snake,* 2.
33. [47] Ōji, Fudō-no Take (fall). *Snake,* 9.
34. [17] Asukayama (hill), view looking North. *Dragon,* 5.
35. [15] Nippori, Suwa-no Dai (terrace). *Dragon,* 5.
36. [14] Nippori, temple gardens. *Snake,* 2.
37. [16] Sendagi, Dango-zaka (hill), flower-gardens. *Dragon,* 5.
38. [100] Yoshiwara, Nihon-dzutsumi (dyke). *Snake,* 4.
39. [38] Kwakuchū Shinonome (early dawn in the Yoshiwara). *Snake,* 4.
40. [101] Asakusa, Tambo (fields), festival of Tori-no Machi. *Snake,* 11.
41. [90] Saruwaka-chō (street), night scene. *Dragon,* 9.
42. [37] Sumidagawa (river), Hashiba-no Watashi (ferry), pottery kilns. *Snake,* 4.
43. [34] Matsuchiyama (hill), Sanya-bori (moat), night scene. *Snake,* 8.
44. [92] Mokubo-ji (temple), Uchi-kawa (river), flower-gardens. *Snake,* 11.
45. [56] Iris (*hanashōbu*) at Horikiri. *Snake, interc.* 5.
46. [36] Suijin-no Mori (wood), Uchi-kawa and Sekiya village, from a house in the vicinity of Masaki. *Snake,* 8.
47. [102] Minowa, Kanasugi, Mikawashima. *Snake, interc.* 5.
48. [103] Senju, Ō-hashi (Big Bridge). *Dragon,* 2.
49. [20] Kawaguchi-no Watashi (ferry), Zenkō-ji (temple). *Snake,* 2.
50. [69] Ayasegawa (river), Kane-ga-fuchi (pool). *Snake,* 7.
51. [93] Niijuku-no Watashi (ferry). *Snake,* 2.
52. [33] Yotsugi-dōri Canal, with tow-boats. *Snake,* 2.
53. [91[Ukeji, Akiha Shrine, grounds. *Snake,* 8.
54. [35] Sumidagawa (river), Suijin-no Mori (forest), a true picture. *Dragon,* 8.
55. [104] Koume-dzutsumi (dyke). *Snake,* 2.
56. [32] Yanagishima. *Snake,* 4.

Meisho Yedo Hiakkei. "The Hundred Views of Yedo, Famous Places,"
continued—

57. [31] Adzuma-no Mori (wood). *Dragon*, 7.
58. [30] Kameido, plum-tree garden. *Snake*, 11.
59. [57] Kameido, precincts of the Tenjin Temple. *Dragon*, 7.
60. [70] Gohiaku-rakan Temple, Sazaye Hall. *Snake*, 8.
61. [60] Mouth of the Nakagawa (river). *Snake*, 2.
62. [58] Sakai-no Watashi (ferry). *Snake*, 2.
63. [96] Horiye Nekozane. *Dragon*, 2.
64. [95] Kōnodai, view of the Tone-gawa (river). *Dragon*, 5.
65. [61] Tonegawa (river), Barabara-Matsu ("scattered pine trees"). *Dragon*, 8.
66. [94] Maples at Mama, Tekona-no Yashiro (shrine). *Snake*, 1.
67. [97] Konakigawa (river), Gohonmatsu (five pine trees). *Dragon*, 7.
68. [29] Sunamura, Moto-Hachiman (temple). *Dragon*, 4.
69. [107] Fukagawa, Susaki, Jūmantsubo (plain). *Snake, interc.* 5.
70. [106] Fukagawa, *kiba* (timber-yard). *Dragon*, 8.
71. [71] Fukagawa, Sanjūsangen-dō (temple). *Snake*, 8.
72. [59] Fukagawa, opening of the Hachiman shrine. *Snake*, 8.
73. [67] Mitsumata, Wakare-no Fuchi (pool on the Sumida River). *Snake*, 2.
74. [51] Fukagawa, Mannembashi (bridge). *Snake*, 11.
75. [52] Ō-hashi (bridge), a summer shower. *Snake*, 9.
76. [5] Riōgoku, Yekō-in (temple), wrestling signs. *Snake, interc.* 5.
77. [53] Riōgoku, Asakusa in distance. *Snake*, 7.
78. [39] Riōgoku-bashi (bridge), Ōkawabata (river-side). *Dragon*, 8.
79. [98] Riōgoku, fireworks. *Horse*, 8.
80. [54] Asakusagawa (river), Shubi-no Matsu (pine tree), Onmaya-gashi (river-bank). *Dragon*, 8.
81. [105] Onmaya-gashi. *Snake*, 12.
82. [55] Komakata-dō (temple), Adzuma-bashi (bridge). *Snake*, 1.
83. [68] Adzuma-bashi (bridge), Kinriūzan (district). *?*, 8.
84. [99] Asakusa, Kinriūzan (temple). *Dragon*, 7.
85. [11] Uyeno, Kiyomidzu-dō (temple), Shinobazu-no-ike (lake). *Dragon*, 4.
86. [89] Uyeno, temple-precincts, Tsuki-no-matsu (pine tree). *Snake*, 8.
87. [12] Uyeno, Yamashita (ward). *Horse*, 10.
88. [13] Shitaya, Hirokōji (ward). *Dragon*, 9.
89. [117] Yushima-tenjin-zaka (hill). *Dragon*, 4.
90. [10] Kanda-miōjin (temple) : daybreak. *Snake*, 9.
91. [73] The city in gala for the Tanabata festival (7th day of 7th month). *Snake*, 7.
92. [46] Shōhei-bashi (bridge), Seidō (Confucius temple), Kanda-gawa (river). *Snake*, 9.
93. [63] Suidō-bashi (bridge), Suruga-dai (terrace). (Boys' Festival, 5th day of 5th month). *Snake, interc.* 5.
94. [75] Kanda, Konya-chō (dyers' quarter). *Snake*, 11.
95. [9] Sujikai, Yatsukōji (avenue). *Snake*, 11.
96. [74] Ōtemma-chō (street), mercers' shops. *Horse*, 7.
97. [6] Bakurō-chō (street), Hatsune-no Baba (place). *Snake*, 9.
98. [7] Ōtemma-chō (street), drapers' shops. *Horse*, 4.
99. [8] Suruga-chō (street). *Dragon*, 9.
100. [45] Yoroi-no Watashi (ferry), Koami-chō (street). *Snake*, 10.

Meisho Yedo Hiakkei. "The Hundred Views of Yedo, Famous Places," *continued—*

101. [4] Yeitai-bashi (bridge), Tsukudajima (ward). *Snake, 2.*
102. [77] Teppō-zu, Inari-bashi (bridge), Minato-jinja (temple). *Snake, 2.*
103. [50] Tsukudajima, festival of Sumiyoshi. Date on banner: Ansei IV (1857), 6th month. *Snake, 7.*
104. [27] Kabata, plum-tree garden. *Snake, 2.*
105. [72] Haneda-no Watashi (ferry), Benten-no Yashiro (temple). *Horse, 8.*
106. [109] Minami (South) Shinagawa, sea-shore. *Snake, 2.*
107. [83] Shinagawa, Susaki. *Dragon, 4.*
108. [28] Shinagawa, Goten-yama (hill). *Dragon, 4.*
109. [82] Tsuki-no Misaki (cape). *Snake, 8.*
110. [81] Takanawa, Ushimachi. *Snake, 4.*
111. [80] Kanasugi-bashi (bridge), Shibaura (shore). *Snake, 7.*
112. [76] Kyo-bashi, Take-gashi (Bamboo wharf). *Snake, 12.*
113. [108] Shibaura. *Dragon, 2.*
114. [44] Nihon-bashi-dōri Itchōme (street). *Horse, 8.*
115. [114] Bikuni-bashi (bridge), in snow. *Horse, 10.*
116. [43] Nihon-bashi (bridge), clear weather after a snow-fall. *Dragon, 5.*
117. [118] Ōji, Shozoku-yenoki, New Year's Eve, fox-fires. *Snake, 9.*
118. [24] Meguro, Shin-Fuji (artificial Mount Fuji). *Snake, 4.*
119. [78] Title: Yedo Hiakkei yokō (supplementary to "The Hundred Views of Yedo"). Teppō-dzu, Tsukiji, remains of gate. *Horse, 7 (1858).*

Note :—The Victoria and Albert Museum contains a complete set in contemporary album, paged as above. It has therefore been thought to be convenient to many students for the double numeration to be given.

Dai Nippon Rokujū-yoshū Meisho Dzuye. Pictures of Famous Places in Japan, in 60-odd Provinces. A set of 69, with title. "Drawn by Ichiryūsai Hiroshige, *Publisher*, Koshimura Heisuke (Koshihei)." Title-page dated Ansei 3rd Autumn Dragon Year (A.D. 1856). The prints are variously dated 1853-1856. *Engravers,* Horitake, Horita, Horikosen, Hori (?), Horisoji, Sennosuke. Ōban Tateye.

Note :—The year of the Ox was equivalent either to 1853 or 1865. The Memorial Catalogue spreads the series over the whole period; but the foregoing reading is preferred, as a complete list is given on the title under date 1856.

Engraver.	Name of Place.	Province.	Date Mark.		A.D.
	Title and Index		Dragon	9	1856
Horitake	Arashiyama	Yamashiro	Ox	7	1853
	River Tatsuta	Yamato			
	Ōtokoyama from Hirakata	Kawachi			
	Takashi-no Hama	Izumi			
	Sumiyoshi beach	Settsu			
Horita	Town of Uyeno	Iga			
	Asamayama	Isé			
	Toba Harbour from Hiyoriyama	Shima			
Horitake	Festival of Sanno, Tsushima	Owari			
	Hōraiji	Mikawa	Ox	8	
	Lake Hamana	Tōtōmi			
	Mio-no Matsubara	Suruga	Ox	7	
Unsigned	Saruhashi (Monkey bridge)	Kai	Ox	8	

Dai Nippon Rokujū-yoshū Meisho Dzuye. Pictures of Famous Places in Japan, in 60-odd Provinces, *continued—*

Engraver.	Name of Place.	Province.	Date Mark.		A.D.
Horitake	Shuzenji	Izu			1853
	Enoshima	Sagami			
Unsigned	River Sumida in Winter	Musashi			
Horikosen	Asakusa, Yedo	Musashi	Ox	10	
Horitake	Kominato	Awa	Ox	8	
	Yazashiga Ura	Kazusa			
Unsigned	Choshi-no Hama	Shimōsa			
Horitake	Kashima Temple (Shintō)	Hitachi			
	Ishiyama on Biwa Lake	Omi	Ox	7	
	Yōrō-no Taki (cascade)	Mino	Ox	8	
	Kago Watashi	Hida			
Hori	Kyodaisan, Sarashima	Shinamo			
Horitake	Snow Scene, Mount Haruna	Kōzuke			
	Urami-no Taki, Nikkō	Shimo tsuke			
	Matsushima	Mutsu			
	River Mogami	Dewa			
Horikosen	Fishing for Soles	Wakasa	Ox	9	
Unsigned	Kebi-no Matsubara Tsuruga	Echizen			
	Lights of Fishing-boats, Kanazawa	Kaga			
Hori	Takino Ura	Noto			
Horitake	Funabashi (boat bridge) at Toyama	Etchū			
Horikosen	Oyashirazu	Echigo			
Unsigned	Kanayama (gold mine)	Sado			
	Tsurigane-zaka	Tamba	Ox	12	
Horisōji	Ama-no Hashidate	Tango			
Unsigned	Kwannon Temple, Iwaidani	Tajima			
Horikosen	Kajikoyama	Inaba			
Horitake	Ōyama as seen from Ōno	Hōki			
Sennosuke	Ōyashiro (Shintō Temple)	Izumo			
Horisōji	Making Salt, Takatsuyama	Iwami			
Horikosen	Takibi-no Yashiro	Oki			
Unsigned	Maiko Beach	Harima			
	Yamabushidani	Mimasaka			
	Torii of Yuga Temple, Tonokuchi	Bizen			
	Gōkei	Bitchū			
Horitake	Kwannon Temple, Abumon	Bingo			
Unsigned	Itsukushima	Aki			
Sennosuke	Kintai-bashi	Suwo			
Unsigned	Shimo-no Seki	Nagato	Dragon	3	1856
	Waka-no Ura	Kii	Hare	9	1855
Hori	Goshiki-no Hama	Awaji			
Unsigned	Whirlpool at Awa	Awa			
Horisōji	Zōzusan	Sanuki			
	Saijō	Iyo			
Unsigned	Fishermen at work	Tosa			
Horisōji	Hakozaki	Chikuzen			

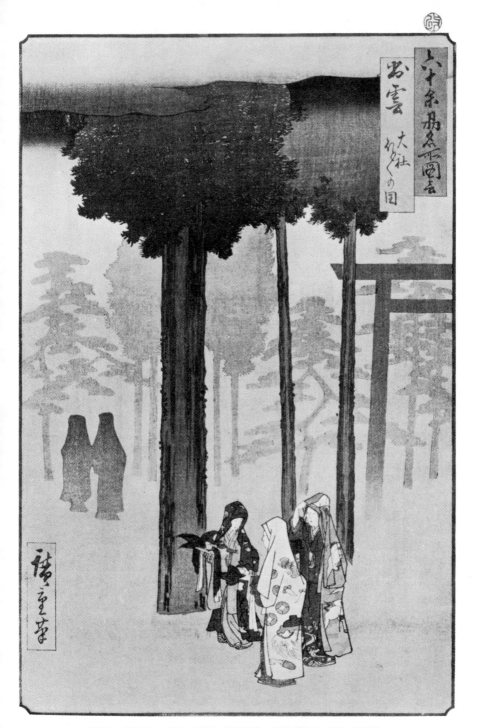

THE GATE OF THE IZUMO TEMPLE IN MIST.

From " The Sixty and More Famous Views of the Provinces."

Dai Nippon Rokujū-yoshū Meisho Dzuye. Pictures of Famous Places in Japan, in 60-odd Provinces, *continued—*

Engraver.	Name of Place.	Province.	Date Mark. A.D.
Unsigned	Rapids	Chikugo	1855
	Cave at Rakanji	Buzen	Tiger 11 1854
	Minosaki	Bungo	Dragon 4 1856
	Inasayama, Nagasaki	Hizen	Dragon 5
	Gokanoshō	Higo	Dragon 3
	Yudzu-no Minato	Hyūga	
Hori	Sakurajima	Ōsumi	
	Bō-no Ura	Satsuma	
Unsigned	Shidzukuri	Iki	
	View of the Coast	Tsushima	

BIRDS AND FLOWERS. Ō-TANZAKU (KWA-CHŌ).

Loquat and Bird. *Publisher,* Jakurindō. *Aizuri* (blue print).
Camellia and Bird. *Publisher,* Wakasaya.
Peacock and Peonies. *Publisher,* Jakurindō.
Macaw and Pine Tree, yellow ground. *Publisher,* Jakurindō.
Macaw and Pine Tree, uneven light blue ground. *Publisher,* Jakurindō.
Cock, Umbrella, and Morning-glory. *Publisher,* Jakurindō.
Frogs and Yamabuki (Yellow Rose). *Publisher,* Jakurindō.
Hydrangea and Kingfisher. *Publisher,* Jakurindō. *Artist's Seal,* Yūsai.
Snowy Heron and Iris. *Publisher,* Jakurindō.
Wild Duck in Snow. *Artist's Seal,* Baka ("fool") in shape of horse and deer.
 Publisher, Yeijudō. Later edition without publisher's mark.
Onagadori (pheasant) and Plum-blossom. *Publisher,* Jakurindō.
Hawk and Pine Tree, Sunrise. *Publisher,* Jakurindō.
Cranes and Sunrise above Waves.
Pheasant and Young Pine Trees on a Hill in Snow.
Monkey under Cherry-blossom. *Publisher,* Jakurindō.
Mandarin Ducks in Water.
Flying Swallows and Peach-blossom in Moonlight.
Parrot and *Pyrus Spectabilis.*
Karashishi and Rocks.
Dragon in Clouds.
Pheasant and Chrysanthemum on top of a Hill.
Sparrows in *Sazanka* (mountain tea-flower, a species of camellia) in Snow.
Bird in Cherry Tree.
*Note :—*The above were issued about the years 1832–1834. On each is an ancient poem.

BIRDS AND FLOWERS. CHŪ-TANZAKU

Sparrows and Bamboo. *Publisher,* Shōyeidō.
Wild Geese crossing the Full Moon. *Seal,* Baka. *Publisher,* Shōyeidō.
Magnolia. *Publisher,* Kawashō.
Egret and Reed. *Publisher,* Kawashō.
Autumn Flowers. *Publisher,* Kawashō.
Hibiscus and small Birds.
Iris and the Eastern Kingfisher.

BIRDS AND FLOWERS. CHŪ-TANZAKU, continued—

Chickens in Snow, back view.
Five flying Swallows.
White Camellia and small Birds.
Owl in Pine tree and Moon.
Green Bird in Persimmon tree.
Two Wild Ducks and Flowering Reeds.
Quail and Poppy.
Macaw in Vines.
Cuckoo and Rain.
Chrysanthemum.
Snail on Pink.
Tessenka (flowering plant).
Iris.
Common Brake and Pheasant.
Crickets and Morning Glory.
Aster and Crane.
Begonia and Dragon Fly.
Ivy and small Bird.
Hawk and Sparrow.
Trout and Hydrangea. *Aizuri.*

Note :—The above were issued about the years 1832–1834. On each is an ancient poem.

Flower and Sparrow. *Publisher*, Kawashō.
Mandarin Ducks and Snow. *Publisher*, Kawashō.
Series representing the Twelve Signs of the Zodiac. *Publisher*, Fujihiko.
Two Water-birds and Reeds on the Suda (Sumida) River. *Publisher*, Murata.
Pheasant on Pine tree in Snow. *Publisher*, Kawashō.
Grey bird with red beak hanging from Magnolia. *Publisher*, Kawashō.
Blue bird and large yellow flower with red centre. *Publisher*, Kawashō.
Mandarin Ducks walking on Ice.
Pair of Quail and Poppies. *Publisher*, Kawashō.
Pair of Sparrows on snow-laden Camellia. *Publisher*, Kawashō.

BIRDS AND FLOWERS. KŌ-TANZAKU

Paper Lantern, Cherry-blossoms and Moon. *Publisher*, Aritaya.
Japanese Bunting and Wistaria. *Publisher*, Marusei.
Green Cuckoo on pink Japonica. *Publisher*, Yamashō.
Kingfisher and Iris. (Signature near middle of sheet on right, with censor's seal above.)
Kingfisher and Iris. (Copy of above ; signature low on right, *seal*, Hiro, no censor's seal.)

HUMOROUS SUBJECTS

Fuji-musume (Wistaria girl) and **Takajō** (falconer), in Ōtsuye style. Ōban Tateye.

Ōkame—an emblem of good luck, in Ōtsuye style. Ōban Tateye.

"Hiakku-iro Banshi." Tales of miscellaneous utensils. A set of 100. *Publisher*, Yamadaya. Ōban Tateye.

Kokkei Chūshingura. The drama of the 47 Rōnin caricatured. *Signed,* Hiroshige kyōgwa (mad drawing). Ōban Tateye.

" Jōrurichō Hanka-no zu." Street stalls and tradesmen in Jōrurichō, Yedo. Caricatures. *Date,* Rat 4 (A.D. 1852). Ōban Tateye.

" Taiheiki Mochi Sake Tatakai." Battle between Mochi (rice cake) and Sake. *Publisher,* Maruya Seijiro, Shimmeimaye Shiba. 3-sheet.

" Mochi Sake Nihen Kasei-no Tatakai." The second war between Mochi (rice cake) and Sake (rice wine). *Publisher,* Maruya Seijirō. 3-sheet.

Ongioku Sekai Awase. Scenes from different plays, combined and caricatured. Snow scene. *Publisher,* Ibasen. 3-sheet.

Shinsei Tobaye Soroi. New series of Tobaye, after the style of drawings by Toba Sojō. *Publisher,* Aito; *date,* Dog 10 (1850). Ōban Yokoye.

Hizakurige Dochū Suzume. Humorous adventures of the two travellers Yajirobei and Kitahachi on the Tōkaidō. *Publisher,* Tsutaya. Ōban Yokoye. Only seven have been identified.

Kyōka Neboke Hyakushu. The Hundred Comic Poems. *Publisher,* Echizenya. Chū-tanzaku. The actual number issued is not known.

HARIMAZE

(Full-sized sheets with several subjects on each—to be cut up.)

Tōkaidō Harimaze Dzuye. Mixed prints of the Tōkaidō. 55 on 12 sheets. *Publisher,* Ibasen, the first sheet also with mark of Marusei.

Tōkaidō Harimaze Dzuye. Mixed prints of the Tōkaidō. 55 on 14 sheets. *Publisher,* Senichi.

Tōkaidō Gojūsan Harimaze Dzuye. Mixed prints of the 53 stations of the Tōkaidō. 55 on 15 sheets. *Publisher,* Yamaguchi.

Kuni Dzukushi Harimaze Dzuye. Mixed prints of Views in the Provinces. 68 on 18 sheets. *Publisher,* Fujikei (1852).

Yedo Meisho Harimaze Dzuye. Mixed prints of Views of Yedo. 10 sheets. *Publisher,* Yamadaya.

Ōyama Dochū Harimaze Dzuye. Mixed prints of the Road to Ōyama Shrine. 3 sheets. *Publisher* unknown. *Seal date,* Horse Year. (1846 or 1858.)

2-SHEET PRINTS

Ushiwaka-maru fighting with Kumasaka Chōhan. Scene from a drama. *Publisher,* Iwatoya. Nimai-tsuzuki.

Momiji Gari. Taira-no Koremochi defending himself in a storm from the man-eating goblin disguised as a Princess. Scene from the drama, *Momiji Gari.* *Publisher,* Iwatoya. Nimai-tsuzuki.

Kanki and Watōnai. The Adventure of the Strong Man, Watōnai, in the Palace of Prince Kanki. Scene from a drama. *Publisher*, Daikokuya. Nimai-tsūzuki. *Note :*—The aforementioned prints are examples of Hiroshige's earliest work—done perhaps before 1817.

Shichifukujin. The Seven Gods of Good Fortune in the Treasure-ship (*Takarabune*). *Publisher*, Sanoki. Kakemono-ye.

Snow Gorge. (No title.) The Fujikawa in Snow : known also as the " Snow Gorge." *Publisher*, Sanoki (about 1832). Kakemono-ye.

Botan ni Kujaku. Peacock on Rock, with Peonies. Kakemono-ye.

Setchū Matsu ni Taka. Hawk, Pine Tree and Snow. *Publisher*, Sanoki. Kakemono-ye.

Sugawara-no Michizane, the Patron of Literature, riding on an Ox. *Publisher*, Sanoki. Kakemono-ye.

Kōyō Saruhashi-no Dzu. Monkey Bridge in Moonlight. *Publisher*, Tsutaya. Kakemono-ye.

Shōki, the Demon-queller. *Publisher*, Tsutaya. Kakemono-ye.

Oni-no Nenbutsu. A Demon offering Prayers. *Publisher*, Marusei. Kake-mono-ye.

3-SHEET PRINTS BY HIROSHIGE I

Note :—All are 3-sheet upright prints (*Tateye Sammai-tsūzuki*), except where otherwise stated.

Festival of the Asakusa Temple of Kwannon. Asakusa Temple during the sixty-days celebration held on the occasion of the 1,200th anniversary of the finding of the image of Kwannon in the sea, in the 36th year of the Emperor Suiko (A.D. 628). The tablet in the right-hand top corner consists of advertisements ; below is an advertisement of a pamphlet describing the history of the image. *Publisher*, Yeijudō. *Dated* Bunsei 10th year (1827).

Imayō Shiki-no Tsuya. Beauties in the fashions of the Four Seasons. A set of 4. *Publisher*, Daikokuya, Yotsuya. (Early work, before 1830.)

Shiju Schichiki Yo-uchi. The 47 Rōnin crossing Ryōgoku Bridge after their successful attack on the house of their lord's enemy. *Publisher*, Sanoki. Yokoye Sammai-tsūzuki.

Onna Giōretsu Takanawa-no Dzu. Procession of Women at Takanawa. *Publisher*, Kikakudō. Yokoye Sammai-tsūzuki.

Ōi, on the Tōkaidō. Travellers crossing the River. Yokoye Sammai-tsūzuki.

Sumida Tsutsumi Yamiyo-no Sakura. Three Women on the banks of the Sumida, on a night in Spring. *Publisher*, Iseichi.

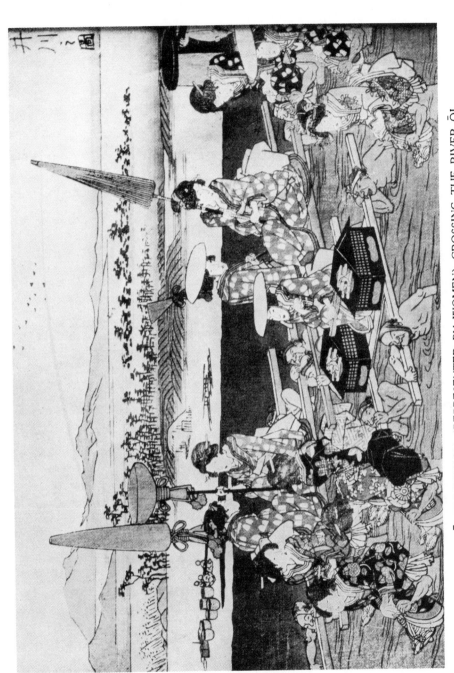

A DAIMYŌ PROCESSION (REPRESENTED BY WOMEN) CROSSING THE RIVER ŌI.

The Centre Sheet of a 3-sheet Print.

Mutsu Adachi Domeki-yeki Hakkei-no Dzu. 8 Views of Domekiyeki, Mutsu Province. *Publisher*, Yamato.

Tōto Meisho. Famous Views of Yedo. A series. *Publisher*, Jōkin.

—— (Another set.) *Publisher*, Wakasaya.

Tōkaidō Kawa Dzukushi. The Rivers of the Tōkaidō, with women. *Publisher*, Fujikei.

Settsugeka-no Uchi. Snow, Moon and Flower Series. *Publisher*, Ibasen.

Yedo Meisho Shiki-no Nagame. Views of Yedo in the Four Seasons. *Publisher*, Marujin.

Snow, Moon and Flowers. A set of 3. *Publisher*, Tsutaya, Snake Year, 1857.

Kisoji-no Yamakawa. Mountain and River on the Kiso Road. *Signed*, Hiroshige fude, on right sheet only.
Note :—There is a dangerous copy without the small peak at junction of right and centre sheets, on sky-line.

Buyō Kanazawa Hatsshō Yakei. Panorama of the Eight Views of Kanazawa under a Full Moon.

Awa-no Naruto. The rapids at Naruto.
Note :—The foam of the rapids is compared with flowers.

Tōto Meisho. Views of Yedo. Daimyō's Mansions at Kasumigaseki. *Dated* A.D. 1851.

Tōto Meisho, Ryōgoku Yū-Suzumi. Young women on the banks of the Sumida River, near Ryōgoku Bridge; Summer evening. *Publisher*, Wakasaya, Shimmei Maye, Shiba.

Shinagawa. View at the time of ebb tide. *Publisher*, Tsutaya.

Uyeno Cherry-blossom in Spring-time. *Publisher*, Sanoki.

Yedo: the Yoshiwara. *Publisher*, Tsutaya.

Yedo: General View of the Nihon-bashi Fish-market. *Publisher*, Tsutaya.

Yedo: General View of the Daimyō Mansions, Kasumi-ga Seki. *Publisher*, Tsutaya.

Tōto Nishiki Gioretsu. Daimyō's procession represented by women. *Publisher*, Nōyasu; *dated* 1852.

Tōto Nihon-bashi Giōretsu. A daimyō's procession passing Nihon-bashi. *Publisher*, Isekane; *date*, Boar Year (1851).

Tōto Ōdemmachō Hanyei-no Dzu. A scene in Ōdemmachō Street in Yedo, with Mt. Fuji and a stork as emblems of Good Luck. *Publisher*, Sakurai; made by special order.

Sumidagawa Anya-no Sakura. Young women admiring cherry-blossoms at night on the bank of the Sumida. *Publisher*, Iseichi.

Yedo. Summer resort on the Sumida under Ryōgoku Bridge. *Publisher*, Sanoki.

Yedo. Summer resort on the Sumida River, with fireworks.

Sumida-Gawa Watashi-no Dzu. Ferry-boats on the Sumida River. *Publisher,* Yorozuya.

New Year's Day Scene. *Publisher,* Sanoki.

Tōkaidō. Travellers crossing the River Ōi. *Publisher,* Sanoki.

Hakone. A young woman enjoying the scenery at Yumoto (hot spring). *Publisher,* Fujikei.

Hakone. Onsen Yutei-no Dzu. Scene in an inn at Hakone Springs. *Publisher,* Fujikei.

Futami. Women travelling on the beach of Futami, Isé province. *Publisher,* Sanoki.

Hana-no Yen. Picnic under cherry tree. One of the 54 Genji poems popularly represented by three young women. *Publisher,* Yamadaya.

Woman and Child, with plum-blossom, in snow. *Publisher,* Hayashi.

Asukayama Hanami-no Dzu. Picnic parties at Asukayama at the time of cherry-blossom. *Publisher,* Yebisuya; *date,* Hare Year (1855).

Kinryōzan Temple (Buddhist), Asakusa, Yedo. General view. *Publisher,* Tsutaya Kichizō.

Zōjōji Temple, Shiba, Yedo. General view. *Publisher,* Tsutaya.

Kameido Temple, Yedo. General view of the courtyard, in plum-blossom time. *Publisher,* Tsutaya.

Tōyeizan Temple, Uyeno, Yedo. General view. *Publisher,* Tsutaya.

Asakusa Temple, Asakusa, Yedo. General view. *Publisher,* Tsutaya.

Furuichi Iseondo. Iseondo dance at Furuichi, Isé. *Publisher,* Sanoki.

Yedo. Panorama of the precincts of the Hachiman Shrine at Tomigaoka in the Fukagawa district of Yedo. *Signed,* "Ichiryūsai Hiroshige, by special request."

Isé Sangū Miyagawa-no Watashi. Ferry-boats on the Miyagawa en route to the Temple. *Seal date,* 1855.

Enoshima chō-bō-no kei. Coast scene at Enoshima with a daimyō riding on an ox. *Publisher,* Aito, of Shitaya; *engraver,* Sennosuke; *seal date,* A.D. 1860 (special order).

Enoshima. View. *Publisher,* Sanoki.

Enoshima. With female visitors. *Publisher,* Sanoki.

Enoshima. With female visitors. *Publisher,* Yamadaya.

Enoshima. People visiting the Shrine of Benten. *Engraver,* Horitake.

Tōto Kasumigaseki-no Kei. The maid-servant of a daimyō (Goten-Jōchū) going out for a holiday. *Publisher,* Wakasaya.

Dōki Yuki-Asobi. Amusements of children; making a giant snowball. *Publisher,* Kawaguchi.

Setsu Getsu Kwa. Snow, moon, flower. Young women enjoying moonlight night. 1 of a set of 3. *Publisher,* Yoshimura.

Kenkyū Rokunen Yoritomo-Kō Jō Kyō-no Dzu. Yoritomo on his way to visit the Emperor at Kyōto, in the 6th year of Kenkyū. *Publisher,* Uyekin; *date,* Boar Year (1851).

Minamoto-no Yoritomo. Kō Kyōto yori Gekō-no dzu. Yoritomo's procession passing the long bridge on the Toyokawa on his homeward trip from Kyōto. *Publisher,* Yenshūya Hikobei; *date,* Boar Year (1851).

Minamoto-no Yoritomo. Kō Jō Kyō-no dzu. Yoritomo's boats crossing Imagiri on the way to Kyōto. *Publisher,* Hirokō; *date,* Boar Year (1851).

Minamoto-no Yoritomo. Kō Jōraku-no dzu. Yoritomo on his way to visit the Emperor at Kyōto. *Publisher,* Isekane; *date,* Boar Year (1851).

Taira-no Tadamori trying to catch a temple servant whom he supposed to be a devil.

Taira-no Kiyomori watching in his garden, where everything seemed to be changed into a skull.

Ōko uwanari uchi-no dzu. Beating the second wife according to an old custom.

Note.—There are many more 3-sheet prints, but the above are given as examples. Most are of late date.

3-SHEET PRINTS BY HIROSHIGE, WITH FIGURES BY KUNISADA (SIGNING TOYOKUNI)

Furyū Genji Sono-no Ume. Prince Genji in the plum-blossom gardens. *Publisher,* Isekane; *engraver,* Horitake; *seal date,* Ox Year, 1853.

Furyū Genji Suma-no Shiogama. Prince Genji talking with a fisherwoman while enjoying the scenery of Shiogama.

Furyū Genji Suma. Prince Genji watching at the Suma beach.

Note :—The above from a series, number not known.

Genji Series. Viewing a snow scene in the garden of a daimyō. *Publisher,* Isekane; *engraver,* Yokogawa Horitake; *seal date,* A.D. 1857.

Azuma Genji Yuki-no Niwa. Garden scene in snow, representing the story of Prince Azuma Genji. Children making a snow rabbit. *Publisher,* Moriji; *seal date,* A.D. 1854.

Imayo Genji Rojaku awase. Old and young people of the day compared with characters in the story of Prince Genji. *Publisher,* Kagishō at Kanda; *engraver,* Sennosuke.

> View of Yoshi-no yama in Yamato; famous for its cherry-blossom.
> View of the sea-coast at Suma in Sesshū.

Gōhitsu, Genji Teichiu-no yuki.—Snow scene in the garden of Prince Genji. *Publisher*, Aito at Shitaya, Yedo.

Taga-no-Ura-no Fukei. A daimyō and a lady composing a poem on the view of Taga-no-Ura, with Fuji. *Publisher*, Marujin; *seal date*, A.D. 1857.

Tsukuda. View in moonlight, with a lady on a balcony.

Kyōto. Hunting fire-flies on the banks of the Uji River.

Minamoto-no Yoritomo Daibutsu Kuyō-no dzu. Kagekiyo being arrested in the courtyard of the Tōdaiji Temple during the visit of Yoritomo. *Publisher*, Yoshimiya Kunikichi, Ningiochō, Shin-norimonochō, Yedo; *engraver*, Renkichi.

HIROSHIGE II (SHIGENOBU)

Shokoku Meisho Hiakkei. One Hundred Views of Famous Places in the Provinces. A Set of (nominally) 100. *Publisher*, Uwoyei. Ōban Tateye.

The series may not have been completed. The Catalogue of the Memorial Exhibition enumerates 80; 75 are in the Victoria and Albert Museum. Each list appears to include a few not in the other. The titles following are those in the V. & A. Museum.

Note :—Sheep Year is 1859, Monkey Year 1860, and Cock Year 1861.

Subject.	Province.	Date.	
1. Megane-bashi (bridge) at Ōtani	Yamashiro	Sheep	10
2. Festival of Gion Temple	Yamashiro	Sheep	8
3. Summer Resort on the River Kamo	Yamashiro	Sheep	8
4. Temple of Hase	Yamato	Sheep	8
5. Yoshino-Yama in Springtime	Yamato	Sheep	10
6. Pine-tree at Naniwaya Garden, Sakai	Izumi	Sheep	10
7. Maple leaves at Ushitaki	Izumi	Sheep	2
8. Festival of Tenjin on Yodo River, Ōsaka	Settsu	Monkey	3
9. Light-house of Tempōzan	Settsu	Sheep	10
10. Nunobiki Fall	Settsū	Sheep	10
11. Kaikoyama	Iga	Cock	5
12. View of Futami Beach	Isé	Sheep	8
13. Ferry-boat on Miyakawa	Isé	Sheep	10
14. Festival of Tsushima	Owari	Sheep	8
15. The Castle of Nagoya	Owari	Sheep	11
16. Mount Akiba as seen from Fukuroi	Tōtōmi	Sheep	11
17. Fuji as seen from Hara	Suruga	Monkey	10
18. Large Cedar-tree called Yatate-Sugi	Kai	Sheep	9
19. Gongen Temple, Hakone	Izu	Sheep	11
20. Shichirigahama	Sagami	Sheep	5
21. Kameki Restaurant, Yokohama	Musashi	Monkey	11
22. In Chichibu Mountain	Musashi	Sheep	7
23. Takanawa Embankment, Yedo	Musashi	Cock	9

Shokoku Meisho Hiakkei, *continued—*

Subject.	Province.	Date.	
24. Noge, the entrance to Yokohama	Musashi	Sheep	10
25. Nihonji (temple) on Nokogiriyama	Awa	Sheep	11
26. Kwannon Temple at Kasamori	Shimōsa	Sheep	11
27. Narita Temple	Shimōsa	Sheep	4
28. Dai Jingū Temple at Funahashi	Shimōsa	Monkey	4
29. Togihari Tōge	Ōmi	Cock	5
30. Ochiai Bridge	Mino	Cock	5
31. Kagowatashi	Hida	Monkey	9
32. Kusuriyama on the way to Zenkōji	Shinano	Sheep	10
33. Snow view in Kiso Mountain	Shinano	Sheep	10
34. Scene on Lake Suwa in winter	Shinano	Monkey	3
35. Kikyō gahara	Shinano	Monkey	10
36. Mount Togakushi	Shinano	Monkey	10
37. Mount Asama	Shinano	Sheep	9
38. Kirifuri Fall, Nikkō	Shimozuke	Sheep	10
39. Lake Chūzenji	Shimozuke	Monkey	10
40. View of Sotogahama	Mutsu	Monkey	10
41. View of Matsushima	Mutsu	Sheep	4
42. Chōkaizan	Dewa	Monkey	9
43. Drying sole fish	Wakasa	Sheep	12
44. Mikuni Harbour	Echizen	Monkey	2
45. Daijō-ji (temple) Kanazawa	Kaga	Sheep	11
46. View of Tateyama	Etchū	Sheep	9
47. Niigata Harbour	Echigo	Sheep	9
48. Gold-mine	Sado	Sheep	11
49. Ama-no Hashidate	Tango	Sheep	10
50. Taka-no Hama	Tajima	Sheep	11
51. View of Shimotani	Hōki	Sheep	11
52. View of Hirose	Izumo	Sheep	11
53. Takibi-no Yashiro	Oki	Cock	9
54. Maiko Beach	Harima	Sheep	9
55. Ferry-boat at Ichikawa, Himeji	Harima	Sheep	9
56. Snow view of Muronotsu	Harima	Sheep	10
57. Tatsu-no Kuchi-yama in rainstorm	Bizen	Monkey	2
58. Torii of Miyajima	Aki	Sheep	7
59. Kintai-bashi, Iwakuni	Suwo	Sheep	11
60. Hunting for mushrooms at Kumano	Kii	Monkey	9
61. Nachi Waterfall	Kii	Sheep	12
62. Kata-no Ura	Kii	Sheep	8
63. Awa-no Naruto	Awa	Sheep	8
64. Kubotani Beach	Sanuki	Sheep	11
65. Gokenzan	Sanuki	Sheep	11
66. Catching wild geese in Iyo	Iyo	Cock	1
67. Tomb of Miyamoto Musashi, Kokura	Buzen	Sheep	12
68. Hidakama Fuchi	Bungo	Sheep	12
69. Hunting whale at Gotō	Hizen	Sheep	8
70. Megane-bashi (bridge), Nagasaki	Hizen	Sheep	11
71. Chinese junk at Nagasaki	Hizen	Sheep	11

Shokoku Meisho Hiakkei, *continued*—

Subject.	Province.	Date.
72. Tea-house at Maruyama	Hizen	Sheep 10
73. Dancing party at Makurazaki	Satsuma	Sheep 12
74. Coast of Tsushima	Tsushima	Monkey 10
75. Theatre signs in Saruwakachō, Yedo	Musashi	Monkey 10

Yedo Meisho Dzuye. Views of Noted Places in Yedo. *Publisher*, Fujikei ; *engraver*, Horikane Horichō. (1861.) A set of not less than 51. Ōban Tateye.

Shrine of Benten, Shinobazu.
Temple of Shirahige Myōjin.
Monzeki (branch of Hongwanji), Tsukiji.
Nishi (west) Arai.
Myōhōji (temple), Horinouchi.
Shōhei-bashi (bridge).
Hōsenji (temple), Nakano.
Ushi Tenjin (temple).
Iris flowers at Hori Kiri.
Komababa.
Gohiaku-Rakanji (Temple of 500 Rakans).
Konnō-cherry tree. Shibuya.
Sekiya-no Sato (Village of Sekiya).
Kaianji (temple).
Nedzu.
Takada-no Baba.
Yoshiwara.
Ushigozen.
Susaki.
Inari Temple at Ōji.
Hanayashiki, Asakusa.
Ryōgoku-bashi.
Yemon-zaka.
Hachiman Temple, Kuramaye.
Tenjin Temple, Kameido.
Asukayama.
Asakusa Temple.
Miyuki-no Matsu (name of the pine-tree).
Shrine of Benten, Haneda.
Yeitai-bashi.
Festival of Shimba.
Sendagaya.
Tōyeizan, Uyeno.
Dentsū-in (Buddhist Temple).
Hyakka-yen (Flower Garden).
Sakurada.
Rengeji (Buddhist Temple).
Nihon-bashi.
Yoroi-no Watashi (ferry).
Hakkeizaka.
Daimondōri (street name).
Taki-no Kawa, Ōji.
Myōken Temple (Buddhist) in Yana-gishima.
Waterfall of Jūnisō.
Sumidagawa.
Hikawa Temple (Shinto), Akasaka.
Heikenji, Kawasaki.
Nippori Village.
Yedo-bashi (bridge).
Giōninzaka.
Flower Gardens in Somei.
Dō Kwanyama.
Akabane.
Matsuchiyama.
Tennōji.
Hachiman Temple (Shinto), Fuka-gawa.
Sanno Temple (Shinto).

Yedo Meisho Hakkei. Pictures of Women, with Views of Yedo. A set of 8. Ōban Tateye. *Signed*, Shigenobu.

Shokoku Rokujū Hakkei. 68 Views of the Provinces. A series of 68. *Publisher*, Tsutakichi. Chūban Tateye.

Yedo Meisho Shijū Hakkei. 48 Views of Yedo. A series of 48. *Publisher*, Tsutakichi. Chūban Tateye.

Tōto Shiki Meisho Dzukushi. Famous Views of Yedo in each of the Four Seasons. By Hiroshige II and Kunisada. *Publisher*, Kameyei at Shitaya in Yedo. *Engraver*, Koizumi Horisen. *Signed*, Hiroshige and Toyokuni, aged 77 (Kunisada) (A.D. 1861). Ōban Tateye.

Furyū Kwacho-no Nagame. Artistic flowers and birds. A series. *Publisher*, Yamajin. *Signed*, Shigenobu.

Silk-worm Industry. *Publisher*, Yamajin. *Signed*, Shigenobu.

Harugeshiki Iriya-no Hanyei. Prosperous scene at a restaurant in Iriya in spring-time. Geisha girl washing her hands. *Publisher*, Tsujiyasu. Ōban Tateye. *Date*, Tiger 12 (1854). *Signed*, Shigenobu.

Tōsei Mitate Gōsekku. The Five Festivals, illustrated by women. A set of 5. *Publisher*, Yamajin. Ōban Tateye. *Signed*, Ichiyūsai Shigenobu.

Ōigawa Kachiwatari. Travellers crossing the River Ōi. *Publisher*, Sanoki ; *seal date*, 1852. *Signed*, Shigenobu. 3-sheet.

Travellers crossing the River Ōi. (Another version.) *Signed*, Shigenobu. 3-sheet.

Procession of Children. *Signed*, Shigenobu. 3-sheet.

Abe Yasunari making an incantation to discover the true form of the Court lady Tamamono-maye (the nine-tailed fox). *Signed*, Ichiyūsai Shigenobu. 3-sheet.

Views (2) of Enoshima. *Signed*, Ichiyūsai Shigenobu. 3-sheet.

Nitta Yoshisada throwing his sword into the sea, as a sacrifice to obtain a low tide, in order that his army might cross. *Signed*, Ichiyūsai Shigenobu. 3-sheet.

Shin Yoshiwara Nakanochō. The Nakana street of the Yoshiwara. *Publisher*, Sanoki. *Signed*, Shigenobu. 3-sheet.

View of Enoshima with figures on the Beach. Landscape by Hiroshige II : figures by Kunisada in his seventy-eighth year. *Publisher*, Moriji ; *engraver*, Mino ; *seal date*, Cock Year, 1861.

JAPANESE CHRONOLOGY

For the Period covered by Hiroshige and his Pupils

Year of Our Lord.	Japanese Period.	Name of the Year.	Year of Our Lord.	Japanese Period.	Name of the Year.
1789	Kwansei	Cock	1829	Bunsei	Ox
1790		Dog	1830	Tempō	Tiger
1791		Wild Boar	1831		Hare
1792		Rat	1832		Dragon
1793		Ox	1833		Snake
1794		Tiger	1834		Horse
1795		Hare	1835		Sheep
1796		Dragon	1836		Monkey
1797		Snake	1837		Cock
1798		Horse	1838		Dog
1799		Sheep	1839		Wild Boar
1800		Monkey	1840		Rat
1801		Cock	1841		Ox
1802	Kiōwa	Dog	1842		Tiger
1803		Wild Boar	1843		Hare
1804	Bunkwa	Rat	1844	Kōkwa	Dragon
1805		Ox	1845		Snake
1806		Tiger	1846		Horse
1807		Hare	1847		Sheep
1808		Dragon	1848	Kayei	Monkey
1809		Snake	1849		Cock
1810		Horse	1850		Dog
1811		Sheep	1851		Wild Boar
1812		Monkey	1852		Rat
1813		Cock	1853		Ox
1814		Dog	1854	Ansei	Tiger
1815		Wild Boar	1855		Hare
1816		Rat	1856		Dragon
1817		Ox	1857		Snake
1818	Bunsei	Tiger	1858		Horse
1819		Hare	1859		Sheep
1820		Dragon	1860	Mangen	Monkey
1821		Snake	1861	Bunkyū	Cock
1822		Horse	1862		Dog
1823		Sheep	1863		Wild Boar
1824		Monkey	1864	Genji	Rat
1825		Cock	1865	Kei-ō	Ox
1826		Dog	1866		Tiger
1827		Wild Boar	1867		Hare
1828		Rat	1868		Dragon

HIROSHIGE'S PUBLISHERS

Iwatoya
Daikokuya
Yeijudō
Kawashō, Kawaguchi Shōzō, Yeisendō
Yedomatsu
Kawachō
Yamachō
Shimizu
Senichi, Izumiya Ichibei
Marujin
Sanoki, *see* Kikakudō
Marusei
Jakurindō, *see* Wakasaya
Shōyeidō
Senkakudō
Hoyeidō, Takenouchi-Hoyeidō, Reiganjima Takenouchi
Yeisendō, *see* Kawaguchi Shōzō
Takenouchi, *see* Hoyeidō
Kikakudō, Sanoki, Sano-ya Kihei, Sanoya
Fujihiko, Matsubaradō
Matsubaradō, *see* Fujihiko
Tsutaya Jūzaburō, Kōshōdō
Kōshōdō, *see* Tsutaya
Reiganjima Takenouchi, *see* Hoyeidō
Kinjudō, Ikenata Iseri
Iseri, *see* Kinjudō
Kinkōdō, Yamaguchi
Yamaguchi, *see* Kinkōdō
Jōkin

Echizenya
Moriji
Marujin, Yenjudō
Yamashō, Yamadaya Shōbei
Nunokichi
Yenjudō, *see* Marujin
Yetatsu, Yezakiya
Yezakiya, *see* Yetatsu
Aritaya, Arisei
Arisei, *see* Aritaya
Marukyū (Shinagawa-ya)
Dansendō, Ibasen
Sanoya (Kihei)
Murata
Takō
Wakasaya Yoichi, Jakurindō
Muratetsu
Fujikei, Shōrindō
Yamajō
Masatsuji (Tsugi Okaya)
Muraichi
Hayashi-shō
Yamadaya Shōbei, *see* Yamashō
Iseichi
Yamato
Ibasen, *see* Dansendō
Koshihei, Koshimura Heisuke
Sanpei
Hōraidō
Uwo-yei, Uwoya Yeikichi, Shita-ya

Note :—The above are the principal publishers of Hiroshige's prints. The names are given, roughly, in the order in which they first issued his work.

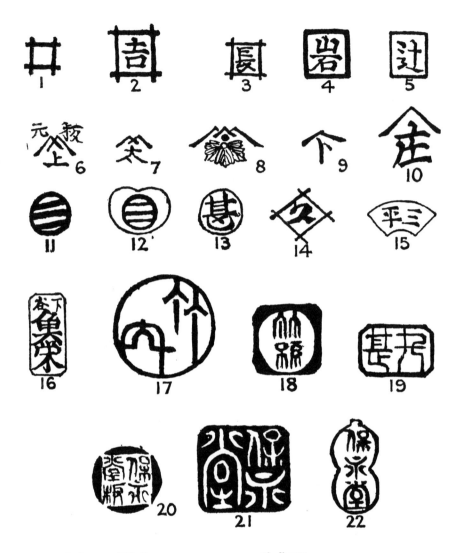

1. Sanoya (Kihei).
2. Hōraidō.
3. Aritaya.
4. Iwatoya.
5. Masutsuji (Tsugi Okaya).
6. Yamajō (Han moto).
7. Yamata.
8. Tsutaya (Tsutaya Kichibei).
9. Yamato.
10. Yamashō (Yamadaya Shōbei).
11. Ibasen.

12. Ibasen.
13. Marujin.
14. Marukyū (Shinagawa-ya).
15. Sanpei.
16. Uwoyei (Shitaya).
17. Takenouchi.
18. Takemago (Takenouchi Magobei).
19. Marujin.
20. Hoyeidō (han).
21. Hoyeidō.
22. Hoyeidō.

SOME PUBLISHERS' MARKS AND SEALS.

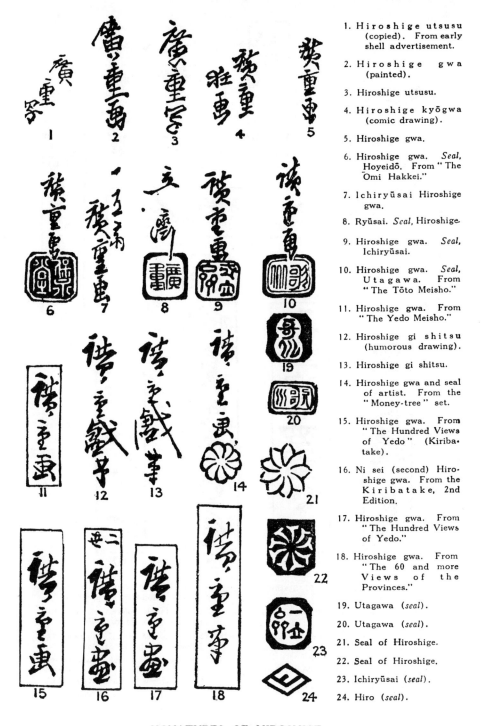

1. Hiroshige utsusu (copied). From early shell advertisement.

2. Hiroshige gwa (painted).

3. Hiroshige utsusu.

4. Hiroshige kyōgwa (comic drawing).

5. Hiroshige gwa.

6. Hiroshige gwa. *Seal*, Hoyeidō. From "The Ōmi Hakkei."

7. Ichiryūsai Hiroshige gwa.

8. Ryūsai. *Seal*, Hiroshige.

9. Hiroshige gwa. *Seal*, Ichiryūsai.

10. Hiroshige gwa. *Seal*, Utagawa. From "The Tōto Meisho."

11. Hiroshige gwa. From "The Yedo Meisho."

12. Hiroshige gi shitsu (humorous drawing).

13. Hiroshige gi shitsu.

14. Hiroshige gwa and seal of artist. From the "Money-tree" set.

15. Hiroshige gwa. From "The Hundred Views of Yedo" (Kiribatake).

16. Ni sei (second) Hiroshige gwa. From the Kiribatake, 2nd Edition.

17. Hiroshige gwa. From "The Hundred Views of Yedo."

18. Hiroshige gwa. From "The 60 and more Views of the Provinces."

19. Utagawa (*seal*).

20. Utagawa (*seal*).

21. Seal of Hiroshige.

22. Seal of Hiroshige.

23. Ichiryūsai (*seal*).

24. Hiro (*seal*).

SIGNATURES OF HIROSHIGE.

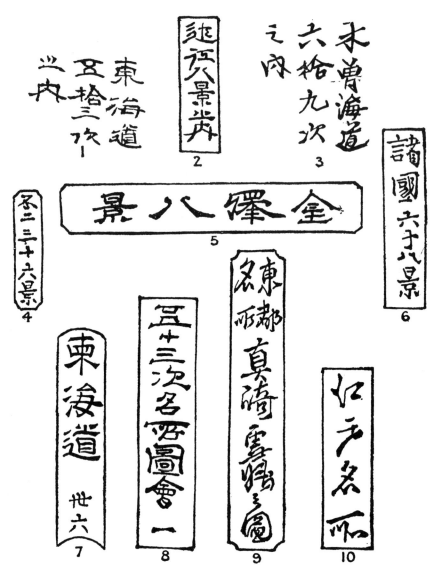

1. Tōkaidō gojūsan tsugi. 53 Stations of the Tōkaidō (1st).

2. Ōmi hakkei-no uchi. 8 Views of Ōmi (Biwa).

3. Kisokaidō rokujū-ku tsugi-no uchi. Views of the 69 Stations of the Kisokaidō.

4. Fuji sanjū rokkei. 36 (Views of) Fuji.

5. Kanazawa hakkei. 8 (Views of) Kanazawa.

6. Shokoku rokujū hakkei. 68 (Views of the) Provinces. (Hiroshige II.)

7. Tōkaidō (sanjū rokkei). No. 36 (of the) Tōkaidō (Marusei Edition).

8. Tōkaidō gojūsan tsugi meisho dzuye. Pictures of the 53 Stations.

9. Tōto meisho. Masaki yukihare-no dzu. Views of Tōto (Yedo). "Clearing weather after snow at Masaki."

10. Yedo meisho. Views of Yedo.

TITLES OF SERIES OF PRINTS.

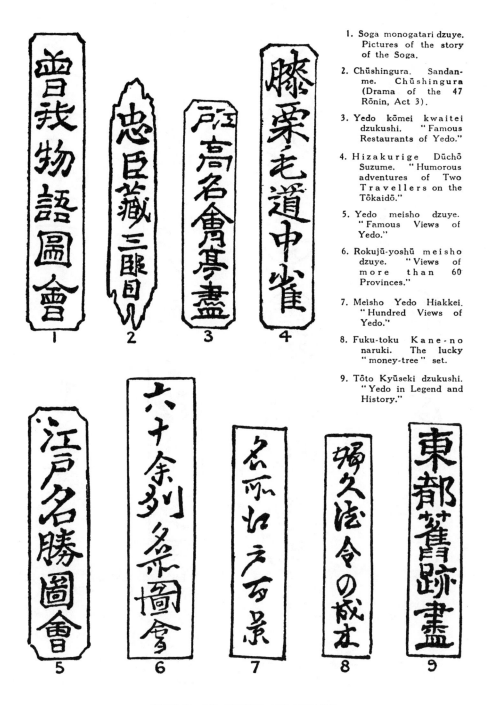

1. Soga monogatari dzuye. Pictures of the story of the Soga.

2. Chūshingura. Sandan-me. Chūshingura (Drama of the 47 Rōnin, Act 3).

3. Yedo kōmei kwaitei dzukushi. "Famous Restaurants of Yedo."

4. Hizakurige Dūchō Suzume. "Humorous adventures of Two Travellers on the Tōkaidō."

5. Yedo meisho dzuye. "Famous Views of Yedo."

6. Rokujū-yoshū meisho dzuye. "Views of more than 60 Provinces."

7. Meisho Yedo Hiakkei. "Hundred Views of Yedo."

8. Fuku-toku Kane-no naruki. The lucky "money-tree" set.

9. Tōto Kyūseki dzukushi. "Yedo in Legend and History."

TITLES OF SERIES OF PRINTS.

201

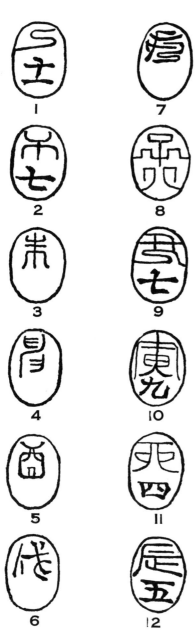

DATE-MARKS OF THE
ZODIACAL CYCLE.

1. Snake, 11 (month).	7. Boar.
2. Horse, 7.	8. Rat *uru* (intercalary).
3. Sheep.	9. Ox, 7.
4. Monkey.	10. Tiger, 9.
5. Cock.	11. Hare, 4.
6. Dog.	12. Dragon, 5.

TITLES AND SIGNATURES OF
HIROSHIGE II (SHIGENOBU).

1. Yedo meisho shijū hakkei. (48 Views of Yedo.)
2. Tōto sanjū roku kei. (36 Views of Yedo.) (1863.)
3. Shigenobu gi gwa. (Shigenobu humorously drawn.)
4. Hiroshige gwa. (Hiroshige painted.) From No. 1.
5. Hiroshige gwa. (Hiroshige drawn.) From No. 2.

202

INDEX